The Sounds of Silent Films

Palgrave Studies in Audio-Visual Culture

Series Editor: **K.J.Donnelly**, University of Southampton, UK

Advisory Board: **Philip Brophy**, Australia, **Michel Chion**, University of Paris III: Sorbonne Nouvelle, France, **Sean Cubitt**, Goldsmiths, University of London, UK, **Claudia Gorbman**, University of Washington Tacoma, USA, **Lev Manovich**, Graduate Centre, CUNY, USA and **Elisabeth Weis**, Brooklyn College, CUNY, USA.

The aesthetic union of sound and image has become a cultural dominant. A junction for aesthetics, technology and theorisation, film's relationship with music remains the crucial nexus point of two of the most popular arts and richest cultural industries. Arguably, the most interesting area of culture is the interface of audio and video aspects, and that film is the flagship cultural industry remains the fount and crucible of both industrial developments and critical ideas.

Palgrave Studies in Audio-Visual Culture has an agenda-setting aspiration. By acknowledging that radical technological changes allow for rethinking existing relationships, as well as existing histories and the efficacy of conventional theories, it provides a platform for innovative scholarship pertaining to the audio-visual. While film is the keystone of the audio-visual continuum, the series aims to address blind spots such as video game sound, soundscapes and sound ecology, sound psychology, art installations, sound art, mobile telephony and stealth remote viewing cultures

Titles include:

Claus Tieber and Anna K. Windisch (*editors*)
THE SOUNDS OF SILENT FILMS
New Perspectives on History, Theory and Practice

Jack Curtis Dubowsky
INTERSECTING FILM, MUSIC, AND QUEERNESS

K.J.Donnelly and Ann-Kristin Wallengren (*editors*)
MAKING MUSIC FOR SILENT FILMS

Palgrave Studies in Audio-Visual Culture
Series Standing Order ISBN 978–1–137–42975–9 hardcover
Series Standing Order ISBN 978–1–137–42976–6 paperback
(*outside North America only*)

You can receive future titles in this series as they are published by placing a standing order. Please contact your bookseller or, in case of difficulty, write to us at the address below with your name and address, the title of the series and one of the ISBNs quoted above.

Customer Services Department, Macmillan Distribution Ltd, Houndmills, Basingstoke, Hampshire RG21 6XS, England

The Sounds of Silent Films
New Perspectives on History, Theory and Practice

Edited by

Claus Tieber
University of Vienna, Austria

Anna K. Windisch
Austrian Academy of Sciences, Austria

Introduction, selection and editorial matter © Claus Tieber and
Anna K. Windisch 2014
Individual chapters © Respective authors 2014
Foreword © Rick Altman 2014
Softcover reprint of the hardcover 1st edition 2014 978-1-137-41071-9

All rights reserved. No reproduction, copy or transmission of this publication may be made without written permission.

No portion of this publication may be reproduced, copied or transmitted save with written permission or in accordance with the provisions of the Copyright, Designs and Patents Act 1988, or under the terms of any licence permitting limited copying issued by the Copyright Licensing Agency, Saffron House, 6–10 Kirby Street, London EC1N 8TS.

Any person who does any unauthorized act in relation to this publication may be liable to criminal prosecution and civil claims for damages.

The authors have asserted their rights to be identified as the authors of this work in accordance with the Copyright, Designs and Patents Act 1988.

First published 2014 by
PALGRAVE MACMILLAN

Palgrave Macmillan in the UK is an imprint of Macmillan Publishers Limited, registered in England, company number 785998, of Houndmills, Basingstoke, Hampshire RG21 6XS.

Palgrave Macmillan in the US is a division of St Martin's Press LLC, 175 Fifth Avenue, New York, NY 10010.

Palgrave Macmillan is the global academic imprint of the above companies and has companies and representatives throughout the world.

Palgrave® and Macmillan® are registered trademarks in the United States, the United Kingdom, Europe and other countries.

ISBN 978-1-349-48905-3 ISBN 978-1-137-41072-6 (eBook)
DOI 10.1057/9781137410726

This book is printed on paper suitable for recycling and made from fully managed and sustained forest sources. Logging, pulping and manufacturing processes are expected to conform to the environmental regulations of the country of origin.

A catalogue record for this book is available from the British Library.

A catalog record for this book is available from the Library of Congress.

Transferred to Digital Printing in 2014

Contents

List of Figures and Tables	vii
Foreword	x
Acknowledgments	xiv
Notes on Contributors	xvi

Introduction: 'The Birth of Cinema from the Spirit of Music' 1
Claus Tieber and Anna K. Windisch

Part I The Historical Practice of Silent Film Sound

1 Organizing a Music Library for Playing to Pictures: Theory
vs. Practice in Britain 13
Julie Brown

2 The Formation of a Swedish Cinema Music Practice,
1905–1915 36
Christopher Natzén

3 The Use of Cue Sheets in Italian Silent Cinema: Contexts,
Repertoires, Praxis 49
Marco Targa

4 Music, Singing and Stage Practice in the Cinemas of Upper
Silesia During the 1920s 66
Urszula Biel

5 The Sound of Music in Vienna's Cinemas, 1910–1930 84
Claus Tieber and Anna K. Windisch

6 The *Moving Picture World*, W. Stephen Bush and the
American Reception of European Cinema Practices,
1907–1913 103
James Buhler and Catrin Watts

7 Musical Beginnings and Trends in 1920s Indian Cinema 123
Olympia Bhatt

v

vi *Contents*

Part II New Approaches to Silent Film Music History and Theory

8 Deconstructing the 'Brutal Savage' in John Ford's
 The Iron Horse 141
 Peter A. Graff

9 'The Hermeneutic Framing of Film Illustration Practice':
 The *Allgemeines Handbuch der Film-Musik* in the Context of
 Historico-musicological Traditions 156
 Maria Fuchs

10 Sergei Eisenstein and the Music of Landscape: The 'Mists'
 of *Potemkin* between Metaphor and Illustration 172
 Francesco Finocchiaro

11 Paradoxes of Autonomy: Bernd Thewes's Compositions to
 the *Rhythmus-films* of Hans Richter 192
 Marion Saxer

12 The Tradition of Novelty – Comparative Studies of Silent
 Film Scores: Perspectives, Challenges, Proposals 208
 Marco Bellano

13 Germaine Dulac's *La Souriante Madame Beudet* (1923) and
 the Film Scores by Arthur Kleiner and Manfred Knaak 221
 Jürg Stenzl

Bibliography 251

Index 261

Figures and Tables

Figures

1.1 Library envelope from the Theatre Royal Picture House, Bradford, held at the National Media Museum, Bradford, UK 30

3.1 Carraro, Omero. *Lento appassionato*. Torino: Casa Editrice Musicale Sabauda, 1929, bars 1–8 53

3.2 Rosetta, Giuseppe. *Piccolo Scherzo*. Roma: Italica Ars, 1927, bars 1–9 53

3.3 List from the collection 'Commento Films' in Puligheddu, Giovanni Erminio. *Scena russa* (Firenze: Casa Musicale Florentia, 1930). Courtesy of the Archivio Storico del Comune di Terruggia (AL, Italy) 57

4.1 Announcement for the touring Edison-Theater by M.B. Wilson 67

4.2 'Only first-class worker will be considered' 69

4.3 Announcement for *Nanuk, der Eskimo*, also on stage: opera singer Victor Lenzetti 77

4.4 Announcement of *Land unterm Kreuz* 79

6.1 Caricature of W. Stephen Bush 112

10.1–10.7 Screen shots, *Panzerkreuzer Potemkin – Das Jahr 1905* (Berlin: Deutsche Kinemathek – Museum für Film und Fernsehen, Transit Classics, 2005), DVD. Courtesy of the Deutsche Kinemathek, Berlin 179

10.8 Music score of *Panzerkreuzer Potemkin* by Edmund Meisel, Music Publisher Ries & Erler, 2005 186

10.9 Music score of *Panzerkreuzer Potemkin* by Edmund Meisel, Music Publisher Ries & Erler, 2005 186

10.10 Music score of *Panzerkreuzer Potemkin* by Edmund Meisel, Music Publisher Ries & Erler, 2005 187

viii *List of Figures and Tables*

10.11 Music score of *Panzerkreuzer Potemkin* by
Edmund Meisel, Music Publisher Ries & Erler,
2005 188
10.12 Manuscript page of the original piano
reduction by E. Meisel, Courtesy of the DAMS
Library in Turin 189
11.1 Score example of *ad Rhythmus 21*, bars 25f.,
courtesy of Bernd Thewes (composer) 197
11.2 Process *ad Rhythmus 21 von Hans Richter*
[author's illustration] 199
11.3 and 11.4 Music example, *ad Rhythmus 21 von Hans
Richter*, courtesy of Bernd Thewes (composer) 200
11.5 Counter Movement (*Gegenläufigkeit*) [author's
illustration] 201
11.6 Analysis by Bernd Thewes, courtesy of Bernd
Thewes (composer) 202
11.7 Analysis by Bernd Thewes, Section M, courtesy
of Bernd Thewes (composer) 203
11.8 Score to *Rhythmus 23*, Section M, Courtesy of
Bernd Thewes (composer) 204
12.1 A cycloid curve drawn by musical notes in Joe
Hisaishi's theme for the 'General' locomotive 218
13.1 *La Souriante Madame Beudet*: 'Charlie Adden,
Tennis Champion', from the illustrated
magazine, carries off Monsieur Beudet (7'06),
Germaine Dulac (1922–1928) (Berlin: Absolut
Medien, 2007), DVD 225
13.2 Monsieur Beudet's 'revolver game' (12'06),
Germaine Dulac (1922–1928) (Berlin: Absolut
Medien, 2007), DVD 226
13.3 Arthur Kleiner: Film music for *La Souriante
Madame Beudet*, No. 7: 'Beudet angry' 228
13.4 Film music, No. 8: *The tennis player comes to
life* = Maurice Baron, *Seduction* (New York:
Irving Berlin Standard Music Corporation,
1927); copy from the author's private
collection 230
13.5 Manfred Knaak: Music for Monsieur Beudet's
revolver game, I, mm. 161–65, p. 23 (7'14–32).
Full score, author's edition, © 2005 234
13.6 Province theme: I, mm. 26–40 (1'26–2'02),
analogous to IV, mm. 1–24 (22'44–23'46) 235

List of Figures and Tables ix

13.7 Madame Beudet's theme: I, mm. 19–25
(1'05–1'24). Used at the end of I, mm. 349–59,
and IV, mm. 349–59 (37'17–38'11) for the
intertitle *'En province...'*　　235

Tables

1.1 Index categories for cinema music libraries from British
trade papers　　20
3.1 Italian collections of musical pieces for film
accompaniment　　56

Foreword

Not so very long ago, a foreword to a volume on film sound could be counted on to begin with a lament about sound's 'poor relation' status. In the real world, we would be told, hearing is subordinated to vision. In society, we would be reminded, sounds take a back seat to images. In the academy, it would be noted, the soundtrack is regularly neglected in favor of image analysis.

We don't need Bob Dylan to tell us that, for the study of film sound, 'the times they are a-changin'. When I edited the Cinema/Sound volume of *Yale French Studies* in 1980, there was virtually nothing else available on film sound.[1] Since that time manifold special journal issues have been devoted to the film soundtrack, including *Cinegrafie* in Italy, *IRIS* between France and the US, *Film History* in the US and *Cinémas* in Canada. Interest in film sound has increased to the point of spawning multiple international journals devoted to soundtrack issues: *Music, Sound, and the Moving Image*; *The Soundtrack*; *Music and the Moving Image*. Virtually every film- or music-related professional organization has sponsored a conference and/or special sessions on the soundtrack. Now there are even two organizations – *School of Sound* and *Cinesonika* – that sponsor annual film sound-related events.

Since the turn of the century, the film sound bibliography has grown at a dizzying pace. Earlier works by John Belton and Elizabeth Weis, Michel Chion, Don Crafton, Martin M. Marks, Gillian Anderson and Rick Altman have provided important points of reference for 21st-century authors, including James Lastra, Germain Lacasse, Jonathan Sterne, Daniel Goldmark, Douglas Gomery, Charles O'Brien, Giusy Pisano, Robert Spadoni and Alain Boillat, not to mention the increasing number of scholars who have studied local film sound practices (Kathryn Fuller-Seeley in the US, Palle Schantz Lauridsen in Denmark, Martin Barnier in France and Jean-Pierre Sirois-Trahan in Québec, among others) or provided a variety of tools for studying film music (Claudia Gorbman; Royal Brown; Kathryn Kalinak; Mervyn Cooke; Roger Hickman; Lawrence E. MacDonald; James Wierzbicki; Daniel Goldmark, Lawrence Kramer and Richard Leppert; James Buhler, David Neumeyer and Rob Deemer; James Buhler and David Neumeyer; Jennifer Fleeger; Mike Slowik).

Foreword xi

Twentieth-century musicology students who had the effrontery to suggest a dissertation topic on film music were consistently rebuffed by committees that considered film music an inappropriate topic for academic music study. Now, around the world, that prejudice is disappearing as one institution after another implicitly sanctions film sound study by accepting soundtrack-oriented dissertation topics. Over the past couple of decades, the University of Iowa alone has produced nearly a dozen dissertations on various aspects of film sound.

In addition, every year brings a new collection of essays on film sound topics. If at first these volumes concentrated on American cinema (Rick Altman's *Sound Theory/Sound Practice*; Pamela Robertson Wojcik and Arthur Knight's volume entitled *Soundtrack Available: Essays on Film and Popular Music*; James Buhler, Caryl Flinn and David Neumeyer's book *Music and Cinema*; Jay Beck and Tony Grajeda's *Lowering the Boom: Critical Studies in Film Sound*), they now increasingly target European practices (from the US, major portions of Richard Abel and Rick Altman's *The Sounds of Early Cinema*; from Belgium, Didier Huvelle and Dominique Nasta's bilingual collection on *New Perspectives in Sound Studies/Le son en perspective: nouvelles recherches*; from France, Giusy Pisano and Valérie Pozner's *Le Muet a la parole*; from Great Britain, Julie Brown and Annette Davison's *The Sounds of the Silents in Britain*; and now, from Austria, Claus Tieber and Anna K. Windisch's *The Sounds of the Silents*).

Where does this leave us? For many years we have been so concerned about filling in the blanks left by decades of soundtrack neglect that we have not always taken the time to ask ourselves just what kind of attention to the soundtrack is needed. Now that work on the soundtrack has actually become a privileged area for academic endeavors we need to pause long enough to analyze and understand what it is that we are doing.

Have we fallen into a rut? Is what we are doing just more of the same? Are we simply extending a type of textual analysis inherited from musicology, music theory and literary semiotics? Is that what we should be doing? Or do we need to be trying something new?

Over 20 years ago, I offered a tentative answer to that question. Looking back in the 1992 Introduction to *Sound Theory/Sound Practice* at the 1980 Cinema/Sound issue of *Yale French Studies*, I noted that most of the Cinema/Sound articles 'treat cinema as a series of self-contained texts, divorced from material existence and the three-dimensional world'. Calling the issue 'heavily marked by the project of semiotics', I somewhat reluctantly concluded that 'Cinema/Sound clearly bears the stamp of its text-oriented era'.

xii Foreword

My response to this situation was rather unexpected, and at first not greeted with the success I had hoped for. I insisted that our work on sound needed to diverge from the familiar textual strategies inherited from literary semiotics and classical music analysis. Championing what I termed a 'cinema as event' approach, I suggested that subsequent sound scholarship should attend to much more than the film image and the narrow range of sounds specifically produced to coordinate with that image. I argued that a full understanding of film sound required careful treatment of ALL the components of the filmic experience: theater location and architecture, projection technology, sound recording and playback equipment, musical and sound effect instrumentation, and much more.

To my great delight, I find that the essays offered by Claus Tieber and Anna K. Windisch in this volume systematically heed my now decades-old call for a performance-oriented approach concentrating on the full cinematic event. In many different ways, the articles in this collection harken to the editors' call to deal with silent cinema sound in all its heterogeneous complexity. Julie Brown studies the music libraries without which no film theater of the teens and twenties could subsist. Christopher Natzén concentrates on film theater programs. Marco Targa analyzes Italian cue sheets. Claus Tieber and Anna K. Windisch take a careful look at the Vienna soundscape. Urszula Biel assesses musicians' working conditions. James Buhler and Catrin Watts analyze trade papers. Olympia Bhatt examines contemporary film technology. Maria Fuchs delves into the complex world of published accompaniment manuals. Peter A. Graff, Francesco Finocchiaro, Marion Saxer, Marco Bellano and Jürg Stenzl offer detailed analysis of specific scores.

We come away from a close reading of this collection of articles with a broadened sense of what cinema study is about. Cinema, as defined by Tieber and Windisch, is not just a collection of texts. It involves everything relating to the performance of films. It defines films as live events. This collection of essays thus follows in the line sketched out by Jeff Smith in his pioneering treatise *The Sounds of Commerce: Marketing Popular Film Music*, by Steve Wurtzler in his masterful *Electric Sounds: Technological Change and the Rise of Corporate Mass Media* and most recently by Katherine Spring's *Saying It With Songs: Popular Music and the Coming of Sound to Hollywood Cinema*. Instead of restricting their work to sounds designed to accompany the film image, these innovative scholars have looked at the broader soundscape that conditions and defines cinema soundtracks.

To be sure, it is easier to frame silent cinema as a live performance event than it is to imagine synchronized recorded soundtracks as live.

Foreword xiii

So much effort has gone into hiding sound technology that we all too easily understand film sound as emanating 'naturally' and 'directly' from the film image. Yet we know perfectly well that cinema sound comes from loudspeakers and not from characters. So why are there not more studies of loudspeakers? Where are the analyses of microphones, recording systems and theater acoustics? And, outside of a brilliant book by Vanessa Ament (*The Foley Grail*), where are the accounts of sound effect creation, editing and recording? We are finally beginning to attend seriously to film music, but even there we very much need more careful attention to the broader context of film music production. In addition to score study and textual analysis, we need to consider such topics as the musical background of silent film accompanists, the shifting constitution of picture palace orchestras and the variations in music recording practices at different studios and in various countries.

For the time being, then, we have much to learn from studying silent film sound. The performative nature of so-called sound cinema is clearly harder to imagine than the live nature of so-called silent cinema. For many years, the study of film sound was virtually restricted to sound cinema, but current scholars have clearly understood that the study of silent film sound has something special to offer. Because silent film sound can more readily be understood as the product of an event, scholarship on silent film sound provides a particularly good model for the study of sound throughout the media. By attending to the performative nature of silent film events, we gain especially useful knowledge about the broader theoretical problem of how to study film sound.

The good news is that Claus Tieber, Anna K. Windisch and the authors published in *The Sounds of Silent Films* have fully understood the importance of defining film sound broadly, as live and performative. What you will find in the pages that follow is thus an appropriate introduction to a new kind of cinema history, an approach that sees cinema more as a series of events than as a collection of texts. The times they are indeed a-changin'.

Rick Altman
University of Iowa

Note

1. Rick Altman, 'Introduction', *Yale French Studies: Cinema/Sound* 60 (1980): 1–15.

For all other references in this foreword, please see the volume's concluding bibliography.

Acknowledgments

The editors of this book would like to thank the following people for their valuable assistance and contributions: Julie Brown, Annette Davison and Maurizio Corbella for lending their informed advice to the preparation of this publication; Rick Altman for kindly contributing a foreword to this volume; and Willem Strank, Tarek Krohn and Guido Heldt for their insightful comments and close readings of articles in the early editorial process.

Special thanks go to Chris Penfold and his team at Palgrave Macmillan for their continuous support, patience and indispensable advice at different stages of the project, as well as to Kevin Donnelly, editor of the *Audio-Visual Cultures* series. We particularly thank Francis Arumugam and Wendy Toole for their patience and editorial vision that competently guided us through the production process of this book.

We are grateful to Sam Osborn, J. Bradford Robinson and Iweta Kulczycka for their translations of the chapters by Maria Fuchs, Jürg Stenzl and Urszula Biel. Thanks to the Kiel Society for Film Music Research (Anna Ehsani for supplying the graphic design for the conference print matter; Simone Vrckovski and all the assiduous hands on location) for hosting the event that led to this publication; and Martin M. Marks for lending his skills as a performer to accompany a screening of *Broken Blossoms* (1919) and thereby creating an unforgettable event for the conference participants.

The Sounds of Silent Films could not have been made without the financial support of the Austrian Science Fund (FWF), which funded the research project 'The Sounds of Silents. Sound and Music in Viennese Cinemas, 1896–1930'. We are grateful to the German Research Foundation (DFG) for their generous support of the conference in Kiel. We are indebted to Bernd Thewes and Manfred Knaak for their permission to print excerpts from their scores. We kindly thank music publisher Ries & Erler for their permission to print excerpts from the score to *Panzerkreuzer Potemkin* by Edmund Meisel, and the DAMS Library at the University of Turin and the Comune di Terruggia for granting the rights to print various items from their collections. We also thank conductor Frank Strobel, Florence Tellier and Beate Warkentien from the

European Film Philharmonic for generously providing such an apt cover illustration for our volume.

Every effort has been made to trace all copyright holders, but if any have been inadvertently overlooked, the publisher will be pleased to make the necessary arrangements at the first opportunity.

We are deeply grateful to all our contributors for their hard work and endless patience with our editorial needling; it has been a rewarding task and a genuine pleasure to work with each one of you.

Finally, the experiences and encounters we have had the pleasure to have throughout the preparation and production of this book speak loudly of another vital concern of this field, that is, the propagation of interest in and curiosity about silent film music and sound to an even wider audience. It must remain integral to our understanding as scholars and educators to foster a dialogue between our work (all too often confined to archives and dreary offices) and the cultural society in general. Therefore we want to give sincere thanks to our authors, collaborators and advisers who are engaging in the instruction, presentation and knowledge transfer on that topic beyond the limits of academia.

Vienna, March 2014

Contributors

Marco Bellano is Adjunct Professor of Music at the University of Padua, Italy. His studies focus on music for silent films and music for animated films. He is the author of *Metapartiture: Comporre musica per i film muti* (2007) and *Animazione in cento film* (with Giovanni Ricci and Marco Vanelli, 2013). He is a member of the editorial board of the cinema journal *Cabiria*. His articles have appeared in the *Journal of Film Preservation* and in the *Animation Journal*. He has been presenting at international conferences and is a main contributor to the educational projects of the Palazzetto Bru Zane – Centre de musique romantique française (Venice), of the Orchestra di Padova e del Veneto and of the Orchestra del Teatro Olimpico, Vicenza. He is studying Composition and Orchestral Conducting at the Conservatory of Vicenza, where he previously graduated in Piano.

Olympia Bhatt is a doctoral candidate at the School of Arts and Aesthetics, Jawaharlal Nehru University, India. Her doctoral research traces the advent of sound technology in 1930s Bombay cinema and investigates how the newly developed sound technology mediated traditional forms of expression and representation. Her prior work experience includes assisting Dr. Annapurna Garimella in curating the art exhibition *Vernacular in the Contemporary*. At present, she is working as Lecturer in the Department of Humanities and Social Sciences at BITS Pilani Hyderabad Campus, India.

Urszula Biel is an independent researcher and film historian who received her PhD in film studies at the Polish Academy of Sciences, Warsaw. Her main subjects concern the cinematographic history and development of Upper Silesia between 1918 and 1939 against the background of Polish–German relations. Her doctoral thesis on the Polish part of this region was published as 'Silesian Cinemas between the Wars', Katowice, 2002. She has published articles in the journals *Movie, Cinema, The World of Cinema* and *Film Quarterly*. She is also managing director of the Art House Cinema AMOK in Gliwice (affiliate of Music Theater Gliwice).

Notes on Contributors xvii

Julie Brown is Reader in Music (Associate Professor) and Director of Graduate Studies in Music at Royal Holloway, University of London. She has published on Schoenberg, Webern and Bartók as well as television soundtracks and uses of music in film. Among her publications are *Bartók and the Grotesque* (2007), *Schoenberg and Redemption* (2014) and the edited collection *Western Music and Race* (2007), wich was awarded the American Musicological Society's Ruth A. Solie Award. She also serves on the advisory boards of the scholarly journals *Music, Sound, and the Moving Image* and *Music Analysis*. Her current research focuses on film music, particularly music of the silent film and transition periods. She was Principal Investigator for the AHRC-funded Research Network 'The Sounds of Early Cinema in Britain' and is currently Principal Investigator for a British Academy Research Development Award entitled ' "Film Fitting" in Britain, 1913–1926', and with Annette Davison is contributing editor of *The Sounds of the Silents in Britain* (2012).

James Buhler is Associate Professor of Music Theory in the Sarah and Ernest Butler School of Music at the University of Texas at Austin. He is an editor of *Music and Cinema* (2000) and a co-author of *Hearing the Movies* (2010). He has published extensively in edited anthologies as well as in *Nineteenth-Century Music, Journal of the American Musicological Society, Cambridge Opera Journal* and *Modernism/Modernity* among others. Along with David Neumeyer and Caryl Flinn, he has edited a collection of essays on film music (2000). He is currently working on *Theories of the Soundtrack*, a comprehensive historical survey of theories of music and sound in film.

Francesco Finocchiaro is Adjunct Professor of Film Music at Conservatoire 'G. Frescobaldi' of Ferrara. His doctoral dissertation in musicology at the University of Bologna was on Arnold Schoenberg's theory of composition. His research interests center on composition, theory and aesthetics in Austro-German music of the 20th century. He translated and edited Schoenberg's theoretical work *Der musikalische Gedanke und die Logik, Technik und Kunst seiner Darstellung*, a book arising from a MIUR sponsored project at the University of Bologna in close collaboration with the Arnold Schoenberg Center and the University of Music and Performing Arts, Vienna. He has worked extensively on film music and is the editor of the journal *Musica Docta*. Further editorial work includes an anthology on *Music and Film in the Weimar Republic* (2012). In 2013 he was awarded the Lise Meitner Scholarship by the Austrian Science Fund (FWF).

xviii *Notes on Contributors*

Maria Fuchs studied musicology, comparative literature and philology, and gender studies at the University of Vienna and at Freie Universität Berlin. Her doctoral thesis in musicology and film studies at the University of Vienna attends to the manner of musical expression and aesthetic context in the seminal film music work *Allgemeines Handbuch der Film-Musik* by Ludwig Brav, Guiseppe Becce and Hans Erdmann (1927), on which she has conducted extensive research at the Deutsche Kinemathek in Berlin funded by a grant by the University of Vienna in 2012. She was dramatic adviser and production assistant for music theater performances in Germany and Switzerland and is a freelance music journalist for the magazine *skug*.

Peter A. Graff is pursuing a PhD in musicology at Case Western Reserve University. His current work investigates film music of the silent and early studio eras. In 2013 Peter completed his MA in musicology at Pennsylvania State University, where his thesis investigates the musical identity of the Indian characters in John Ford's Westerns. Peter has presented at conferences of the College Music Society and the American Musicological Society and in 2012 was awarded a graduate residency award from Pennsylvania State University Institute for the Arts and Humanities.

Christopher Natzén received his PhD in cinema studies at the Department of Cinema Studies from Stockholm University in 2010. Since 2009 he has held a position as archivist and researcher at the Collection and Research Development Division, National Library of Sweden (*Kungliga biblioteket*), primarily involved in the recently completed three-year EU project EUscreen (euscreen.eu), which aims to make television content available on the Web. Currently he is responsible for the National Library's film program project and is also part of the steering committee for the film portal filmarkivet.se, an ongoing collaboration between the National Library and the Swedish Film Institute of making nonfiction films accessible. His research interests focus on sound and music in relation to moving images.

Marion Saxer studied music, musicology, political science, philosophy and science of education in Mainz and Berlin. Since 2013 she has been Professor of Musicology at the Goethe-Universität Frankfurt. Her main areas of research are music since 1950, experimental music, contemporary music theater, origins of opera, and music in changing media landscapes. Recent publications include 'Zeit der Oper – Zeit des

Notes on Contributors xix

Films. Der Rosenkavalier im Stummfilm', in *Musik & Ästhetik* 57 (January 2011): 42–62; and 'Komponierte Sichtbarkeit: Intermodale Strategien in Annesley Blacks Video-Komposition 4238 de Bullion für Klavier solo und live-elektronische Klang- und Videobearbeitung' (2007/08), in Marion Saxer (ed.), *Mind the Gap! Medienkonstellationen zwischen zeitgenössischer Musik und Klangkunst* (2011).

Jürg Stenzl is Professor Emeritus of Musicology at the University of Salzburg, Austria. He completed his academic studies at Bern and Paris-Sorbonne with a PhD in 1968. He was an assistant at Freiburg University (Switzerland) until his habilitation in 1974, followed by a professorship (1980–1992). He held numerous visiting professor positions in Switzerland, Germany, Italy and in the US (2003 visiting professor at Harvard University). In 1993 he completed a second habilitation at the University of Vienna. From 1996 to 2010, he was Professor for Musicology at the University of Salzburg. His books and numerous articles center on music history from the middle ages to the present, as well as on music in the 20th century (in particular Luigi Nono) and on the history of interpretation as well as on film music. Recent publications include *Jean-Luc Godard – Musicien* (2010) and *Auf der Suche nach Geschichte(n) der musikalischen Interpretation* (2012).

Marco Targa obtained his PhD in music history and criticism in 2011 from the University of Turin. He devotes himself to the study of Italian opera and is the author of the book *Puccini e la Giovane Scuola. Drammaturgia musicale dell'opera italiana di fine Ottocento* (2012). He has published articles in reviews and books about Debussy, 19th-century *Formenlehre* and silent film music. He is also a concert pianist. Recent publications include *Sonata e concerto a confronto: Hepokoski-Darcy e la teoria delle forme strumentali della 'Wiener Klassik'*, *Il Saggiatore musicale* XVIII (2012/2): 99–110 and *The Silent Opera: The Beginnings of Melodrama in Cinema*, in *Film Music: Practices and Methodologies* (2013): 169–185.

Claus Tieber studied theater studies, philosophy, political science and communication studies at the University of Vienna. He completed his MA with a thesis on the American Western film and his PhD with a dissertation on the Hollywood gangster films, and obtained his habilitation in 2008. He worked as commissioning editor in the TV movie department of the Austrian Broadcasting Corporation (ORF). Recent publications include *Stummfilmdramaturgie: Erzählweisen des amerikanischen Feature Films 1917–1927* (2011); *Fokus Bollywood: Das indische Kino in*

xx *Notes on Contributors*

wissenschaftlichen Diskursen (ed.) (2009); *Schreiben für Hollywood: Das Drehbuch im Studiosystem* (2008); and *Passages to Bollywood: Einführung in den Hindi-Film,* 2nd edn. (2007).

Catrin Watts is a doctoral student in music theory at the University of Texas at Austin and a graduate of Queen's University, Belfast. She is currently working on 'The Zombification of Popular Music' and 'Blurred Lines: The Use of Diegetic and Non-Diegetic Sound in Atonement (2007)' for conference presentations.

Anna K. Windisch studied theater, film and media studies, French and German philology and communication studies at the University of Vienna. She held a doctoral research fellowship at the Wirth Institute at the University of Alberta (2011/12) and a research assistant position at the University of Salzburg (2012/13). She is an editorial board member of the *Kieler Beiträge zur Filmmusikforschung* and the coauthor of 'Sound Synthesis, Representation and Narrative Cinema in the Transition to Sound (1926–1935)' (with Maurizio Corbella) in *Cinémas,* ed. Martin Barnier and Jean-Pierre Sirois-Trahan (2013). She was awarded a doctoral fellowship by the Austrian Academy of Sciences (2014–2016).

Introduction: 'The Birth of Cinema from the Spirit of Music'

Claus Tieber and Anna K. Windisch

Paraphrasing the title of Friedrich Nietzsche's famous book *The Birth of Tragedy from the Spirit of Music* has been tempting enough to call an introduction to a book about silent cinema music 'The Birth of Cinema from the Spirit of Music'. Music's ability to attract broad and varied audiences, to evoke emotions and to fulfill narrative and structural functions in combination with fictional art forms such as opera and operetta was heavily utilized by the young medium of film. Cinema's special relationship with music had started even before moving images were invented in the early 1890s. Illustrated songs were, at least in the US, a precursor of cinema, insofar as this format helped define the relationship between narrative visual elements and music.[1] Some early films were barely more than technically updated versions of illustrated songs.[2] In fact, music as a cultural practice entertained a crucial relationship with silent film on structural and narrative levels: in cinema's history, the strategies of combining dramatic scenes with music were drawn from prior and contemporaneous media and art forms. This precise convergence of media practices constituted a large part of the attraction for contemporary audiences. Seen in this light, cinema is much more dependent on music and musical formats than is generally acknowledged and this volume aims to address that perspective.

Researching silent cinema music is not just an attempt to fill in the blanks of film history: it entails widening the perspective from the individual film as text towards film as event and performance. Right from cinema's inception the medium became conflated with different art forms and media practices characterized by live performed and technically reproducible elements, mostly deploying music in one way or another. It is thus useful to emphasize the performative, multi- and transmedial aspects of cinema, drawing on an approach that became

2 *The Sounds of Silent Films*

fashionable in the past decades, not least since Rick Altman's appeal to regard *cinema as event* with no 'clear distinctions between inside and outside, between top and bottom'.[3] If we try to disengage from imposing retrospective categories and lines of separation between the various media and art forms of cinema's historical development and instead, as Altman reminds us, view film history *prospectively*, we can find that 'cinema takes on a series of disparate identities, its sound-based affinities with other media often challenging its apparent image-based unity'.[4]

Cinema carries an inherently performative aspect, and this notion is nowhere more apparent than with regard to cinema's sound identity in the silent era. The 'text' of a silent cinema screening is not the film itself, but a *multimedial* and *multimodal event* that consists of film mixed with live performances. Research on silent cinema music tries to reconstruct modes of musical accompaniment for films, the relations acted out between different media and the historical reception of these modes. Given the difficult state of research materials – scarce and all too often lost – these reconstructions can never be complete or final, but this revised approach for the study of silent cinema music can generate an understanding of cinema as a chain of processes of production, exhibition and reception. Such a focus is potentially able to change our comprehension of cinema as a whole by producing new insights into audiovisual and intermedial relationships.

Recent scholarly literature in the field of audiovisual studies demonstrates this penchant for exploring historical processes, contexts and relationships.[5] To augment the existing literature on silent film sound – currently mainly addressing North American practices – this volume aims to link this knowledge with new information and move into focus European contexts, enhanced by one essay dealing with Indian cinema. In tracing cross-cultural and transnational histories, which are best studied from a local perspective, this investigation aims to advance both musicology and film studies beyond national historiographies.

The emphasis on performance practices does not abnegate research by means of case studies that are dealing with individual scores or films, but it advocates a cultural-historically informed approach, in which the filmic and musical texts are also historically contextualized. The majority of silent film scores, for example, contain preexisting music, which in turn refers to a performance practice whose study can advance our understanding of the relationship of various media practices with one another.

In the past decades, the increasing global interest in the field of silent film music and sound has been aided greatly by the spadework of

single scholars. The incessant efforts by historians and practitioners such as Rick Altman, Martin M. Marks, Gillian B. Anderson, Richard Abel, Stephen Bottomore and others have provided the vital groundwork on which other historians can build upon. The mentioned researches – predominantly focusing on the North American cultural context and herein on the pivotal and exemplary film exhibition in New York's movie palaces – serve as valuable sources and starting points for comparisons with other historical and geo-cultural contexts. However, as researchers attempt to reconstruct an ephemeral acoustic reality that lies a century and more in the past, they are facing numerous challenges and difficulties. It might be tempting for the researcher to take for granted some of the established models and categorizations concerning silent film sound and apply them in a different socio-cultural context. Instead, as varied as the historical and cultural sites where film accompaniment was practiced were, cinema music and sound were just as diverse in their implementations throughout the three decades of the silent era. Only a history that takes the socio-cultural, political and economic circumstances into account can counteract a spread of oversimplified views. Furthermore, the ubiquitous scarcity and dispersion of source material and the lack of any regular or institutionalized discourse in some regions require the attempt to reconstruct historical modes while crucial parts are missing or non-existing.

In its engagement with differentiated regional contexts, this collection of articles should not merely be regarded as illuminating new aspects of the considered historical period and supplying some of the 'missing pieces' for mapping a global history of silent film sound. It is intended to expand the current knowledge and – if appropriate – redefine the fundamental principles of the medium of film itself by regarding 'film history as part of the history of media' and encompassing intermedial relationships of production, performance, exhibition and reception. As Altman put it, 'Only by recognizing the tendency of representational technologies to take on multiple identities, constantly redefined, can we understand the complexities of the historical object.'[6]

In the framework of a research project collaboration conceived to advance knowledge about this topic for the Viennese context,[7] the two editors of the book organized an event dedicated to the study of silent film sound in order to cross-link the various local and methodological approaches. An international conference entitled 'Silent Film Sound: History, Theory & Practice', held in February 2013 at Kiel University in collaboration with the Kiel Society for Film Music Research, brought together more than 30 scholars from over 13 different countries to

4 *The Sounds of Silent Films*

share and discuss their research and engage in fruitful discussions on various aspects of silent film sound. The chapters in this book result predominantly from selected papers that were presented at that conference. In the early planning stages of the conference, it soon became clear that one of the most fascinating aspects to focus on would be the historical performance practice of specific regional contexts. While the existing literature provides in-depth discussions of silent film accompaniment carried out throughout various stages of the silent period in the US,[8] France,[9] Germany[10] and, more recently, Great Britain,[11] studies on other cultural-historical sites that were less in the spotlight of academic attention remained long wanting or were carried out solely in their national language, often inaccessible to a larger audience. The exploration of such sites is particularly significant if we consider the potential exchanges of *modi operandi* within silent film exhibition that came about with migration experiences or business trips of people working in the film trade who would explore Europe and other continents for inspiration and new ideas for silent film exhibition (see Chapter 6 by Buhler and Watts).

In undertaking these researches and, more importantly, in connecting the results, we can certainly begin to grasp a more comprehensive perspective of this audiovisual configuration with regard to intermedial and transnational practices.

The book is laid out in two parts and 13 chapters. The first part (chapters 1–7), entitled 'The Historical Practice of Silent Film Sound', explores economic and social processes of specific regions from various methodological perspectives based on original research. The second part (chapters 8–13), 'New Approaches to Silent Film Music History and Theory', attends to theoretical issues of audiovisual combinations and sheds light on the historiographical development of silent film music as a 'history of film interpretations'.

Connecting the dots – local approaches to historical performance practices

In Chapter 1, Julie Brown details the construction of a cinema music library from both a theoretical and a pragmatic point of view by the example of preserved materials at a cinema in Bradford, UK. In her article, she puts into perspective how various comments and suggestions given in the trade press reflected on the actual practice of establishing and maintaining a cinema music library.

Gathering evidence from cinema program collections, Christopher Natzén (Chapter 2) applies a number of angles to his investigation on Sweden's cinema music between 1905 and 1915, such as the unionization of musicians, the role of new (sound) technologies and the establishment of permanent venues, situating the formation of a cinematic music practice in the wider context of the country's film exhibition history.

Marco Targa (Chapter 3) explicates the reasons why a certain repertoire, that of salon orchestras (*orchestrine*), was mainly used in Italian silent film exhibition, focusing on the cities Turin, Parma and Rome. His remarks advocate a historically informed reconstruction of silent film music, which, drawing on the known repertoire and existing cue sheets, would potentially benefit present-day performances of silent films.

Upper Silesia is a highly interesting region that is the center of attention in Urszula Biel's contribution (Chapter 4). In this German-speaking enclave, divided between the Weimar Republic and Poland after World War I, the local participants in silent film exhibition negotiated cultural references via films and the accompanying music. This essay serves as a prime example of transnational historiography that can offer deeper insights by focusing on performance practice rather than on individual films.

With regard to an affinity for operetta, opera and folk art performances, Upper Silesian silent film sound shared traits with Viennese traditions, where a strong connection of film with other art forms was integral to film exhibition. In Chapter 5, devoted to Viennese silent cinema sound, Claus Tieber and Anna K. Windisch present an overview of the fundamental principles of film music production in the city of Vienna and its entanglements with established media practices. Rather that focusing on a specific time period, they provide a general outline of cinema music practice in light of the most influential factors such as the development of the Austrian film exhibition industry, the status and organization of cinema musicians and the connections of film with (musical) theater. The results portray Viennese film exhibition locations as highly musical spaces.

These explorations of the performance practices in specific European locations constitute a valuable context for the study by James Buhler and Catrin Watts (Chapter 6), who examine the impressions of American trade paper journalist and editor Stephen Bush on his trip through Europe in 1913. In his reports Bush details various aspects of German,

6 *The Sounds of Silent Films*

Italian, British and French film exhibition and concludes that American film exhibition could gain sustainable effects by modeling itself on European counterparts.

Another viewpoint as to how the political and social developments of musical cultures shaped the history of regional silent film sound practice is finally presented by Olympia Bhatt (Chapter 7), who traces the correlations and interdependencies of Hindustani music and Indian silent cinema of the 1920s. Therein, the reformative musical currents that were affected by Western music theory as well as by new sound technologies form an important influence on Indian cinema music of the silent period as they do on the early sound era.

Silent film sound – a history of interpretations

As an ephemeral live event, performed in the moment for a single presentation, silent film accompaniment remains a matter of interpretation(s), in many respects. Year in and year out, screenings of silent film classics and lesser-known works at film and music festivals worldwide appeal to broad audiences with original, compiled, adapted, reconstructed or remixed musical accompaniment and *reinvent* the interpretations of silent film sound in novel ways. Even the few recovered film scores of the silent era that have been synchronized with the corresponding films continue to spark debates among scholars. Inevitably, such discussions are revived as new materials surface and they stimulate present-day research.[12]

This fact is compellingly represented by Peter A. Graff, who, in his study on John Ford's *The Iron Horse* (1924) (Chapter 8), provides an account of how the newly recovered score by Erno Rapée offers a more complex reading of Ford's film. The article provides insight into Rapée's scoring techniques – utilizing preexisting songs and compositions – and draws a genealogy of the use of music in Ford's sound film oeuvre.

Not only do the scores for specific films remain a matter of interpretation, but also the great amount of preexisting music that was used to illustrate moving images and that, after a certain point in time, was subsumed in film music collections continues to be under investigation. This is the case with the well-known German film music anthology *Allgemeines Handbuch der Film-Musik* (1927) by Guiseppe Becce, Hans Erdmann and Ludwig Brav, which Maria Fuchs critically analyzes with regard to its relationship with the contemporary German discourse on

film music theory (Chapter 9). In doing so, Fuchs draws connections with Hermann Kretzschmar's concept of 'musical hermeneutics' for the creation of the *Handbuch*.

Studying the principles of autonomy of sound and vision from a Russian formalist's perspective, Francesco Finocchiaro (Chapter 10) addresses theoretical concepts of the audiovisual language by means of Sergei Eisenstein's 'music of landscape' theory, in which Eisenstein regards landscape as an emotional element that functions as a musical component drawing from musical vocabulary.

In Chapter 11, Marion Saxer continues this investigation of the audiovisual autonomy from a different cultural angle by exemplifying the two contemporary film scores (2006 and 2007) by Bernd Thewes to the abstract *Rhythmus-films* (1921 and 1923) by Hans Richter.

It is the pronounced aim of the second part of this volume to present to the reader crucial concepts of the historicity of silent film sound and put them up for debate to advance the study of audiovisual cultures. Calling to attention this 'tradition of novelty', Marco Bellano (Chapter 12) advocates a comparativist approach to various musical interpretations of silent films, disclosing the conditions, advantages and limitations of this concept. He exemplifies this method by aligning different interpretations of Fritz Lang's *Metropolis* (1927) and Buster Keaton's *The General* (1926).

Finally, Jürg Stenzl (Chapter 13) also deals with the 'history of interpretations' by comparing two scores for the film *La Souriante Madame Beudet* (Germaine Dulac, 1923, FRA), compiled and written decades apart by different composers: Arthur Kleiner in 1939 and Manfred Knaak in 2005. This confrontation, in addition to discussing a highly fascinating work of cinematic art, aims to develop approaches and criteria for the history of film interpretations from a musicological perspective.

Prospects

As a topic worth academic attention, silent film is no longer considered merely a nostalgic form of expression from the past. Instead, engaging with the performance contexts of silent film exhibition promises insights not only for the scholarly understanding of silent film sound but for the full range of film history. The editors intend this volume as a continuation of the publications and projects carried out to investigate the astonishing diversity of silent film sound's historical practices,

8 *The Sounds of Silent Films*

challenging preconceived notions within different cultural and historical contexts. It is particularly thrilling to be able to provide first insights into novel regional contexts that will facilitate future comparative studies of silent film sound. In short, the book sets out to revive the debate about the importance of sound to cinema in general, and to silent cinema in particular.

Notes

1. For comprehensive studies on the illustrated song tradition, see Richard Abel, 'That Most American of Attractions, the Illustrated Song', in Abel, Richard and Rick Altman (eds.) *The Sounds of Early Cinema* (Bloomington: Indiana University Press, 2001): 143–155; Richard Abel, 'A "Forgotten" Part of the Program: Illustrated Songs', in Richard Abel (ed.) *Americanizing the Movies and 'Movie-Mad' Audiences, 1910–1914* (Berkeley: University of California Press, 2006): 127–138; and Rick Altman, *Silent Film Sound* (New York: Columbia University Press, 2004): 107, 462.
2. Rick Altman (ed.) *Sound Theory, Sound Practice* (London, New York: Routledge, 1992): 114f.
3. Altman, *Sound Theory, Sound Practice*, 4.
4. Ibid., 122.
5. See, among other works, Altman, *Silent Film Sound*; Altman, *Sound Theory, Sound Practice*; Martin Barnier, *Bruits, Cris, Musiques de Films. Les Projections avant 1914* (Rennes: Press Universitaires des Rennes, 2011); Claus Tieber and Hans-Jürgen Wulff, 'Pragmatische Filmmusikforschung: Vom Text zum Prozess', *Montage AV* 9/2 (January 2010): 153–165; Julie Brown and Annette Davison (eds.) *The Sounds of the Silents in Britain* (New York: Oxford University Press, 2012); Jonathan Sterne, *The Audible Past: Cultural Origins of Sound and Reproduction* (Durham, NC: Duke University Press, 2003); Peter Franklin, *Seeing Through Music: Gender and Modernism in Classical Hollywood Film* (New York: Oxford University Press, 2011) and Douglas Kahn, *Noise, Water, Meat: A History of Sound in the Arts* (Cambridge, MA: MIT Press, 1999).
6. Altman, *Sound Theory, Sound Practice*, 123.
7. 'The Sound of Silents – Sound and Music in Viennese Cinemas, 1895–1930' funded by the Austrian Science Fund (FWF).
8. Among the most significant studies on the subject for the North American context are Altman, *Silent Film Sound*; Martin M. Marks, *Music and the Silent Film* (New York/Oxford: Oxford University Press, 1997) and Gillian Anderson, *Music for Silent Films, 1894–1929: A Guide* (Washington, DC: Library of Congress, 1988).
9. See Barnier, *Bruits, Cris, Musiques de Films*.
10. See Michael Wedel, *Der deutsche Musikfilm* (Munich: Edition Text + Kritik, 2007) and Martin Loiperdinger, 'German Tonbilder of the 1900s: Advanced Technology and National Brand', in Klaus Kreimeier and Annemone Ligensa (eds.) *Film 1900: Technology, Perception, Culture* (Herts: John Libbey Publishing, 2009): 187–199. See also the online publication of the Kiel Society for Film Music Research (http://www.filmmusik.uni-kiel.de/beitraege.php).

11. A comprehensive collection of essays exploring silent film sound in Britain is *The Sounds of the Silents in Britain*, edited by Julie Brown and Annette Davison (2012).
12. Gillian B. Anderson has recently contributed clarifications to the ongoing debates about the performance history and musical accompaniment of Griffith's *Intolerance* (1916) with her article 'D.W. Griffith's *Intolerance*: Revisiting a Reconstructed Text', *Film History* 25/3 (2013): 57–89.

Part I

The Historical Practice of Silent Film Sound

1
Organizing a Music Library for Playing to Pictures: Theory vs. Practice in Britain

Julie Brown

In November 1928, as synchronized sound film was establishing itself, renowned London cinema musical director (MD) Louis Levy proclaimed in a film trade paper:

> It would not be too much to say that three-quarters of a musical director's best work is done in the library. Fifty per cent of his work is in the organizing of his library, and twenty-five in fitting the picture there.[1]

Whether other MDs would have agreed with this valuation of different aspects of their work or not, selecting and arranging music to accompany a cinema's weekly film offerings was certainly the key job of an MD, and had been since at least the early teens. Only a solo pianist or organist could realistically improvise to a film, and many voices in the trade actively discouraged that approach to film accompaniment. Playing from printed music dominated musical practice, and cinema proprietors had long considered a substantial collection of music to be an essential tool of trade for an MD.[2] The extent to which developing a personal library was promoted as an investment comes out vividly in a statement made by columnist Arthur Roby: it was the MD's 'bank', and 'there must always be a good balance to draw upon'.[3]

In this chapter I will examine discussions of cinema music library management in the British film trade papers and then turn to a library that survives from the Theatre Royal Picture House in the city of Bradford, North Yorkshire.[4] I have examined papers from the years 1915–1930 which cater specifically for cinema musicians and identified

14 *The Historical Practice of Silent Film Sound*

six articles specifically on the topic, the first of which appeared in 1922 in a paper for music professionals.[5] However, getting from the 'professional uplift' advice offered in such papers to actual practice remains a key challenge. The Bradford collection is not an unproblematic data source, for reasons I will explain, but scrutinizing it will not only provide a different national perspective to Rick Altman's and Tobias Plebuch's accounts of library catalogues in the US.[6] It will also enable me to consider a library's contents in the round, rather than through the lens of its photoplay music content, and to compare its organizational system with those proposed in the local trade paper columns. On the evidence of the Bradford library, creating order seems to have been less achievable in practice than the often sketchy advice suggests.

Library size matters

The expectation that solo pianists and musical 'leaders' or directors would acquire libraries of music to serve as their tools of trade emerged early in the history of cinema. Almost as soon as British film trade papers started to discuss the musical presentation of moving pictures, they also started featuring and reviewing 'music received' – that is, music sent to them by publishers hoping for a plug. Only two weeks after *Kinematograph and Lantern Weekly* started its regular music column 'The Picture Pianist', its author Henry A. Watson formalized the publisher connection by including a section 'Music Reviews and Notes'.[7] As little as three months later one moving picture musician's anxiety about these expectations was registered on the same paper's 'Notes' pages:

> I have received a letter from a correspondent in the West of England, which is somewhat pathetic in its way. The writer is a pianist in a picture theatre and has a repertoire of over 600 pieces, which he plays at sight. This wonderful collection, he tells me, includes 'waltzes, two-steps, intermezzos, and fairly classical music', and he has had to purchase it all out of a salary of *twenty-five shillings a week – less fourpence insurance!* He asks what he should do under the circumstances. My advice is brief – look out for another job.[8]

Twenty-five shillings was a very low salary in 1912.[9]

The pianist's concern is perhaps understandable in an industry in which size mattered: every film seemed to be promoted as the biggest and best, with the most actors, the best costumes and the latest in

technology. Similar trends are found in claims and increasing expectations about the musical presentation of moving pictures. Small wonder that this, and the eventual emergence of distributor-produced cue sheets which presupposed access to large stores of music, led some MDs to write to the trade papers to clarify the 'normal' size of a library. By the mid-1920s in Britain about 3,000–4,000 'sets' (i.e. pieces for which the MD had a set of instrumental parts for his 'orchestra') was periodically cited as average; organist and music columnist George Tootell cited precisely this number in November 1921, but felt that 'considerably more' was needed for 'a large cinema where films are shown with a competent musical setting'.[10] He offered slightly different advice to cinema organists six years later, however, saying that 2,000 pieces was the minimum an organist could get away with – perhaps assuming that s/he would be improvising at least some of the time.[11] But experience and judgment varied; only two months later a different contributor to the same journal described a library of the same size as *large*, without, however, mentioning the size of the cinema itself,[12] and several small orchestras (duos and trios) advertising for work four years later claimed 2,000 or 3,000 items.[13] By the late twenties expectations had increased. In November 1928, 4,000 would only be suitable for a small theater, according to Levy; 5,000 sets, still 'a quite small-sized store of music', would be a better starting point for 'a fairly large theatre, catering for critical audiences, with the orchestra playing to perhaps only one feature per week'.[14] However much music the columnists suggested their readers acquire, they tended to claim that they personally possessed considerably more. In April 1922 Jean Michaud boasted that he had 'probably one of the largest privately owned libraries in existence', at 13,000 numbers.[15] Whether this was an attempt to answer reports in the previous month's issue of *Kinematograph Weekly* that the music library of the Strand, New York, extended to an anxiety-inducing 40,000 musical numbers is unclear. Michaud was writing for the *Musical News and Herald*, a journal for the concert music profession; as his column was likely to be read by conductors working actively in both cinema and concert spheres, it may have felt especially important to set out his professional stall in the face of statistics from a flagship picture palace in New York. Three years later he revealed in another trade paper that his own library had grown to 21,000 items (still boasting that it was the largest in London).[16] Not to be outdone, Levy (then MD of the Shepherd's Bush Pavilion) slipped into the end of a January 1928 article titled 'Putting Over the Right Oriental Music' that he had a library of no fewer than 60,000 numbers (an excuse for lamenting that, even

16 *The Historical Practice of Silent Film Sound*

then, he found that he did not possess a 'Chinese agitato').[17] Whether 60,000 was a typo for 6,000, a genuine figure, or pure hyperbole, or indeed whether the cinema owned the library rather than him personally, it is equally difficult to tell. In any case, his claim was likely yet another anxiety-inducing blow for his rank-and-file readership, by then facing a very uncertain future. As far as we know, none of these libraries survives.

Whatever its ultimate size, owning and developing a personal music library involved an ongoing financial commitment. Arthur Roby reported in February 1921 that an MD was spending on average two or three pounds per week on music purchases, and was probably also being sent bundles of music 'on approval' from publishers.[18] He regularly exhorted cinemas to alleviate the MDs' financial burden by acquiring these libraries themselves,[19] but tried in the meantime to enthuse his readership to start up a cooperative help scheme: MDs might lend each other a parcel of music for a month, which would save many pounds, 'especially in the provinces, where the salaries are none too high'.[20] He asks his readers to write and tell him if they are willing to exchange; if so, he will put them in communication with each other; it would then simply be a matter of postage. The idea disappeared from his columns as quickly as it had appeared, so it is fortunate that lending systems of more conventional sorts had long provided help for those struggling to justify purchases. Commercial music libraries were quick to advertise in the film trade papers: Library Algernon Clarke did so in *Kinematograph and Lantern Weekly* as early as November 1911, claiming to have over 10,000 pieces available,[21] and others soon followed.[22] What proportion of MDs took advantage of commercial libraries, and precisely how they used them, is difficult to reconstruct in all its complexity, although it seems likely that they were principally used to supplement core personal collections. Roby reports visiting one cinema in early 1922 and noting that all the music in use was stamped by a lending library: the MD claimed that he had locked up his own music collection for six months to rest it.[23]

Managing an existing cinema music library

Despite the ubiquitous advice during the teens concerning music acquisition, it was not until the early twenties in Britain that attention was devoted to how one might best organize a collection once accumulated. Some of the advice was practical, such as how to avoid the widespread tendency to repeat favorite pieces over and over and again. If Roby is to

be believed, up until 1920 the matter was generally addressed by a strict rotation system.[24] An anonymous columnist with the *nom de plume* The Veteran offered a slightly less draconian variant of this in 1927: an MD might stack up his chosen music for the week on one of eight clear spaces on his shelves, and not until all eight are full should he re-shelve and hence re-use the music from space one. If he has a sufficiently large library, he could extend this to 10 or 12 spaces, leaving up to 12 weeks between music repetitions. In other advice an MD might also operate a 'repair shelf', where he puts any damaged music so that he repairs it before returning it to its rightful place in the library.

Of course, the main library-related advice focused on how to organize and index its music. In the UK ledgers of some sort were the preferred tool, rather than card catalogues. The advice is always to list all pieces owned in one ledger, with some suggesting to do so within a series of organizational categories (which I discuss below as first-level index headings). One should indicate a certain number or attributes such as composer, title, date purchase, catalogue number, size of orchestration, etc. Only one columnist (Levy) suggests including key information and tempo, and another (Michaud) the duration of the piece. Levy actively advises *not* to include duration, reasoning that even though some MDs do, 99 percent of the time the whole piece will not be heard: 'The duration depends upon the requirements of the film, not upon the length of the piece of music as published'. When completed, the ledger provides the MD with a full record of the music he owns (Foort, Goldsmith, The Veteran),[25] and also helps him to keep track of how many pieces he already has in each category, lest he over- or under-stock in any one of them (Goldsmith). These first-level categories would provide the basis for the shelving system, though Foort and The Veteran also suggests shelving according to folio size.

Each columnist advocates a multi-level indexing system. In the US and Germany such systems took 'mood' (*Stimmung*) categories familiar from photoplay music as their key concepts.[26] These 'moods' were musical 'topoi' that had grown out of theatrical traditions of 'incidental music' and were tailored to the stock characters of moving pictures (the drunk, the cowboy), common locales (the 'Orient'), settings and scene types ('murder scenes'), as well as 'gait' (e.g. chase, gallop), emotions ('sentimental'), objects (e.g. airplane, telephone), etc., and were sometimes further divided into, for instance, 'heavy', 'medium' and 'light'.[27]

Cross-references were often added to this. But the serendipity of topical inclusions and exclusions meant that there was a certain

18 *The Historical Practice of Silent Film Sound*

inconsistency too; 'the topical order of cinema library music has little to do with the neat order of biologists, librarians, lexicographers, or, for that matter, musicologists', as Plebuch put it.[28] In Britain, the written ledger would include both first-level and second-level indices, the latter of which were more analytical and reflected conventional mood and descriptive categories. Although none of the columnists offers a fully worked-out set of second-level indices, I have included in Table 1.1 those that they do specify. The ledger would also facilitate cross-referencing. Several columnists point out that cross-referencing is important because pieces can often be characterized in more than one way and, as such, can serve more than one cinematic function. Most advocate devising at least two written catalogues in order to afford different points of access into the material: Foort maintains that he cannot manage his library without three.[29]

Among the systems outlined in the British trade press, two different principles inform the first-level indices: musical genre on the one hand, and 'mood' or topical categories on the other. The first approach is most pronounced in Goldsmith's and The Veteran's advice, but to some extent also in Foort's and Francklin's. The second approach, which takes 'mood' or topical category for the first-level indices, is reflected in Michaud's and Levy's advice, and to a lesser extent also in Reginald Foort's. Let us consider each in turn.

The genre system

The musical genre headings that Goldsmith, The Veteran, Foort and Francklin choose for the first index level are Overture, Suite, Entr'Acte/Intermezzi, Selections (these last two divided into 'Light' and Dramatic' by Goldsmith), March, and Dance (Foxtrot, Waltz), Incidental or Photoplay Music, Popular Song and, in three cases, Oriental.[30] Foort has slightly fewer genre categories compared to the others; notably he produces the 'mood' opposites of Light and Serious instead of Entr'Actes, and offers second-level indices under those. Two further genre issues also emerge from the advice columns. First, everyone except Levy treats incidental music (by the 1920s, photoplay music specially prepared for moving pictures according to topical principles) as a separate genre; Levy doesn't separate it out at all, and Francklin implies, rather than names, it as a category.[31] Second, oriental is in most cases cited at the level of genre, not as a second-level index of Incidental Music or Descriptive Music. Although Goldsmith and Foort specify certain second-level indices to be added into the ledger taking into account finer descriptive nuance, others don't.

The genre system reflects, and may have helped to perpetuate, the prevailing culture of music marketed for moving picture use, though it may also have served a practical purpose. Table 1.1 makes it clear how the system is closely aligned with, and in some cases more or less identical to, the subheadings used by W. Tyacke George in his February 1912 treatise *Playing to Pictures: A Guide for Pianists and Conductors of Motion Picture Theatres*.[32] (I have listed George's categories in Table 1.1 for comparison.) This was not only the first book of advice for cinema musicians in Britain; it was one of the first in the world, pre-dating by almost a decade the better-known treatises by George Beynon, and Edith Lang and George West.[33] It offers wide-ranging practical advice, including, at this quite early stage, what music to obtain and where (listing useful music publishers and music library contacts). The musical titles that might serve as a cinema musician's foundational repertory are presented according to three broad musical types: 1. instrumental genre (Overture, Intermezzo, etc.); 2. Suggested Appropriate Music, subdivided into various national and dance musics, as well as broadly defined mood types ('sad pathetic music' and 'quiet restful music') and incidental music, the latter an entirely separate subcategory for which he identifies a few dedicated volumes for 'all dramatic purposes'; and 3. Popular Songs, presumably for accompanying by song title.[34] George himself doesn't advocate a library cataloguing system around his acquisition headings, but as is clear from the table, most subsequent library advice echoes if it does not more or less duplicate them. The Veteran follows a similar pattern of creating a broader category of Descriptive Numbers, under which 'dramatic and incidental music' stands as a subcategory.

George's headings reflect the music genres that had served as common marketing categories for music publishers, and continued to do so. Hawkes & Sons, Schirmer, Lafleur & Co., Larways, Witmark, Photoplay Music and Bosworth all sold pieces under the broad heading Intermezzo; Hawkes & Sons marketed many pieces under the category of Entr'acte, and Chappell & Co., Lawrence Wright Music, Ascherberg, Hopwood & Crew, and Francis, Day and Hunter all sold excerpts from opera, operetta, musical comedy and ballet as Selections. George's subcategories not only reflected, but may have helped to embed the value of, these genre categories for the British cinema. They seem more generic than the 'proper heads' that Riesenfeld used for his organizational system, which extended to what I would describe as 'mood' or topical categories, such as 'love scenes' or 'home scenes'.[35] From a publishing point of view, incidental or photoplay music was, quite properly, recognized by the columnists discussed here as a completely separate genre of music.

Table 1.1 Index categories for cinema music libraries from British trade papers

W. Tyacke George book 1912	Jean Michaud MNH, Apr 1922	S. O. Goldsmith Bios, Nov 1926	Reginald Foort MM, Feb 1927	'The Veteran' MM, Apr 1927	Martin Francklin KW, Jan 1928	Louis Levy TC, Nov 1928
Overtures	Dramatic movts *'murder scenes' Agitato movts *'battle scenes' *Hurry agitato *Light agitato movts ('ordinary fight scene')	Overtures (O) *Light Overtures (LO) *Heavy Overtures (HO)	Overtures *Light *Dramatic	Overtures (B)	Overtures	
Suites, ballet music, etc.	Heavy agitato movts	Suites & Ballets (S) Symphonies & Symphonic poems (S & P)		Suites (C)		
Entr'Actes, intermezzos	Flowing melodies *Light flowing melodies *Light intermezzi *Ordinary intermezzi *Fairly lively intermezzi *Lively intermezzi Semi-dramatic melodies Dramatic melodies	Light entr'actes (LE) ['sufficiently described', so no further indices] Dramatic entr'actes (DE) ['sufficiently described', so no further indices]	Light *Exciting *Allegro *Comedy light flowing *Quiet light flowing *Quaint Serious *Sentimental *Serious *Sad *Very sad *Ethereal	Light numbers (intermezzi) (F) Melodies & slow movts (G)	Light (intermezzi, gavottes, etc.) Flowing melodies Neutral scenes Dramatic	Light-dramatic Heavy-dramatic

Selections, opera, musical comedy, etc.	Agitato melodies Sad melodies	Light selections (LS) Dramatic selections (DS)	Selections *Suite *Ballets *Operatic selections *Musical comedy selections *Symphonic *Selection of melodies	Selections – light and musical comedy (E) Selections – operatic (D)	Selections – light Selections – serious	
Appropriate music *Incidental music [from 'Photoplay' collections]	Incidental music	Incidental (Inci.) 'Mood' catalogue *Religious *Poetic *Love-scenes *heroic *pastoral	Photoplay *Mysterioso *Sinister *Tension *Dramatic *Climax *Heavy agitato *Light agitato *Hurry	Descriptive numbers (N) Dramatic & Incidental music (H)	Pathetic Dramatic Tense drama Hurries Combats	Sentimental Quiet misterioso Heavy misterioso [&c. to 60 headings]
*Spanish, Mexican & Indian	National *Spanish *Old English tunes *Scottish *Welsh *Irish *Italian *Russian (Slavonic) *Hungarian *Scandinavian *Negro		National *Every nationality	Foreign-general (K) Spanish (J)	National airs	

Table 1.1 (Continued)

W. Tyacke George book 1912	Jean Michaud *MNH*, Apr 1922	S. O. Goldsmith *Bios*, Nov 1926	Reginald Foort *MM*, Feb 1927	'The Veteran' *MM*, Apr 1927	Martin Francklin *KW*, Jan 1928	Louis Levy *TC*, Nov 1928
*Oriental or eastern	*Oriental (General) *Japanese and Chinese [Sad melodies]	Oriental (Ori.)		Oriental (I)	Oriental	
*Sad pathetic pieces						
*Quiet restful pieces						
*Light dainty pieces						
*Pieces for harmonium, pno & vln or vc						
*A few useful selections	Religious *Catholic *Protestant *Hebrew *Russian Church (Old Byzantine style) *'Mahomedan chants' *Hindu chants *old Greek chants	Miscellaneous & characteristic (misc.)		Miscellaneous (O)		

*Grand/slow marches *Patrols *Quick marches		Marches & Galops (M)	Marches *Marches *One-steps *Galops	Marches (A)	Marches Galops Hurries
*Popular two-steps		Foxtrots, two-steps (FT)	Foxtrots	Foxtrots, two-steps, etc. (M)	Foxtrots
*Hunting scenes *Dances	Dances Classical style *Minuet *Bouree *Gavotte *Sarabande				
*Famous waltzes		Waltzes (W)	Valses *Lente *Brilliant	Waltzes (L)	Valses
Popular songs	Popular songs	Songs (Sg.)			Songs
			Solos		Recital pieces
			Themes *Love *Villain *Various		

24 *The Historical Practice of Silent Film Sound*

The mood system

Jean Michaud's system, using mood and pace rather than genre as first-level indices, was outlined in *Musical News and Herald*; it retains certain genre implications, but only of a general type. Of the eight first-level indices that he says 'should' be used, five were broadly defined *melodic* types and three broadly defined *movement* types; within those he nominates 'dramatic' and 'agitato' divisions, and sometimes further divisions of 'semi' and 'heavy'. Second-level indices involve anything from scene type ('murder scene') to further nuancings of mood: 'light' and 'lively', for instance. Further subsidiary parts of his catalogue correspond more closely to the genre system: national music (for which he offers detailed subdivisions), classical styles (including minuets, gavottes, bourées, sarabandes) and religious music (subdivided into Catholic, Protestant and 'Hebrew'). The outline he offers is only partial; he claims to arrange his own music library into 300 such (sub)headings.

Michaud's was the first library advice to appear of all those being considered here, and did so only a month after a North American mood-oriented model had been brought to the British film trade's attention. In March 1922 *Kinematograph Weekly's* music columnist Gilbert Stevens listed 34 of what he said were 50 principal categories used by Carl Edouarde to classify the music library at the Strand, New York, a system which seems to correspond with that used around 1920 by Hugo Riesenfeld of the Paramount theaters in New York (Rivoli, Rialto, Criterion), and in 1920–1923 by Erno Rapée of the Capitol Theatre. Edouarde's categories are those of photoplay or cinema 'incidental music'.[36]

1. Agitation, Anxiety, Fear, Slightly Dramatic, Resentment, Subdued, Tense Worry, Suspense.
2. Allegros, Aeroplanes, Chases, Cowboys, Gallops, Ice Boating, Skiing, Sleighing, Races, Railroad Trains.
3. Alaska, Allies, American, Light, Popular, Patriotic

 . . .
6. Battle Scenes, Military Hurries and Gallops

 . . .
22. Humoreskes, Comic, Slide Trombone, Sneezes.
 Etc.

Although Michaud adapts this approach, turning to very broadly conceived 'moods' for the first level, and more nuanced or 'descriptive'

subdivisions at the second level, he initially fails to mention incidental or photoplay music at all. He cites only works from the classical concert repertoire, doubtless aware of his *Musical News and Herald* readership. It was over a year later that he acknowledged that some cinematic incidental music might be useful for specific moving picture scenarios.[37]

Louis Levy's somewhat sketchily described system is the closest to the mood-oriented indexing one. He creates Light-dramatic and Heavy-dramatic indices, but then starts to enumerate obviously 'mood'-oriented cinema categories. He suggests having around 60 descriptive categories, but again, instead of detailing them, mentions only sentimental, quiet mysterioso, heavy mysterioso, 'etc.', which suggests that the rest will be indices familiar from photoplay music collections. He proposes that meter can be a useful system for second-level indices: one might divide Marches into 6/8, 2/4, 4/4 and 2/2, for instance. Given his principally 'mood'-derived categories, it is notable that Levy is the most meticulous in terms of including information about tempo and key signature.

Rationales

If closely fitting mood was an MD's overriding concern, as it was for Levy, the time constraints under which cinema musicians worked provided a clear rationale as to why mood might form the basis of his indexing system.[38] The Veteran points out that there was a changeover of program twice a week, on Mondays and Thursdays. But what might explain a choice of genre? At the heart of the matter is how we interpret the 'first-level' library indices, which also often served as the basis for the shelving system. Were those indices conceptually significant, or merely a shelving convenience?

In George's treatise, genre headings were useful because they were the categories that musicians would need to have known when purchasing the recommended pieces. Their rationale as cataloguing indices is less clear. Perhaps their advocates were simply being lazy: it was easier to list these categories from George than to think through alternative cataloguing titles (which none of them present in much further detail than George). The MD could write his trade paper column, and take his fee, with the (non-musician) editor being none the wiser. Yet perhaps they were suggested in good faith after all, and for similarly labor-conscious reasons. For cinema musicians lacking formal musical education this system could be easily followed, because a piece's genre tended to be written on the music itself, or on the marketing leaflet

26 *The Historical Practice of Silent Film Sound*

in which it was wrapped. Systematic second- and third-level indexing could be undertaken on a more piecemeal basis as time allowed; but with this almost automatic system an MD would at least have some way of organizing his accumulated music. Another reason is that through the teens and twenties, British cinemas in possession of a music license could also feature stand-alone musical numbers around films. Music's role in moving picture exhibition went well beyond that of accompanying moving pictures themselves. Being able to access works according to their genre, rather than mood, was an important possibility to retain.

These seem perfectly reasonable explanations. Yet certain formal attributes of these instrumental genres might also account for their ongoing significance as first-level indices even for a 'mood'-conscious MD. From Goldsmith's perspective, overtures, selections, intermezzi and suites are especially useful in the cinema because they are composite works, larger pieces containing diversity of mood within a broader stylistic unity. They already contain sections that can be deployed according to atmospheric need; with the judicious use of additional sectional labeling and cuts, such pieces can easily be harnessed according to atmospheric need. Composite works could be shelved together for these and perhaps other reasons, but also analyzed and given second-level indices. Bizet's 'L'Arlesienne' Suite might have its first movement included under the heading 'Heroic', and its second movement under 'Religious', and possibly further 'mood' headings he suggests. Goldsmith also defends the use of operatic selections, arguing that even if they are probably not suitable to be played all the way through without change or break because they change mood too often, they can be divided up by the MD into more sections than they usually already are, and each section can be included in the analytical catalogue (e.g. an additional reference between an already marked A and B might be called AA...). This form of modular labeling was becoming increasingly common within commercial cinema music itself.[39] For Goldsmith, some dramatic works, such as entr'actes, are nevertheless 'sufficiently described' already, and need no further indices.

An additional perspective on these larger forms comes from Francklin, who argues that genre works are useful because there are always many scenes in which, as he puts it, 'there is nothing which needs a special musical illustration. These indefinite scenes...provide ample opportunity for playing much interesting music for "filling-in" between the points which need definite fitting'. For these he recommends intermezzi, valses lentes, ballet and other suites, and classics: 'in fact, anything of a melodious interest. The main point is – BE BRIGHT'.[40] His claim to 'be bright' seems a little odd, but Goldsmith too feels a

cinema MD will need more 'dramatic and light entr'acte' music than other music, and of those the light should be even more preponderant, because music in other categories will also serve 'dramatic purposes' – by which he seems to mean the dramatic scenarios catered for by the various categories of 'mood' music.

'Filling in' was obviously a key concern for long stretches of a film, but it is also the case that musical accompaniment did not always aim to follow the drama closely. A library collection approaching the completeness of Hugo Riesenfeld's – that is, one with a well-kept stock of scores and original cataloguing artifacts – is yet to be discovered in Britain. However, sufficient evidence survives between the Bradford collection and trade advice columns to raise questions about how central the minutiae of 'mood' always was, both in practice and – by extension – in thinking about how to organize a library of music. The considerable emphasis placed upon larger structures in British cataloguing advice may reflect an approach to film accompaniment that retained quite a strong hold in Britain right through the 1920s. Alongside those who advocated 'close fitting' in the American style were others who preferred less attention to every detail. Roby reported in 1921 that he knew someone who gave up his position at a cinema where they 'fit' the film; two years later another commentator claimed that 'extremely close fitting is largely confined to the London area', and in late 1924 a series of articles argued that 'the use of mood music closely fit is actually detrimental'.[41] 'Close fitting' was not always assumed to be the best way to accompany moving pictures in Britain.

Bradford collection

The single cinema library collection currently known to survive in Britain is at once revealing and frustratingly problematic as a concrete source against which to compare this advice.[42] Sets of instrumental parts for a small orchestra survive in their original library envelopes, complete with cataloguing subheadings and numbers. They are stamped 'The Bradford Theatre Royal Picture House Limited' or 'Property of Harold Gee', a violinist and band master in Bradford in the late twenties; a small number have the latter stamp in addition to 'The Property of G. W. Lunn'. Some also have a labeling stamp that has not been completed: 'P.C. No: [blank]'. The library provides a tantalizing glimpse into the actual practice of building and maintaining a library for a substantial 'provincial' picture theater in Britain.[43] The 1,350-seat Theatre Royal Picture House in Bradford came into being in December 1921, having previously been The Theatre Royal, a so-called legitimate theater dating

28 *The Historical Practice of Silent Film Sound*

from 1864 – during which time it had already long been used for moving pictures. Although Bradford's industrial heyday had passed its peak, when the Bradford Theatre Royal was launched in 1921 it was still a substantial regional city with a population of around 286,000. Unfortunately the collection presents the historian with challenges. It is difficult to be certain about the pattern of ownership. It was acquired by the National Media Museum in the mid-1990s from a private collector. In his letter (dated 17 May 1994) offering the collection to the archive, he writes that it is 'the entire library' of the theater, which he bought 'about 33 years ago from a second-hand shop in Ambleside[,] the proprietor of which hailed from Bradford. He bought the music as soon as he learned that it was available at the actual Theatre Royal premises'.[44] We don't learn from the letter how long the shop proprietor had owned it, and given the library sizes cited in the film trade papers in the teens and twenties, the seller might also have been mistaken that it represented the entire library of the theater; if it did, it was small compared to the average. The absence from the collection of a written ledger means that we cannot confirm whether the surviving collection does indeed represent the entire library; without a ledger we are also limited as to potential insights into how it was organized and used. The ownership names stamped on the music in ink certainly suggest that the library eventually sold from the theater was the product of the merger, and/or purchase, of music from several previous owners.

Numbering 1,039 pieces of music, most with full sets of parts, the collection's individual library bags are labeled in a somewhat ad hoc way. There seems not to have been a systematic transfer of genre from the printed music to the 'Description' field on the bag, nor a systematic analysis based on mood. For instance, 72 bags are labeled Intermezzo, 48 Overture, 57 Waltz (or Valse), 69 Selections, 90 March, 11 Galop, etc., (see Fig. 1.1), yet other music with similarly clear genre labels are sometimes described according to a mood or topic: Dominico Savino's 'In Tientsin' is clearly marked Intermezzo, but its library bag is labeled Chinese; Herbert Haines's 'An Autumn Song' is also clearly marked Intermezzo but is analyzed and labeled as Sentimental No. 20. Lesser genre categories also abound as 'descriptions' on bags – Barcarolle, Aubade Florentine, Madrigal, Caprice and Rhapsody – when some (Tango Discreto, Flower dance, Dance Parade, Gavotte) might have happily been subsumed under Dance, with the detail (Tango, Gavotte, etc.) given in a ledger. The lack of thought that went into the labels or 'descriptions' is perfectly illustrated by a selection from the operetta *Jung muss man sein* by Leo Leipziger and Erich Urban, to which

Hannover-based publisher Louis Oertel gave the subheading Potpourri; rather than calling it Selections, which would have brought it formally into alignment with other pieces, the MD dutifully transferred the word 'Potpourri' to the orchestra bag. Nor does there seem to be a consistency between which of the two sets of handwriting do which. It is possible that a new MD had to assimilate his own indexing system to that of his predecessor, but simply didn't have the time to re-index items to make the library internally consistent. The extremely large number of labels in the 'Description' field also makes it hard to discern what the shelving arrangement might have been, though the fact that many items were given a number (a piece might be Intermezzo 27, for instance) points to there having once been some sort of 'finding' ledger that listed the pieces. The bag labeling is further complicated by the fact that the final owner, by his own admission, engaged in his own cataloguing interventions.[45] Fortunately, it is usually a simple matter to differentiate between his late additions and labeling dating from much earlier; more recently added notes are generally in blue pencil, though there are also some gray pencil additions – mainly corrections to authorial mis-attributions (e.g. the arranger had sometimes been named as the composer, especially on music stamped and – one assumes – cataloged by Harold Gee) (cf. Fig. 1.1).

The exception to the shelving conundrum is the photoplay, or incidental music, which is generally not in envelopes. It appears to have been shelved as it stood, possibly all together, suggesting that it was treated as a separate genre in the way most of the library systems propose, not assimilated to the whole with a thoroughgoing mood-based indexing system. The collection includes music from photoplay collections by the *Kinothek* (69 items), Sam Fox (65 items), Fischer Playhouse (19 items) and Fischer Concert Orchestra Series (9 items), most of which bear The Bradford Theatre Royal Picture House stamp. Curiously, items in the smaller-format Collection Adapta series (32 items) were treated differently; mostly bearing Harold Gee's stamp, they *are* generally in library envelopes and sometimes afforded a separate description. There are also random other items of photoplay music in the collection.

One of the intriguing aspects of this collection is that although the Adapta series is very well-thumbed, and other photoplay collections reasonably so, the *Kinothek* music is in pristine condition, suggesting that little use was made of it. Although incidental music created specifically for moving pictures was manifestly available and purchased by many British MDs, there is evidence in the trade paper columns that its highly

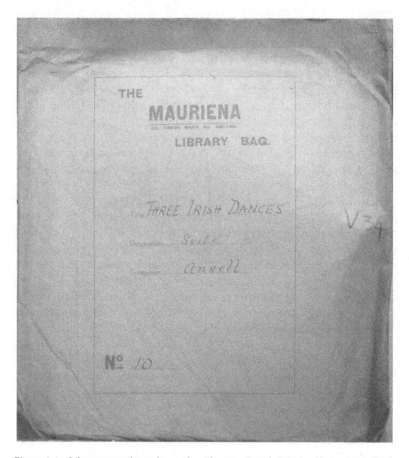

Figure 1.1 Library envelope from the Theatre Royal Picture House, Bradford, held at the National Media Museum, Bradford, UK

mood-specific and modular approach to 'close fitting' was not always embraced as a good *musical* solution to the problems it sought to solve. Goldsmith says:

> You will certainly need incidental numbers, but for goodness sake don't make up your program of such pieces, which are only suitable for the accompaniment of short episodes in the story which is being unfolded on the screen. Some pictures (badly constructed) certainly consist of little else, and must be treated accordingly, but a decently constructed film demands some sort of continuity in the music, which is out of the question if you only employ such pieces.

Kinematograph Weekly's columnist Arthur Owen was quite blunt in September 1928: he advises his readers that while incidentals are a necessity, a very careful selection is necessary because so much of this music is 'devoid of musicianly merit'. The virtually unused state of the *Kinothek* set in Bradford suggests that the musicians there found this series particularly wanting in musical terms, notwithstanding its impressively rational conceptual underpinning.[46]

What we find in all the library systems advocated in British trade papers seems to be an attempt to balance two needs. The first is a need to be able to access particular 'atmospheres' and moods, even if for some MDs this was only for sections of a film in which dramatic scenarios and moods changed rapidly. The second is a need to be able to access large pieces that might serve either a stand-alone performance role in exhibition, or a fairly broadly conceived accompaniment role concerned with form or musical 'quality', more than with mood. It is interesting that it is not until Louis Levy's suggestions at the end of 1928 that mood seems to take over as the main category for grouping a library's contents: he was one of the key proponents of 'close fitting'. He was also supposedly in possession of an enormous personal collection of music, and for these reasons it is curious that he provides one of the sketchiest accounts of how to catalogue a library effectively. He names only five first-level indices, and even these seem odd partners on the one index level. Indeed, most of the organizational systems discussed here would have caused as many problems as they solved once a musician had accumulated a couple of thousand items. Small wonder that each of those offering advice is highly selective about what they reveal of the 'analytical' side of their indexing systems. The Theatre Royal Picture House's library, though most likely partial and certainly tampered with, and only one exemplar among the thousands of such music collections that must have existed, reveals something of the practical difficulties that all musicians, but perhaps above all some 'provincial' MDs, must have faced in navigating this professional sphere. The fact that one of the people cataloguing the Bradford music was unable to tell the difference between a composer and an arranger did not matter for the day-to-day running of the cinema, but it reminds us how much more challenging it must have been for many MDs to construct a workable analytical catalogue than it was for a Rapée, Riesenfeld or professional trade columnist. My guess is that there was more chaos than order in many libraries, and more reliance on memory than the (sketchy) advice coming from the trade papers suggests.

32 *The Historical Practice of Silent Film Sound*

Notes

1. Louis Levy, 'Organising the Music Library', *The Cinema News and Property Gazette* (hereafter *The Cinema*), 8 November 1928, xxxiv. The other 25 percent is in the first rendering of the selections, he argues: 'if the orchestra is not "tuned up" on the first night it is ten to one they will never be through the whole run of that picture'; the MD needs to 'drive home his ideas' first time.

2. Arthur W. Owen described it as the equivalent of a carpenter's saw or plane: 'The M.D. & His Library: Some Points for Purchasers', *Kinematograph Weekly* (hereafter *KW*), 6 September 1928, 81.

3. Arthur Roby, 'Cinema Music. It Pays to Play to Plays', *The Cinema*, 24 March 1921, 35.

4. Now held by the National Media Museum (part of the National Science Museum group) in Bradford.

5. Jean Michaud, 'The Importance of the Cinema Library: Indexing the Music', *Musical News and Herald* (hereafter *MNH*), 15 April 1922, 476 and 22 April 1922, 508; S. Goldsmith, 'A Music Library? How to Arrange – What to Include – How to Use', *Bioscope Service Supplement* (hereafter *Bios*), 11 November 1926, xvii–xviii; Reginald Foort, 'Organ Accompaniment. Article II: "Library and Organisation" ', *The Melody Maker and British Metronome* (hereafter *MM*), 'Music in the Cinema Supplement', February 1927, 170; Anon, 'The Veteran Shows His Medals. II: How to Catalogue and Keep a Library', *MM*, April 1927, 401; Levy, 'Organising the Music Library', xxxiii–xxxiv. In addition to these is Owen's *KW* column (see endnote 2) and Martin Francklin, 'At the Console. II – Arranging the Music Library', *KW*, 19 January 1928, 57. However, as neither really discusses organization, I have not included them in the table, but may refer to their more general comments. Henceforth I will refer to these advice columns by author surname and date only.

6. Altman writes about the Balaban and Katz library, which served that company's many Chicago theaters and comprises about 26,000 items (according to the Chicago Public Library catalogue), and the smaller library of violinist and itinerant small band leader Alvin G. Layton of about 2,000 pieces: *Silent Film Sound* (New York: Columbia University Press, 2004): 354–357. Tobias Plebuch mentions Hugo Riesenfeld's and Ernö Rapée's from two New York Picture Palaces, but depends mainly on treatises and the marketing categories of publishing companies: in 'Mysteriosos Demystified: Topical Strategies within and beyond the Silent Cinema', *Journal of Film Music* 5/1–2 (2012): 77–92.

7. *Kinematograph and Lantern Weekly* (hereafter *KLW*), 12 September 1912, 1422. Watson's column started on 29 August 2012; from October 1912 W. Tyacke George handled the reviews and notes, though Watson wrote the column itself.

8. 'Weekly Notes', *KLW*, 26 December 1912, 900.

9. The average weekly salary for a cinema pianist in Glasgow in 1912 was rough £2 2s (= 42 shillings). See Annette Davison, 'Workers' Rights and Performing Rights: Cinema Music and Musicians Prior to Synchronized Sound', in Julie Brown and Annette Davison (eds.) *The Sounds of*

the Silents in Britain (New York: Oxford University Press, 2012): 243–262 (245).

10. Tootell, 'Music in the Cinema', Supplement to *The Cinema*, 10 November 1921, xvii.

11. Tootell, *How to Play the Cinema Organ: A Practical Book by a Practical Player* (London: Paxton, [1927]): 71.

12. Arthur Roby, 'Music. Necessity of Suitable Accompaniment. Points to Avoid', *The Cinema*, 12 January 1922, 17.

13. *The Cinema*, 24 September 1925, 30. Goldsmith assumes about 3,000 'numbers', without saying how big a cinema such a library might serve. (Goldsmith, 'A Music Library?', xvii) Three and a half years later in April 1928, a letter to the editor reveals that the MD of the Silver Cinema in Worcester had a library of around 4,000 sets (*The Cinema*, 14 April 1928, 8).

14. Levy, 'Organising the Music Library', xxxiii.

15. At the time Michaud wrote this, he was reported as being managing director of the London and Continental Music Publishing Company (see Gilbert R. Stevens, 'Picture Music', *Supplement to KW*, 26 October 1922, ix), though whether he was also working in a cinema is uncertain. In January 1918 he had certainly been MD at the Brixton Pavilion, and from late 1923 served at the Majestic, Clapham. Tootell likewise claimed to have a personal library of 12,000: *How to Play the Cinema Organ*, 71.

16. 'Some Suburban Musicians', *KW*, 9 April 1925, 48.

17. Levy, 'Putting Over the Right Oriental Music. Musicians Who Play Egyptian Tunes for Turkish Love Scenes. A New Year Message for the Band', *The Cinema*, Technical Section, 12 January 1928, xlvii–xlviii (xlviii). In September 1922, he is reported as having a personal collection of 6,000 pieces. (Michaud, 'A New Era Is Dawning', *MNH*, 30 September 1930, 296.)

18. Roby, *The Cinema*, 10 February 1921, 43.

19. Roby, 'Hints on Management', *The Cinema*, 17 February 1921, 40; Albert Cazabon airs the same view six years later, as if it were new: 'Music Libraries. Who Should Meet the Cost? Topics of the Moment', *Bios*, 3 March 1927, xvi.

20. Roby, 'It Pays to Play to Plays', *The Cinema*, 24 February 1921, 55–56.

21. *KLW*, November 1911. The classified ad itself appears under its own new subheading on 1531. The paper draws attention to it inside: see 1501.

22. Cooper's Lending Library advertises in *The Cinema*, 5 March 1914, 103.

23. Roby, *The Cinema*, 12 January 1922, 17. I would note that this supposed visit to a cinema reads partly as Roby's invention in order to encourage musicians to rest their music.

24. *The Cinema*, 24 February 1921, 55.

25. The Veteran suggests a simple cumulative numerical log of all music owned as the Catalogue Book; the other catalogue (the Library Book) would have about 15 categories.

26. See Plebuch, 'Mysteriosos Demystified', and Altman, *Silent Film Sound*, 258–263; 345ff.

27. Plebuch ('Mysteriosos Demystified', 87) describes Ernö Rapée's cataloguing arrangement for Agitatos in his *Encyclopaedia of Music for Pictures* (New York: Belwin, 1925) as a three-tiered, mono-hierarchical model of classification, however the 'third level' refers to one musical piece listed within what is actually a two-level system; it is a piece of photoplay music by Carl Breil,

34 *The Historical Practice of Silent Film Sound*

such as is often divided into several sections. Likewise the four-level system attributed to Edith Lang and George West in their *Musical Accompaniment of Moving Pictures: A Practical Manual for Pianists and Organists and an Exposition of the Principles Underlying the Musical Interpretation of Moving Pictures* (Boston: Boston Music, 1920) refers to a short list of pieces for suggested purchasing, not a proposal for a cataloguing system (Plebuch, 'Mysteriosos Demystified', 86).

28. Plebuch, 'Mysteriosos Demystified', 87.
29. (i) General Fitting Book, (ii) Special Effects Book; (iii) Alphabetical index of every piece in his library.
30. Goldsmith advocates abbreviating the first-level category for inclusion on the library envelope (for example, 'Overtures' = O.) as well as the piece number.
31. Francklin seems to mean this category in his initial statement about Pathetic, Dramatic, Tense Drama, Hurries and Combats.
32. A full-page advertisement for George's book appears in the 22 February 1912 issue of *KLW*, and George himself took out a classified advertisement offering advice to cinema musicians as to what to play – directing them to his book, which is available to buy via the *KLW* office.
33. George Beynon, *Musical Presentation of Motion Pictures* (New York: Schirmer, 1921); Lang and West, *Musical Accompaniment of Moving Pictures*.
34. On 'verbal matching' by popular song title, see Altman, *Silent Film Sound*, 220–226.
35. T. Scott Buhrman, 'Photoplays Deluxe', *The American Organist* 3/5 (1920): 171–173, quoted in Gillian Anderson, *Music for Silent Films, 1894–1929: A Guide* (Washington: Library of Congress, 1988), xxiii.
36. Stevens, *Supplement to KW*, 30 March 1922, ix. See Plebuch, 'Mysteriosos Demystified', 87.
37. Michaud, 'Incidental Music', *MNH*, 23 June 1923, 625–626.
38. Well before he wrote his column about organizing a library, Louis Levy had noted in 1921 that publisher titles (e.g. intermezzo) are often 'misleading', and argued that the cinema musician is best placed to add these secondary labels himself. He illustrates this strategy by means of a mood-related description: 'For instance, "Wooing" might be chosen as a title. Under this I should like to see "Slow, Flowing Romance".' *The Cinema*, 10 March 1921, 53–54.
39. In addition to short, single-mood pieces, longer, more complexly structured 'moods' also began to be created. In his 'Original Collection of Dramatic Music for Motion Picture Plays', published in 1917 by Chappell and Co., Carl Breil titles No. 3 in the series 'Agitato Mysterioso and Grandioso con Morendo'. The piece contains sectional markers A, B, and C (each inside very visible circles), and states in large type at the top of the piece the descriptive potential for those sections: '(A) For Scenes of Fear, Inner Dread, Hopelessness, Premonition of Doom, etc. and (B) an outcry of despair and indignation, a desparate [sic] appeal, followed by (C) an utter sense of hopelessness, or a clam and soothing aftermath.'
40. Francklin's account of his method is a little sketchy overall. On the one hand, he identified five broadly classified 'types of music': Pathetic, Dramatic, Tense Drama, Hurries, Combat. In practice, these are 'Types of scenes'.

Julie Brown 35

However, he actually seems to be referring to specific types of dramatic scene warranting particularly clearly directed dramatic music.

41. Roby, *The Cinema*, 14 April 1921, 45; H.A. Harrison, 'Cinema Music', *MNH* 22 July 1922, 89; Horace Shepherd, 'Music for Films on the Downward Path', *The Cinema*, 23 October 1924, 28.

42. A collection of photoplay music about the same size is held by Birmingham City library, but not in the form of an actual cinema library.

43. 'The provinces' was a term used freely in the film trade papers at this time.

44. Letter, National Media Museum.

45. In his outline description of the collection to the museum he admits that for about '300 miscellaneous sets' he personally has broadly filed them 'under such headings as Wagner [W], solos [B], Eastern Fantasias [E] and Operatic [Fantasias – F], Marches, Waltzes [M for both these!], Oriental [O], Rhapsodies [R] and Dances, suites [V], selections [S], and other'. In the previous quote, I have indicated in square brackets the code letter that he wrote on the library envelopes in blue pencil. Others are: Sch (Schirmer series), X (Overtures, but also some symphonic movements, or symphonic poems), Z (Schirmer's Galaxy of Orchestral Music, or Orchestral Miscellany series) and the extremely vague 'G', which may stand for 'General', but is used to label a wide variety of pieces: serenades, reveries, pastorals, some intermezzi (given this, why re-label these and not all the other intermezzi?), humorous sketches, etc. Assigning these 'G's does nothing at all to clarify function or meaning.

46. On this, see Plebuch, 'Mysteriosos Demystified', 82–84.

2
The Formation of a Swedish Cinema Music Practice, 1905–1915

Christopher Natzén

Introduction

This chapter will explore the formation of a Swedish cinema music practice between 1905 and 1915. Little is known about the use of music in this early period in Swedish film history. Few contemporary sources exist that discuss the musical accompaniment of film screenings. If sound is mentioned at all, it is due to special guest appearances or the use of a new technical device. Before the 1910s, the musical accompaniment of moving images in Sweden is believed to have been characterized by improvisation, performed on a single piano or another instrument, although evidence suggests that there were some exceptions that had better-prepared music. Some cinemas may, for example, have employed small ensembles to perform. However, in-depth research has not yet been done and it is heretofore unknown how a Swedish cinematic music practice was established.

In 2005 the Swedish State Archive for Sound and Image (SLBA), which became a department of the National Library of Sweden in 2009, started a project to digitize two cinema program collections from Lund and Uppsala, respectively. The collections consist of 7,755 program notes from across Sweden covering the period 1905–1920. The programs illustrate the mixture of actualities, journals, short films and later feature films that were screened in Swedish cinemas. In this chapter, I argue that live musical accompaniment and music provided by different mechanical sound carriers played an important role in establishing these programs and that this is visible in the programming. The documents not only list films, but also mention guest appearances, musical accompaniment, information regarding the venue and special screenings. The programming was a way of presenting the films in a sophisticated way to

attract greater audiences. The scanned cinema programs, their graphic design and the placement of films and other acts provide an illustration of contemporary cinema music practice in Sweden that has so far been difficult to analyze. Music in any shape was part of presenting the mixed programs of actualities of Swedish everyday life, nature films, footage of significant events and comedies filling in 'dead spots' as the projector was reloaded; and as these programs were developed further, so was the musical accompaniment.

Now, what exactly can a collection of early film programs tell us about the use of music in the organization of the performances? How is music approached in the programs? Is music a selling point used in competition between different cinema venues? Is it even worth mentioning or do the owners of the cinemas view the accompaniment as an evident fact not worth advertising? What do the programs tell us about the music practice in Sweden's various regions and towns, and is music a part of the development of the cinemas? In short, can an analysis of the cinema programs, together with other sources, help to address the many questions regarding the formation of early Swedish cinema music?

My aim is to approach the cinema programs from six different perspectives, investigating respectively the use of technology; the use/non-use of music/musicians; the establishment of permanent exhibition venues; the formation of the Swedish Musicians' Union; the length of the films shown/the length of the programs; and the role of female musicians. In the following, I will present some preliminary results from my research-in-progress in order to illustrate what the programs can disclose about a Swedish cinema music practice.

Technology and live accompaniment

The period preceding 1908/1909 in Sweden was the heyday of itinerant exhibitors who, to a large degree, used technology as one means to attract audiences. The experimentation with different sound carriers in combination with the exhibition of moving images started in Sweden at an early point in film history. Numa Peterson brought the sound film to the country in 1901 after witnessing a screening of a Phono-Cinéma-Théâtre at the world exhibition of 1900 in Paris. Peterson's impressions of the invention resulted in the so-called 'Swedish Immortal Theater' (Svenska Odödliga Teatern). Soon he began producing his own films. One of his films was screened at the industrial and

38 *The Historical Practice of Silent Film Sound*

public exhibition in Helsingborg in 1903, but despite such a prominent premiere, the reception was rather lukewarm during the following tour throughout Sweden, and in 1905 the Immortal Theater was silenced.[1] Instead, Peterson's efforts encouraged others to experiment with sound. Between 1905 and 1908 a diverse group of characters tried to capitalize on the name 'Immortal Theater' by screening short sound films with mixed success. The hub for sound film production was also relocated to Gothenburg, where Otto Montgomery, Jarl Östman and Erik Montgomery started to produce song films with the company Svensk Kinematografi. However, soon this production also dwindled, and in 1909 the company was dismantled.[2]

In 1908 Svenska Biografteatern had acquired the exclusive rights to the Biophon system by German engineer Oskar Messter, but had also started to develop a similar apparatus of their own. In 1909 Charles Magnusson became the new CEO, which resulted in the experimentation becoming more goal-oriented. Magnusson had had previous contact with sound film production when working at Svensk Kinematografi, and now he started to produce gramophone-based sound films with song numbers, with the bulk of the production taking place in the years 1909 and 1910. The machinery was also developed to be automatic and electric. Despite this, the economic result was not satisfactory and production was discontinued.[3]

In the collection of cinema programs that I have analyzed, Magnusson's song films are listed in numerous places. The song films are highlighted and given a specific place in the programs. At times, two numbers per program are shown, intertwined with screenings of other films. Technology in itself becomes a selling point, and several other early programs in the collection emphasize the use of technology when it comes to both the images and the music. Since film technology in itself prior to 1908–1909 was still much of a technical novelty, it must have seemed natural to also include the almost equally new technology for music reproduction in an exhibition environment. The programs typically focus on the sound technology of the phonograph and the gramophone rather than on the music or the musicians. Part of a 1906 program, for instance, reads: 'The Light Cinema is a newly designed, high-quality machine that reproduces vivid images astonishingly lifelike... during the screening an instrumental and vocal concert by a giant gramophone will also take place.'[4]

There are few recollections in Swedish newspapers at the time of how such performances might have sounded. Until around 1910 many early sound film reproduction systems were handled manually

which, of course, could create problems in fitting the music to the image. The following anecdote illustrates the sometimes parodic situation:

> The gramophone was placed in the cinema on a platform under the screen. It was run by hand – as was the picture machine. To achieve coherence, one constructed a meter with one white arrow for the image and one red arrow for the sound. The arrows had to coincide and move at the same speed. However, from time to time the red arrow happened to linger behind, and then it was important to start cranking so that the gramophone caught up with the Kinematograph. The race could give the most picturesque results.[5]

Then there were also the self-playing instruments that during two phases – 1910–1915 and from 1920 up until the conversion to sound film – played a part in exhibition practices, although they seem to have had a relatively short lifespan in their first phase and were also quite unreliable, making them a poor substitute for musicians. However, the first sound experiments should not be seen foremost as a means of integrating the sound into the unfolding narrative, but more as additions in order to highlight and give 'life' to images that were already filled with intradiegetic sound.

Apart from illustrating the experimental nature of film exhibition, the use of these different sound carriers and their placement within the programs highlight the use and non-use of music and musicians. The question of non-use of music during silent film exhibition is an ongoing discussion at least since Rick Altman's article 'The Silence of the Silents' from 1996.[6] Without delving too far into the American context, it is worth noting what Donald Crafton convincingly argued in 'Playing the Pictures: Intermediality and Early Cinema Patronage' in 1999 when he wrote that 'it goes against common sense' for films to be shown in silence when an exhibitor had invested in musicians.[7] My aim here is not to take sides in this debate, but rather to note that there are advantages in taking into account both of these perspectives. This allows for an understanding of cinema culture that comprises both conditions and changes between the film medium and other media and cultural expressions, and between various aspects within the film medium itself, for example between music, images and sounds, but also between different aspects of exhibition practices and other technological parts of the production apparatus. Thus, from this perspective,

40 *The Historical Practice of Silent Film Sound*

the use of different sound carriers plays a role in establishing a music practice. Using live music was then another aspect of establishing that practice.

The Swedish cinema programs of the period prior to 1908 provide information about the music, where the utilization of different technological sound carriers and the use and non-use of music/musicians seem to walk hand in hand. For example, the program for the 'Stockholm Theater', which toured the country in 1906–1907, reads: 'During the screenings – Piano Concerto by music director H. Nilsson – if a usable instrument is available on the premises.'[8] The programs in the collection also show the diversified use of music and other performances. Music often has its own place in the programs and seems not always to accompany the actual images. A program from the Pariser-Cinema-Theater in Gävle lists 'music' as a special feature without describing it in closer detail, which opens up questions as to whether it was rendered by a gramophone or by live musicians, and if music was played throughout the program or not. However, these acts probably filled the 'breaks' allowing for the exhibitor to reload the projector, which is spelled out in other programs by the same exhibitor.[9]

Apart from reel breaks that could involve some kind of performance or music, what happened during the actual screenings of images? Did they have any musical accompaniment, and if so, was the music technically reproduced by a gramophone or performed by musicians? As mentioned previously, it is hard to know exactly how these things worked in Sweden, since the daily press and other sources rarely mentioned the accompaniment. To further complicate matters, some programs also presented 'music' before every item in the program, such as the Swedish itinerant exhibitor brothers Gustaw and Anton Gooes who were famous for hiring well-known musicians.[10] In contrast, other programs specify in detail when there is musical accompaniment and when there is no music, even mentioning at which specific hours of the day music will be featured.[11]

What has become clear is that all these programs in the collection show diversified ways of including music – sometimes music was used together with the images, sometimes not; sometimes a reproduction technology was used to accompany the images, sometimes the accompaniment was provided by musicians – in short, there is a palette of different options in which the use of musicians was one possibility. However, as both Altman and Crafton have argued, even if they arrive at different conclusions, the musical accompaniment also came to be

influenced by other aspects of the exhibition environment. These features all tended to be part of the formation of a cinema culture, which was geared towards a more controlled environment. The developing music practice was one means of establishing this culture. That is, the development of the cinematic programs occurred contemporaneous with the establishment of more permanent exhibition venues.

Permanent venues and organization of music practice

With the establishment of permanent venues after 1909, a shift in music practices occurred which is reflected in the collections of cinema programs. The introduction of locations designated to film exhibition and a more solidly established cinema culture led to other demands being raised, concerning both the content of the films and their presentation. The skills of the accompanying musicians became an advantage in the competition with other cinemas. This put more pressure on the actual performers. If musicians during the heyday of the itinerant exhibitors played to the same film day after day at different locations, the establishment of permanent venues for film screenings meant that it became harder to have a well-planned accompaniment following the constant rapid change of programs; sometimes a venue would show several different programs per week. It is during these years that periodicals and daily newspapers increasingly comment on the musical practice in cinemas:

> No ideal cinema exists in Sweden. There are those who have some kind of proper music, mediocre and bad, but none exists, which could be much better. Hopefully improvements will come about with time. The music that accompanies the images, with which it should be in perfect harmony, is usually not given as much importance as it should. Piano and some sound equipment for the imitation of water noises, etc. are considered sufficient for several of the capital's major cinemas.[12]

Prior to the establishment of conventions for musical accompaniment, music was more a part of a film's overall exhibition than an integrated part of the film itself. The music was often improvised on a single piano or another instrument. Some cinemas had smaller ensembles, although they generally were limited to quintets. Often the small ensemble or pianist underlined aspects of the narrative in a very

42 *The Historical Practice of Silent Film Sound*

rudimentary manner, and one can sense that the overriding ambition of some cinema owners was to lure the audience into the cinema with the help of music.[13] In the words of Louis Levy:

> The first step towards any improvement in the type of music played as an accompaniment to films actually came from the filling in of these internal gaps by a relief pianist. Usually he (or more often she) adopted the same attitude as the orchestra, and was generally more concerned with showing-off prowess as a performer rather than with playing music suitable to the mood of the film.[14]

The diegetic function of music was greatly augmented during the second half of the 1910s and throughout the 1920s, when musical themes to accompany film were gathered and catalogued according to subject matter and emotions.[15] The early period of film music accompaniment is characterized by diversity rather than similarity between musical practices. The actual meaning of a certain kind of accompaniment could change over time; for example, as Rick Altman has shown, prior to approximately 1910 the term 'appropriate music' in the US meant independent musical performances, while after 1910 the same term referred to the musical accompaniment for the actual films. This can also be seen in the changing meaning of the term 'cue music', which first stood for music as sound effects, before changing into an understanding of the term as proper music.[16]

The changing music practice along with the establishment of permanent venues also entailed implications for audience participation. As musical accompaniment became a self-evident and integrated part of the film medium, the audience, who up to then had been quite lively, became more silent and finally wholly absorbed by the 'synchronous' and diegetic sounds. As Rick Altman argues, in an American context, when the films were screened by traveling showmen, the charm of novelty constituted the main attraction. The audience came into the 'theater' straight from the street, only separated by a thin drapery, which did not shut out street noise. These presentations encouraged a high degree of participation from the audience, and their comments were an important part of the screening.[17] Other acts were also performed alongside the films, which were increasingly shown with musical accompaniment. These acts and, as mentioned above, the skills of the accompanying musicians became in themselves an advantage in the competition with other cinemas. The audience was still an active part, as lecturers and even musicians turned directly towards the film

viewers.[18] When musical accompaniment became an understood part of the medium together with other developments of the film medium, this gradually silenced the audience, as it demanded a higher level of attention to be able to follow what happened on the screen. When finally dialogue was added through the technical synchronization of sound film systems in the late 1920s, all sounds emanating from the audience were silenced.[19]

It is too early to draw similar conclusions for the Swedish context but the analyzed cinema programs suggest that a comparable progression took place in Sweden. In the programs this shift is shown in the use of general expressions concerning the use of music instead of listing 'music' as a specific point in the program. During 1908/1909, comments regarding the musical accompaniment increasingly appeared in the daily press and periodicals and many of these accounts emphasized the bad quality of the music. However, in the programs, if mentioned at all, the music was described, as 'good', 'of high-quality', 'with piano', etc. Unless a prominent musician was giving a guest appearance, music was no longer specially emphasized in the programs: it was presumed to be there throughout the program but did not need to be advertised any longer.

Parallel with the establishment of permanent exhibition sites in Sweden, the national Musicians' Union was formed. The union was inaugurated in December 1907, and clearly made an impact on music practice. The growing importance of musical accompaniment for moving images is illustrated by an early tariff from the union in 1909 that lists 'cinema' as one possible employer – the low tariff also illustrates the position cinema musicians had vis-à-vis other musicians.[20] The newly founded Musicians' Union in Sweden worked in favor of establishing regulations concerning both working conditions for cinema musicians and to create a raison d'être for film music by trying to establish a better reputation than was reflected in the increasing comments in periodicals and the daily press.

From its foundation in 1907 the Musicians' Union struggled both with being accepted as an organization and with their self-identity, which mainly revolved around one issue: should they be considered as artists or workers? This seemingly simple question haunted the Musicians' Union from the start and was the origin of many disputes since it was not easy to draw a line between amateurs and professional musicians, as many amateurs played for wages while many professionals took non-musical side jobs. The whole idea of a union for musicians was questionable in the first place, as a union would link them to other unions for industrial

44 *The Historical Practice of Silent Film Sound*

workers. In this respect, the Musicians' Union in Sweden was not any different from, for example, the union in the US which struggled with the same issue from the late 1880s onwards,[21] or the union in Germany which had initiated an investigation on the matter in 1926, the result of which was published in the Swedish Musicians' Union's mouthpiece, *Musikern*.[22]

One crucial difference between the Swedish union and its counterparts in the US was that the former addressed labor-related issues from the start in 1907, while the latter, during its first years, functioned more as a labor exchange association than a true union.[23] In this sense, the US unions acknowledged the differences between musicians, and tried to solve the contradictory agendas that affected their professional lives. In Sweden, however, instead of recognizing such differences, the Musicians' Union tried to fit every musician into the same fold, thereby creating tension among its members.

These union matters are of course not articulated in the cinema programs, but with the formation of the Musicians' Union, a standardization of musical content can be traced in Sweden during 1908/1909, which is related to the previously mentioned shift in musical practice that occured with the establishment of permanent venues. This process reaches a certain finalization in the late 1910s and the most common way to set music to film became the compilation of already existing compositions. Ann-Kristin Wallengren has shown that it soon became customary to use compositions from the classical romantic repertoire of the 18th and 19th centuries as well as popular melodies from the melodramatic theater.[24] This music seems to be comparable with Rick Altman's findings in the American context, functioning in an autonomous state vis-à-vis the image so that it was rather unrelated to the filmic content, although familiar pieces from other contexts were used. It is noteworthy here that improvising single pianists or small ensembles had an advantage, as they were more flexible to change musical direction and mood to follow the action on the screen.

The establishment of permanent venues and the formation of a Musicians' Union meant that all cinema music started to share the aim of absorbing the audience into the film's diegesis. Evidenced by the numerous film music catalogues that were produced at this time, a continuous accompaniment, a correspondence between the music and the overall theme of the film, and the use of musical motifs for structural coherence became increasingly standardized as film form gradually transformed into more complex and longer narratives.

While the preserved correspondences and minutes from the Swedish Musicians' Union are an important source for exploring the changing music practice, these documents are more concerned with the working conditions than focused on how, when and where the music should be used when scoring a film. The cinema programs on the other hand describe the day-to-day activity as exhibitors aim to attract a wide audience. Music is one aspect of this programming and the permanent venues facilitated the introduction of longer films, which, starting in 1911, were distinctly presented in the programs. At the same time, a development emerging in Stockholm and spreading out from there to the south of the country and finally to the north is traceable via the programs: from 1911 onwards there is a clear and constant tendency in Swedish film music practice for the compilation score becoming the norm, European romantic composers being favored alongside Swedish popular melodies, and the Musicians' Union gaining greater control.

However, a key to understanding the formation of a Swedish music practice and its continued development is the role played by female musicians – a highly under-researched subject in Sweden. If musicians' sons during the early 1900s became employed at more prominent orchestras, their daughters often took engagements at cinemas. This becomes evident from the membership rolls of the union, which since its foundation counted many women among its members. Furthermore, all-female ensembles played in restaurants and cafés, and later, when the cinema orchestras grew larger, many included female musicians.

This can be seen in the 1920s – a period in Swedish music life which is better-documented – where several women reached the position of conductor and musical leader of ensembles without many obstacles. One example is Greta Håkansson, who in the 1920s was even put forward as a role model. Although her musical skills were emphasized, it was foremost because of her loyalty as a union member in a time of crisis that the Musicians' Union periodical, *Musikern*, published an honorary article on her devotion to union concerns in 1928. From the short biography of Greta Håkansson in the periodical, she seems to have followed a development similar to that of any male cinema musician. Born in 1890, she studied piano and music theory. Later she took a position as an assistant teacher at Richard Andersson's School of Music in Stockholm, and after joining the Musicians' Union in 1921 she started working in small cinemas in Stockholm before becoming the musical leader, conductor and pianist of a small ensemble at Påfågeln (the Peacock) in central

46 *The Historical Practice of Silent Film Sound*

Stockholm for the 1928–1929 season. In addition to Greta Håkansson, the 300-seat cinema counted three male musicians.[25] Another female conductor was Siri Hildebrand from the Orion cinema. But the contrast between the two musicians could not be greater. Hildebrand was also a conductor and pianist, but unlike Håkansson she paid her ensemble below the stipulated tariff and was a non-member, thus violating union regulations.

The cinema programs further illustrate this early and ample presence of female musicians as several female pianists are mentioned. But perhaps the most important document with regard to the importance of female musicians records a decision made by the Gothenburg branch of the Musicians' Union in 1908 in relation to an employment question at the Concert Association. On 3 April 1908 the following decision was made: 'On the lady question for the orchestra the board expresses that they should have equal salary as the male members',[26] a note indicating that women were well represented in this job. However, there is a lot more research to be done in this area and I have only begun to focus on this. One assertion that can already be drawn from the analysis of the cinema programs is that female cinema musicians played a central role in the process of establishing a Swedish cinematic music practice.

Conclusion

This analysis of Swedish cinema programs shows a high degree of involvement of music. Be it technically reproduced by a sound carrier or provided by accompanying musicians, or, for that matter, absent from the screening, music was seen as an important part of the organization of early film performances. When film form and exhibition changed, the musical accompaniment developed too, strengthening this transformation. The musical accompaniment was highlighted, but during the 1910s a process of assimilating these sounds and music into the narration of the films began. In this manner Swedish music practice seems to have evolved congruently with what Rick Altman has shown for the American context, that is, the transformation of integrating the audience into the diegesis – in fact, as equal to other aspects of the medium such as camera angles, lighting and editing.

The music in cinemas and the performing musicians in Sweden acted as intermediaries between producers, distributors and audiences. From itinerant exhibitors with their experimental way of including music

Christopher Natzén 47

by means of both technically reproduced and live accompaniment, to increased standardization with permanent venues, and finally through the formation of the Musicians' Union, a uniform and nationwide musical accompaniment for film was established in Sweden. The collection of the 7,755 cinema programs from every corner of Sweden all contribute to the same story.

Notes

1. Jan Olsson, *Från filmljud till ljudfilm: samtida experiment med Odödlig teater, sjungande bilder och Edisons Kinetophon 1903–1914* (Stockholm: Proprius Förlag, 1986): 20–28.
2. Olsson, *Från filmljud till ljudfilm*, 42–54.
3. Ibid., 77–84. Simultaneously, during 1909–1910, Frans Lundberg in Malmö produced a number of song films, although very little is known about these recordings, see Olsson, *Från filmljud till ljudfilm*, 105.
4. Cinema program for Ljus-Biografen. Bollnäs, 1906. [All translations by the author of this chapter].
5. Ragnar Allberg and Idestam-Almquist Bengt, *Film igår, idag, i morgon* (Stockholm: Albert Bonniers Förlag, 1932): 84.
6. Rick Altman, 'The Silence of the Silents', *The Musical Quarterly* 80/4 (Winter 1996): 648–718.
7. Donald Crafton, 'Playing the Pictures: Intermediality and Early Cinema Patronage', *Iris* 27 (Spring 1999): 152–162 (154).
8. Cinema program for Stockholms-Biografen. Orsa, 1906, 2.
9. Cinema program for Pariser-Biograf-Teatern. Örebro, 1906.
10. Cinema program for Bröderna Gooes biografuppvisningar. Eskilstuna, 1905.
11. Cinema program for Jönköpings Biografteater. Jönköping, 1906.
12. 'Musiken å biograferna', *Nordisk Filmtidning*, 1/9 (August 1909): 1–2.
13. 'Musikens anpassande för filmen', *Musikern*, 13/21 (1 November 1920): 213–214.
14. Louis Levy, *Music for the Movies* (London: S. Low, Marston, 1948): 21.
15. Numerous catalogues exist. For a Swedish example see A.E. Wappler, *Katalog över Universal-Film-Musik samt Orkester-Bibliotek International* (Stockholm: Musikhandel International, 1927).
16. Altman, 'The Silence of the Silents', 653, 655, 671, 679–680, 704–705.
17. For a more thorough analysis of this development see Altman, 'Film Sound – All of It', *Iris* 27 (Spring 1999): 31–48. Here I only give a brief account of the main points on this issue in Altman's article. See also Altman, *Silent Film Sound* (New York: Columbia University Press, 2004): 278–285.
18. Altman, 'Film Sound – All of It', 40.
19. Altman, 'Film Sound – All of It', 42.
20. Tariff for Swedish Musicians' Union, Malmö branch. Malmö, 1909.
21. James P. Kraft, *Stage to Studio: Musicians and the Sound Revolution, 1890–1950* (Baltimore/London: The Johns Hopkins University Press, 1996): 22, 26.

48 *The Historical Practice of Silent Film Sound*

22. A. Prietzel, 'Musikeryrket och yrkesmusikerna: En social och ekonomisk utredning', *Musikern*, 22/13 (1 July 1929): 169–172. The recapitulation of Prietzel's investigation continues in the following issues of *Musikern*, 22/14 (16 July 1929): 181–182; 22/15 (1 August 1929): 193–197; and 22/16 (16 August 1929): 209–211.
23. Karl-Olof (Olle), Edström, *På begäran: Svenska Musikerförbundet 1907–1982* (Stockholm: Tidens förlag, 1982): 31–37.
24. Ann-Kristin Wallengren, *En afton på Röda Kvarn: svensk stumfilm som musikdrama* Diss. (Lund: Lund University Press, 1998): 119–120.
25. Gustaf Gille, 'En kvinnlig biografkapellmästare', *Musikern* 21/23 (1 December 1928): 336–337.
26. Minutes from board meeting, Swedish Musicians' Union, Gothenburg branch (3 April 1908): §3.

3
The Use of Cue Sheets in Italian Silent Cinema: Contexts, Repertoires, Praxis

Marco Targa

Italian music historiography has only recently oriented its attention towards music in silent cinema in its multifaceted aspects: praxis, musical repertoires, production contexts, the public, organization of performances and so forth. Research on music in Italian silent films has so far mainly focused on music expressly composed for specific films. Italy holds the chronological primacy for the first musical accompaniment ever written for a film: the music by Romolo Bacchini for *La malia dell'oro*, a film directed by Gaston Velle in 1905, whose score and film have unfortunately been lost. An ongoing survey counted about 40 films as being fitted with an original score throughout the entire silent era; of these only ten orchestral scores or piano scores survive, and some of the films have been digitalized with the synchronization of the original musical accompaniment (see Appendix 1).

Forty scores out of many thousands of films produced in Italy during the silent era is a very small percentage: we know that the everyday praxis of live musical accompaniment for silent films was mainly based on the use of a compilation of preexisting musical pieces. Although many articles in newspapers and the trade press periodically claimed the strong necessity of increasing the composition of original scores for each film in order to ensure that the musical accompaniment was not completely left to the discretion of the conductor or improvisation of the pianist,[1] it was absolutely impossible to achieve this objective. This had many reasons: the excessive production rate of new films, the economic unattractiveness of the process, and the difficulty in always imposing new scores on the musicians of the exhibition venues.

50 The Historical Practice of Silent Film Sound

My research therefore starts with the questions: What music was most often played in Italian cinemas? Which repertoires were used? How was this music applied to create a musical accompaniment for a film? The answers to these questions and an attempt at reconstructing how silent films were accompanied can not only deepen our historical knowledge, but can also give numerous suggestions on how to create a musical accompaniment for the modern presentation of a period silent film. Today, the great majority of silent films, which do not have an original score, are provided with an accompaniment of newly written music or a compilation of music, which often has little to do with the musical style of the silent cinema period.

Recent research on silent film sound has revealed how varied the types of musical activities were in cinemas and exhibition venues, to the extent that a standard practice in different countries cannot be described univocally. Rick Altman particularly stressed this fact in his book on the North American context:

> Neither natural nor universal, neither homogeneous nor borrowed lock-stock-and-barrel from some previous practice, silent film sound varies according to difference in date, location, film type, exhibition venue, and many other variables, and thus cannot possibly be reduced to a single practice or even a single line of development. The only history that can do this topic justice is a history that treats silent films sound's variety and complexity with full seriousness.[2]

The new trend of research has taken this caveat as an important premise for all historiographical reconstructions: the history of music in the silent cinema should always be reconstructed starting from local contexts, revealing the differences and similarities between different geographical and cultural contexts.[3]

As a general example, various striking differences can be indicated between musical practices in cinemas in the US or other parts of Europe and in Italy. The use of organs for film accompaniment in cinemas, for example, was almost totally absent in Italy. This instrument, which from 1910 onwards began to be widely used in cinemas throughout North America, had no appeal in Italy: no review in newspapers, chronicles or descriptions of film exhibitions have ever reported the use of organs in Italian cinemas. This fact might be explained by considering the strong separation between profane and sacred music contexts in Italian culture and how the timbre of an organ characterized it as being an instrument exclusively used for liturgical purposes. It was hardly considered suitable

for the musical accompaniment of, say, a love scene or comical situation in a film.

Another particular feature of the Italian context, which considerably affects the historical survey on film accompaniment practices, is the complete absence of any publication that describes or teaches how to create a musical accompaniment for films. As far as we know, no manual for film music was ever published in Italy during the silent period; there are numerous manuals addressing various cinematographic professions (actors, screenwriter, cinema managers and so on) but not any concerning the practical organization of musical accompaniment for films. The topic of music and cinema was dealt with in manuals destined for the new cinematic art, but only from an aesthetical point of view, for example in *Il teatro muto* by film director Piero Antonio Gaiazzo or in *Verso una nuova arte: il cinematografo* by the critic and musicologist Sebastiano Arturo Luciani.[4] There are no other practical manuals comparable with those published in the US and in Germany, such as Edith Lang and George West's *Musical Accompaniment for Moving Pictures* (1920) or the *Allgemeines Handbuch der Film-Musik* (1927) by Hans Erdmann, Guiseppe Becce and Ludwig Brav.[5]

Italian cue sheets: *Commento musicale* and *adattamento musicale*

The main source of information relating to music adopted in cinemas (and how it was used for film accompaniment) is found in the extensive coverage of the trade press, which could claim a flourishing market of numerous titles of reviews, magazines and newspapers, rich in information about music.[6] The trade press is also the almost exclusive source of the few Italian cue sheets, which have been discovered so far. Unlike in the US, after a certain point in time production studios in Italy did not generally provide cinemas with cue sheets containing descriptions of the musical accompaniment for the film being projected. This task was the responsibility of the cinema orchestra conductor, who had to prepare the appropriate musical accompaniment for every new film, using his own musical repertoire.

All known Italian cue sheets are written by conductors employed in cinemas and not by the staff from the production studios; they were indicated with the terms *adattamento musicale* (musical adaptation) or *commento musicale*. The *commento musicale* (musical accompaniment) was very rarely printed in the advertisement of a film or in the *libretto*, which was distributed before the projection of a film, containing

52 *The Historical Practice of Silent Film Sound*

information about the plot and the cast. Only in the late twenties did reviews begin to publish cue sheets, and publications of the exhibition venues also began to report information on the music played during their film projections.[7]

Appendix 2 shows three cue sheets (*commenti musicali*) compiled by three different conductors who were active in cinemas in Parma, Rome and Turin. Scanning the pieces listed in these compilations, we detect a large number of classical composers, the majority of whom are represented by Italian opera composers. There are also, however, a large number of unknown composers: Cristofaro, Frontini, Scassola, Cerri, Maj, Scavino, Drigo... Who were they?

The 'Musica per Orchestrina' repertoire

These composers devoted their compositional activity almost exclusively to the particular genre of 'musica per orchestrina', which is the equivalent of 'Salonorchestermusik' in German or 'salon orchestra music' in English. This particular musical genre, which is today almost totally neglected by music history, at least in Italy, was probably the most frequently played *Gebrauchsmusik* in everyday life during the first decades of the 20th century. The term 'musica per orchestrina' indicated a genre with a precise set of features, where the diminutive did not necessarily mean the use of a small ensemble, but rather pointed to the nature of the music being without any great pretentions and suitable to be used as 'lounge music'. It was adopted on many different occasion to create a musical background for various situations: vaudevilles, tabarins, ballrooms, cafè-chantants, beach clubs, cinemas, ballets and so on. This repertoire was the main source of music for the silent cinema in Italy for three decades. As already mentioned, it had a very specific set of features, which were very clearly recognizable and standardized. The main feature was its typical modular instrumentation: 'salon orchestra music' was written to be played by any kind of instrumental ensemble, from a solo piano to a large orchestra (with trombones and percussions) passing through all established formations. The music was written in such a way as to make any instrument useful but not necessary; the piano part is already musically complete and self-sufficient and a variable number of instruments could be added to it.

The collections of these pieces can be divided into three main categories. The first is represented by the transcription of famous opera or symphonic pieces; the second is the music written by minor composers, active only as composers for salon orchestra music. The style of this

Marco Targa 53

music stems directly from the tradition of Romantic and Late Romantic *Salonmusik*, reflecting its typical harmonic, melodic and rhetorical features. The titles of the pieces also recall this genre: *barcarola, notturno, pezzo caratteristico, rêverie* and so forth; sometimes also ancient dances such as the *gavotta, minuetto*, and *pavana* were included. The most frequent title was the *Intermezzo*, a piece intended to be played as an interlude between the different numbers of a cafè-chantant, or the different acts of a theatrical play as well as during the pauses between the different parts of a film.

To better illustrate the style of this type of music, Figures 3.1 and 3.2 show some bars of two different pieces. As can be seen, the musical style of these pieces is not at all similar to that of light songs or dance music

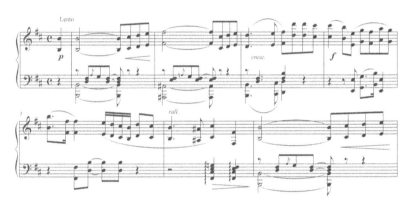

Figure 3.1 Carraro, Omero. *Lento appassionato*. Torino: Casa Editrice Musicale Sabauda, 1929, bars 1–8

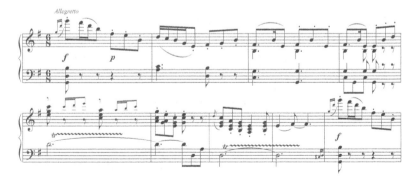

Figure 3.2 Rosetta, Giuseppe. *Piccolo Scherzo*. Roma: Italica Ars, 1927, bars 1–9

54 *The Historical Practice of Silent Film Sound*

usually associated with the idea of a salon orchestra, but rather much more related to a Romantic musical style. Dance music, in fact, forms a separate third branch of these musical collections: the most popular dances were the foxtrot, one-step, paso doble, tango, waltz and valzer-hésitation. Dance music was, naturally, played as an accompaniment to ballroom dancing, but also as 'easy listening music' in cinemas while waiting for the film to start and it was frequently provided with words to be sung by a *chanteuse* or a *canzonettista*. It is important to note here that there was often dancing in cinemas before or after the projection of the films and the orchestra that played in the hall was very often identical with the one that played during the film. Larger theaters could have two orchestras, one for the dancing hall and one in the theater. For example, in one of the most important exhibition venues in Turin, the Sala Ambrosio, there were always dances, ballets, song performances and many types of musical entertainment:

> Whoever can find space in the hall is lucky; it has become one of the most popular meeting places for the people of Turin, who do not even have to enter the cinema but have well-spent their evening, as the excellent music, extremely elegant dances, performed by the charming couple Prof. Stephan and Miss. Eva, the blonde dancer who always wears new outfits, provide entertainment which many people do not wish to renounce. In addition to this there are the refined songs by the salon singer 'Enzo Tacci'... and this is why the 'Ambrosio' is the most popular meeting place where foreigners also rush to visit.[8]

Another important cinema, the Salone Ghersi, gave great importance to music as a means of attraction and there were no fewer than three *orchestrine* employed for different purposes:

> When you pass in front of *Ghersi*, it seems as though you were passing in front of a musical palace, an orchestra outside, an orchestra in the large hall, so majestically decorated, an orchestra, which accompanies the performance. And the music is first-class, the hall crowded, very crowded.[9]

Many forms of entertainment took place in the cinema for which a musical accompaniment was required, so the *orchestrina* had to provide music for each of these activities, either for dances in the halls, as lounge music or as film accompaniment. This is why their collections

of music contained pieces of such differing musical styles, in order to provide the right accompaniment for the various occasions. This stylistic heterogeneity was also reflected in the musical accompaniment of the films, where varied musical genres were juxtaposed without any aesthetical scruple: a tragic symphonic piece would be followed by a light, cheerful song or a funny one-step.

The publishing market of collections for *orchestrina* began to flourish at the beginning of the 20th century, when over 30 editors of this kind of music can be counted in Piedmont alone,[10] and the number increases significantly when considering the whole country. The strong link between the musical repertoire for *orchestrina* and cinema is further confirmed by the fact that almost every composer who wrote an original score for a specific film was mainly active in the field of salon orchestra music. Osvaldo Brunetti, author of the music for *Lo schiavo di Cartagine* (Ambrosio, 1910), wrote for salon orchestras for the editors Gori and Ars; Vitaliano Bianchi, author of the music for *La Fata Carabosse* (1914), wrote for the Buongiovanni (Bologna); also the priest Don Giocondo Fino, a composer who wrote original scores for important films (*Il mio diario di guerra*, 1915; *Christus*, 1917; and *Joseph*, 1921), did not refrain from composing music for salon orchestras, publishing his pieces with the Casa Editrice Italiana Piemonte and Zanibon. Conductors of cinema orchestras were also frequently active in musical compositions for salon orchestras: Alberto Consiglio, conductor at the Sala Ambrosio in Turin, Luigi Desenzani at the Salone Ghersi and Cinema Vittoria in Turin, and Manlio Steccanella at the Cinema Moderno in Rome. The only known archival cinema music collection of a conductor employed in a cinema in Italy is the 'Fondo Felice Andreis',[11] a musician who held the position of conductor at the Cinema Vittoria in Gorizia during the twenties. His entire archive consists of collections of music for salon orchestras by editors of different nationalities: Beltramo, Carish, Ricordi (Italy); Wrede, Drei Masken, Schott's Söhne (Germany); Salabert, Francis Moulin (France). There was certainly a high level of international circulation of music for salon orchestras in the various countries, and the cue sheets of Italian films usually presented a great deal of music by French, German and British composers.

From 1910 onwards, editors took note of this cinematographic use of music for salon orchestras and began to advertise their musical collections in the trade press, recommending them specifically for film accompaniment. One of the largest editors of music for salon orchestras in Turin, Gori Editore, published advertisements in many Italian cinematographic magazines: *La vita cinematografica*, *La cine-fono* and *Il*

56 *The Historical Practice of Silent Film Sound*

Maggese cinematografico. Every week, starting in 1915, this latest review offered its readers the piano score of a selection of three or four pieces from the Gori collection, recommending them for use as film accompaniment.[12] In this time frame, pieces for salon orchestras were proposed for film use, but there were rarely any particular indications concerning their expressive content and the dramatic situation they could accompany, as in other cinema music publications such as Becce's *Kinotheken*, which began to be published in Europe and in the US. Only during the second half of the twenties did publishers begin to provide the collections with specific suggestions concerning their use in musical accompaniment for films. The pieces in the collections were divided into different groups relating to moods, character, dramatic situation and exotic features, following the model of the *Kinotheken*. Usually, the historiography of film music only mentions the best-known collections of music for film accompaniment, the 'Biblioteca Cinema' edited by Ricordi between 1927 and 1929.[13] This, however, was only one of the numerous collections present in the music publishing market, as Table 3.1 shows:

Table 3.1 Italian collections of musical pieces for film accompaniment

Editor	Title of the collection	Year of publication
Edizioni musicali Impero	Repertorio Cine-Dramma	1927
Italica Ars	Adattamento Films	1927
Ricordi	Biblioteca Cinema	1927–1929
Casa Editrice Italiana Piemonte	Repertorio Sincronis-Film	1928
Curci	Kinoteca	1928
	Cinemusica	
Beltramo	Collezione Cinema	1929
Edizioni Theo-Muccy Roma	Sincrono film	1929
Florentia Film	Commento Films	1930
Casa Editrice musicale Sabauda	Adattamenti cinematografici	1930

The collections of music for silent films showed absolutely no differences compared to the collections of music for salon orchestras published up to that moment in Italy. Sometimes they contained the same pieces, simply offering new suggestions for film use and a categorization of their expressive content. Figure 3.3 shows the collection of the editor Florentia.

Edizioni "FLORENTIA" - COMMENTO FILMS
DELLO STESSO AUTORE IN PREPARAZIONE:

Carovana allegra ~ Intermezzo

Durata min. 2

Commenta: scene gaie, vivaci, burlesche, capriccio-se; festa di popolo: situazioni comiche.

Incubo ~ interm. tragico

Durata min. 5½

Commenta: scene tragiche, angosciose, melenconiche: Num. **1** sgomento: N. **2** e **7** affanno: **3 - 4 6** schianto: **5** lamento: **3, 9** dolore, acca-sciamento: **10** profondo sconforto

Harem - intermezzo

Durata min. 3½

Commenta: scene d'ambiente orientale.

Misterioso agitato

Durara min. 3½

Commenta: 1.º tempo *(andante)* afflizioni, accoramen-to profondo, dolore, timore, sgomento: 2.º tempo *(All'agitato mosso)* movimento di popolo, paura e spavento, lotta d'anima, baruffa, inseguimento, amas-samento.

La danzatrice di Tiflis

Durata min. 3½

Commenta: situazioni di carattere orientale: 1.º tempo *(Allegro)* per scene festose: 2.º tempo *(Moderato)* per scene nostalgiche, passionali, idilliache.

Serenatella Spagnola

Durata min. 4

Commenta: scene idilliache d'ambiente Spagnolo

Marcia Trionfale

Durata min. 1½

Commenta: scene marziali di carattere militare: esul-tanza di Popolo.

Cavalli rossi

Durata min. 3½

Commenta: scene di carattere festoso; cavalcate.

Coru Sardu (Cuore di Sardegna) - intermezzo

Durata min. 3½

Commenta: scene nostalgiche e gaie, idilliache e briose

Figure 3.3 List from the collection 'Commento Films' in Puligheddu, Giovanni Erminio. *Scena russa* (Firenze: Casa musicale Florentia, 1930). Courtesy of the Archivio Storico del Comune di Terruggia (AL, Italy)[14]

58 *The Historical Practice of Silent Film Sound*

Reconstructing historical practices

We can now go even further and try to understand how these pieces were used in the musical accompaniment of a film. We do not have much information in this respect since the only compiled score available is Manlio Mazza's music for the film *Cabiria* (Giovanni Pastrone, 1914).[15] Apart from this, there are various articles in newspapers that deal with the topic of compiling a film score, providing the conductor with a few suggestions and formulating some general principles in order to create an appropriate accompaniment.[16] Each conductor could naturally choose the music according to his own taste and following his personal style, but through an analysis of cue sheets from different conductors, some recurring features can be detected. First of all, the number of pieces used in an Italian cue sheet was less than those adopted in an American cue sheet. This means that each piece was played in its entire length, or in any case for a longer time than was common practice in the US, which had a standard duration for each piece that rarely went beyond two minutes. This fact can be verified by analyzing Mazza's score for *Cabiria*, where the duration of many pieces goes beyond two minutes, linking together many different scenes. Another confirmation of this fact can be found in a list of instructions for a compiled film score, in the column 'Musica al buio' (Music in the dark) of the review *Il Cinematografo*, addressed to cinema conductors. One of the items on this list recommends that the compiler choose the pieces in order to 'clothe the action without adhering to it' (*vestire l'azione senza aderirvi*)[17]: a musical piece should accompany a sequence of different scenes without over-frequent changes in music. A well-finished accompaniment should also have some recurring themes (*Leitmotive*) relating to the different characters and situations, and specifically composed musical bridges should connect the different musical pieces in order to create a better link between the changes of scenes.

Such information can not only be useful as historical knowledge, but can also promote a more historically documented reconstruction of original musical accompaniment for films, based on original musical repertoires. As stated above, the modern presentation of Italian silent films or their digitized versions for the home entertainment market rarely follow the objective of a historically informed reconstruction of the musical accompaniment, presenting genres and styles of music not contemporary to the films. This stylistic disassociation between the aural and visual dimensions is inherently inborn in many other audiovisual shows. In opera, for example, where the musical component

is constant (with a fixed musical score written by the composer), the visual apparatus is always newly recreated by the stage director. Silent cinema reverses this relationship: the image in the film is fixed and the music is always new. The anachronistic gap that can occur between the audio and video dimensions, the styles of which belong to two different historical periods, is a normal fact in our perception mode of multimedia shows and is not a reason for complaint. Along with this standard 're-creative' practice, however, a much less spread 'restoring' practice should be fostered, whose aim should be a rendering of the original musical accompaniment or, at least, an accompaniment that tries to recreate the original musical style of the silent cinema era.

Nowadays, it would be possible to reconstruct the musical accompaniment of many films presented in Italian cinemas during the silent era with the help of the original cue sheets. For other films that both either the score and the original cue sheet, the repertoire of pieces for *orchestrina* lends itself to creating a historically informed accompaniment. It would in fact be unusual if the same attention and philological concern paid to reconstructing the original status of the film copy, the quality of the images and the correct montage, were not also paid to the musical component, which was such an important element of the presentation of silent films. This attention could contribute to restoring cinematic performances closest to the ones the public enjoyed at the films' first presentations.

Appendix 1

List of films provided with score specifically composed
* film and orchestral score (or piano score) available
** only film available
*** only orchestral score (or piano score) available

1. *La malia dell'oro* (1905, dir. Gaston Velle [Filoteo Alberini], m. Romolo Bacchini)
2. *Nozze tragiche* (1906, dir. Gastone Velle, m. Romolo Bacchini)
3. *Romanzo d'un Pierrot* (1906, dir. Mario Caserini, m. Romolo Bacchini)
4. *Danze a trasformazioni* (1906, dir.?, m. Romolo Bacchini)
5. *Povero arlecchino!* (1907, dir. Egidio Rossi, m. Romolo Bacchini)
6. *Il Risorgimento italiano* (1910, m. Lorenzo Pupilla)[18]***
7. *Lo schiavo di Cartagine* (1910, dir. Luigi Maggi, m. Osvaldo Brunetti)*

60 *The Historical Practice of Silent Film Sound*

8. *Inferno* (1911, dir. Francesco Bertolini, Giuseppe de' Liguoro, Adolfo Padovan, m. Raffaele Caravaglios)**
9. *La fata Carabosse* (1913, dir.?, m. Vitaliano Bianchi)
10. *Ultimi giorni di Pompei* (1913, dir. Caserini-Ridolfi, m. Carlo Graziani-Walter)*
11. *Ultimi giorni di Pompei* (1913, dir. Ubaldo Maria Del Colle, m. Colombino-Arona)
12. *Fedora* (1913, dir. Achille Consalvi, m. Raffaele Bossi)
13. *Fenesta che lucive*...(1914, dir. Roberto Troncone, m. autore anonimo)
14. *Germania* (1914, dir. Piero Antonio Gariazzo, m. Alberto Franchetti, elab. Raffaele Tenaglia)***
15. *Nel regno di Tersicore* (1914, dir. Romolo Bacchini, m. Romolo Bacchini?)
16. *Sperduti nel buio* (1914, dir. Nino Martoglio, m. Enrico De Leva)
17. *Nerone e Agrippina* (1914, dir. Mario Caserini, m. di A. Berni)
18. *Luisianna* (1914, dir. Emilio Graziani-Walter, m. Virgilio Aru)
19. *L'Historie d'un Pierrot* (1914, Baldassare Negroni, m. Pasquale Mario Costa)*
20. *Cabiria* (1914, dir. Giovanni Pastrone (Piero Fosco), m. Ildebrando Pizzetti e Manlio Mazza)*
21. *Il mio diario di guerra* (1915, dir. Giovanni Semeria, m. Giocondo Fino)
22. *Rapsodia satanica* (1914, dir. Nino Oxilia, m. Mascagni)*
23. *Antonio e Cleopatra* (1914, dir. Enrico Guazzoni, m.?)
24. *Mondo Baldoria*, futurist film (1914; dir. Aldo Molinari; music especially written by an unknown comp.)
25. *L'alba* (Goffredo Mameli) (1916, dir.?, m. Ruggero Leoncavallo)
26. *Anima Redenta* (1916, dir.?, m. Ruggero Leoncavallo)
27. *Invocazione 'Ave Maria'* (1916, dir.?, m. di Leopoldo Mugnone)
28. *O Giovannino o la morte* (1916, dir. Gino Rossetti, m. Ion Hartulari-Darclée)
29. *La crociata degli innocenti* (1915–1917, dir. Alessandro Blasetti, Gino Rossetti, Alberto Traversa, m. Anacleto Masini, poi Marco Enrico Bossi)
30. *Christus* (1916, dir. Giulio Antamoro, m. Giocondo Fino)*
31. *La canzone del fuoco* (1917, General Film, m. Virgilio Ranzato)
32. *La figlia del mare* (1917, dir. Ugo Falena, m. Alberto Gasco)
33. *Frate Sole* (1918, dir. Mario Corsi, m. Luigi Mancinelli)*
34. *Fantasia bianca* (1919, dir. Alfredo Masi e Severo Pozzati, m. Vittorio Gui)

Marco Targa 61

35. *Il Carnevale di Ivrea* (1919, dir. Romolo Bacchini, m. Giocondo Fino)
36. *Deus judicat* (1920, dir. Atto Retti Marsani, m. Enrico Magni)
37. *Giuliano l'apostata* (1920, dir. Ugo Falena, m. Luigi Mancinelli)*
38. *L'eredità di Caino* (1921, dir. Giuseppe Maria Viti, m. Giuseppe Maria Viti)***
39. *La bibbia* (1920, dir. Sandro Properzi, m. Fiorello Traversi)
40. *Joseph* (1921, dir. Romolo Bacchini, m. Giocondo Fino)*
41. *Piccola monella* (1924, dir. Giuseppe Lega, m. Enrico Toselli)
42. *Sirena* (1925, dir. Guido di Sandro, m. Giovanni de Simone)

Appendix 2

Il commento musicale al film I PROMESSI SPOSI [1922, Mario Bonnard] Adattamento del M. Dante Dall'Aglio di Parma[19]

1. parte (Alle parole "Voi lo sapevate?") (Quando entra dall'avvocato) 2. parte (Alla parola "Esci!!") (Quando getta in terra il tavolo e il lume) 3. parte (Alle parole "Ai forni") (Quando lascia Renzo e inneggia "Viva Ferrer") ("Allo spuntar del giorno russava ancora") 4. parte (Alle parole "Mi liberi, mi liberi") (Quando Lucia prega)	1. *Rêve des amoureux* 2. *Barcarole 2ème* 3. *Madrigale* 4. *Cuore in pena* (due volte) 5. *Aubade tendre* 6. *Coriolano* 7. *Pieux souvenir* 8. *Arlésienne* n. 2 9. *Salut à la France* 10. *Tango del cigno* 11. *Norma* 12. *El Rasa* 13. *Meditazione* 14. *Hymne à la nuit* 15. *La figlia di Madame Angot* (sinfonia) 16. *Resurrection*	[Filomeno De] Cristofaro [Francesco Paolo] Frontini A.[ristide] Scassola [Carmelo] Giacchino Buisson Beethoven Carias [?] Bizet Scassola Cardio Bellini C.[esare] Senesi I. Cuneo Scassola Lecocq [G.?] Smet	Carish Forlivesi Moulin Profeta Moulin Moulin Salabert Allione Ferrario Gori Scassola Gori Lorette Ricordi Id. Canzonetta

62 The Historical Practice of Silent Film Sound

(Continued)

5. parte (La partenza di Don Rodrigo) (Partenza dell'Innominato per la guerra) 6. parte 7. parte (Quando sono riuniti in paese e Don Abbondio annuncia la scomparsa della Perpetua – fino alla fine)	17. *Madame* *Butterfly* *[Grande* *fantaisie]*, I e II parte 18. *Madame* *Butterfly*, III parte 19. *Bambola* *piange*	[Émile] Tavan da G. Puccini Id. G.[aetano] Lama

II Commento musicale del film IL FIGLIO DELLO SCEICCO [1926, George Fitzmaurice]
 Concertazione e direzione del Maestro ESTILL[20]

GRUMBACH – Danses Arabes TSCHAIKOWSKY [*sic!*] – Der Nutknacker [*sic!*] – Danse Arabe SAINT-SAËNS – La Princesse Gaune SAINT-SAËNS – En vue d'Alger de la Suite Algerienne SAINT-SAËNS – Reverie du Soir de la Suite Algerienne GOMEZ – Salvator Rosa	Atto Terzo SALABERT – Rêverie Exotique GAUWIN Fête a Hanoi GRIEG – Andante de la Sonata op. 13 MONTEMEZZI – Giovanni Gallurese SAINT-SAËNS – Sansone e Dalila
Atto Secondo FÉVRIER – Monna Vanna – Preludio alto III POUGET – Angora SCHUBERT – Le Roi des Aulnes RENAUD – Divertissement Persan MOUTON – Impressions Exotiques MAYLLIS – La Danse d'Aladine SALABERT – Danse du voile DEBUSSY – Enfant Prodigue – Prelude	Atto Quarto ZANDONAI – La femme et le pantin TAGSON – O la fraicheur du soir SAINT-SAËNS – Phaéton SAINT-SAËNS – Rapsodie Mauresque MASSENET – Phedre – Ouverture DE LENA – Oriente

Il Commento musicale del film SOLE! [1929, Alessandro Blasetti] programma musicale del M.E. De Risi[21]

Cue	Title	Composer	Editor
– All'inizio dei titoli	Iris: Inno al sole	Mascagni	Ricordi
– Si presenta la	Preludio	Rachmaninoff	Benjanni
palude	Sturm Musik	Arnandola	Roehr
– Le bufale	Cynico	D'Albert	Curci
rovesciano	Agitato	Savino	Robbins
la barca di	drammatico	Franchetti	F. Day
Costantino	Jannine (valse)[22]	D'Indy	Ricordi
– Il campo dei	Figlia di Jorio	Drigo	Menestrel
bonificatori	Foresta incantata	D'Indy	Curci
– 'Avviso'	Tragico con moto	Carraro	Menestrel
– Casa di Marco	Jannine (tema)	Mulé	T. Muccy
– All'osteria della	Foresta incantata	Cerri	Mulé
Torre	Canti di Lucania	De Micheli	Ricordi
– L'ingegnere sulla	Jannine (tema)	Kaps	Beltramo
barca	Selinunte	Mascagni	Inedito
– L'ingegnere si	Minuit berceuse	M. Cortopassi	T. Mucci
allontana da	Brigata allegra	Culotta	Profeta
Giovanna	Jannine (tema)	Rachmaninoff	Benjanni
– Riunione	Coro	De Micheli	Beltramo
all'osteria	Intermezzo	Roland	Curci
– Verso il tramonto	Iris	Rachmaninoff	Benjanni
al campo dei	Posillipo	Escobar	Carish
bonificatori Fox	Maggiolata	Charpentier	Menestrel
(allegro)	Preludio	Brusselmann	Buyst
– Vi vuole	In campagna	Carabella	L'Italica
l'ingegnere	Love and Passion	Zamecnik	Sam fox [sic!]
– Lieta di	Jannine (tema)		
accompagnare il	Preludio		
padre,	Resurrection		
Giovanna...	Impressioni		
– Barbara pulisce	d'Italia		
stivali	Telemacus a		
– L'Angelus	Gaulus		
– Interno del bar	Villaggio in		
– Una donna	fiamme		
– Un accordo di	Fureuse emotion		
chitarra	Iris (primi raggi)		
– Studio			
dell'ingegnere			

64 *The Historical Practice of Silent Film Sound*

(Continued)

Cue	Title	Composer	Editor
– Restituitevi alla civiltà			
– Casa di Anna			
– Nel cantiere			
– Palude			
– Scossa dell'emozione			
– Ingegnere e Giovanna soli sulla porta			
– Il sinistro araldo dell'inverno			
– Di capanna in capanna			
– Giovanna corre per salvare l'ingegnere			
– Corriamo al campo			
– Palude			

Notes

1. See for example Gattuso-Fasulo, 'Musica al cinema', *La rivista cinematografica*, 15 June 1925; and Anonymous, 'Una buona idea', *Lux*, May 1920.
2. Rick Altman, *Silent Film Sound* (New York: Columbia University Press, 2004): 12.
3. For some information on music in Italian cinemas see Ermanno Comuzio, 'Industria e commercio dell' "Incidental Film Music" ', *Immagine* 2 (1986): 16–21; and Ermanno Comuzio, 'Pianisti estemporanei e di carriera, orchestrine e orchestrone', *Immagine* 23 (1993): 19–22.
4. Pier Antonio Gariazzo, *Il teatro muto* (Torino: Lattes, 1919); and Sebastiano Arturo Luciani, *Verso una Nuova Arte: il Cinematografo* (Roma: Ausonia, 1920).
5. Edith Lang and George West, *Musical Accompaniment of Moving Pictures. A Practical Manual for Pianists and Organists and an Exposition of the Principles Underlying the Musical Interpretation of Moving Pictures* (Boston: Boston Music, 1920), repr. (New York: Arno Press, 1970); Hans Erdmann, Giuseppe Becce and Ludwig Brav, *Allgemeines Handbuch der Film-Musik* (Berlin–Lichterfelde: Schlesinger, 1927).
6. For a general description of the Italian trade press in the silent cinema era, see Silvio Alovisio, 'I libri e le riviste', in Carla Ceresa and Donata Pesenti Campagnoni (eds.) *Tracce. Documenti del cinema muto torinese nelle collezioni del Museo Nazionale del Cinema* (Torino: Il castoro, 2007): 171–187.
7. For example, the review *L'Eco del Cinema*. Other commenti musicali can be found in a publication edited by 'Supercinema', one of the largest exhibition venues in Florence (Archive of Museo del cinema di Torino).

8. Il cronista, 'Cronaca degli spettacoli–Sala Ambrosio', *La Rivista Cinematografica*, 10 June 1920, [All translations by the author of this chapter].

9. Il cronista, 'Cronaca degli spettacoli'.

10. Here is a list of some musical editors of music for orchestrina in Piedmont: Silmar (Torino); Ad Astra (Cuneo/Torino); Rex Edizioni (Torino); Casa editrice nazionale (Torino); Rolando (Asti); Casa editrice musicale sabauda (Torino); Gnocchi (Torino); Mac-Mac (Torino); Cines Pittaluga (Torino); Littoria (Tortona); Rotellini (Alba); Chiappo (Torino); Le Canzoni di Ripp (Torino); Leandro Chenna (Torino); Augusta (Torino); Agnello (Tortona); Ugo Ferri (Torino); Sampietro (Asti); Zoboli (Torino); Impero (Torino); La fisarmonica (Torino) Checchini (Torino); Gori. Minghetti (Torino); De Muro (Torino); Ars Nova (Torino). See Mario Dall'Ara, *Editori di musica a Torino e Piemonte* (Torino: Centro studi piemontesi, 1999).

11. The archival collection is held by the library of the Conservatory 'Vivaldi', Alessandria.

12. See for example *La Vita Cinematografica*, 15 July 1912.

13. Sergio Miceli, *Musica per Film. Storia, Estetica, Analisi, Tipologie* (Lucca: Ricordi/LIM, 2009): 59.

14. This document belongs to the Archivio storico del Comune di Terruggia (AL, Italy). I am grateful to Filippo Arri, Annarita Colturato and the 'Istituto per i Beni Musicali in Piemonte' for bringing this document to my attention and to the Comune di Terruggia for giving the copyright permission.

15. Archive of the Museo del Cinema di Torino. For an analysis of this score see Emilio Sala, 'Per una drammaturgia del ri-uso musicale nel cinema muto: il caso di "Cabiria" (1914)', in Annarita Colturato (ed.) *Film Music. Practices and Methodologies* (Torino: Kaplan, 2014): 73–107.

16. Pier da Castello, 'Ancora della musica nei cinematografi', *Il Maggese Cinematografico*, 25 February 1914.

17. Roberto Falciai, 'Musica al buio', *Il Cinematografo*, 14 April 1928.

18. This is a *Grande fantasia descrittiva con pitture cinematografiche* composed for the 50th anniversary of the Unification of Italy. The autograph of the score is held by the Biblioteca Reale in Turin.

19. *L'Eco del Cinema*, May–June 1925, 228.

20. *Supercinema*, s.d., 1928, 9–10 (Museo del cinema di Torino).

21. Riccardo Redi, 'Musica del muto', *Immagine* 36 (1996): 9–13.

22. This piece is the leitmotiv related to the character of Giovanna.

4
Music, Singing and Stage Practice in the Cinemas of Upper Silesia During the 1920s

Urszula Biel

Musical settings of the first projections

In December 1896 itinerant exhibitor M.B. Wilson began presenting motion pictures advertised as 'Edison-Theater' in several large cities in Upper Silesia (Figure 4.1).[1] Already these first cinematographic shows held in the region were accompanied by music. One of Wilson's first shows was held in the theater-cum-concert hall in Gliwice. In order to convince the Gliwice public that this screening was finally an actual film screening, Wilson's advertisement contained slogans such as *'Kein Schwindel, Keine Nebelbilder, Keine Jahrmarktausstellung'* (No fake. No shadowgraphs. No fair exhibit).[2] While the exhibitor supplied the film reels and the machinery, the musicians for the performance were recruited in Gliwice. These first motion picture programs presented subjects such as the tsar's visit to Paris, traffic in a metropolis, scenes from railway stations in Paris and Berlin and cavalry exercises and were accompanied by the local *Infanterie-Kapelle*, a military band, which might indicate that this music ensemble was selected to provide 'adequate' background music for some of the films in the program. Subsequent shows in the following year were projected with Edison's apparatuses combined with phonograph records, which played, for example, African American songs and the speech of Kaiser Wilhelm given at the opening of the Kiel Canal.[3] Although the novel technical devices of sound recordings to accompany moving images evoked great interest, they remained a mere curiosity, yielding the field predominantly to musical performances and live declamations.

Ohne Concurrenz.

Neu! Phänomenal! Sensationell! Neu!

Im kleinen Saale des Theater= und Concerthauses.

Eröffnungs-Vorstellung

Mittwoch, den, 9. Dezember d. Js., Abends 8 Uhr:

Edinson - Theater.

M. B. Wilson.

Neuheit allererjten Ranges! Keine Jahrmarktsschaustellung!

Kinematograph,

Edinson's Ideal! Interessanteste Erfindung des 19. Jahrhunderts.

Lebende Photographien.

☞ Alles athmet Leben und zeigt natürliche Bewegung!
Mujik von der Infanterie-Kapelle.

Entree an der Kasse: Refervirter Platz 75 Pfg., Saal 50 Pfg. —
Im Vorverkauf bei Herrn J. Rund Jr. und in Café Jung: Refervirter
Platz 60 Pfg., Saal 40 Pfg.

Donnerstag, den 10. Dezember er:

Zweite große Vorstellung.

Neu! Bisher nur in Haupt- und Residenzstädten. Neu!

Kein Schwindel! *Keine Nebelbilder!*

Figure 4.1 Announcement for the touring Edison-Theater by M.B. Wilson
Source: *Der Oberschlesische Wanderer*, 9 December 1896, 288.

Interpreters, or reciters, gained a high status in the hierarchy of cinema employees during the first years of film exhibition. Their names were mentioned in press announcements as frequently as the names of persons in charge of the musical setting of a show. However, the introduction of subtitles slowly brought these 'performances' to an end, whereas music continued its prolific development, which will be investigated in this article by selected examples. Due to the well-preserved archival documents that remain from the management of the movie theater Städtische Lichtspiele in Gliwice, this location will present the first point of investigation for cinema music in the region of Upper Silesia.

68 *The Historical Practice of Silent Film Sound*

Nur erste Kräfte kommen in Frage

The front lines of World War I did not affect the region of Upper Silesia to a large extent and perhaps that was one reason why in January 1918 the municipal authorities of Gliwice, virtually disregarding the highly unstable socio-political situation, decided to open and maintain a new local cinema. Considering the fact that most movie theaters were in private hands, it was quite a precedential decision, but as a result a great amount of vital information on the background of the cinema's operation that serves present-day research on the topic has been preserved in official correspondences.

The city purchased the aforementioned theater-cum-concert hall situated in the city center of Gliwice and allocated the space to regular film showings. The opening of the venue was held on 31 August 1918. The organizers intended the hall as a prestigious venue and most of all they were competing with three other cinemas already operating in the city. Therefore, not only an excellent interior design was provided for both the ground floor and the balcony with its boxes, but also the audience's comfort was given special attention by the designing of a large foyer and a cloakroom. The venue's upgrade included another important component: the music. A large stage was installed, as well as a special space for a band of several musicians, who were to be conducted by Viktor Lomnitzer, an experienced local film musician since the 1910s. Prior to the cinema's opening, Lomnitzer supervised the purchase of proper orchestra instruments and a sufficiently large harmonium that was later also played during intervals and between individual films. He personally picked the best available musicians, which was not an easy task, considering the wave of migration occurring directly after the war. As far as the size of cinema 'orchestras' was concerned, ensembles of four musicians were providing musical accompaniment for films at both other movie theaters in the city, the Welt Theater and the newly opened, smaller Amor Theater; therefore, the Städtische Lichtspiele put an emphasis on their permanent band consisting of at least six musicians plus conductor Lomnitzer, who selected the following instruments for his orchestra: piano, first and second violins, double bass, cello, drums, accordion and flute, and trumpet, if necessary. Later on, the oboe, trombone and clarinet were added to the ensemble[4] (Figure 4.2).

The most prestigious movie theaters operated with one bandmaster on a permanent basis. His name was found on posters and, together with the name of the theater, constituted a theater's specific trademark. Viktor Lomnitzer from the Städische Lichtspiele belonged to this group

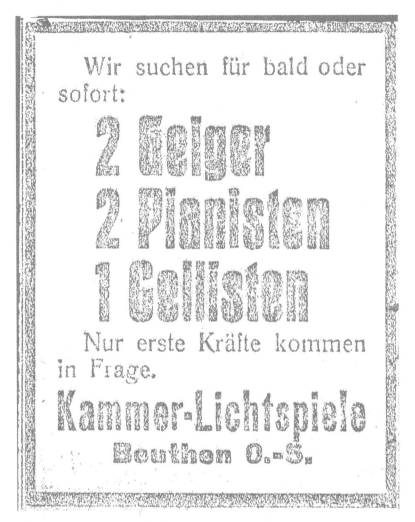

Figure 4.2 'Only first-class worker will be considered'
Source: *Der Oberschlesische Wanderer*, 19 October 1924, 155.

of 'advertisable' personalities in Gliwice. After the opening of another cinema in the city, the Schauburg movie theater in 1924, local musician Willi Wunderlich gained fame with his solo violin renditions, which accompanied numerous hits produced by the Ufa (Universum Film AG) that were shown in this theater. Distinguished bandmasters had their cameo appearances in different cinemas of the region, in both the

70 *The Historical Practice of Silent Film Sound*

German and the Polish part. For example, A. Ziehr was mentioned in advertisements of the Städische Lichtspiele in Gliwice (Germany)[5] and in announcements of the Apollo in Katowice (Poland).[6] Other bandmasters, such as Samuel Spielmann, led permanent music ensembles with which they would occasionally play background music for films.[7]

Working conditions of cinema musicians

Cinema musicians were tough negotiators when it came to their employment conditions. Although they were usually not full-time employees at movie theaters, they would unite in trade unions in order to define work regulations and wages. The *Kapellmeister* (conductor/band master) was paid the highest rate, followed by the first violinist and the pianist. All other musicians were paid lower, equal rates. Also the size of a cinema could affect the salary, so that in halls exceeding 400 seats the wages were slightly higher.[8] Due to the hyperinflation of currency at that time, the salaries changed frequently.

Judging from their wages, the musicians' position in a movie theater hierarchy was quite high; they were considered more or less equal to projectionists. According to a tariff from 1920 a cinema pianist earned 155 Mk (*Mark*) per week, whereas operators, depending on their seniority, would earn between 110 and 165 Mk per week. This list does not cover the bandmaster, but it seems safe to assume that he earned even more. The reciter, still listed in a 1920 tariff, could count on around 165 Mk per week: the same rate as an experienced operator. By comparison, the cashier, who would receive the highest wage among other cinema employees, would earn 225 Mk per month.[9] A closer look at a 1925 tariff of the municipal film theater in Cieszyn shows that the bandmaster earned slightly more than the theater's manager.[10] These rates, negotiated by the trade unions, applied also to other places where musicians performed such as cafés or bathhouses.

In the following, employment conditions of cinema musicians are examined on the basis of a contract concluded between the *Verein der Lichtspieltheaterbesitzer für Schlesien und Posen, Sektion Oberschlesien* (Association of Cinema Owners for Silesia and Poznania, section Upper Silesia) and the *Musikverband Ortsverwaltung für Oberschlesien* (Local Board of the Musicians Society for Upper Silesia).[11] A normal working day for a cinema musician was supposed to last no more than six hours, and on Sundays and bank holidays up to seven hours; the seventh hour was to be paid as overtime, except in the event that the working weekday lasted only 5.5 hours. The working time should not exceed eight

hours a day or go beyond 10 p.m. Only in case of a failure of the projector could the working day be extended by half an hour, up to 10.30 p.m. at the latest. This is perhaps the reason why in 1924 the newly employed bandmaster of the Städische Lichtspiele, Arthur Wiedemann, despite his claims to improve the quality of the orchestra, demanded that the operator should project films faster in order to finish the shows by 10 p.m.[12]

Musicians were guaranteed breaks, constituting 25% of the whole working day and to be held in agreement with their employer. Unfortunately, there is no information whether or how this agreement was respected. In numerous theaters a program consisted of several films that were screened without intervals and patrons could enter the theater at any moment and chose any seat as soon as they had bought their tickets. In this situation the orchestra would have had to play continuously, yet we can assume that single musicians went on their break while their colleagues continued to play.

Musicians were entitled to two or three paid holidays each month. However, they were not allowed to perform music in gainful employment on these days; should they do so, relevant amounts would be deducted from their salaries. It is difficult to ascertain whether this rule was actually enforced, as we know that some musicians performed in cafés, bathhouses or other public venues quite frequently.

Also female musicians were not uncommon in the region. In 1923 the Städische Lichtspiele hired a Mrs Kienbaum as the first or second violinist and a Ms Onderka to play the harmonium.[13] In a small cinema in Kluczbork, a 17-year-old girl played the piano, which led to complaints from local moralists, who claimed that she was watching films inappropriate for her age when performing.[14] In one of the smaller cinemas in Gliwice, the Amor Theater, a Ms Edeltraud Klossek even fulfilled the function of *Kapellmeister*.[15] It seems odd, then, that one of the tariffs of the *Ensemble-Musiker-Bund* of the Upper Silesian industry district from 1919 contained the following note: 'Ladies' orchestras are to be entirely excluded from such venues.[16] It might be argued that this restriction was revised thereafter, or that it applied only to all-female groups.

Unfortunately, the documents at hand do not offer much insight on the details of preparing the music for the film performances, but since the program was changed twice a week – usually on Fridays and Tuesdays – the preparation of suitable musical illustrations must have been an absorbing part of the operation of any cinema. Up until the mid-1920s, only a minor share of films were fitted with originally composed background music. The majority of the music depended on the

72　*The Historical Practice of Silent Film Sound*

commitment and ingenuity of the individual *Kapellmeister* or musician. *Kapellmeister*, who were responsible for this aspect of the cinema's program, did not compose music to films themselves; neither did they commission scores from local composers, but they selected various preexisting pieces, predominantly from the classical and late romantic repertoire, to use them in so-called compilation scores. In rare cases film producers or distributors included suggestions on what type of music was to be played with regard to the mood and atmosphere of individual scenes, even indicating specific composers. In order to follow such suggestions, however, a cinema needed a wide array of scores. When bandmaster Arthur Wiedemann was employed at the Städtische Lichtspiele by the city of Gliwice in 1924, he brought not only his musical competence but also his own music collection consisting of over 1,000 compositions, on which he could draw in compiling his music accompaniment.[17] Nevertheless, bandmaster and musicians had to report to the *Verband zum Schutze Musikalischer Aufführungsrechte für Deutschland* (GEMA), the *Association for the Protection of Musical Performing Rights in Germany*, representing also the *Gesellschaft der Autoren, Komponisten und Musikverleger* (AKM) in Vienna. The GEMA, established in 1916 in Germany, was strict at reprimanding cinema owners that they were also legally responsible for the music played in their cinemas. A bandmaster, even if he was not a member of the association, was obliged to present his set of manuscripts to the organization prior to a performance, and only after obtaining a permit and paying the corresponding fees was he allowed to perform the music. If he failed to comply, the cinema owner was held responsible for illicit business under §37 and §38 of a copyright law from 19 June 1901.[18]

Popular names and musical genres

A review of contemporary press announcements shows that – besides actors, who were becoming more and more celebrated icons of the film industry – cinemas began listing musicians and composers with equal frequency in their promotional material in the 1920s. At first, well-known composers and other popular artists whose compositions were intended to illustrate a certain film were recognized. For example, *Das alte Lied* (Karl Otto Krause, GER 1919) was accompanied with music by Richard Wagner and Giuseppe Verdi, as well as by the less renowned artists Bela Laszky, Luigi Arditi, Stanislao Gastaldon and Franz Abt. The same composers were first listed in an advert of the Lichtspielhaus in Zabrze and ten months later by the Städische Lichtspiele in Gliwice,

which strongly suggests that the cinema's bandmasters were adhering to certain musical guidelines on what scores to use in order to musically accompany this film.[19] For the film *Figaro's Hochzeit* (Max Mack, GER 1920), music by Wolfgang Amadeus Mozart was an obvious choice.[20] When announcing the film *Beethoven* (*Beethoven: Der Märtyrer seines Herzens*, Emil Justiz, GER 1918), the Städische Lichtspiele signaled that this film would be accompanied with a great symphonic concert of Beethoven's Fifth Symphony, informing the viewers that there would be numbered seats for that particular performance.[21]

Within a few years, authors of original music for specific films were mentioned as well. In the case of the screening of *Die Fledermaus* (Max Mack, GER 1923), which was inspired by Johann Strauss's operetta, the press announcement contained only the widely known classics although the music for the actual film performance was provided by composer Alexander Schirmann.[22] The announcement concerning the film *Lumpen und Seide* (Richard Oswald, GER 1924), on the other hand, listed Hugo Hirsch, an operetta composer who prepared a score for this film, which contained the catchy tune 'Shimmy'.[23] Advertisements of the first-class production *Metropolis* (Fritz Lang, GER 1927), presented at the Ufa Schauburg cinema, listed all individuals involved in music-related aspects, both from the production side – that is, film music composer Gottfried Huppertz – and from the point of view of the Schauburg performance: the bandmaster Wente and the concertmaster Wunderlich, who introduced the film with a solo violin piece by Johann Sebastian Bach.[24]

The names of operettas composers were also frequently mentioned on posters and in the press, as this form of musical entertainment was highly popular in the region and had generated an independent genre in connection with film: the operetta film. Usually associated with the sound cinema of the early 1930s, this term is encountered as early as 1920 in announcements by the local cinemas referring to the film *Das Kußverbot* (Ludwig Czerny, GER 1920).[25] In the late 1920s the operetta film had established itself firmly in the repertoires of movie theaters, helped and secured by live performances of well-known arias of this genre. Announcements not only listed composers of operettas, such as Leo Ascher (*Der Soldat der Marie*, Erich Schönfelder, GER 1926; Ascher also composed the music for this film),[26] or Oscar Straus (*Ein Walzertraum*, Ludwig Beger, GER 1925; compilation score by Erno Rapeé),[27] but also listed the names of famed librettists: Victor Léon (*Die Geschiedene Frau*, Victor Janson, GER 1926), Alexander Landesberg and Leo Stein (*Das Süße Mädel*, Manfred Noa, GER 1926).[28] Operetta was

74 *The Historical Practice of Silent Film Sound*

so popular that in 1929 the Ufa cinema Schauburg put on the three-act farce *Die Sechser-Operette*, composed by Walter Bromme, with the participation of Austrian stage actor Fritz Spira. The act was shown following the film screening, starting as late as 10.45 p.m.[29]

Another noteworthy type of music that was played frequently in cinemas was marching or military music. It was mainly chosen to accompany subjects that would justify the application of this musical style such as films with a strong national content. In this border region, patriotic manifestations would gain a special meaning; therefore movie theaters were very conscientious when preparing the background music for such films. The premiere of *Fridericus Rex* (Arsen von Cserépy, GER 1921/22) was accompanied by a specially prepared military music score, played by the 25-piece band of the Ufa cinema Schauburg in Gliwice.[30] The 'fatherland film' *Deutsche Helden in Schwerer Zeit* (Curt Blaschnitzky, Franz Porten, GER 1924) was treated in a similar manner, a score being prepared that contained not only military marches but also folk songs.[31] The same band played the accompaniment for the feature film *Aschermittwoch* (Wolfgang Neff, GER 1925), which depicted the tragedy of an officer from the pre-war times. When the film was brought to the Ufa cinema Helios in neighboring Zabrze, the orchestra from the Schauburg cinema went along to play the prepared military marches.[32] The marching rhythms accompanied also the premiere of motion pictures shot to commemorate the celebrations of the local voluntary fire brigades (*Florianifeier der Vereinigten Gross-Gleiwitzer Feuerwehren*) in 1927. The Städische Lichtspiele invited a 25-piece brass orchestra consisting of members of various fire brigade bands (*Grosses Blasorchester der Gesamten Feuerwehrkapelle*), conducted personally by its bandmaster, Peckmann, to play the accompaniment to this short film, which constituted part of an elaborate Pentecostal program.[33]

Vocal music in cinemas

Popular film accompaniment in Upper Silesian cinemas was not confined to instrumental music, but also included live singing during film shows with considerable frequency. This practice can be traced back to the shadowgraph and lantern slide shows of the late 19th century and was continued in the region during the subsequent decades by a strong cinema reform movement. In 1912, one of the movement's most active members, local teacher Scholz, issued the booklet *Programme, Lichtbildvorträge, Theaterstücke für die Volks- und*

Elternabende in Oberschlesien, advocating that film screenings in schools should present not only educational films, but also slide shows. The second part of the book contained sets of available slides devoted to all sorts of topics – most of which were fitted with lectures – and the author of the brochure strongly recommended singing and reciting, providing specific titles and publications with adequate music numbers for this purpose.[34] The film *Rübezahl's Hochzeit* (Paul Wegener, GER 1916), a favorite of Upper Silesian reformers, was accompanied by a double quartet conducted by headmaster Gebauer in 1922.[35] In fact, local teachers were repeatedly engaged in the preparation of appropriate background music for film programs.

In 1926 the local reformers, united in the *Oberschlesischer Bilderbühnenbund* (OBB), were preparing for an extremely prestigious event: the Seventh German Film Week, which was to be held in Wrocław, Eastern Germany, for the first time. The significance of this event was enhanced by its political context, in view of the recently ratified Locarno treaties and the change of priorities of the Weimar Republic with regard to the revision of its eastern borders, particularly the Silesian section. For this important presentation, premieres of two Silesian films (titles unknown) were prepared, and one of them was accompanied by a performance by a choir of teachers.[36] Also other organizations or societies sought to present films that corresponded to the profile of their activities and organized film shows beyond the lines of commercial film distribution. Live singing as part of the performance further emphasized the exceptional character of these special events. The congregation of Young German Marian Women of St Andrew lent such grandeur with a vocal performance by the staff choir to the showings of the film *I.N.R.I.* (Robert Wiene, GER 1923), held for a week in the Casino hall, which belonged to Donnersmarck's steelworks in Zabrze.[37] On another occasion, at a school screening of the short film *Ich Fahr' in die Welt* (GER 1924), the OBB hired the youth club of a trade union to provide the vocal accompaniment.[38]

These practices were also taken over by commercial cinemas. For very popular films, particularly for operetta adaptations, special guests were invited to increase the prestige of a show. Such films often featured performers from Berlin or Vienna and were extensively promoted and well received. For example, the advertisement of the aforementioned film *Das alte Lied* announced a performance by a Berlin-based opera ensemble; however, the final program noted that five artists from the Viennese Burgtheater accompanied the actual screening.[39] The Städtische Lichtspiele in Gliwice, when advertising the operetta

76 *The Historical Practice of Silent Film Sound*

film *Das Kußverbot* (Ludwig Czerny, GER 1920), boasted of its cooperation with a first-class singer from Berlin,[40] and the Lichtspielhaus in Zabrze, which presented the same film in the subsequent weeks, featured a vocal performance by 12 women and men from Berlin and Vienna and welcomed one of the composers of the original score for that film, Hans Ailbout, as a special guest.[41] At another occasion, a 'superb singing quartet' from Berlin added splendor to film shows in the Ufa cinemas: *Die Brigantin von New York* (Hans Werckmeister, GER 1924, music by Tilmar Springfeld)[42] and *Gretchen Schubert* (Carl Moos, GER 1925).[43] The compilation score for the latter consisted of musical motifs by Franz Schubert, Robert Schumann and Johann Strauß Jr.

In addition to famed artists who traveled to specific premieres, local performers were engaged to contribute live music performances to such screenings. The showing of the film *Der Rosenkavalier* (Robert Wiene, AUT 1925), set to music by Richard Strauss, featured some of the opera's arias performed by Rose Pahlen, a famous concert singer in Gliwice and Bytom.[44] Well-known singer Martha Cassier from Bytom intoned 'melodious inserts' to *Das Süße Mädel*.[45]

Film exhibitors were constantly trying to distinguish their venues from their business rivals, which entailed improving the sound aspect of the film program. In doing so, they were not hesitant to utilize opera to secure business in the stiff Upper Silesian competition. For the already mentioned opening of the Schauburg movie theater in 1924 – which soon after was taken over by the Ufa – the film *Nibelungen* (Fritz Lang, GER 1924) was selected and this became not only a memorable filmic event, but also a musical one. The curtain was raised to the overture from *Il nozze di Figaro*; then Bernhard Goetze from the Deutsches Theater in Berlin recited the poem *Der Zauberlehrling* by Johann Wolfgang Goethe and *Herr von Ribbeck auf Ribbeck im Havelland* by Theodor Fontane. After that, an opera singer from Berlin performed an aria from the opera *L'Africaine* (Giacomo Meyerbeer, 1865), which was followed by a lecture devoted to the saga of the Nibelungen delivered by a Berlin-based professor. Finally, the film was shown, accompanied by a 22-piece orchestra.[46]

The Lichtspielhaus in Hindenburg, when advertising *Nanook of the North* (Robert J. Flaherty, USA 1922), announced a cameo performance by opera singer Victor Lenzetti, who performed the prologue from the opera *Pagliacci*, the song *Matinatta* (both by Ruggero Leoncavallo) and the aria *O, wie so trügerisch* from *Rigoletto* by Giuseppe Verdi during the course of the show, although the materials do not disclose whether

Lichtspielhaus Hindenburg

Kaniastraße

Nur 4 Tage Der weltberühmte Film: Nur 4 Tage

NANUK, der Eskimo

New York, Paris, London spreche., monatelang davon

AUF DER BUEHNE: Als Gast Herr Ooernsänger

VICTOR LENZETTI

Programm: 1.) Prolog aus Bajazzo, 2.) „O' wie so trügerisch" aus Rigoletto, „Mattinata" von Leon Cavallo
2. Film:

Der Rhoenflug

Eine Darstellung des Segelflugs in drei Teilen.

Kasseneröffnung für dieses Programm: An Wochentagen 5½ Uhr nachmittags. — Am Sonntage 2½ Uhr nachm.

Figure 4.3 Announcement for *Nanuk, der Eskimo*, also on stage: opera singer Victor Lenzetti
Source: *Der Oberschlesische Wanderer*, 4 July 1924, 155.

the singing took place before, during or after the film's projection[47] (Figure 4.3).

Such an approach implied a certain musical competence on the part of the cinema manager and therefore it is not hard to comprehend that we encounter talented figures among that profession, who would also undertake various public functions. One of the most popular performers was the aforementioned Viktor Lomnitzer, who had been singing in the local synagogue before he was appointed directing manager of the Städtische Lichtspiele, where he also frequently rendered vocal performances.[48] He sang, for example, at the presentation of the film *Der Trompeter von Säckingen* (Franz Porten, GER 1918, with original music by Ferdinand Hummel)[49] and at the screening of the operetta film *Ein Walzertraum*.[50]

When the Städtische Lichtspiele was taken over by the Deulig company (Deutsche Lichtbildgesellschaft) on 31 December 1925, the venue's managing director Schwartz gave a vocal performance as film accompaniment. He sang not only the famous aria 'Vesti la giubba' from

78 *The Historical Practice of Silent Film Sound*

Pagliacci at the reopening, but also other musical numbers at subsequent film showings such as *Klovnen* (A.W. Sandberg, DNK 1917).[51] His voice sounded again during the pan-German premiere of the film *Land unterm Kreuz* (Ulrich Kayser, GER 1927), which was held at the renamed Deulig-Palast on 20 March 1927. The screening was considered as the political – and filmic – event of the decade in the region while simultaneously becoming a sort of summary of the musical potential of the local cinemas. This ultra-propagandistic film was shot in Gliwice and in several other towns of Upper Silesia to commemorate the fifth anniversary of the plebiscite, as a result of which the eastern part of the region was allocated to Poland. *Land unterm Kreuz* was to be a manifesto of its German character. The Gliwice premiere, to which several hundred prominent figures were invited, was prepared with special reverence. Gliwice citizen Leo Kluge composed original songs, the lyrics were written by Dr O. Vogt, also from Gliwice, a choir of 300 boys was invited to sing them and managing director Schwartz intoned the song *Mein Oberschlesien*[52] (Figure 4.4).

Auf der Bühne – stage practices

The diversity of musical live performances in Upper Silesian cinemas was complemented by artistic acts which were clearly of variety origins[53] and presented usually before the films: electric puppets, serpentine dances, Indian dances, operetta sketches with music played on the balalaika, humorists, impersonators of specific types (*Typendarsteller*), gymnasts, dancing duets, the Lotte-Neumann-ballet, acrobats, equilibrists, a jazz band, a world dance tragedian, the Marx clowns – these are but a few of the acts that performed on the stages of Silesian cinemas, in both the Polish and German parts of the region. Due to the density and proximity of movie theaters – more than 100 movie theaters operated within the region – employment possibilities for such performers were guaranteed. It is most likely that the accompanying music for these performances was as diversified as the palette of artists themselves. With regard to adjusting the stage performances to the character of the subsequent feature film, there were no apparent rules to follow. While the programs sometimes displayed a certain uniform content, more often the selection was at the cinema manager's discretion. For example, in 1922 the Städtische Lichtspiele announced the film *Die Schrecken der Weißen Hölle* (unidentified), a film about the experiences of an emigrant in Alaska. The film was accompanied by a stage performance of Fritz Schwiegerling's 'Marionetten Theater', during which electric puppets

Figure 4.4 Announcement of *Land unterm Kreuz*
Source: *Der Oberschlesische Wanderer*, 5 March 1927, 70.

80 The Historical Practice of Silent Film Sound

showed comical scenes and the serpentine dance, enriched with first-class lighting effects.[54] Likewise, a 1924 showing of the film *I.N.R.I.*, portraying the life of Christ, was preceded by a gymnastic act from the Liebich Variete-Theater in Wrocław.[55]

The already mentioned reopening of the Deulig-Palast on 31 December 1925 was conceived as yet another prestigious event with a varied program. Officials from the town hall, councilors and police authorities were invited. The newly appointed director Schwartz sang the prologue from *Pagliacci*, after which the comedy *Hilfe, Ich Bin Millionär* (probably it was the French comedy *600000 Francs par Mois*, Nicolas Koline and Robert Peguy, FRA 1925) was displayed; next on the program was the jazz band The Figaro-Boys, and afterwards the audience was invited to the dances held in the Bierstube in the theater's basement. The program was similar on the subsequent days.[56]

For screenings of operetta films certain conventions were soon established, however. *Die Brigantin von New York* was not only accompanied by a vocal quartet, but between the acts nine ballet dancers of the Lotte Neumann group performed, probably intended to substitute some of the genre's typical attractions for the viewers.[57]

An eloquent manifestation of how strong this tradition of mixed-media programs was can be found in contracts concluded between local cinemas and the film studio Ufa. It would seem logical that the Ufa, when leasing venues intended for moving picture showings, would aim at displaying only its own film productions. Nevertheless, in one paragraph the contracts reserved that the rented halls would be intended for cinema-related purposes, as well as for variety and theatrical performances of all kinds (opera, operetta, musical sketches),[58] which implied that even the Ufa, which took over several movie theaters in the largest cities of the region in 1925, maintained the local tradition of stage performances.

Conclusion

Our notion of silent film music is to a great extent constituted by contemporary music arrangements for silent films rather than by authentic reconstructions of the sound settings that accompanied early film presentations. The examples discussed in this article attest to the rich musical and performative settings of movie shows in Upper Silesia. While it is important to bear in mind that the majority of historical documentation and source material stems from so-called first-run movie theaters located in large cities, which constructed their repertoire on the basis of premiere performances, it is safe to assume that such events

influenced other, smaller venues. While cinema managers of smaller houses could not afford to invite performers from Vienna or Berlin, they never displayed motion pictures in absolute silence.

Many researchers of early cinema have indicated its close relationship with variety (or vaudeville in the US), especially during the period when motion pictures – struggling to conquer designated exhibition spaces – were incorporated in programs that featured stage performances. The examples illustrating practices in Upper Silesian cinemas were taken mainly from the 1920s and therefore demonstrate how durable the symbiosis of stage acts and film was in certain regions. The establishment of independent theaters did not end this relationship in the least. When film moved out of variety theaters, stage acts 'followed' film into movie theaters. Live acts (musical or other) were performed in Upper Silesian cinemas as late as the 1930s, even in venues that were already equipped with sound systems. What finally drove live performers out of the cinemas was the length of sound pictures that could not be accelerated and consequently made it impossible to shorten the time of their screening. This left no time for additional stage performances. Live music and singing, highly appreciated by many viewers, was eliminated by strong marketing campaigns by tycoons of the film industry, who wanted their costly sound productions to be the only attraction in movie theaters. The management of the Ufa, for example, issued special press releases assuring both cinema managers and viewers that with their sound films the most beautiful voices would reach the smallest towns[59] and the accompaniment would not depend on the skills of a third-rate pianist.

From the perspective of Berlin (or other metropolises), it must have been hard to imagine how the artistic standards were upheld in an industrial province like Upper Silesia without any culture-forming status. While first-rate artists did not visit the region on a regular basis, the public cultural standards and the fierce competition motivated owners of movie theaters to maintain a high level of music-related measures surrounding the film programs. The cinemas' own ensembles, which were extended if necessary,[60] and various additional musical formations built a sophisticated musical space. The juxtaposition of films with various music and stage performances also reflected audience expectations with reference to the diversity of experiences when visiting a movie theater, comparable to a variety or vaudeville venue. Until the end of the silent film period patrons attended theaters not only to see films, but also to enjoy multi-layered performances, in which a film was an important, but not the only, element.

Translation: Iweta Kulczycka

82 The Historical Practice of Silent Film Sound

Notes

1. Upper Silesia (German: Oberschlesien, Polish: Górny Śląsk) constitutes a south central part of present-day Poland. Until 1918 it was part of the German Empire, being its most southeastern province. After World War I, Upper Silesia was divided between both countries into an eastern part under Polish rule and a western, mostly German-speaking part that remained with the German Reich. This study covers examples from both parts of Upper Silesia. [Note: In the article present-day names of towns are used, but in the endnotes the names appear as in the announcements. This concerns the cities of Gliwice (named Gleiwitz until 1945) and Zabrze (named Hindenburg until 1945).]
2. *Der Oberschlesische Wanderer* (hereafter *DOW*), 9 December 1896, 288.
3. Weronika Jaglarz, 'Dziesiąta muza w Gliwicach – pierwsze lata i rozwój', in Andrzej Gwóźdź (ed.) *Historie celuloidem podszyte. Z dziejów X muzy na Górnym Śląsku i Zagłębiu Dąbrowskim* (Kraków: Rabid, 2005): 23.
4. Archiwum Państwowe in Katowice, branch in Gliwice (hereafter: APKoG), Magistrat Gleiwitz [akta miasta Gliwice] (hereafter: MGl) 5697, 317.
5. *DOW*, 4 August 1925, 179.
6. *Polonia* 22, 18 October 1924.
7. *Goniec Śląski* 60, 10 March 1924.
8. APKoG, MGl 5697, 153, 193, 223, 237.
9. APKoG, MGl 5697, 62.
10. Archiwum Państwowe in Katowice, branch in Cieszyn, municipal files of Cieszyn, 615. Wages in the municipal cinema in Cieszyn in the year 1925 were as follows: manager PLN 3,637, cashier PLN 2,272, projectionist PLN 1,929, bandmaster PLN 3,684, musicians PLN 3,302, auxiliary musicians PLN 6,050, singers PLN 1,440, usher PLN 1,192.
11. APKoG, MGl 5697, 119–120.
12. APKoG, MGl 5697, 253.
13. APKoG, MGl 5697, 223.
14. Archiwum Państwowe in Opole, Regierung Oppeln [Rejencja Opolska], Wydział Ogólny, 10329, 240.
15. *DOW*, 6 February 1920, 29.
16. APKoG, MGl, 1869, 173.
17. APKoG, MGl, 1869, 230.
18. APKoG, MGl, 1869, 222, 225–226.
19. *DOW*, 2 May 1920, 102; *DOW*, 15 February 1921, 36.
20. *DOW*, 14 September 1920, 212.
21. *DOW*, 25 January 1921, 19.
22. *DOW*, 22 March 1923, 68.
23. *DOW*, 8 May 1925, 107.
24. *DOW*, 26 August 1927, 196.
25. *DOW*, 15 October 1920, 239.
26. *DOW*, 19 April 1927, 89.
27. *DOW*, 3 February 1926, 27.
28. *DOW*, 12 November 1926, 263.
29. *DOW*, 7 June 1929, 130.
30. *DOW*, 16 April 1925, 88.

31. *DOW*, 31 July 1925, 176; *DOW*, 12 November 1925, 265.
32. *DOW*, 19 March 1925, 66.
33. *DOW*, 3 June 1927, 127.
34. Scholz, *Programme, Lichtbildvorträge, Theaterstücke für die Volks- und Elternabende in Oberschlesien* (Königshütte, O.-S.: Königshütter Tageblatt, 1912): 30–31, 56–57.
35. Information in the column 'Oberschlesisches Kunstleben', *DOW*, 17 May 1922, 114.
36. For more details, see Urszula Biel, 'Niemiecka reforma kinowa na Górnym Śląsku', in Andrzej Dębski and Marek Zybura (eds.) *Wrocław będzie miastem filmowym...Z dziejów kina w stolicy Dolnego Śląska* (Wrocław: Wydawnictwo GAJT, 2008): 109–126.
37. *DOW*, 9/10 August 1924, 186.
38. *DOW*, 7 November 1924, 262.
39. *DOW*, 2 May 1920, 102.
40. *DOW*, 15 October 1920, 239.
41. *DOW*, 13 November 1920, 263.
42. *DOW*, 5 November 1924, 260.
43. *DOW*, 5 March 1926, 53.
44. *DOW*, 17 May 1926, 113.
45. *DOW*, 12 November 1926, 263.
46. 'Eröffnung der Schauburg Gleiwitz', *DOW*, 1 September 1924, 205.
47. *DOW*, 4 July 1924, 155.
48. APKoG, MGl 5697, 91.
49. *DOW*, 27 March 1920, 72.
50. *DOW*, 19 July 1920, 164.
51. *DOW*, 7 January 1927, 4.
52. 'Uraufführung des OS-Films', *DOW*, 21 March 1927, 66; *DOW*, 25 March 1927, 70.
53. For detailed information, see Joseph Garncarz, *Maßlose Unterhaltung. Zur Etablierung des Films in Deutschland 1896–1914* (Frankfurt am Main: Stroemfeld, 2010).
54. *DOW*, 16 February 1922, 39.
55. *DOW*, 31 January 1924, 26.
56. 'Eröffnung des Deulig-Palast', *DOW*, 2/3 January 1926, 1; and *DOW*, 6 January 1926, 3.
57. *DOW*, 14 November 1924, 268.
58. Bundesarchiv Berlin, Ufa 115, Pachtvertrag zwischen Ufa und Hotel Kaiserhof 21 August 1925; Ufa 134, Satzung Kammerlichtspiele in Oppeln, no page numbering.
59. Ernst Hugo Correl, 'Wesen und Wert des Tonfilms', *DOW*, 12 July 1929, 160.
60. The Lichtspielhaus in Zabrze brought in a harpist from Wrocław when showing the film *Das Tanzende Wien* (Friedrich Zelnik, GER 1927).

5
The Sound of Music in Vienna's Cinemas, 1910–1930

Claus Tieber and Anna K. Windisch

> Also the musical accompaniment has made significant progress, as the music numbers are now adapted to the film plot and – besides the *perpetual waltzes and marches* – also opera parts, *Lieder* and classical pieces are played.[1]
>
> Kinematographische Rundschau, 1915

Premise

This comment, entitled *Wünsche eines Kino-Stammgastes* (desires of a movie theater patron) and printed in an Austrian trade paper in 1915, aptly describes a number of issues related to the musical repertoire heard in Vienna's cinemas: exorbitant waltzes and marches, interspersed by opera and operetta arias, *Wienerlieder*[2] and pieces from the 'classical' canon had accounted for a considerable portion of the musical repertoire used in film accompaniment up to that point. However, despite this notion of a relatively small variety of typical Viennese music played in the city's movie theaters the actual modes of musical accompaniment display a diverse and differentiated picture of the cinema sound in the 'city of music' during the silent film era.

Quite surprisingly, the topic of silent cinema music has been largely elided by Austrian film studies, musicology and historiography so far: most accounts of Austrian silent film deal either explicitly with film plots, with famed industry personalities, with specific phenomena of film production such as the 'erotic Saturn-films' and in a few instances with Austrian film production companies.[3] Even more, national silent film production, distribution and exhibition, which form the essential context for analyzing and reconstructing the musical aspect of film screenings, have not yet been researched to a great extent, so that

there are still fields to explore in order to obtain a more comprehensive understanding of the subject.

Rather than in-depth analyzes of specific aspects or 'texts' of silent film sound, this chapter thus responds to the demand for basic research with an overview of the most common practices and significant developments of cinema sound in Viennese film exhibition during the 1910s and 1920s.[4] The information we present is a non-exhaustive account of the fundamental typologies of sound and moving image combinations, as they were deployed in Vienna in the early 20th century. Due to the vanishingly small amount of evidence that remains from these early years of Vienna's film exhibition, the majority of examples and materials are taken from 1913 onwards: time when Austria's own film production gained momentum. By aiming to reconstruct certain historical performance practices that were acted out in silent film exhibition we aim to shed light on what the contributors of film sound production devised as solutions for concrete problems.

As Rick Altman notes, 'film is always the product of performance',[5] and this notion holds strikingly true for silent film. In trying to uncover and piece together information on the musical practices of Vienna's silent film exhibition, it is a principal concern to seek out the locations of such screenings and to examine the surviving materials that document the 'performance settings' of cinematic events. This approach signifies a complementing of textual analyses with the investigation of different modes of musical accompaniment and processes of production, performance and reception, which are contextualized in a broader cultural-historical framework. Music in Viennese cinemas has to be seen both in the context of the city's musical past and within the development of the cinematic landscape during this period.

Our findings give evidence of Vienna's movie theaters as thoroughly musical places; as venues of acoustic and cinematic performances and events, where the incentive to visit a cinema was also motivated by, as well as advertised with, the chance to hear 'good' (Viennese) music.[6] Further findings unearthed an astonishing amount of music films,[7] numerous cinematic productions in which the singing voice featured prominently, discussions about the functions of music in cinemas – for example the use of well-known songs and their connotations in connection with the film narrative – and, rather surprisingly, very little sheet music explicitly written for cinematic use or other kinds of musical suggestions for film accompaniment. Nevertheless, one originally composed score from Vienna's silent film period has recently surfaced at the archive of the Konzerthaus, and it will prospectively

86 The Historical Practice of Silent Film Sound

serve as an example to explore the musical approach of an Austrian composer to a film screening in the specific context of a benefit performance.

Now, what might the accompaniment for a silent film in a city like Vienna have sounded like? How did the city's rich musical tradition influence the development of film accompaniment? And to what extent do preconceived notions such as that of the 'lonely pianist' or of the 'full size symphony orchestra residing in a 3,000 seats moving picture palace' cloud our endeavor to imagine the diversity of Viennese cinemas' soundscapes? In the remainder of this chapter, we will attempt to offer relevant information and examples to begin answering these decisive questions.

Vienna's cultural spaces and their soundscapes

Rick Altman defines soundscape as '[t]he characteristic types of sound commonly heard in a given period or location'.[8] Already throughout the 19th century, Vienna enjoyed the label of the 'city of music' as its cultural scene was characterized by thriving competition and a multiplicity of musical styles and genres. While the dichotomy between 'highbrow' and 'lowbrow', between 'serious' and 'popular' music emerged around the time when film was invented in the 1890s, Vienna featured an additional *interjacent musical sphere* that resulted in less sharply defined cultural spaces: a highly popular tradition of waltzes, *Wiener Lieder* and operettas, which can be seen as an intermediary layer between high and mass culture. Contemplating the significance of the waltz, Derek B. Scott claims that 'the Viennese version of the revolving dance known as the waltz stimulated the development of a revolutionary kind of popular music that created a schism between entertainment music (*Unterhaltungsmusik*) and serious music (*ernste Musik*)'.[9] He goes on to argue: 'It was a style that gave new meaning to entertainment music: the thesis here being that the concept of the "popular" began to embrace, for the first time, not only the music's reception but also the presence of specific features of style.'[10] While in the early 19th century waltzes were still excluded from aristocratic events in Vienna, by mid-century – not least since the emergence of the 'symphonic waltzes' of the 1860s[11] – waltzes were regularly played at events at the Imperial Palace.

The second crucial aspect of this specific entertainment sphere in addition to the waltz tradition was the flourishing musical theater genre of the operetta, whose significance for the development of film in the 1910s is highlighted by Thomas Elsaesser:

the theatrical operetta as an institution had, after the war, entered into a state of terminal decline, in direct proportion to the cinema fulfilling its social function and taking over its forms. What arose on the back of this decline was therefore a popular culture, or rather, a multi-media, sound-and-vision entertainment culture, in which the metropolis itself started to transform itself into an operetta-like ensemble, medial and mediated... '[O]peretta' in this wider sense is the intermediary medium and always implicit, reference point of mainstream cinema in the Weimar Republic.[12]

This notion holds even truer for Vienna, which had experienced the genre's success during the last quarter of the 19th century – performances of operetta potpourris at the court were not uncommon by the late 19th century[13] – well represented by the Strauss Family, Carl Millöcker and Franz von Suppé, to name but a few.

Operetta and waltzes were not only a common source for films, but also were crucial for the formation of audiences. Numerous operettas were adapted for the screen and filmed operettas were among the most successful cinematic events presented in Viennese movie theaters: well-known operetta stars acted in films – sometimes they portrayed the same characters as on stage – and acclaimed composers like Franz Lehár, Robert Stolz, Carl Michael Ziehrer and Edmund Eysler regularly worked for the film industry on specific productions. Waltzes and operettas were heard at various locations and in numerous arrangements across Vienna – from the public amusement park, the *Prater*, to the court, from the celebrated *Kaffeehäuser* to the concert hall; all of these locations decisively shaped the musical landscape of the city in catering to their specific audiences in specific musical formats. Frequent public performances by military bands, concerts in coffee houses and restaurants, dance hall orchestras, and the famed music ensembles playing in bars and wine taverns (*Heurigenmusik*) introduced the public to specific tunes. While waltzes and operettas were palpably cutting across social classes,[14] the music publishing industry – driven by its own pragmatic and economic reasons – played a significant role in the dissemination of this musical repertoire by issuing various arrangements that catered to a specific performance location and audience.

As a corollary, this widely disseminated 'familiar' music repertoire was utilized in movie theaters as indicated in the trade paper comment at the chapter's outset.[15] In fact, the audience's familiarity and expectations in turn influenced the musical choices of cinema musicians. For example, the canonical popular songs and arias in Vienna were closely connected

88 *The Historical Practice of Silent Film Sound*

to the singers and actors who had previously performed these tunes on stage, as is illustrated by the following press comments on the production *Der Millionenonkel* (AUT, 1913) that featured Austrian operetta and theater stage favorite Alexander Girardi:

> Alexander Girardi, who appears in all his splendid roles in this extremely funny plot, is only fully understood with the sounds of the Viennese waltzes by our famous operetta composers, and what the eloquent mimicry of Girardi alone cannot express is completed by the lively music without which we cannot imagine our Girardi.[16]

Film producers and exhibitors exploited this appeal by casting Viennese stage stars for their productions to attract larger and more heterogeneous, and higher paying, audiences.

Vienna's cinematic landscape

The first documented public film screening in Vienna was held on 20 March 1896 with a Lumière *cinématographe* at the corner of Kärntnerstraße and Krugergasse in Vienna's first district, a bourgeois location.[17] Shortly after this first exhibition, which had even attracted Emperor Franz Joseph to one of the showings,[18] variety venues and other entertainment establishments were quick to implement the new attraction into their programs.[19] A great majority of these venues were situated in Vienna's large public and amusement park: the *Prater*.[20] Starting in 1902, the first locations exclusively designated to film exhibition were rededicated or newly built there.[21] Prior to that, most of Vienna's early film shows were presented by itinerant exhibitors (*Wanderkinos*) and in so-called *Zeltkinos* (tent cinemas). By 1903 Vienna counted three permanent cinemas; in 1907 there were ten. The number rose to 62 in 1909 and to 150 in 1915.[22] Additionally, films were shown at places as diverse as *Arbeiterheime* (working men's clubs), in schools and educational facilities, and at prestigious venues such as the Beethovensaal and the Wiener Konzerthaus, which opened in 1913 and took up film screenings in its first years of existence.

A venue not primarily designated for cinematic presentations that nonetheless played an integral part in Vienna's film exhibition history by emphasizing the educational value of moving images was the Wiener Urania.[23] In fact, the inclusion of films into the programs of this adult education center had been preceded by a long tradition of presenting still images – in the form of photographs and slides – which were used to illustrate public lectures. With the rising popularity and

availability of moving images, film was integrated into these lectures which met with great success. At first, the projections – which became known as *Kinematogramme*[24] – were mainly short travelogues and scientific documentaries that were introduced and accompanied by lectures, sometimes held in connection with dance and musical performances, if appropriate to the subject. Soon, the majority of these multimedia lectures were accompanied by some sort of music. Until 1919, the in-house band of the Urania, the Kapelle Karl Klein under the latter's direction, provided the musical accompaniment for most of the institutions' programs. By 1921 the Urania started to exhibit *Kulturfilme*[25] – non-fiction feature films like *Im Kampf mit dem Berge* (1921), *Indien* (1922) and *Das Mittelmeer* (1922) – which attracted large audiences with their instructional content and were accompanied by the Urania orchestra under the direction of *Kapellmeister* Josef Mayer-Aichhorn, who had replaced previous musical director Karl Klein in 1919. In June 1928, the first sound film was presented to Austrian audiences in the halls of the Urania.

Another significant aspect of Viennese film exhibition were venues of 'legitimate culture', such as the Beethovensaal and the Viennese Konzerthaus, which presented films as special events, often as benefit performances and with great efforts regarding the musical accompaniment. The Konzerthaus opened in 1913 and its interior architectural structure was conceived to host two projectors, thus allowing for the projection of still and moving images. Given the circumstance that in 1913 fictional feature films were still somewhat a novelty in Vienna, this fact remarkably provides hints that film was not only seen as an entertainment for the lower social classes, but that the bourgeoisie became interested in film at a relatively early stage. The musical settings of such programs, if given enough consideration and preparation, carried a great part of the attraction exerted on the middle and higher classes. A short overview of the film screening activities reveals the following as the most important performances: on 17 and 18 June 1915, the film *Kammermusik* (GER, 1915) was presented in the great hall with orchestral accompaniment as well as a quartet (*Künstlerquartett*). The program billed the names of the soprano soloist, the harpist, the *Kapellmeister*, the organist, the concertmaster and the solo cellist, to illustrate the elaborate musical setting of the performance. This film was hosted by the association of the Red Cross of Lower Austria as a benefit performance – a common occasion for such events, especially during World War I. Also the 1918 presentation of the Danish anti-war film *Pax Æterna* (1917), which featured the only surviving originally composed film score for a Viennese performance by Austrian *Kapellmeister* Franz Eber, was a benefit event.[26] In 1916, the Wiener Konzerthausgesellschaft presented *Mit*

90 *The Historical Practice of Silent Film Sound*

Gott für Kaiser und Reich (Kunstfilm Wien[27]), a patriotic tone-painting (*patriotisches Tongemälde*) with music by Carl Michael Ziehrer.[28]

A crucial and rather idiosyncratic circumstance of Vienna's cinematic landscape was the fact that, at a time when other world metropolises such as Berlin, London, Paris and New York began to embellish the architectural settings and most of all increase the capacities of their cinemas in the mid 1910s, Vienna did not feature a considerable number of grand motion picture palaces that could seat over 1,000 visitors. The largest cinemas were situated in the Prater, for example, the Münstedt Kino Palast (520 seats in 1922) and the Zirkus Buschkino (Vienna's largest movie theater with 1,800 seats), which prided itself by advertising its 60-piece symphony orchestra.[29] By comparison, the Mercedes Palast in Berlin could seat 2,500 people and the Ufa-Palast in Hamburg held 2,665 visitors. Movie palaces built along New York's Broadway in the 1910s would usually seat more than 1,000[30] and in the 1920s the standard capacity for grand motion picture palaces was 3,000 and over.[31]

By 1920, Vienna counted 163 cinemas – or rather 163 film screening licenses, which included clubs and societies – with a capacity of over 50,800 seats in which 554 musicians regularly played.[32] These spaces distinguished themselves not only sociologically from each other but also in terms of the musical accompaniment. Whereas in many suburban cinemas slapstick comedies were screened without any musical accompaniment, small theaters often employed a pianist and a violinist and cinemas in Vienna's inner districts, as well as in bourgeois districts, explicitly announced their orchestras and praised the skills and qualities of their musicians.[33] By the end of the 1920s all of these different modes of accompaniment were at work simultaneously: comedy shorts and animated films could still be seen in a variety theater, most likely with some music performed by the in-house musicians, whereas feature films were accompanied by small orchestras. The way a film 'sounded' was above all influenced by the location where it was shown.

Vienna's cinema musicians: Repertoire, social status and organization

The high number of musicians active in cinemas after the mid-1910s challenges the widespread concept of the 'lonely pianist' as film accompaniment for the Viennese context, and points to different formations that primarily played in Vienna's cinemas: quartets, small ensembles and salon orchestras (the two terms *Salonkapelle* or *Salonorchester*

were used interchangeably in the historical documents and the ensembles consisted of 6 to 12 musicians).[34] Such musical ensembles had long been active in various Viennese entertainment establishments before the advent of cinema as they had been performing in dance halls, restaurants, salons, health resorts (*Kurorte*), wine gardens and other such locations.

Repertoire

Vienna's cinema musicians came predominantly from the realm of entertainment music (*Unterhaltungsmusik*), which was to a great extent characterized by the above-mentioned repertoire of waltzes, operetta potpourris, *Wienerlieder* and 'light classical music'. *Kinokapellmeister* were expected to possess and maintain their own sheet music collections as this had been the standard procedure for salon ensembles that made their living by taking engagements at various venues, often changing location. Employment ads for cinema pianists in the trade press were also explicitly looking for 'capable pianist with own sheet music repertoire' ('*tüchtiger Pianist mit eigenem Notenrepertoire*').[35]

In a 1914 trade paper comment on the issue of royalties for cinema music, entitled '*Ist die Kinomusik tantiemenpflichtig?*' ('Is cinema music subject to royalties?'),[36] journalist W. Waldmüller provides an apt example of how Vienna's cinema conductors 'utilized' popular songs in film accompaniment. Referring to §33, clause two of the copyright act, he claims that songs can be used in film accompaniment as 'musical citations', notwithstanding copyright protection. To illustrate his point he presents a hypothetical film accompaniment:

> Let's take the case of an accompaniment to a comedy, in which the lover sneaks to his beloved one's house at night for a rendezvous at the garden fence where he is caught by his sweetheart's father and forced to turn tail and run. The *Kapellmeister* now wants to illustrate the action musically and chooses the following pieces: 1. *Bei der Nacht, wenn die Liebe erwacht* (At night, when love awakes); 2. *Püppchen, du bist mein Augenstern* (Little doll, you are the apple of my eye); 3. *Was kommt dort von der Höh'* (What is approaching from that hill); 4. *Jetzt geh'n ma g'schwind nach Nußdorf 'naus.* (Now we'll swiftly walk to Nußdorf).[37]

Aligning these well-known tunes in such a way already tells a story in itself. The fact that this is not a report from an actual screening but a 'potential scenario' given in the trade press does not diminish but

92 *The Historical Practice of Silent Film Sound*

rather heightens the comment's exemplary value as the 'potential scenario' can be read as paradigmatic of the actual practice. Songs and their connotations and implied lyrics were frequently used to comment on, as well as emphasize or caricature, the film plot. Later in the article, Waldmüller gives a list of 40 royalty-free composers including Ludwig van Beethoven, Gaetano Donizetti, George Bizet, Friedrich von Flotow, Georg F. Händel, Jacques Offenbach, Franz Schubert, Franz Haydn and Richard Wagner, just to name a few. These remarks attest to the fact that the music choices of cinema musicians – after a certain point in time when performance rights societies enforced their regulations more rigidly – were also influenced by legal concerns. As hinted at earlier, our research on Vienna's cinema music did not yield any cue sheets – a common device to organize film music on the part of distributors and producers in the US – or other forms of music suggestions. To our knowledge, neither film production companies nor music publishers were offering cue sheets for specific films in Vienna. Hence, used music was mostly preexisting and we could also argue that solo musicians – pianists or harmonium players – relied on memory and extemporizations over known pieces for much of their accompaniment.

Social status

With regard to musical decisions in Vienna's cinemas, the *Kapellmeister* was in control and not the film producer or even the exhibitor. Film accompaniment required a great diversity in style and *Kapellmeister* who had often previously worked in variety theaters, cabarets, coffee houses, or restaurants were well equipped for these specific artistic demands, as they possessed a considerable musical 'flexibility'. However, *Unterhaltungsmusik* contained certain pejorative connotations, at least from the perspective of music critics and colleagues who were performing 'serious music' on opera and concert stages. With few exceptions, cinema musicians were not regarded as equal with their colleagues from concert halls or opera houses. Reviews and comments in the film trade press hint at the inferior qualities of cinema musicians, and the pianists employed in film accompaniment were not even part of the Musicians' Union. Adding the fact that film was consistently struggling to establish and defend its standing among legitimate art forms, it is not surprising that cinema musicians had a lower social status. The competition in Vienna was stiff and jobs were much sought-after, which also resulted in low salaries in this profession. The mouthpiece of the Austrian Musicians' Union, the *Österreichische Musiker-Zeitung*, campaigned on behalf of cinema and variety theater musicians that they be regarded and

treated as more equal to their concert hall colleagues[38] and also noted the high number of part-time musicians, which further aggravated the competitive job situation.[39]

Organization

First efforts of organization among cinema musicians were protracted by the war. However, between 1915 and 1917 (an exact date could not be determined as yet), cinema musicians joined the Musicians' Union's sub-organization *Wiener Salonkapellenmusiker* (founded in 1914),[40] which was acting as an independent union between 1918 and 1920 until they re-joined the Musicians' Union as an autonomous body named *Gremium der Wiener Salonkapellenmusiker*. The *Kapellmeister* became part of the section *Salon- und Kinokapellmeister*.[41] After the unionization of cinema musicians, they were able to better confront the exhibitors to assert their rights with regard to salaries, working conditions and recognition of their union[42] and they did so by threatening to go on collective strikes.[43] Pianists (*Alleinklavierspieler*), however, were organized together with cinema employees (operators, projectionists and ushers). This circumstance was the background for advice given in 1924 in the *Kinematographische Rundschau*, the organ of film exhibitors, which recommended replacing orchestra musicians with pianists if they were to execute their threats of strike, stating just one example of a rather strained relationship between cinema musicians and film exhibitors.[44]

Music films in Viennese film exhibition

One of the most astonishing discoveries in the course of researching Viennese silent film sound has been the vast amount of music films and the various inventive modes of accompaniment in connection with them. The number of these films that were produced and shown from the early 1910s to the end of the silent period – particularly in the form of operetta and musical-biographical films – is remarkable. Musical issues were among the most popular in Austrian silent film production and exhibition, and this feature might even distinguish the country's film history from other national histories.

A pivotal example of such a music film with regard to operetta traditions was the 1913 production *Der Millionenonkel*, starring Vienna's celebrated operetta and Volkstheater[45] persona Alexander Girardi in some of his most famous stage roles.[46] The film featured music by famed operetta composer Robert Stolz, who reworked the well-known

94 *The Historical Practice of Silent Film Sound*

melodies that were connected with Girardi's theater and operetta stage performances into a new potpourri score, augmented with some original melodies. While the accompaniment received rave reviews in the press and was praised as showing 'typically Viennese traits' (*echt wienerische Marke*),[47] two years later (in 1915) the complaints about the sheer amount of waltzes and operetta melodies played in Viennese cinemas[48] serve as further evidence that this 'intermediary musical sphere' was consistently employed in Vienna's cinemas.

Another crucial aspect of music films with regard to their exhibition was the use of the human voice. Viennese cinemas featured soloists, quartets and choirs as accompaniment to film screenings, not only for opera- and operetta-related films. A great number of music films were based on songs and arias as their main attraction. Thus, the singing voice was crucial in Viennese cinemas: on- and off-screen, diegetic, as well as an essential part of the musical accompaniment and multimedia program. Singers in movie theaters were explicitly announced and they could be heard before, during and in between films. As music films displayed the on-screen images of a singing person, sounds were evoked in the audience's minds, regardless of the actual accompaniment. A complex net of relations between actual, implied, imagined and remembered voices could be sketched according to this evidence in order to deliver a revised and richer picture of silent film music.[49]

Richard Grünfeld, one of Vienna's most famous *Kinokapellmeister* employed at the Kärntnerkino, commented on this issue in 1927:

> Oftentimes vocal pieces from operas are being used in film illustration. I do not think this is always the right thing, because on hearing the respective melody, the attentive opera goer will involuntarily think of the corresponding words, which are often in stark contradiction to the action on the screen.[50]

In addition to such implied voices, a number of music films already contained certain musical suggestions for the accompanists within the film images.[51] While we cannot ascertain to what degree such 'denoted music suggestions' were actually followed, the widespread knowledge of this repertoire among audiences and musicians encourages the assumption that they were observed more often than not.

The so-called *Volkskunst-Vortragsfilme* (folk art lecture films),[52] a multimedia performance mode compiled of live drama, lectures, illustrated slides, songs and films, were a popular genre in the 1920s. Most of these programs presented nostalgic notions of 'Viennese *Gemütlichkeit*' with

illustratory titles such as *Im Reich der Wiener Melodien* (1923); *Wien, die Stadt der Lieder* (1923); *Die Wienerstadt in Bild und Lied* (1923); and *(Carl Michael Ziehrer's) Märchen aus Alt-Wien* (1923). These films – also somewhat disguised as educational productions – were presented in cinemas throughout the city and even in the largest venues: the Zirkus Busch Kino and the Haydn-Kino.[53] In order to draw large crowds, the producers of these programs relied heavily on the appeal of well-known musical styles, mixed with famous names of Vienna's musical culture.

Viennese cinema music and arrangements for cinematic use

Sheet music composed specifically for films is extremely rare to find in Vienna. The earliest known score explicitly composed for a film presentation is a score by Erich Hiller for the Asta Nielsen film *Der schwarze Traum* in 1911.[54] Hiller initially wrote music for individual screenings, and he went on to compose music for cinemas as well as for distributors, which means that his scores accompanied predominantly foreign films and not necessarily Austrian productions. The nowadays best-known score for an Austrian film is the music for the screen version of Richard Strauss's *Der Rosenkavalier* (1926), arranged from the opera by the composer himself. In 1918 the trade paper *Der Kinobesitzer* announced compilation scores by cinema conductor Fritz Zeillinger from the Flottenvereinskino (one of Vienna's first-run cinemas) as 'flawlessly adapted, partly originally composed music'.[55] Unfortunately, documents such as Hiller's original or Zeillinger's compiled scores remain lost to date with the exception of the music for the performance of *Pax Æterna* at the Konzerthaus in 1918.

The late years of the silent film period (between 1926 and 1932) witnessed the publication of arrangements of existing musical pieces advertised as specifically intended for film accompaniment. These publications consisted of known musical works arranged for formations from solo piano, duo, trio, quartet, quintet, salon orchestra, to small and full orchestra; yet the bulk of sheet music was available for salon orchestra and small orchestra. The well-established Universal Edition[56] – founded in 1900 by Josef Weinberger, Anton Robitschek and B. Herzmansky – issued two series that were dedicated to cinema music: the *Vindobona Collection* and the *Filmona*. The *Vindobona Collection*, subtitled *Modern Classics for Concert and Cinema Use: Selected Works of the Leading Modern Composers Arranged for Small and Full Orchestra*, contained arrangements of pieces by composers such as Richard Strauss, Erich Wolfgang Korngold, Karl Goldmark, Anton Bruckner, Gustav Mahler,

96 *The Historical Practice of Silent Film Sound*

Max Reger, Kurt Weill, Alexander von Zemlinsky, Jaromir Weinberger, Franz Schreker and Ernst Krenek as well as numerous lesser-known artists. The collection was published from 1926 until the mid-1930s. The *Filmona*, subtitled *Film-Illustrations-Musik: Die neue Sammlung moderner Film-Illustrations-Musik*, offered pieces by contemporary composers in the style of the established mood categories for film illustration (merry, passionate, dramatic, pursuit, storm, fire and so on) some of which were composed by Viennese *Kapellmeister* and composers Franz Eber, Victor Hruby and Emil Bauer. The collection was issued in German, English and French, which points to an international marketing of the publication.

Other international publishers with branches in Vienna had provided music for use in cinemas since the beginning of the twenties. The series *Universal-Film-Musik*, distributed by Schlesingersche Buch- und Musikhandlung, contained a number of atmospheric pieces for film illustration comprised from famous anthologies such as the *Kinothek* or the *Hawkes Photo Play Series*. In 1926/1927 Bosworth & Co. published volumes (*Englische Filmmusik*, *Internationales Kino-Orchester*) containing atmospheric pieces written by Albert Ketèlbey and J. Engleman among others.

While the *Vindobona Collection* and the *Filmona* – undoubtedly two of Vienna's most valuable publications of cinema music – might offer some clues on what kind of classical as well as popular music was suggested for film screenings in the city's cinemas, it seems reasonable to question how much and how often these specific cinema music publications were actually employed, considering the well-established repertoire of cinema orchestras, the lack of comment on such music – that is, 'modern classics' from Mahler to Krenek – in the (trade) press and the moment of publication as already rather late in the silent era. What remains important to note is that – because of multilingual versions – these publications were not solely intended for the German-speaking market and it is safe to assume that, driven by economic interests, the music publishers were exploring new markets with the musical repertoire for which they already owned the rights. It is also telling in this regard that the 'testimonials by prominent professionals on the salon orchestra edition of the Universal Edition' [the *Filmona* collection] that were used as promotional tools list 'reviews' by six cinema music directors from Berlin and two from Munich, and exclusively by German trade journals such as *Deutsche Musikerzeitung*, *Film-Ton-Kunst* and *Der Artist*; the two Viennese testimonials stem from conductors André Hummer and Isy Geiger, who both successfully directed dance orchestras and not *Kinokapellen* at the

time. In any case, the existence of these arrangements raises important notions for the actual practice of cinema music in Vienna.[57]

Historical discourse on Vienna's silent film music

While music was soon established as an integral part of film screenings, it was rarely addressed in the public discourse. Only special circumstances, such as a live performance by a famous musician or singer, or an exceptionally well or badly received accompaniment, seemed to warrant a mention in the trade or, even less frequently, the daily press. Hence, the public discourse on film music in Vienna was not as organized and institutionalized as, for example, in the US or in Great Britain. This absence can be related to several reasons, the most significant being the specific structure of Austria's film industry, which consisted of numerous production companies and even more distributors with no successful vertical integration of these business strands throughout the silent period. Consequently, producers did not make any notable efforts to increase their control over film exhibition standards, which resulted in a modicum of music written for specific films or screenings. As a corollary, decisions concerning the music were left to the judgment and taste of the *Kapellmeister* and that of the musicians and, rarely, the exhibitor.

Additionally, while outstanding film music was praised, the few remarks on cinema musicians that were printed in film trade journals such as the *Kinematographische Rundschau*, *Die Filmwoche*, *Das Kinojournal* and *Der Filmbote* display a severe antagonism between film exhibitors and musicians (especially after the musicians unionized), as they would usually report on orchestras striking[58] or on the 'exorbitant demands of the Musicians' Union'.[59] This adverse attitude also applied to the musicians' trade paper, *Österreichische Musiker-Zeitung*, which portrayed film exhibitors as money-mad and power-hungry businessmen and blamed them for halting developments in Vienna's film exhibition industry that could potentially provide new positions for the numerous struggling orchestra musicians in the city. The scarce full-length articles in the trade press that deal with the issue of film music stem from the 1920s. Well-known composers or *Kapellmeister* such as Franz Lehár,[60] Alfred Grünfeld[61] and Richard Grünfeld[62] would contribute the occasional half or full page to a film journal, discussing their own experiences with film music and their general approach to film accompaniment.

Conclusion

Considering these elaborations, any assumption of silent film history as a linear narrative from fairground mass entertainment and variety attraction to motion picture palaces within the three decades of silent film is not an accurate description of a far more complex historical situation. Vienna's cinematic landscape was marked by heterogeneous venues, co-existing throughout the silent period: variety theaters, itinerant exhibitors, *Zeltkinos*, small movie theaters rebuilt theater halls, a diminutive number of larger cinemas, and films being screened at places of legitimate culture and in educational institutions. Those venues were places of musical performance, in which vocal music featured to a considerable extent as the prestige of a film was connected with higher (and more expensive) musical values. In addition, music fulfilled multiple functions with regard to audience formation and social differentiations, and was used according to practical, social and economical issues that film exhibitors were facing.

We can further infer from the information unearthed in the course of this research – the type of ensembles mainly employed at cinemas, a negligible amount of cinema sheet music and original compositions, and the lack of discussion in the trade and daily press – that the music played in Viennese cinemas was predominantly written for other media and art forms. The music chosen to accompany films was based on past and prevalent traditions of Vienna's musical-cultural history that enjoyed mass popularity and a cultural legitimacy across social classes. Film accompaniment in Vienna did not yield any new kind or style of music: on the contrary, the *Kapellmeister* and cinema musicians relied heavily on preexisting genres that combined music with dramatic art forms such as opera, operetta, theater and variety, and on *Unterhaltungsmusik* in general. This circumstance led to a virtual absence of public discourse on this topic. Moreover, the fact that cinema musicians were of low social status further substantiates the fact that the sparse discourse on cinema music was limited to film exhibitors and that very few original compositions exist in Austrian silent film history. Given these points, Vienna's specific soundscape and the preceding and co-existing musical-dramatic art forms shaped the sounds of the city's cinematic locations in a peculiar way and differently than in comparable European and American cities.

With the conversion to technically synchronized sound, cinema's production side won control over the medium's sound identity. What was lost in this process were the myriad modes of combining and mixing

Claus Tieber and Anna K. Windisch 99

(moving) images with sound – modes that were distinguished by their performance aspect. Today, the notions of 'multimedia performance' or 'mash-up culture' are highly topical in the humanities as well as in the cultural industry, thus, the *re*-construction of different (historical) media becomes an acutely current activity.

Notes

1. C.F. Pataky, 'Wünsche eines Kino-Stammgastes', *Kinematographische Rundschau* (hereafter *KR*), 28 September 1915, 5. [All translations by the authors of this chapter. Emphasis added].
2. *Wienerlieder* are a specific Viennese genre of popular folk songs, mostly revolving around the theme of life in Vienna and usually sung in the Viennese dialect.
3. The most important studies include: Walter Fritz, *Kino in Österreich, 1896–1930: Der Stummfilm* (Vienna: Österreichischer Bundesverlag, 1981); Michael Achenbach, Paolo Caneppele and Ernst Kieninger (eds.) *Projektionen der Sehnsucht. Saturn – die erotischen Anfänge der österreichischen Kinematografie* (Vienna: Edition Film + Text, 1999); Francesco Bono, Paolo Caneppele and Günther Krenn (eds.) *Elektrische Schatten: Beiträge zur österreichischen Stummfilmgeschichte* (Vienna: Verlag Filmarchiv Austria, 1999); and Christian Dewald and Werner Michael Schwarz (eds.) *Prater. Kino. Welt. Der Wiener Prater im Film* (Vienna: Filmarchiv Austria, 2005).
4. This chapter was developed from a research project that set out to examine cinema sound in Vienna during the silent period for the first time on a large scale. The project entitled 'The Sound of Silents: Sound and Music in Viennese Cinemas, 1895–1930' was funded by the Austrian Science Fund (FWF) and conducted from 2010 through 2013 by principal investigator Claus Tieber with the assistance of Anna K. Windisch during the fall term of 2012. The authors are currently working on a German-language monograph that details the results of this research.
5. Rick Altman (ed.) *Sound Theory, Sound Practice* (New York and London: Routledge, 1992): 9.
6. Numerous advertisements of cinemas in the posher districts pointed to their 'first-class orchestras', see advertisement for the Maria Theresien-Kino in Vienna's 6th district, *Die Theater- und Kino-Woche* 4, 1919, III; or the newspaper advertisement of the city's largest cinema, the Zirkus Busch Kino in the Prater that promoted its 'Viennese Symphonic Orchestra of 60 pieces', *Neue Freie Presse*, 6 May 1920, 7.
7. For this context we define music films as films in which music played a significant role, such as biographies of famous musicians, composers or singers, or films based on operas, operettas, songs or symphonies.
8. Altman, *Sound Theory*, 252.
9. Derek B. Scott, *Sounds of the Metropolis: The Nineteenth-Century Popular Music Revolution in London, New York, Paris, and Vienna* (New York: Oxford University Press, 2008): 117.
10. Ibid., 119.

100 *The Historical Practice of Silent Film Sound*

11. Ibid., 142.
12. Thomas Elsaesser, *Weimar Cinema and After: Germany's Historical Imaginary* (London and New York: Routledge): 198f.
13. http://www.naxos.com/mainsite/blurbs_reviews.asp?item_code=8.223222& catNum=223222&filetype=About%20this%20Recording&language=German. (accessed 6 November 2013).
14. Bridging class divides was the very topic of operettas like Carl Zeller's *Der Vogelhändler* which premiered at the Raimundtheater in Vienna in 1891. See also Christian Glanz, 'Unterhaltungsmusik in Wien im 19. und 20. Jahrhundert', in Elisabeth T. Fritz-Hilscher and Helmut Kretschmer (eds.) *Wien Musikgeschichte. Von der Prähistorie bis zur Gegenwart* (Vienna, Berlin: Lit Verlag, 2011): 495.
15. See endnote 1.
16. 'Der Girardi-Film', *KR* 282, 1913, 4.
17. Siegfried Mattl, 'Wiener Paradoxien. Fordistische Stadt', in Roman Horak [et al] (eds.) *Metropole Wien, Texturen der Moderne 1* (Vienna: Wiener Universitätsverlag, 2000): 22–96 (50).
18. 'Der Kaiser beim Cinematographen', *Neue Freie Presse*, 17 April 1896, 17.
19. Vienna's variety theaters (also known as *Singspielhallen*, although these would focus even more on musical entertainment) became important stages and employers for orchestra musicians in Vienna, as they would often present operettas in the second part of their programs. The most famous Viennese venues were Varieté Apollo, Varieté Ronacher, Gloria Theater, Kabarett Renz, and Kabarett Die Hölle.
20. Edison's Kinetoscope was first introduced here in 1895: Siegfried Mattl, 'Wiener Paradoxien', 50.
21. In 1902, director Gustav Münstedt of the *Singspielhalle* in the Prater applied for a cinema licence to open the Münstedt Kino Palast.
22. See Walter Fritz, *Geschichte des österreichischen Films* (Vienna: Bergland Verlag, 1969): 22; and Werner Michael Schwarz, *Kino und Kinos in Wien. Eine Entwicklungsgeschichte bis 1934* (Vienna: Turia & Kant 1992): 22f.
23. The Urania, founded in 1897 as *Wiener Urania Syndicat*, was an association dedicated to adult education. The idea for this institution was born after University professors had been giving folkloristic public lectures at the University of Vienna, and the first Urania (named after the Greek muse *Urania*, the patron of astronomy), on which the Viennese association was modeled, was opened in 1888 in Berlin. Today, the space hosts a cinema and a lecture hall. For a detailed historical account, see Wilhelm Petrasch, *Die Wiener Urania. Von den Wurzeln der Erwachsenenbildung zum lebenslangen Lernen* (Vienna/Cologne/Weimar: Böhlau, 2007).
24. Ibid., 39.
25. Ibid., 103, 107.
26. The complete score was donated to the Archive of the Konzerthaus by the composer's heirs in the 1990s and is presently preserved there.
27. The Kunstfilm Wien was one of Vienna's leading film production companies, managed by Austrian film pioneers Luise Kolm and Jakob Fleck.
28. Such cinematic productions intended to stir patriotic and nationalistic sentiments among the public were frequent during World War I. The Kunstfilm Wien also produced the 'tone-picture' *Der Traum eines österreichischen*

Claus Tieber and Anna K. Windisch 101

Reservisten (1915), a film based on the preexisting *patriotisches Tongemälde* ('patriotic tone-painting') by C. M. Ziehrer and *Mit Herz und Hand fürs Vaterland* (1916) with music by Franz Lehar.

29. 'Viennese Symphonic Orchestra of 60 pieces', *Neue Freie Presse*, 6 May 1920, 7.
30. Rick Altman, *Silent Film Sound* (New York: Columbia University Press, 2004): 249.
31. Ibid., 291.
32. The *Österreichische Musiker-Zeitung* noted 200 cinemas in Vienna in 1921. Johann Jaschke, 'Entstehung und Organisation des Gremiums österreichischer Salonkapellenmusiker und-musikerinnen', *Österreichische Musiker-Zeitung* (hereafter *ÖMZ*) 10 (1921): 115.
33. Advertisement, *Die Theater- und Kinowoche* 4 (1919): III.
34. See job advertisement: 'Large cinema hires *Kapellmeister* with good musicians', *KR* 425, 20 February 1916, 56., and Advertisement: 'First-class cinema orchestra', *KR* 136, 20 August 1916, 441. In a report from 1911, after a visit to the factory for mechanical instruments, the Hupfeld Inc., the columnist of the *KR* describes the instruments as being able to 'replace a small salon orchestra'. See 'Die richtige Musik für das Kino', *KR* 184, 1911, 18. However, World War I implicated the availability of musicians in Vienna, so that cinema owners between 1914 and 1918 were seeking for 'capable pianist, *military free*'. See, Advertisement, *KR* 333, 13 December 1914, 43. [emphasis added].
35. Advertisement: 'Tüchtiger Pianist mit eigenem Notenrepertoire', *KR* 230, August 1912, 11.
36. W. Waldmüller, 'Ist die Kinomusik tantiemenpflichtig?', *KR* 326, June 1914, 10–11.
37. Ibid.
38. Karl Biedermann, 'Die Leiden der Varietémusiker', *ÖMZ* 5 (April 1916): 34–37.
39. Fritz Gruber, 'Doppelverdiener', *ÖMZ* 15/16 (1925): 64.
40. Jaschke, 'Entstehung und Organisation', 115.
41. Ibid.
42. 'Das Gremium der Salonkapellenmusiker', *ÖMZ* 4 (March 1919): 31.
43. 'Organisation', *ÖMZ* 1, December 1920, 4.
44. 'Schlechte Musik', *Der Filmbote* 7, January 1924, 11–12.
45. Especially the *Alt-Wiener Volkstheater* was a much-loved theatrical form that featured plays by legendary dramatists from the *Biedermeier*, such as Johann Nepomuk Nestroy and Ferdinand Raimund. The *Volkstheater* was strongly connected to musical performances, as the *Couplets* (humorous songs; music-hall songs) were integral parts of most plays and became strongly associated with their performers over time.
46. The film premiered in the Beethovensaal in Vienna's first district, a location that hosted performances by artists such as Arnold Schönberg and Gustav Mahler.
47. 'Der Girardi-Film', *KR* 282, July 1913, IV.
48. Pataky, 'Wünsche eines Kino-Stammgastes', 5.
49. While highly interesting, a detailed discussion of this topic is beyond the scope of this chapter.

102 *The Historical Practice of Silent Film Sound*

50. Richard Grünfeld, 'Kinomusik und Filmillustration', *Mein Film* 76, June 1927, 14.
51. For example, the film *Der Millionenonkel* features inserts of music incipits of the first few bars of the *Couplets* and operetta arias that Alexander Girardi had famously performed on Vienna's stages.
52. *Der Filmbote* 11, February 1923, 29.
53. Ibid.
54. *KR* 180, August 1911, 6.
55. Advertisement, *Der Kinobesitzer* 20, 12 January 1918, 10.
56. The Universal Edition was one of Vienna's most successful music publishers. From 1909 onwards, the organization started to focus on modern composers such as Richard Strauss, Gustav Mahler, Arnold Schönberg and Franz Schreker, among others.
57. Francesco Finocchiaro is currently undertaking a research project that explores avant-garde music and cinema in the silent era in the course of a Lise Meitner Scholarship by the Austrian Science Fund (FWF).
58. 'Der Musikerstreik', *Der Filmbote* 36, September 1924, 11–12.
59. 'Der Streik der Kinomusiker', *Der Filmbote* 38, September 1924, 23.
60. Franz Lehár, 'Ich lasse mich überraschen', *Mein Film* 149, 1929, 4.
61. Alfred Grünfeld, 'Kinomusik und Filmillustration', *Mein Film* 76, 1927, 14.
62. Richard Grünfeld, 'Kinomusik', *Die Kinowoche* 8, 1919, 6.

6
The *Moving Picture World,* W. Stephen Bush and the American Reception of European Cinema Practices, 1907–1913

James Buhler and Catrin Watts

First published in 1907, *The Moving Picture World* (*MPW*) was a leading film industry trade journal through most of the silent era. It was aimed primarily at exhibitors and committed to elevating the status of the moving picture house in North America through a strategy of 'cultural uplift'.[1] As such, it devoted many articles to improving the quality of both the films and their exhibition. In an earlier essay, one of the authors of the present chapter traced the reception of British exhibition practices in *MPW*.[2] This essay seeks to do something similar by examining how Europe in general served as a figure for legitimizing a certain image of what the moving picture business in America should look like, with a particular emphasis on how this affected the musical practice in American theaters. This essay begins with a general overview of the coverage of European exhibition practices in *MPW* before 1913 and then concentrates on explicating a long trip W. Stephen Bush, an editor for the paper, took through Europe in April, May and June of 1913.

In the early years, *MPW* reported frequently on the state of exhibition in Europe, as theaters there were considered to be following practices more in keeping with the ideals of cultural uplift than were their North American counterparts, which remained housed primarily in small, undercapitalized venues. Reports in *MPW* suggested that in Europe moving picture theaters generally charged more, occupied larger and better-appointed houses sooner, and offered a higher standard of program, including more educational films and better music than the American theaters. About the only points on which American

104 *The Historical Practice of Silent Film Sound*

theaters were considered ahead of European ones were in a lack of censorship and in the practice of changing films daily – and even the latter was deemed mostly a deficiency because it meant that the managers could not properly look after their programs or have any opportunity to rehearse the shows. In this chapter, we will consider how various debates over the place of entertainment and education in the cinema affected exhibiters' choices on exhibition practices in general and on music in particular in the critical years before 1914 when the institution of cinema was coming into existence. During this period, *MPW* consistently made the argument – and used the European practices as an example – that, to increase the quality of exhibition, theaters needed 'better patronage', which meant audiences that could reliably fill larger venues and whose membership was economically better off. Such an audience, it was thought, would solve several acute problems – most notably making the industry less sensitive to general economic downturns and less likely to be subject to troublesome government regulation – thereby placing the business on firmer economic foundations.[3]

France, cultural uplift, and the 'Americanization' of the cinema

At the time *MPW* was founded in 1907, France was recognized as a leading innovator in moving picture production and exhibition. Not only did many of the best films come from France at the time,[4] but Leon Gaumont's engineering work on synchronizing the phonograph to moving pictures – understood as the real future of the business until the advent of the long feature in the early teens – received regular notice in *MPW*.[5] Gaumont's exhibition showcase in Paris, the Palace Hippodrome, seated 6,000 to 7,000 people (depending on the account), boasted an orchestra of up to 60 players,[6] and in 1913 was still routinely named as 'the finest picture theater in the world'.[7] Gaumont's theater was by no means unique: a report from 1908 noted that Parisian theaters generally featured orchestras, occasionally augmented by 'choruses of fifty or more voices'.[8] At a time when most independent moving picture theaters in North America were small and lucky to have an indifferent pianist banging out popular ditties to attract passersby into the theater, the musical accompaniment of Parisian theaters served as a sign of a future success and opulence.

Yet in the early years of the paper, *MPW* had to be careful and selective in its use of Paris. The city was an international cultural center

to be sure, but Paris was also a city whose moral sensibilities were widely understood by American cultural authorities to be unacceptably 'foreign'. What was good for Parisian entertainment was therefore not necessarily good for American entertainment. In the cinematic realm, the issue was made more fraught by the fact that France was the leading competitor to American filmmakers during the early rise of the nickelodeon and the establishment of the cinema. As Richard Abel explains, Pathé was particularly influential during this period, and American firms had good business reasons to work to reduce its share of American markets.[9] This period also saw the first moral panics over moving picture shows, as the nickelodeons proved quite attractive to the poor, recent immigrants, women and children,[10] and authorities were very concerned with ensuring that theaters were 'safe' and that exhibitors ran a 'clean' show.

As with most discourse of social regulation, such terms as 'safe' and 'clean' were doubled, referring both to the physical state of the theater (proper exits, sanitary conditions, etc.) and to the actual content of the shows (free from lewd vaudeville acts, bawdy illustrated songs, and salacious or excessively violent films).[11] Usually, the discursive emphasis fell on the latter.[12] If the goal of the exhibitor was, in the words of Bush, to attract 'a better and cleaner patronage',[13] this required a purging, a moral cleansing. 'No house can be properly decorated before it is thoroughly cleaned: The evil spirits of greed, cheapness and nastiness must all and singular be exercised before the house can be swept and garnished.'[14] Many were also concerned that the recent wave of immigrants be quickly and properly assimilated, and some social activists saw moving picture theaters as a place that effective cultural pressure could facilitate socialization.[15]

Because growing the business required negotiating these cultural currents, *MPW* developed a nuanced position: on the one hand, the paper supported raising admission prices and generally improving exhibition conditions including the music; on the other hand, it encouraged both exhibiters and film companies to uplift their business by producing and programming more films with educational and literary values and to generally police their films (through self-censorship) to ensure that they were consistent with American values. As Abel documents, French firms also came under increasing attack for producing disreputable films, and these films were frequently deployed by *MPW* to shift criticism from the American side of the industry.

In December of 1911, when a wave of Italian multireel features had just begun to sweep across the country, *MPW* was still willing to claim

106 *The Historical Practice of Silent Film Sound*

(albeit excepting the recent success of the features): 'foreign films have never been popular in this country. The ordinary foreign picture, portraying the social, moral and political conditions prevailing in Europe, is often unintelligible to Americans, and not infrequently offensive and disgusting.'[16] By making the quality of the moving picture into a question of foreign taste, *MPW* was able to frame the problems with the moving picture industry in terms of the 'alien' moral sensibility of the 'foreign' product being unsuitable for the American public rather than a failing of American films or the institution of the cinema in the US. By 1913 the attack on foreign features was in full force. Returning from a long trip visiting with exhibitors around the US, Albert Warner, at the time President of Warner Feature Film Company, reported that 'it has taken the American manufacturer a long time to convince exhibitors that American-made features are what they want, and that they are the equal, if not the superior, of foreign productions in two and three reels'.[17] Warner, himself an immigrant but one whose business was tied to pushing aside competition from foreign firms, made an explicit call for American productions, claiming that exhibitors were now clamoring for 'American features, made in America by American actors and actresses'.[18]

Education films, films d'art and the influence of pantomime

Another tactic that *MPW* adopted to counter criticisms of moving pictures was to emphasize their potential for education, and, as with theaters, Europe could be drawn in rhetorically to bolster the case. During this crucial period of institutionalization, education was understood to be a means of attracting a better patronage while also serving to answer the medium's many critics. Better audiences, *MPW* argued on numerous occasions, would appreciate the educational content, and the lower classes would likewise better themselves through access to these educational experiences, which would otherwise be beyond their means. On a more mundane level, the educational films – or at least the mission of cultural uplift they underwrote – also offered a defense of the moving picture theater against government censorship and preempted the frequent diatribes against moving pictures from clergy and other prominent social reformers.

The French firms were in fact considered to be the leaders in the area of educational films.[19] Even as their regular productions came under increasing attack, the French manufacturers formed special units, notably Film d'Art and SCAGL (Société Cinématographique des Auteurs

et Gens de Lettres), to make adaptations of classic literature and even productions from original scripts by well-known authors. The tradition of pantomime, a mute dramatic form with music often akin to ballet, was also strong in Europe, where official limitations on spoken theater had long encouraged the development of wordless theatrical forms that grew out of the *commedia dell'arte*. With the push to produce literary adaptations, French filmmakers turned especially to this line of 'elevated pantomime' to distinguish the quality of these productions from the acting of the regular films based in the melodramatic tradition. An example is Gaumont's 1907 film version – often described as a visual recording of the stage play – of the most famous pantomime of the time, Michel Carré's *L'Enfant Prodigue* (1891).[20]

With the critical success of these more ambitious French productions, American firms followed suit. To this end in late 1909, the Edison company contracted with pantomimist Pilar-Morin for a series of films. Pilar-Morin had since long before 1900 regularly toured the US with a French pantomime company and was known especially for her work as Pierrot in American productions of *L'Enfant Prodigue*.[21] According to Richard DeCordova, Edison promoted Pilar-Morin during 1910 very much in the same manner that Vitagraph and Imp promoted Florence Turner and Florence Lawrence, respectively – as a picture personality.[22] In a publicity piece Edison used to introduce Pilar-Morin and her art to exhibitors and reprinted in *MPW*, she wrote that pantomime was a special and dignified form of acting. Toward the end of this article, Pilar-Morin explicitly made a connection between elevated pantomimic technique and the success of the French films d'art: 'The French pictures are so wonderfully artistic', Pilar-Morin claimed, 'because all these details, which form "Silent Drama" or Pantomime, are the very base of their acting.'[23]

Even restricted to the domain of less commercial fare, this claim to French superiority would prove troublesome to American filmmakers, and by 1911 Pilar-Morin had been released from her contract, much to the surprise of the editors of *MPW*.[24] This might have been purely a business decision, but as Jon Burrows notes, Edison's decision was consistent with the long campaign, mentioned above, that American firms had been waging against French filmmakers: 'It obviously started to make little sense that companies like Edison and Vitagraph should promote and valorize the skills of French-born players and denigrate those of native actors in the context of a covert commercial war with French manufacturers.'[25] For Burrows, whatever cultural uplift pantomime provided nonetheless proved insufficient to prevent the foreign bodies of

108 *The Historical Practice of Silent Film Sound*

its actors from becoming casualties in the US industry's campaign for the Americanization of film.[26]

This point needs to be complicated somewhat, as it was at a quite late historical moment that broad movement and excessive gesticulation became identified specifically with pantomime and that the term 'pantomime' was opposed to the supposedly natural style of American acting. Indeed, in 1913 *MPW* still complimented D.W. Griffith for having 'moulded' his acting company at Mutual into 'pantomimic artists'.[27] The pantomime practiced by Pilar-Morin, however, was not naturalistic, but rather abstract and stylized; it depended on defined poses and precise movements between the poses in order to avoid equivocal signification.[28] For his part, Bush considered the pantomime a highly conventionalized theatrical form that gained its clarity of expression only because it 'is held fast in rules that apply like clamps of iron'.[29] According to Bush, the moving picture drama was comparatively a much freer form, but because the pantomime was overly constrained by its conventions not because it gesticulated excessively. Impresario and frequent *MPW* contributor Robert Grau, on the contrary, thought the fundamental problem with filmed pantomime was not the acting but the inadequate music. Pantomime, he argued, depended on an exceptionally close coordination of action and music, and few moving picture theaters at the time had musicians who were properly trained for the work. 'What is needed to make pantomime a sensational vogue', Grau thought, 'is a complete organization of Pilar-Morin, a veritable pantomime stock company, and as an added requisite, a Composer-Pianist, who will expressly make a piano score for each production, but which in interpretation can be played by any first-class pianist, such as must soon be an absolute necessity of every progressive picture theater.'[30]

Max Reinhardt, whose pantomimic spectacles closely synchronized to music were proving immense hits across Europe, likewise spurred the editors of *MPW* to warn exhibitors to reflect carefully on their whole show, since they would likely soon find themselves in competition with this kind of spectacle: 'That [such productions] will come sooner or later there can be no doubt. Their success abroad is blazing a trail across the big pond. Reinhardt is really using the very methods which, if properly applied, would make sure and permanent the success of the moving picture of the higher quality.'[31] Reviewing a New York City stage production of Reinhardt's *Sumurun* for *MPW*, an anonymous 'M[oving] P[icture] Man' noted the strong affinities of the pantomime spectacle to moving pictures, stating that Reinhardt's theatrical success owed a considerable debt to the popularity of moving pictures. The writer went

on to add: 'The most valuable lesson to be drawn from the success of "Sumurun" is in the music. The music supplied the need of words in a most acceptable manner. It was written for that very purpose. Without music the play would have been unendurable.'[32] Bush, in reviewing the 1912 Continental-Kunstfilm version of *The Miracle*, a pantomime that had also just been recently staged in London to great acclaim by Reinhardt, likewise noted:

> No picture that I have seen affords greater opportunities for effective and impressive music than 'The Miracle'. Every person looking at the pictures must feel a bulging for the sound of music. The owners of the American rights have recognized the musical opportunities of the play and have provided a complete musical score, said to have been composed by a competent musician. It is claimed that the music is thoroughly appropriate to the subject.[33]

In reviewing the US premiere of the filmed version of Reinhardt's production a few months later, Bush added that it 'is not a moving picture drama, but filmed pantomime. Such pantomime, however, as Professor Reinhardt's looks exceedingly well in films, and accompanied by music and singing it grew into the proportions of a unique and magnificent spectacle.'[34] The music used by the Park Theater, Bush was quick to point out, had been adapted from the score Engelbert Humperdinck had composed for the London stage production.[35] As Gillian Anderson has recently argued, pantomime was an important force in getting musicians and exhibitors to reevaluate their musical practices and to strive for a different kind of synchronization between music and the action on screen.[36]

Germany, music, and the campaign for higher prices

Although *MPW* followed the rest of the American trade press, sometimes reluctantly, in the campaign to Americanize film, the paper always seemed much more concerned with uplift than with Americanization per se despite its interest in the success of American firms.[37] Therefore, it had little difficulty turning to Europe as a model for running moving picture theaters.[38] By 1910, *MPW* was reporting frequently on specially built moving picture houses in Europe. In Berlin, for instance, an upscale theater had been constructed on the site that had previously housed the Mozarthall.[39] The author feigned surprise that 'the once despised kino has become a social factor'. The theater was designed to attract an

110 *The Historical Practice of Silent Film Sound*

affluent audience, with higher prices, a better interior, and a request that patrons attend in evening clothes appropriate to the regular theater or opera. The author noted that the performance opened with a concert of 'first-class music which continues during the evening'.[40]

This new theater was a harbinger of the picture palace aesthetic that was to dominate the culture of moviegoing throughout the rest of the silent era, though how common such theaters were in Germany in 1910 would be impossible to gauge from the pages of *MPW*, which had no real interest in giving an accurate view of the matter. Reconstructing the reality of European theaters and exhibition practice, we should be clear, is not our aim, either.[41] Instead, we seek to understand what the writers of *MPW* were doing, what interest they were representing, when they gave such accounts. An article from 1913 celebrating American theater manager Al Woods's recent entrance into the German exhibition market suggested that he was bringing American-style exhibition to Germany in order to modernize it by emulating a theatrical experience. J.J. Rosenthal, whom Woods had hired to help open the theaters, noted: 'All of these houses will be regular theaters, mostly those formerly given over to dramatic performances. This, in itself, is something unusual in Germany where most of the picture theaters are up on the third or fourth floors.'[42] He also remarked on the inclusion of vaudeville as a distinguishing and innovative part of Woods' programming. 'The vaudeville will be a big attraction, for in spite of its size Berlin boasts only one real vaudeville theater, the world-famous Wintergarden [*sic*] where only "dumb" acts can be shown, since the vast auditorium does not permit the use of talking acts.'[43]

The situation in Germany as described by Rosenthal seems far removed from the description of the Mozarthall given above, and also runs counter to Horace Plimpton's claim from 1913 that he found theaters in Berlin to be 'of very high class',[44] to Bush's flattering descriptions of Berlin theaters that appeared in the very same issue of *MPW* as Rosenthal's account,[45] and to comments by Herbert Brenon, a director for Imp (Universal), who returned from a trip to Europe, claiming:

> As to exhibiting, I think Germany in general and Berlin in particular lead the world. There they are strong for three-hour performances. The programs are balanced...The picture houses in Germany compete with the regular theaters and they charge and get good prices, as high in some instances as $1.00 or $1.50, and range down to 25 cents. The houses are filled. There are magnificent orchestras and splendid projection.[46]

The discrepancy in these accounts can be explained somewhat by a recognition that trade papers produced primarily a discourse of interest rather than a discourse of consistency, and it was in Rosenthal's interest (in a way that it was not in the interest of Brenon, who had other concerns) to argue for the significance of Woods's (and his own) entrance into the German market, an entrance that Rosenthal evidently thought would be bolstered with an image of Woods heroically reforming a backward practice.

Given that his discourse aims at disseminating Woods's success at introducing and cultivating a higher class of theater in Germany, it is a little disorienting to read Rosenthal at the end of the article recognizing the cultural importance of ragtime to the process of Americanizing the entertainment industry abroad.

> Strange as it may seem, I think that the American ragtime is going to help greatly in assuring a welcome to the American amusement caterer. They are ragtime mad in England and on the continent, and the ragtime craze has caused a change of feeling toward all forms of amusement.[47]

The new American feature films, Rosenthal astutely noted, were riding a wave of ragtime, the immense popularity of which was gaining the American films access to theaters whose 'ragtime mad' patrons were demanding or at least much more accepting of American subjects when they shared a program with ragtime.

Rosenthal's invocation of ragtime is surprising in this context because *MPW* and film trade papers in general associated ragtime with the exhibition practice of the old nickelodeons, and *MPW* had been running a campaign since 1909 against the practice of accompanying films with 'eternal' and 'noisy' ragtime,[48] most spectacularly in Louis Reeves Harrison's diatribe, where he memorably termed it 'jackass music'.[49] A retrospective article from early 1912 noted that the previous year had seen a marked shift away from the nickelodeon towards larger, better-appointed theaters. Such theaters distinguished themselves by, among other things, the 'quality' of their music, but the low admission price placed limits on the ambition of any moving picture theater. Prices were often higher in Europe – or at least more variable – and more theaters were large, had orchestras and generally approximated the experience of legitimate theaters. This, at least, was the story *MPW* was interested in telling.

W. Stephen Bush, the state of American exhibition, and a visit to Europe

A higher admission had been a frequent theme of *MPW*, and Bush had been making the case on and off since 1908.[50] A frequent contributor to the paper who later joined the editorial staff, Bush entered the industry in the role of a professional film lecturer, a position that greatly influenced his understanding of the business (Figure 6.1).[51]

First, Bush favored larger theaters with higher admissions. The lecturer depended on a theater being sufficiently large or the price of admission being sufficiently high that potential revenues could cover the additional labor cost. With respect to the economics of exhibition, the lecturer provided labor similar to that of a musician, vaudeville act or singer: the lecturer was an 'added attraction',[52] not necessary to the basic business of showing films as was the projectionist and ticket seller, but such added attractions could nevertheless materially improve the show, resulting in higher receipts.

Second, he favored films that could be enlisted in the progressive project of cultural uplift:[53] 'In judging of the future of the moving picture business it behooves us to take the highest ground possible. Whatever may be the mission, whatever the destiny of mankind, its course is forever upward and not downward.'[54] Too often, Bush argued,

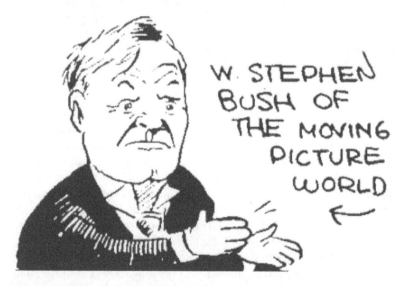

Figure 6.1 Caricature of W. Stephen Bush
Source: *MPW*, 4 March 1916, 1422.

exhibitors aimed too low and so in fact cheated the poor. He also noted that educational films 'helped the exhibitor to secure the moral support of the best classes of the community'.[55] He advocated for educational films and those based on literary sources,[56] both genres that were most conducive to lecturing.[57] Although he often followed the trade in attributing the release of immoral films principally to foreign manufacturers that did not understand American sensibilities, he also strongly defended those foreign films, such as the Pathé Film d'Art and the Italian long features, that he found edifying.[58] Consequently, he generally favored the development of the multireel or long feature, which he saw as a 'clean and wholesome influence'.[59]

Third, he strongly opposed vaudeville and singers of illustrated songs.[60] He always couched this opposition in terms of the values of the moving picture, that the two forms did not mix,[61] casting the live aspect of vaudeville in particular as 'foreign' to the moving picture, even when it was good, and he extended this critique to the illustrated song, even though it was an entertainment form that, like film, was mediated by the screen.[62] Indeed, aside from lecturing, the only added attractions that Bush favored were music and disciplined sound effects.[63] It is hardly coincidental that whereas Bush supplemented his lectures with music and effects, vaudeville and the illustrated song were in essence direct competitors for the money exhibitors might spend on added attractions.

In April, May and June of 1913, *MPW* sent Bush on a major tour around Europe to report on the state of the industry in England, Germany, Italy and France. He visited and sent letters from London, Berlin, Rome, Turin, Milan and Paris, with a brief stop in Innsbruck on the trip from Berlin to Rome, and sent a total of nine reports.[64] The focus of his trip varied by locale. In London and Berlin, perhaps because films from England and Germany were not very competitive in the US market at the time, Bush's reports centered on exhibition, on the luxurious theaters where moving pictures were being screened. In Rome, Turin and Paris, by contrast, he concentrated on the studio production facilities, with much briefer discussions of the exhibition conditions.

England

The first stop on Bush's tour of Europe was London, where he was most impressed with the exhibition in the capital city. Indeed, he opened his inaugural letter trumpeting London as a location American exhibitors should visit to get ideas: 'If you happen to be an exhibitor it might pay you to come and see, and then go back and put your experience into dollars and cents.'[65] He noted that the films on the

114 *The Historical Practice of Silent Film Sound*

program and attention to projection were high, but that these were generally equaled or even surpassed by the best American exhibitors. What distinguished the London theaters was the other aspects of their presentation, especially the quality of the music. One modest-sized theater, he noted, had 'an invisible orchestra, which played music suitable to the pictures... No doubt the music had been carefully rehearsed, as it invariable struck at home at the psychological moments.'[66] Bush compared the exquisite treatment of the music in this theater to the indifferent treatment of music in most American theaters.

> I have a painful recollection of an orchestra in New York engaged in an effort to follow the pictures with suitable music, and frequently coming to a dead stop at precisely the wrong moment, closing, for instance, with a crashing finale just a minute before the climax of the play on the screen.[67]

Bush attributed the higher quality of presentation primarily to higher admission prices (the better theaters charged scaled prices from 25 cents to $2.60 whereas in New York the highest price was 15 cents), longer runs of films (even the cheapest theaters avoided daily changes of pictures), and the exhibitors' full control over programming decisions.

Germany

In Germany, Bush was also impressed by the state of exhibition practices, despite the presence of an intrusive governmental hand. Theater management and the government, he suggested, had been historically much more closely intertwined in Germany than in either the US or Great Britain. 'The great amusement trust in Germany', Bush proclaimed forthrightly, 'is the government.'[68] When moving picture theaters came along, he said, they faced the usual resistance from the regular theaters but the state also had a strong financial interest in those theaters. Government regulation, censorship and especially tax policy made running a moving picture theater a difficult proposition. Taxes, Bush claimed, forced a low admission for many theaters since any admission above ten cents was subject to a substantial levy, and censorship was not only somewhat strict, it was also quite unpredictable. Despite these adverse conditions, moving picture theaters were thriving, Bush suggested, in part because those theaters that maintained higher prices were forced to compete more directly with the legitimate theaters, and those theaters that kept prices below the tax levy were still forced to operate in an

environment of capricious censorship and uncertain distribution rights, which had the effect of discouraging theaters from changing programs too often.

As would be expected, Bush was most impressed by the expensive theaters, especially those in Berlin, which he claimed 'are wonders of artistic architecture and scientific management'.[69] He reserved his highest praise, however, for the musical portion of the show, calling it 'the crowning achievement of the German theater'.[70] In general, German theaters had larger orchestras and better-trained musicians than their American counterparts, and the fact that the program was usually changed only once a week facilitated 'the proper selection and rendition' of the music because the musicians had time to rehearse and fit the music to the picture.

> Orchestras of fifteen and twenty pieces are not uncommon. The musicians are artists led by capable and experienced directors. The slightest detail is looked after. Every important psychological moment in the drama is effectively elaborated by the music and when a climax comes music aids motion in a most acceptable manner. I admired their music for comedies; it always fitted like a glove. No subject puzzles the musical director.[71]

The quality of the music, Bush thought, also went 'a long way to reconciling the public' to the higher prices that German theaters charged.

Italy

Bush's three reports on Italy all emphasized production and other aspects of the business over exhibition, and indeed he began his first report from Rome and closed his final one from Turin noting important production advantages – 'magnificent natural light',[72] beautiful locations steeped in history – that Italy's film companies enjoyed. Bush cautioned, however, that 'the taste of the [Italian] public is decidedly low. Indeed it verges on the morbid and on the vulgar.'[73] Films created principally for the Italian market were therefore difficult to market abroad. Bush in essence crafts a cautionary tale out of the Italian situation. Companies that chose to 'cater for the lovers of the cheap melodrama' struggled to sell their films, even in Italy:[74] 'They cast their lot with the "crowds" in Italy and now they are lucky to sell on an average of three copies in Italy, with an occasional print for the French, Spanish or South American market.'[75] Fortunately, Bush said,

116 *The Historical Practice of Silent Film Sound*

the major Italian producers were aware of the problem and had found success making films for the international market, where there were much larger profits than in the local Italian market. The strategy of these Italian filmmakers, Bush claimed, suggested that producers could make more money pursuing higher quality than giving into lowest levels of popular taste.

Bush found exhibition practices in Italy far more rudimentary than in London or Berlin: 'The average Italian moving picture house compares most unfavorably with the average theater in England, America or Germany.'[76] The theaters, even in a large city such as Naples, were generally small: 'Outside of Rome there are a few moving picture theaters with a large seating capacity, and in Rome there is but one with 1,500 seats.'[77] They also had low admission prices on order with those charged in the US, but the theaters were also dirty, uncomfortable, and lacking in effective ventilation and basic safety regulation. With respect to demographics, 'to an even greater extent than with us, the audiences here consist of women and children'.[78]

Although Bush delivered three reports from Italy and he talked at some length about the exhibition, none of them mentioned the musical aspect of the exhibition practices. He did note that the crowds were boisterous to the point of distraction, especially in Rome and Naples. Given that the theaters were small and the admission price low, it seems likely that he omitted observations on the musical practices because they were simply unimpressive and did nothing to bolster his argument for improving the exhibition practice of American moving picture houses.

France

As with his reports from Italy, Bush's letter from France is dedicated primarily to discussing the studios that he visited. His brief comments on exhibition in Paris make it clear that he found the city's theaters generally deficient. He thought the projection was uneven, was mystified by the long breaks between reels, and noted that 'the service of the attendants and the music fall below the English and German standards'.[79] He described a visit to the 'Colisee' on the Champs Elysées, one of the newer theaters in an upscale part of Paris, where he paid two francs for a 'fair seat', as something of a travesty.[80] He claimed that it was worse, and far more expensive, than many shows on the lower East Side in New York. He was especially appalled by the live acts: 'The vaudeville shown was of the anthropoid variety which prevailed in many sections

of our own country just about four years ago. The cheaper places are correspondingly worse.'[81] Only the Pathé Palace and the Gaumont Palace Hippodrome – 'probably the largest and most successful moving picture theater in the world' – lived up to the city's reputation for fine theaters. Bush described the Gaumont theater thus:

> The theater was well filled on the warm night in June when I visited there. I have seen some exceptionally fine projection in my day and have known many operators who were past-masters in the science of giving good light and a steady picture, but I never saw anything to surpass the projection in the Gaumont Palace. Even the most critical eye could not help being delighted by this picture-steady, always steady, without even the faintest trace of a tremble or a flicker. The most perfect order prevailed in the audience and what there was of vaudeville was tolerably good.[82]

Although Bush praised the projection and even grudgingly accepted the vaudeville, it is perhaps noteworthy that he did not specifically mention the music, especially as the theater had a high reputation for its musical program. Whether this is because Bush did not deem it exceptional compared to his experience in London and Berlin or he did not want to praise the music on a program shared with vaudeville is difficult to say.

Bush's trip through Europe allowed him to articulate once again a vision for American exhibition. His priority was cultural uplift, and by picking and choosing the highlights of European exhibition practices in his letters from abroad, Bush gave American theaters something to aspire to, a challenge to better their European counterparts in exhibition just as American filmmakers increasingly were in production. He highlighted the value in American educational films at home as well as their popularity abroad. He praised the moral sensibilities of the American filmmakers that negated the need for strict censorship. And most importantly with regard to exhibition, he paid close attention to the admission prices in each location, repeatedly noting a correlation between exhibition quality and higher prices.

Notably, exhibition quality was to a large extent determined by the musical program. If theaters wanted to better themselves, then they had to invest time and money in the music and musicians that accompanied their features. In this way, the cinema might promise something more than being an efficient and cost-effective way of

118 *The Historical Practice of Silent Film Sound*

delivering entertainment to its poor. If an aristocratic Europe had historically been the font of western art and culture, this new vision for the cinema was of an uplifting cultural institution capable of addressing the whole of the people, forging a nation through this industrial and most democratic art.

Notes

1. Eileen Bowser, *The Transformation of Cinema, 1907–1915* (New York: Scribner, 1990): 121.
2. James Buhler, 'The Reception of British Exhibition Practices in *Moving Picture World*, 1907–1914', in Julie Brown and Annette Davison (eds.) *The Sounds of the Silents in Britain* (New York: Oxford University Press, 2012): 144–160.
3. Noël Burch, *Life to Those Shadows*, Ben Brewster (ed. and trans.) (Berkeley: University of California Press, 1990): 126.
4. Richard Abel, *The Red Rooster Scare: Making Cinema American, 1900–1910* (Berkeley: University of California Press, 1999).
5. See, for instance, 'Moving Pictures That Talk', *Moving Picture World* (hereafter: *MPW*), 16 March 1907, 24; 'Noted Dramatists to Write Motion Picture Plays', *MPW*, 28 March 1908, 263.
6. 'Statement by George Kleine', *MPW*, 7 March 1908, 182.
7. 'Pimpton Back from Europe', *MPW*, 12 April 1913, 144. See also 'Foreign Trade Notes', 25 October 1913, 369.
8. 'Noted Dramatists to Write Motion Picture Plays', *MPW*, 28 March 1908, 263.
9. Abel, *Red Rooster Scare*.
10. The actual demographics of nickelodeon audiences has been hotly disputed. While it is clear that almost from the beginning the actual patronage of any particular nickelodeon depended greatly on where the theater was located, that nickelodeons were situated in diverse places across cities, and that vaudeville theaters continued to be important sites of motion picture exhibition during the institutionalizing phase of the cinema, it is nevertheless also the case that the nickelodeons in particular were understood at the time and by those writing for trade publications such as *MPW* as the 'poor man's theater' which attracted primarily immigrants, women and children. Highlights of the debate include: Robert C. Allen, 'Contra the Chaser Theory', *Wide Angle* 3/1 (1979): 4–11 and Allen, *Vaudeville and Film 1895–1915: A Study in Media Interaction* (New York: Arno Press, 1980); Charles Musser, 'Another Look at the "Chaser Theory"', *Studies in Visual Communication* 10/4 (1984): 24–44 (see also the ensuing exchange in the journal, 45–52); Miriam Hansen, *Babel and Babylon: Spectatorship in American Silent Film* (Cambridge, MA: Harvard University Press, 1991); Ben Singer, 'Manhattan Nickelodeons: New Data on Audiences and Exhibitors', *Cinema Journal* 34/3 (1995): 5–35; Sumiko Higashi, 'Dialogue: Manhattan's Nickelodeons', *Cinema Journal* 35/3 (1996): 72–74; Allen, 'Manhattan Myopia; Or, Oh! Iowa!', *Cinema Journal* 35/3 (1996): 75–103; and Singer, 'New York, Just like I Pictured It ...', *Cinema Journal* 35/3 (1996): 104–128.

11. The issues are nicely twined in the response to the mayor of New York ordering all the moving picture theaters at the end of 1908. See, for instance, 'Quality Film', *MPW*, 9 January 1909, 30.
12. For one of many articles on this theme, see 'The Importance of Running a Clean Show', *MPW*, 8 August 1908, 100.
13. W. Stephen Bush, 'The Coming Ten and Twenty Cent Moving Picture Theater', *MPW*, 29 August 1908, 152.
14. Bush, 'The Film of the Future, with a Few Remarks on Some Films of the Present', *MPW*, 26 September 1908, 234.
15. Bowser, *The Transformation of Cinema*, 37–52.
16. 'Facts and Comments', *MPW*, 9 December 1911, 792.
17. 'Warner Back from Long Trip', *MPW*, 26 April 1913, 359.
18. Ibid.
19. Bush, 'Lines of Cleavage', *MPW*, 1 March 1913, 865.
20. Carlo Piccardi, 'Pierrot at the Cinema. The Musical Common Denominator from Pantomime to Film. Part III', *Music and the Moving Image* 6/1 (2013): 4–54 (6).
21. Pilar-Morin was playing Pierrot in a New York run of *L'Enfant Prodigue* as early as 1893. Richard DeCordova, *Picture Personalities: The Emergence of the Star System in America* (Champaign: University of Illinois Press, 2001): 43–44; Jon Burrows, *Legitimate Cinema: Theater Stars in Silent British Films, 1908–1918* (Exeter: University of Exeter Press, 2003): 58–59.
22. DeCordova, *Picture Personalities*, 44. *MPW* featured her several times during 1910: 'The Future of the Silent Drama', *MPW*, 22 January 1910, 84–85; Pilar-Morin, 'Silent Drama Music', *MPW*, 30 April 1910, 676; Thomas Bedding, 'The Wordless Play and the Silent Drama', *MPW*, 13 August 1908, 342; Bedding, 'The Wordless Play and the Silent Drama. Second (and Concluding) Article', *MPW*, 10 September 1910, 565; and 'Mme. Pilar–Morin', *MPW*, 23 September 1910, 682.
23. Pilar-Morin, 'The Value of Silent Drama', 682.
24. 'Mme. Pilar Morin', *MPW*, 18 March 1911, 591; Robert Grau, 'A Vital Question Answered', *MPW*, 8 April 1911, 757.
25. Burrows, *Legitimate Cinema*, 59.
26. As evidence of the foreign gesticulating body, Burrows, *Legitimate Cinema*, 59–60, cites the following passage, which he attributes to Louis Reeves Harrison, though the article carries no byline:

> The fact of the matter is that it is the very infrequency and simplicity of the gesture that gives it effectiveness. When we see two Frenchmen or Italians gesticulate we take small notice, because we are accustomed to see the Latin races go through a perfect fury of gesticulation over nothing in particular. The gestures of Americans, or Englishmen for the matter of that are on the contrary, pregnant with meaning, because the whole man has to be charged with the tensest emotion, before he seeks to give it utterance by gesture.
>
> ('The Eloquence of Gesture', *MPW*, 4 November 1911, 357)

Although this article invokes pantomime and distinguishes movie acting from it, it never directly links up pantomimic acting with the apparent 'fury of gesticulation' of French or Italian actors on film.

120 *The Historical Practice of Silent Film Sound*

27. 'Actresses Must Be Young', *MPW*, 27 December 1913, 1556.
28. On this point, see Burrows, *Legitimate Cinema*, 53–56.
29. Bush, 'The Bliss of Ignorance', *MPW*, 11 October 1913, 132.
30. Grau, 'A Vital Question Answered', 757.
31. 'Fact and Comments', *MPW*, 16 September 1911, 772.
32. ' "Sumurun", the Wordless Play', *MPW*, 3 February 1912, 373.
33. Bush, 'The Miracle', *MPW*, 2 November 1912, 443. Many of the ads for the film carry notice that special music has been composed for the production and a short notice in *MPW* states that the music has been completed and another notice that special music had been performed to the film in Cleveland. The composer may have been Ernst Luz, music columnist for *MPW*'s primary trade paper competitor, *The Motion Picture News*, as he is named as having prepared a score for the film for a performance in Baltimore ('The Miracle at Baltimore', *MPW*, 1 February 1913, 441). Throughout, the distributor's ads for the film are coy, since it was playing on confusion with Reinhardt's London production, and a film version of the latter was about to be released as well. The result was a well-known court case that required a name change for the Continental-Kunstfilm version, which became *Sister Beatrice*.
34. Bush, 'Reinhardt's Miracle', *MPW*, 1 March 1913, 868.
35. Though Bush says Humperdinck's score was used for the Park Theater performance, *MPW* carried several short notices that special music had been arranged for it, with no indication of who composed it.
36. Anderson also points out that pantomime remained an elevated theatrical form in the US into the 1920s ('The Musical Common Denominator in Pantomime and Film in the United States', paper delivered at *Music and the Moving Image Conference*, New York University, 31 May 2013).
37. See, for instance, 'Facts and Comments', *MPW* 2 September 1911, 604; 'Facts and Comments', *MPW*, 21 September 1912, 1152.
38. Issues with American exhibition practices could, however, still be blamed on 'foreigners'. In an article discussing a wave of moral panic following a report from the Society for the Prevention of Cruelty in 1913, Bush argued for self-policing by exhibiters:

> It is their duty and the duty of the organized exhibitors to drive these black sheep out of business. As a rule they are foreigners who have but recently come to this country and who are utterly insensible to any moral reproach or appeal. They understand neither the law nor the language of the country and have not the slightest conception of their responsibilities. It is greatly to be deplored that these men have it in their power to discredit the reputable majority, but there can be no doubt about the fact. The influence of the organized exhibitors ought to be exerted against such men.
>
> ('Danger Ahead', 12 April 1913, 140)

39. 'Full Dress and Kinematograph in Germany', *MPW*, 1 October 1910, 745.
40. Ibid.
41. Older historians, such as Robert Sklar, seem to have taken the writing of trade papers like *MPW* at face value, arguing that the cinemas in Berlin were ahead of those in the US until Rothapfel appeared in New York City, *Movie-Made*

America: A Cultural History of American Movies (New York: Random House, 1975): 45. *MPW* was certainly interested in suggesting that American exhibition, especially in New York City, was lagging behind Europe. Miriam Hansen had already complicated this story for Germany in 'Early Silent Cinema: Whose Public Sphere?' *New German Critique* 29 (1983): 162ff., especially n. 27.

42. 'An American in Berlin', *MPW*, 31 May 1913, 924.
43. Ibid.
44. 'Plimpton Back from Europe', *MPW*, 12 April 1913, 144.
45. Bush, 'Conditions in Germany', *MPW*, 31 May 1913, 924. This article will be considered in more detail below.
46. 'Herbert Brenon Returns from Europe', *MPW*, 8 November 1913, 615.
47. 'An American in Berlin', 924.
48. The Chicago representative, probably John Bradlet, was particularly hostile towards ragtime: Our Western Representative, 'Notes from Chicago', *MPW*, 13 March 1909, 300; 'Chicago Notes', 26 February 1910, 293; 'Chicago Notes', 12 March 1910, 379; 'Chicago Notes', 26 March 1910, 465; 'Chicago Notes', 23 April 1910, 650; 'Chicago Notes', 4 June 1910, 947; J[ohn] M. B[radlet], 'A Miserable Show', *MPW*, 10 September 1910, 583.
49. Louis Reeves Harrison, 'Jackass Music', *MPW*, 21 January 1911, 124–125. Despite its title, Harrison's article is actually more concerned with inappropriate sound effects than with inappropriate ragtime.
50. Bush, 'The Coming Ten and Twenty Cent Moving Picture Theater', *MPW*, 29 August 1908, 152–153; 'Higher Prices Are Possible', *MPW*, 14 December 1912, 1058.
51. For a brief overview of Bush's work at *MPW*, see Richard L. Stromgren, 'The Moving Picture World of W. Stephen Bush', *Film History* 2/1 (1988): 13–22.
52. Bush, 'The Added Attraction', *MPW*, 18 November 1911, 534–535.
53. Bush, 'Suggestions to a Worried Critic', *MPW*, 9 December 1911, 794–795.
54. Bush, 'The Film of the Future', 5 September 1905, 172.
55. Bush, 'Lines of Cleavage', *MPW*, 1 March 1913, 865.
56. Bush, 'A Word of Good Cheer to All Friends of the Moving Picture', *MPW*, 26 March 1910, 462; idem, 'Simplifying the Teaching of History', *MPW*, 21 October 1911, 199; idem, 'Bernhardt and Rejane in Pictures', *MPW*, 2 March 1912, 760.; idem, 'The First Moving Picture Library', *MPW*, 23 November 1912, 751–752; idem, 'History on the Screen', *MPW*, 22 February 1913, 757; idem, 'A Survey of the Educational field', *MPW*, 9 August 1913, 64; idem, 'Educational Catalogues – I', *MPW*, 25 October 1913, 357; idem, 'Educational Catalogues – II', *MPW*, 8 November 1913, 589; idem, 'Educational Catalogues – III', *MPW*, 15 November 1913, 713.
57. Bush, 'Special Lectures on Notable Films', *MPW*, 8 January 1910, 19.
58. Bush, 'Dante's Divina "Commedia" in Moving Pictures', *MPW*, 8 July 1911, 1572–1573; idem, 'A Great Epic in Moving Pictures', *MPW*, 15 July 1911, 14–16; idem, 'Dante's "L'Inferno" ', *MPW*, 29 July 1911, 188–189.
59. Bush, 'Do Longer Films Make Better Show?', *MPW*, 28 October 1911, 275; idem, 'New Functions of the Motion Picture', *MPW*, 6 July 1912, 21; idem, 'Feature Programs', *MPW* 9 November 1912; idem, 'The Future of the Single Reel', *MPW*, 19 April 1913, 256.

122 *The Historical Practice of Silent Film Sound*

60. Bush, 'The Misfit Amusement Parlor', 17 October 1908, 296–297; idem., 'The Human Voice as a Factor in the Moving Picture Show', *MPW*, 23 January 1909, 86; idem., 'The S.P.C.V.', *MPW*, 23 January 1909, 89–90; idem, 'A Waste and a Danger', *MPW*, 22 July 1911, 105.
61. Bush, 'The Misfit Amusement Parlor', 297; 'A Waste and a Danger', 105.
62. Bush, 'Some Timely Observations', *MPW*, 17 February 1912, 558.
63. Bush, 'Lectures on Moving Pictures', *MPW*, 22 August 1908, 136–137; idem, 'The Coming Ten and Twenty Cent Moving Picture Theater', 152–153; idem, 'Hints to Exhibitors', *MPW*, 24 October 1908, 317; idem, 'The Human Voice as a Factor in the Moving Picture Show', *MPW*, 23 January 1909, 86; idem, 'Giving Musical Expression to the Drama', *MPW*, 12 August 1911, 354–355; idem, 'Possibilities of Musical Synchronization', *MPW*, 2 September 1911, 607–608; idem, 'When "Effects" Are Unnecessary Noise', *MPW*, 9 September 1911, 690; idem, 'Music and Sound Effects for Dante's Inferno', *MPW*, 27 January 1912, 283–284; idem, 'The Picture and the Voice', *MPW*, 2 November 1921, 429.
64. The series of articles are as follows: 'Yankee Films Abroad', *MPW*, 10 May 1913, 573–574; 'British Censorship', *MPW*, 17 May 1913, 683–684; 'Americans Win on Quality', *MPW* 24 May 1913, 788–789; 'Conditions in Germany', *MPW*, 31 May 1913, 899–901; 'How Our Films Educate Abroad', *MPW*, 7 June 1913, 1005; 'Notes from Italy', *MPW*, 21 June 1913, 1229–1230; 'Jottings from a Motion Picture Notebook', *MPW*, 28 June 1913, 1337–1338; 'Italy's Film Center', *MPW* 5 July 1913, 25; and 'The Film in France', *MPW*, 12 July 1913, 179–181.
65. Bush, 'Yankee Films Abroad', 573.
66. Ibid.
67. Ibid.
68. Bush, 'Conditions in Germany', 899.
69. Ibid.
70. Ibid.
71. Ibid., 900.
72. Bush, 'Notes from Italy', 1230.
73. Ibid., 1229.
74. Bush's second letter from Italy suggested that the theaters in the country played predominantly crude melodramas. See 'Jottings from a Motion Picture Notebook', 1337.
75. Bush, 'Notes from Italy', 1229.
76. Ibid., 1230.
77. Ibid., 1229–1230.
78. Bush, 'Jottings from a Motion Picture Notebook', 1337.
79. Bush, 'The Film in France', 179.
80. Ibid.
81. Ibid.
82. Bush, 'The Film in France', *MPW*, July–September 1913, 179.

7
Musical Beginnings and Trends in 1920s Indian Cinema

Olympia Bhatt

Introduction

In the decade of the 1920s, when sound was beginning to be incorporated as part of the cinematic apparatus, most historical accounts observe an aesthetic rupture as silent films made the transition to talkies. This rupture is highlighted as a discontinuity in visual aesthetics as films moved away from pure visual representation. In these accounts, theater became a defining paradigm for incorporating sound within the cinematic frame and providing actors, writers, singers and others for this new need that had arisen. Wherever the form had already stabilized, any new elements in the technological apparatus could easily be explained in terms of its assimilation in the new form. Take the case of the American film industry: this moment of interruption, when new sound recording technologies were being incorporated in the mode of production, is historicized as the period when sound is adapted and stabilized in the classical narrative form, the form which had already become an industry standard by the late teens. But what about film industries where the form was still in the process of being imagined and realized, as in the case of Indian silent cinema? Critics like Ashish Rajadhyaksha[1] attribute the development of a neotraditional cinematic form to the ongoing negotiations between local aesthetic and modern technologies of representation. These negotiations developed alternative contexts, with new technologies of sound like the gramophone and radio becoming prominent in the 1920s. The large presence of theater producers in the film industry in the same decade makes for a convenient argument for how sound in films directly borrowed from different theater practices. Theater's immense influence on early talkies cannot be easily dismissed, but establishing an easy correlative between the

124 *The Historical Practice of Silent Film Sound*

two leaves little scope to examine the role of these new technologies in the complex aesthetic, moral and social economy where music was an important commodity for exchange. Music in the 1920s was central to debates about nation and tradition even as it was becoming a popular form with its growing commodification.[2] This is the period when sound-reproducing technologies participated in the fluid cultural ethos as a public culture of listening was being defined where music had a dominant presence at the level of discourse and in these new technologies of representation. Instead of examining the music of theater as a source of influence on cinema in this period, I would like to contextualize music as part of a dynamic public sphere where theater and cinema participated in its constant characterization. This framework will also reconceptualize the relationship of the sound practices of silent cinema and the talkies in terms of continuity instead of disruption. I will examine how the reform movements around Hindustani music directly influenced new representational forms like cinema and gramophone music and draw a possible connection between silent films made in the Bombay Presidency and its 'residual history' – to borrow a term from Raymond Williams – that influenced the talkies that emerged by the end of the decade.

Music became an important part of the public cultural sphere at the beginning of the 20th century. Indian music was undergoing an institutional and aesthetic transformation, as post-Enlightenment aesthetic categories became important criteria to develop local paradigms for both musical theory and performance. There was also a growing presence of marching bands and other traveling performers who brought different forms of Western music and instruments to India towards the end of 18th century.[3] The public sphere was getting defined by the kind of music that was considered acceptable and appropriate for performance. The Habermasian notion of a unified bourgeois public sphere had not completely uprooted traditional and indigenous forms of transaction. The local bazaar remained a crucial site that continued to mediate and connect the global economy to the rural hinterland in the country and had a prominent influence on the aesthetic and political economy of the period. The bazaar was also where new representational and sensuous technologies were first encountered and later adapted for local forms of representation.[4] Though the bourgeois desire for a unified moral cultural space became influential in shaping the new urban centers, the Indian public sphere was a dynamic site which was simultaneously literary, aural, visual and dramatic.[5] This public sphere is the backdrop of the ongoing reformation of music by Vishnu Bhatkhande and Vishnu

Paluskar, and the growing hegemonic presence of Indian music as part of new technologies like cinema. Before focusing on the developments in music in the 20th century, the historical transformation of music that began in the 19th century will be addressed.

Indian music and reform in the 19th century

The earliest writings on Indian music began as part of an imperialist anthropological and archaeological study of local musical forms and theory. This colonial interest in Indian music began primarily for two reasons: first, Orientalists like William Jones considered Indian music as the missing link to the harmonic music of ancient Greece;[6] and second, music became an anthropological subject of enquiry for administrative reasons. Music in the 18th and 19th centuries was mostly performed in courts or temples as part of an older patronage system. Colonial writers like William Jones, Robert Kyd, Augustus Willard and others tried to understand Indian music and correlate it to the rigours and framework of Western classical music. Indian music is different from the textual approach of Western classical music; it works with a raga-based framework involving a musical theme and a structure whose chief element is rooted in improvisation and performance. Though the Orientalist perspective was the initial point of enquiry, the ethnographic approach soon became the predominant approach to understanding Indian music as part of a cultural milieu of 'Hindoo' religion and civilization.

Most of the early writers of Indian music were army officers, travelers and civil servants, and the paradigms of Western classical music became their framework to invariably gauge the 'deficiencies' of Indian music. Their twin concerns were the absence of a notation system which enables musicians to read the music being performed, and the moral and behavioral concerns that arose from the lifestyle of the performers and musicians. For some writers like C.R. Day, the absence of notation implied that Indian music was at an inchoate state of development and that its teleological progression would eventually lead to something akin to Western classical music. Janaki Bakhle mentions how these writers missed the civilizational complexity of Hindu/Muslim identity in their writings and often denounced the eroticized devotional elements or the lifestyle of performers with a tone of Christian moral outrage.[7] N. Augustus Willard in his *A Treatise on the Music of India* (1793) focused on the behavioral and psychological issues associated with music. He mentions drunkenness as being encouraged in Indian music and a major cause of a weak sense of social responsibility in Indian society, as the

126 *The Historical Practice of Silent Film Sound*

lyrics of the songs encouraged practices like polygamy and child marriage. Willard misunderstood the devotional metaphor of intoxication (*Mast/Madhura*), which is a crucial representational technique in *Bhakti* and *Sufi* music and poetry.

These colonial critiques were addressed by the locals to create a space for Indian musical practices in the emerging colonial discourse. The issue of notation was taken up by the Music Appreciation Societies, which became popular among the rising middle class in upcoming towns and cities like Bombay, Pune and others around the mid-19th century. Societies such as Pune Gayan Samaj (PGS, founded in 1874) and Gayan Uttejan Mandali (GUM, founded in 1870) addressed the concerns of colonial writers, and their criticism of the lack of notation systems in Indian music was theorized and argued in different ways. By the end of the 20th century, a lot of writings were produced that either refuted the claims of the colonialists by historicizing the prevalence of notation in Indian music, which had been lost over a period of time, or opposed the system of notation completely and were proud that Indian music resisted it. Teaching music through Western notation and various self-help books on learning the basics of Indian music became very popular during this period. These texts were rarely referred to by the traditional performers, but served the purpose of educating the emerging middle-class audience whose expectations and demands from the performers were very different from those of the traditional audience.[8] Furthermore, these new texts on music also played a major role in educational reform in the 19th century, especially for women's education. Kaikhushroo Naoroji Kabraji, founder of GUM, and other such reformers considered music to be a respectable aesthetic form that needed to be reinvented in order to become part of bourgeois modernity; music training for bourgeois women would make them ideal companions for their Western-educated husbands. According to Kabraji, this process of reinvention would allow 'respectable' women to enter the public sphere, which was occupied by *baijis* who, in spite of their vast musical knowledge, were women of ill repute. *Baijis* were female performers with music and dance as part of their repertoire who were previously maintained by royalty along with other musicians.[9] With the loss of their patronage system, their sites of performance shifted from the courts to the urban salon and their new clientele included landlords, the urban middle class and Anglo-Indians who were all part of the emerging urban milieu. Towards the end of 19th century, their aesthetic and social status became a subject of moral scrutiny; their musical repertoire was marginalized by the emerging classical discourse

while their independence and inability to fit into a socially acceptable and normative patriarchal role made them subjects in need of social reform. Interestingly, these female artists would return to the debates around music and performance and would be responsible for popularizing a musical style, which became a dominant source of influence for cinematic sound.

Cinema's beginnings in India

While the discussions and issues around Indian music were being addressed, many experiments on motion photography were also finding success in public exhibition. In 1895, the Lumière brothers exhibited ten short films made with the cinematograph at Salon Indien du Grand Café in Paris. The novelty and success of their new apparatus ensured that their films found wider audiences across the world. The brothers trained others to operate the cinematograph and sent them to different parts of the world to exhibit as well as produce films on location, which would be screened later. Marius Sestier, one such trained operator, was given the responsibility of screening the cinematograph films in India and Australia.

On 7 July 1896, the Lumière films were screened at the Watson Hotel in Bombay. The local newspapers described the cinematograph as 'the marvel of the century' and 'the wonder of the world', and the local response to the films was extremely enthusiastic.[10] Buoyed by the success of the initial screening, Sestier booked another venue, the Novelty Theater, while newspapers explained how the cinematograph worked.[11] Initially, film screenings were part of stage shows as a novelty attraction and towards the end of the century Indians ventured into filmmaking. Hiralal Sen, a local photographer, shot scenes from a stage show for his film *The Flower of Persia* (1898) while Harishchandra Bhatavdekar made a film called *The Wrestlers* (1899) based on a wrestling match held at the Hanging Gardens in Bombay and which is claimed to be the first documentary film made in India. In the first decade of the 20th century, imported films continued to be a large part of the films screened in the country as different exhibitors and inventors scrambled for a foothold for their new apparatus in the available markets worldwide. When Dadasaheb Phalke made his first feature film, *Raja Harishchandra*, in 1913, film exhibition was slowly establishing itself in colonial India, with Bombay city leading with four theaters while Rangoon and Calcutta had one each. Further, there were 70 touring cinema companies, which brought cinema to the rest of the country.[12]

128 *The Historical Practice of Silent Film Sound*

For the initial couple of decades, the Indian encounter with cinema is aptly described as a 'cinematograph performance' bound to the institution of film exhibition comprising the machine, the films shown, the site of exhibition, the commercial company owning the machine and the audience.[13] Cinema-going and -viewing had yet to become an intrinsic part of the urban experience as it was tied to the traveling showmen who brought different cinematograph machines and films along the trade circuits of the world. In the 20th-century teens, the local film industry was slowly gaining a foothold in Bombay Presidency, which was further consolidated in the subsequent decade, especially when cinema halls came under the direct control of film-producing companies.

Music reform in the 20th century

The issue of music reformation continued in the 20th century as the two pioneers, Vishnu Narayan Bhatkhande (1860–1936) and Vishnu Digambar Paluskar (1872–1931), attempted not just to address the colonial critique of Indian music, but also to create a 'modern' classical tradition for an imagined nation. Their contribution to the development of Hindustani music is immense and impossible to cover in its totality in this chapter. Rather, my heuristic approach would argue that this reformist streak was an important reason that led to music's hegemonic presence in determining the soundscape of all modern representational media.

Even though Bhatkhande and Paluskar were driven by the same impulse of reforming Hindustani music, they took completely diverse routes to address the issues that had arisen. Being a student at GUM, the musicologist Bhatkhande was already part of the ongoing reformation of music in India. He traveled all over the country as part of his ethnographic search to create a rational discourse around Indian music based on a 'textual authority' which would underscore the formal education of a musician. His biggest contribution to the development of Hindustani music was the development of a *thaat* system to classify different ragas in his four-volume compilation *Hindustani Sangeet Padhati* (compiled 1910–1935). Today, this text has become a major theoretical work in the formal training of students learning Hindustani music at university. He insisted on keeping music away from religion and believed classicization was instrumental for the creation of a 'modern' music for the new nation. According to Bhatkhande, this process would involve setting up institutions with a centralized and standardized approach to teach

music and would replace the archaic through contemporary method of imparting musical education in the *gharana* system. Bhatkhande's reformative zeal emanated from his desire to open up an extremely secretive nepotistic music educational system and has to be contextualized in terms of both the reformative discourse and marginalized artists like the *baijis*. *Gharanas* were different music schools that emerged around the performance style of a musician, mostly men patronized by the royal courts, who ensured through exacting standards of oral training that it continued among the disciples. The musicians of a particular *gharana* usually belonged to the same family as very few outsiders or women were chosen for training. The *gharana* system rarely acknowledged *baijis* or any female singer as part of their formal setup, and these women would also trace their musical lineage to an *ustad/guru* (maestro) of a particular *gharana* and not the *gharana* itself. This relationship is explained as driven by pragmatic rather than esoteric concerns of musical training. The *ustad* ensured that his female protégés acquired sufficient training for subsistence so that they continued their profession as 'highly skilled "entertainers" practicing a refined art'.[14] After acquiring a certain level of proficiency, these *baijis* would 'collect compositions' from other maestros which ensured a multilingual oral/aural intertextuality in their musical repertoire.[15]

Bhatkhande's concern for the modern was shaped by his perception of contemporary musicians whom he considered as artisans and craftsmen to provide information about musical performance, which needed interpretation from musicologists like him. His reform concerns are determined by his presumption of a 'Great Tradition' being threatened with dilution, variation and complete disappearance in the improvisational approach of these musicians. His growing desire for standardization and control of musical pedagogy was in response to the immense proliferation and popularization of music, especially when these maestros were vying for their performance style and technique to find acceptance in the modern discourse.[16] He also did not deem female musicians as worthy of the slightest attention, and their absence in his interviews and records is testimony to this. One reason is that the music and eclectic performance style of the *baijis* was already a marginalized form in the traditional hierarchy of music that Bhatkhande neither questioned nor challenged.[17] However, they made a comeback by adapting their performance and singing style for new recording technologies. Women musicians were the first to become technology-savvy in the 20th century and the reasons behind this could be attributed to the other strain of musical reform initiated by Vishnu Paluskar.

130 *The Historical Practice of Silent Film Sound*

Paluskar also wanted to modernize Hindustani music even though his approach to pedagogy and performance involved different meanings and methods. Paluskar, unlike Bhatkhande, was a musician who successfully established an institution for music, Gandharva Mahavidyalaya (GMV) in Lahore, in 1901, which soon also started up in other parts of the Bombay Presidency. GMV followed the traditional pedagogy of *gharanas*, where most of the instruction remained oral and the maestro was the unchallenged authority on music. These schools were also responsible for training music teachers, whom Paluskar imagined as instructing others all over the country and truly institutionalizing his pedagogical approach. One of the pivotal points of his musical agenda was to encourage women to be part of his program, and he was successful in getting them to enroll in his schools. His apparent concern for music was that it was being nurtured by illiterate Muslim singers whose emphasis on the erotic element (*shringar ras*) in their music was weaning it away from the *bhakti* (devotional) traditions of Hindustani music which, according to Paluskar, was its true purpose. His emphasis on women from the Maharashtrian middle class learning classical music was based on the belief that these new aural skills would aid them in their daily religious rituals as well as prevent their husbands from visiting the *baijis*, a concern which was raised by Kabraji before. His primary concern for reform was to bring together religious devotion and music performance that would heighten its appeal among the rising middle class. Paluskar's project managed to succeed as it introduced a new tenor into the discourse of Hindustani music even though it did not radically change the traditional status quo. His reformation of music has to be understood as a continuity of religious reformation that had begun in the 19th century. It allowed performers, especially women, to enter this public sphere, whereby they maintained their respectability by adhering to the new expectations defined by Paluskar and his demands for the sacralization of music performance.

Even as both Bhatkhande and Paluskar set out to modernize traditional practices, their framework for music ignored alternate possibilities of meaning in the contemporary system of Hindustani music. These two reformers merely addressed a few of the bourgeois concerns, which soon became central to the discourse of music in India. However, the traditional performers who were neglected in this very Hindu nationalist project adopted new metonyms of the modern that ensured the survival of their performative space and ethos as an alternative to bourgeois-defined modernity. The new sensuous technologies of gramophone and cinema gave them access to the commodity economy

with means for mass cultural production. The remaining section of this chapter will propose an alternative to the reformist paradigm, where the bazaar becomes the site of an alternative encounter and interpretation of the modern even as its economic and popular networks were sought by the modern bourgeois reformists as well.[18]

The *baijis* were marginalized by the classical discourse of Bhakhande while Paluskar's approach to Hindustani music was setting the tone for its performance. The new breed of performers trained at GMV and music teachers were changing the musical repertoire and performance space of Hindustani music. The *baijis* could either accept the new performance standard or find new ways to respond to these changing demands. These singers responded by adopting new modes of self-representation, which allowed them access to the modern and granted another kind of legitimacy. They were the first to respond to new recording technologies of gramophone and cinema, and quick adoption of these mass-mediated forms was part of a self-fashioning in order to become relevant in the new aesthetic and social economy. They changed and adapted their repertoire to the demands of the new technology, thus allowing their method and style a mass circulation and popularity that also affected emerging aesthetic forms such as cinema. Their presence in shaping the song format for the gramophone record as well as the way their performance is reflected in the background score of a silent film will be further explored.[19]

Music and silent film exhibition

The first film screening of the Lumière cinematograph at the Watson Hotel did not have any musical/instructional accompaniment. However, this mode of exhibition did not last for long as background sound effects and music became an important part of early cinema in India. Sound became part of silent films, as film viewing moved to permanent sites of exhibition where music was an important accompaniment added to the film-viewing experience.[20] Music in silent cinema was introduced to impose an order of spectatorial behavior on a noisy fidgeting audience.[21] Some of the subsequent screenings of the Lumière films had added background music under the direction of a certain F. Seymour Dove.[22]

Different kinds of theaters catering to different classes sprang up in and around the port town of Bombay as film exhibition became part of the urban leisure economy and growing commerce during the First World War. In addition to films, each theater developed different

132 *The Historical Practice of Silent Film Sound*

modes of appealing to its clientele, and background music and variety entertainment became additional attractions. Some of these theaters, like the Excelsior and the Empire, were plush picture palaces catering to Europeans, Eurasians and upper-class Indians while others, like the Royal Opera House, which opened in 1915, became sites where Western and Indian popular culture converged and featured music-hall entertainment, Parsi theater and imported cinema. Both Indian and Western music were played as part of a film's background score. Some theaters had their own orchestras led by European and Indian conductors to accompany film shows; the orchestra at the Empire included a local conductor, J.P. Da Costa, who was in charge of the music for the film version of *La Tosca*.

The theater owners preferred musicians who could read and play Western music. One of the silent film musicians trained in Western music, Joseph Nazareth, also noted the presence of Indian musicians as silent film accompanists. He mentioned tabla and harmonium players as accompanists to silent films:

> Douglas Fairbanks' sword fencing fights in the silent *Don Juan* were accompanied by blazing rolls on the *tabla*, while the harmonium players, for their part, tried to supply rapid *taans* in *ragas* to suit the climactic end of these blood-curdling fights.[23]

In the ongoing debates around music in the 20th century, the provenance of these musicians playing Indian music gives interesting insights about the possible shared spaces of music and the marginalized *baijis*. Further, the kind of instruments that became de facto part of silent film music can be explained in terms of their presence in other spaces. The songs of the *baijis* were usually accompanied by musicians playing the sarangi, tabla, harmonium, esraj and mandira (cup-shaped cymbals)[24] during a song performance, while a dance performance like Kathak included music from the tabla, shehnai and tanpura.[25] Both these instruments – the harmonium and the tabla – had a specific role in the ensemble and their ambivalent status allowed for a successful transition to silent film exhibition. No other Indian musical instruments have been mentioned or encountered in the accounts of music in silent cinema in India. The Indian harmonium was a hand-pulled derivation of the European reed organ and both featured in silent film exhibition. Eminent filmmaker Satyajit Ray recounts his childhood experience of watching silent films in the city of Kolkata. He mentions one of

the Madan theaters – Madan Theatres was a film production company that also controlled a chain of movie theaters – with a Wurlitzer organ that was used to reduce 'the noise of the projector while heightening the drama on the screen'.[26] The hand-pulled version of the organ was adapted in the 19th century to suit Indian musicians who performed seated on the floor. However, it was perceived as foreign by music reformers, and its presence and role in the emerging discourse of Hindustani music was quite controversial. Colonial writers like E. Clements proposed the harmonium as a substitute to the sarangi as a Western-based instrument could initiate the process of mapping Indian music to an unmodified notational system of Western classical music.[27] Further, its close association with theater and the salon diminished its appeal in the institutionalization of Hindustani music. Interestingly, the harmonium was also used to teach members of the stage who came to learn music at Paluskar's GMV. It found an easy acceptance in the salons of the female musicians, where it became an added accompanying instrument as it enhanced the melodic structure of their performance without hindering their eclectic singing style. Though Bhatkhande had serious misgivings about the harmonium, today it has become one of the instruments on which to learn and practice the 'reformed' Hindustani classical music.[28] It is easy to learn and loud enough to provide a drone in a concert hall, which is an important factor vindicating its presence in the silent film screenings.

The other instrument that has now become part of the classical music ensemble is the tabla. In Hindustani music, the tabla provides the rhythmic structures and patterns for the performance of a raga. Interestingly, tabla players were at the bottom of the traditional musical hierarchy and by and large shared this status with female musicians.[29] So their ready acceptance of new spaces of performance such as film theaters is not surprising. Though performing for a film would have been a very different experience for these *ustads*, their training as part of the *baiji* ensemble helped them in working in tandem with the action of the film. They usually provided accompaniment to the stunt genre that needed rapid improvised playing for the quick-paced action in the film. In this new kind of performance, the filmic visual replaced the song of the *baijis* and became the new site that needed rhythmic accentuation. The marginalized artists of Indian music found another space for expression in silent cinema as they localized the experience of witnessing a new kind of visual technology. The exigencies of cinema were fulfilled by local music as it found diverse circuits and means of expression.

134 *The Historical Practice of Silent Film Sound*

Baijis and gramophone: Shaping the sound of the talkies

Indian music was witnessing another kind of transformation at the beginning of the 20th century as gramophone recording companies made their foray into recording Indian music. In the 19th century, travelers from Europe would often bring a gramophone, which was considered a luxury possession by the Indian elite. The commercial viability of the phonograph grew in India as the Mutoscope Biograph Company established its office in Calcutta in 1901. Recording on wax also began in the same year, which allowed for easy duplication and led to the rising popularity of the gramophone.[30] A year later, the Gramophone Company representative F.W. Gaisberg traveled to India to record 'Hindoostani airs'. As mentioned above, the emerging discourse of Indian music marks the transition from traditional sources of patronage, the courts and the temples, to bourgeois spaces of modernity. With the rise of urban centers, new sites of performance such as the salon, the theater and the recording studio had emerged that not just changed the milieu of the audience, but also increased the accessibility of music as a source of popular entertainment. Further, new technologies of photography and recorded sound turned Indian music and musicians into saleable commodities.[31] In 1908, a local factory was set up in Beliaghat Calcutta to develop gramophone records, for which demands grew further in the 1920s when the influx of cheap Japanese gramophone players began in the country.

The gramophone technology was first embraced by the courtesans who eventually had a crucial role in determining the soundscape of the talkies. The cloistered pedagogical system in a *gharana* made its musicians less receptive to this new technology. There was a constant fear that their voices were being recorded in order to steal their technique. Another reason that the gramophone was received with much suspicion was that it was seen as a foreign apparatus with no connection to India or Indian musical traditions. Not surprisingly, then, that the earliest singers recording for the gramophone were women, whose music, though popular, was largely marginalized in terms of the emerging discourse and practice of music in the 20th century. Their repertoire of *ghazal*, *thumri* and *dadra* was considered 'light or semiclassical' and 'the other' of the 'classical' forms, *dhrupad* and *khayal*. The liminal space of these musicians and their music did not stop them from recording the different genres from their own repertoire or classical forms like the *khayal*. The first gramophone recording of *khayal* was by a Calcutta courtesan named Gauharjaan, who adapted it for

the three-and-a-half-minute format of the 78 rpm record. In the new mass-mediated format of her *khayal* rendition, Gauharjaan emphasized the pre-composed parts over the improvised ones and ended with a flourish-like declaration: 'I am Gauharjaan'. These artists' records were sold as by amateur artists in order to disassociate their bazaar provenance and to establish them anew in the bourgeois moral economy.[32] The technology of the gramophone had an important role in determining the format of the film song and performance, and when silent cinema adopted sound recording technology, the 'status' of the singing female actor became a constant source of concern. The cinema journals that emerged at the cusp of this technological transition constantly put forth these concerns about how songs in Indian talkies had upset any scope of 'intelligent' or 'respectable' cinema. Interestingly, the immense popularity of talking films in the 1930s is a result of the localization of sound technology through songs. There is also a stylistic continuity in the early gramophone records and film songs as some of these courtesans opted for the new profession of film actress.[33] Further, the nasal voice of the female singers became a ubiquitous expectation from all singing actors, male and female, and the earliest talkie songs testify to this fact.

Conclusion

This chapter has tried to establish a continuity in the discourse of Indian music as it was being heavily determined by new contexts of reform and forms of mass circulation. The emergence of sound as part of silent films and later talkies is heavily shaped by these shifts in the categorization and perception of music. In other words, music becomes an important unifying link that could help understand the quick and sudden transition to the musical format in the talkie films produced in India. The marginalized figure of the *baiji* returns with new identities and a popularity that takes recourse to an alternative interpretation of the modern that is responsible for creating the musical form of the talkies which has become unique to and ubiquitous in Indian films.

Notes

1. Ashish Rajadhyaksha, 'The Phalke Era: Conflict of Traditional Form and Modern Technology', in Tejaswini Niranjana, P. Sudhir and Vivek Dhareshwar (eds.) *Interrogating Modernity: Culture and Colonialism in India* (Calcutta: Seagull Books, 1993): 47–82.

136 *The Historical Practice of Silent Film Sound*

2. The term 'music' here refers to what is now called Hindustani music. In the context of this paper, Hindustani music and Indian music will be used interchangeably.
3. One important example is the indigenization of the violin in Carnatic music whose extensive history and evolution in the country is documented by Amanda Weidman. See Amanda J. Weidman, *Singing the Classical Voicing the Modern: The Postcolonial Politics of Music in South India* (Calcutta: Seagull Books, 2007).
4. Kaushik Bhaumik, *The Emergence of the Bombay Film Industry, 1913–1936* (Oxford: University of Oxford, 2001): 7.
5. Janaki Bakhle, *Two Men and Music: Nationalism in the Making of an Indian Classical Tradition* (Delhi: Permanent Black, 2005): 51.
6. Ibid., 9.
7. Ibid., 56.
8. The traditional audiences were bound to older patronage systems of the royal courts and temples, where performance served a social and ritual function.
9. The *baijis* were known by different names across the country, and Maciszewski mentions the problematic usage of the term 'courtesan' to describe these women.

> Before the early twentieth century, these traditions were known by a variety of names across India, names either representing their song and dance repertoires or the women themselves ... Among the colonisers and, by early twentieth century, the reform-minded, urban Indian upper and middle classes, these women became generalised as courtesans, often synonymous with prostitutes.

See Amelia Maciszewski, 'North Indian Women Musicians and Their Words', in Amlan Dasgupta (ed.) *Music and Modernity: North Indian Classical Music in an Age of Mechanical Reproduction* (Calcutta: Thema, 2007): 161.
10. 'New Advertisements', *The Bombay Gazette*, 7 July 1896, 2a.
11. *The Bombay Gazette*, 13 July 1896, 6b.
12. Stephen Hughes, 'The Music Boom in Tamil South India: Gramophone, Radio and the Making of Mass Culture', *Historical Journal of Film, Radio and Television* 22 (2002): 445–473.
13. Bhaumik, *The Emergence*, 20.
14. Maciszewski, 'North Indian Women', 168.
15. Maciszewski, 'North Indian Women', 181.
16. Urmila Bhirdikar quotes an incident concerning the way the patron–musician relationship was evolving in traditional spaces like the royal courts. Alladiya Khan, the maestro of Jaipur-Atrauli *gharana*, narrates an incident in the royal court of Baroda where his potential employment as a court musician was no longer dependent solely on his performance but on his ability to answer questions about music. 'To survive in Baroda it seems was only through negotiating with the new forms of pedagogy ... as well as the ruler's westernized administration and bureaucracy.' Urmila Bhirdikar, 'The Spread of North Indian Music in Maharashtra in the Late Nineteenth and Early Twentieth Century: Sociocultural Conditions of Production and Consumption', in Amlan Dasgupta (ed.) *Music and Modernity: North Indian Classical Music in an Age of Mechanical Reproduction* (Calcutta: Thema, 2007): 223.

Olympia Bhatt 137

17. On the one hand, when a *tawa'if*'s [another name for *baijis*] performance was/is classified vis-à-vis her musical repertoire (*thumri* and related genres), it fit/s into the somewhat marginal semi- or 'light' classical category, one that 'falls between the cracks of classical and folk'. On the other hand, when categorized by the dance style performed (Kathak), it was/is described as classical. Moreover, a Kathak performance usually includes/-ed one or more of the above musical genres.

 (Maciszewski 2007, 160)

18. Bhaumik, *The Emergence*, 7. Bhatkhande's project of institutionalizing music sought the same sites of patronage that were sought by early filmmakers too. In the late teens and twenties, Bhatkhande organized All India Music Conferences (AIMC) in different princely states of India. The emphasis for each conference was to set up a national academy of music where theory and practice would come together. Interestingly, these princely states that patronized musicians in their courts failed to take an interest in Bhatkhande's attempt at setting up a national institution for music. Bakhle states: 'The AIMCs were one of the few nation(alist) venues in which the princes could hold on to their old roles as the patrons of music. Yet they could neither make the transition into a national sphere nor augment their vocal flourishes with material support' (*Two Men*, 194).

19. Vikram Sampath (2010) also discusses this particular point in his biography of the first gramophone artist, Gauharjaan. Also, refer to Sarah Niazi's dissertation on early female performers in Bombay's film industry. Sarah Rahman Niazi, 'Cinema and the Reinvention of the Self: Women Performers in the Bombay Film Industry (1925–1947)', PhD. diss., Jawaharlal Nehru University (2011).

20. The 1920s marks a spurt in the number of movie theaters in the country. By 1927 there were 265 permanent sites of exhibition which in 1923 had been a mere 150 (ICC Report). Also, 1923 was an important year as it marked the beginning of year-round exhibition of films in certain theaters in Bombay. Previously, most of the screenings were held during the winter months. Most of the traveling showmen avoided the hot and wet conditions of the summer and monsoons months respectively as they could easily damage the film celluloid.

21. During each of these periods, a number of systems of representation of moving images are in favor, depending on, among other things, the site and type of exhibition... [The] *second period cinema*... qualifies as a period in terms of screening conditions, because it witnessed the gradual consolidation of practices that resulted in the organisation of the sound space of the theater.

 Jean Chateauvert and Andre Gaudreault, 'The Noise of Spectators, or the Spectator as Additive to the Spectacle', in Richard Abel and Rick Altman (eds.) *The Sounds of Early Cinema* (Bloomington: Indiana University Press, 2001): 183–191 (184).

22. It has often been suggested the exhibitions of the Cinematographe [*sic*] might be made even more attractive than they are if they were interspersed with some other forms of entertainment. This suggestion has not escaped the notice of the proprietor, who has decided to give three special

138 *The Historical Practice of Silent Film Sound*

> exhibitions this week, interspersed with music, under the direction of F. Seymour Dove.
>
> *The Bombay Gazette*, 11 August 1896, 4f.

23. Bhaskar Chandravarkar, 'Sound in a Silent Era', *Cinema Vision India: Pioneers of Indian Cinema, The Silent Era* 1 (1980): 117–119 (118).
24. Vikram Sampath, *My Name Is Gauharjaan! The Life and Times of a Musician* (New Delhi: Rupa, 2010): 82.
25. Gerry Ferrell, 'The Early Days of the Gramophone Industry in India: Historical, Social and Musical Perspectives', *British Journal of Ethnomusicology* 2 (1993): 31–53 (39).
26. Satyajit Ray, 'I Wish I Could Have Shown Them to You', *Cinema Vision India: Pioneers of Indian Cinema, The Silent Era* 1 (1980): 6–7 (6).
27. Bakhle, *Two Men*, 186.
28. The harmonium was a subject of much controversy and discussion in the first All India Music Conference organized by Bhatkhande in 1916 in Baroda, and its slow acceptance as an accompanying instrument needs to be investigated further.
29. Maciszewski, 'North Indian Women', 166–167.
30. G.N. Joshi, 'A Concise History of the Phonograph Industry in India', *Popular Music* 7 (May 1988): 147–156.
31. Ferrell, 'The Early Days'.
32. See Ferrell, 'The Early Days', and Sampath, *My Name Is Gauharjaan!*
33. Yatindra Mishra, 'The Bai and the Dawn of the Hindi Film Music (1925–45)', *Book Review* XXXIII (February 2009): 46–47; and Niazi, 'Cinema and the Reinvention of the Self', (2011).

Part II

New Approaches to Silent Film Music History and Theory

8
Deconstructing the 'Brutal Savage' in John Ford's *The Iron Horse*

Peter A. Graff

'But you're a white man!' shouts David, seconds before being bludgeoned with an axe. The murderer's sinister face fills the frame, confirming this Indian as indeed a white man in disguise. Deroux, the man in question and the principal antagonist of John Ford's *The Iron Horse*, fundamentally subverts the archetypal clarity of Indian identity. Intended as a historical dramatization, the film depicts the construction of North America's first transcontinental railroad and the struggles of progressing through hostile Indian Territory. Only brief scholarly discussions of this film exist, and the score by Erno Rapée is seldom acknowledged. With the recent resurfacing of Rapée's piano score, a complete version of the film with its intended aural accompaniment is now available for study for the first time since its American and worldwide debut in 1924–1926. Analysis of the newfound score sheds significant light on both Rapée's compositional methods and the Indian characters' narrative agency.

Bringing to life the formulaic plot are varied characters whose intentions, morality and demeanor go largely unchanged over the course of the film. Rapée's score, which accompanied the film's domestic release, reveals a similar strategy in which themes remain unchanged upon repeated iterations, thereby reinforcing the characters' fundamental qualities. The narrative evolution of the Indians ultimately opposes this consistency and clarity. Careless readings of this film often group the Indians as a singular 'brutal savage' force – a problem compounded by their pairing with music that traditionally signals Indian hostility. A close investigation of the narrative and Rapée's score, however, reveals a much more complex role. The white characters' manipulation of Cheyenne and Pawnee Indians as aggressors and protectors, respectively, undermines common readings of Indian villainy. Deroux himself further complicates the Indian-as-villain view by disguising himself as

141

142 *New Approaches to Silent Film Music History and Theory*

an Indian while carrying out nefarious deeds. Through the process of thematic borrowing, Rapée identifies the Indians as pawns of white characters, thereby weakening the 'brutal savage' association and clarifying their complex identity amid a film built from otherwise simple archetypes.

The story

The Iron Horse deals with the construction of the transcontinental railroad, recalling, as Fox advertised, 'the thrills of terror which surged into the hearts of civilization's advance guard when the war whoops of the Sioux and the Cheyennes shrilled in their ears'.[1] Within the confines of a railroad story, the film follows the adventures of Davy Brandon, whose shrewd father, David, envisioned a railroad uniting America's East and West. After finding an ideal route through the Black Hills, Davy's father is murdered by a two-fingered 'Indian' named Deroux – a white man in disguise. Years after the murder, Davy reappears as a Pony Express rider being chased by Indians. Seeking refuge on a passing train, he encounters Miriam Marsh, his childhood sweetheart. After a brief reunion, Miriam's father Thomas, the Union Pacific contractor, grants Davy a surveying position. White-Deroux here returns to the story, as he owns land on which the railroad is progressing. Deroux is concerned that Davy will foil his plans to sell the information of the mountain passage at a high price by offering up these details. In order to prevent this knowledge from surfacing, Deroux conspires with Miriam's fiancé and engineer for the Union Pacific, Mr Jesson, in a plot to kill Davy. After a failed murder attempt, Davy exposes Jesson and defeats Deroux, who again dresses as an Indian during a raid on the tracklayers. In the conclusion of this Western epic, Davy and Miriam reunite as an embodiment of the tracks of the Union Pacific and Central Pacific joining at Promontory Point, Utah.

William Fox intended to capitalize on, and surpass, the popularity of the previous year's blockbuster, *The Covered Wagon*, by producing a Western of massive scope shot on location throughout the American Southwest. An advertisement that ran in the *Los Angeles Times* declared, 'If you thrilled over *The Covered Wagon* your enthusiasm will know no bounds when you see *The Iron Horse*.'[2] In an effort to exceed the grandeur of *The Covered Wagon*, Fox enlisted Ford and allotted him 'the largest budget of any Fox picture to date, $450,000'.[3] By the time production began on New Year's Eve 1923, Ford had already directed at least 50 films – 41 of which were Westerns – but had yet to land himself

a blockbuster.[4] As he would do in the screenwriting process for many later films, Ford sought historical accuracy by commissioning extensive research in libraries across the country, including the Library of Congress, the Smithsonian Institution, and the archives of the Central Pacific and Union Pacific railroads.[5] Yet when it came to filming, the director all but abandoned his script. In an interview with Peter Bogdanovich, Ford admitted, 'we never worked closely with them [the writers]. John Russell wrote the original *Iron Horse* and it was really just a simple little story.'[6] Despite these haphazard methods, Ford earned praise after the August 1924 premiere for his prodigious artistic ability; it was the first film, according to John Baxter, 'to draw attention to him as a stylist'.[7]

Production and reception

The story of the filming, complete with bootleggers, brawls, disease and even death, is almost more interesting than the film itself.[8] Late in life Ford confessed, 'I wish I had time some day to write the story of the making of *The Iron Horse*.'[9] Living out of circus train cars, the cast and crew endured subzero temperatures and blizzards that stretched the filming schedule from four to ten weeks.[10] According to Ford, 'it's by chance that it became a great film. [During bad weather] we had nothing else to do, so we filmed, and little by little, the story developed.'[11] During the ten-week period, Ford enlisted actual Cheyennes, Paiutes, Pawnees and Sioux to play the story's large bands of Indians, instructing them to arrive in their traditional tribal dress to add authenticity and reduce production costs.[12] He similarly enlisted roughly 40 Chinese men for scenes of the Central Pacific railroad, among whom the oldest had actually worked on the original rail.[13] Fox often took advantage of these touches of authenticity by exaggerating that the filming used '1,000 Chinese Laborers' and '800 Pawnee, Sioux and Cheyenne Indians'; the actual figures were much smaller, as Indians and Chinese often doubled for one another during filming.[14]

After a drawn-out production period, *The Iron Horse* premiered at New York's Lyric Theatre on 28 August 1924. The film received an extravagant promotional campaign including heavy newspaper and billboard coverage and even airplanes 'writing in the sky by day and carrying electric signs by night'.[15] Reviewers even noted the transformation of the Lyric itself with 'hundred [sic] of yards of silk in a combination of blue and gray'.[16] Six months later, the film began its 17-week run at Grauman's Egyptian Theatre in Los Angeles. For this

144 *New Approaches to Silent Film Music History and Theory*

engagement Sid Grauman packaged the film with an elaborate eight-to ten-act prologue (depending on the week) entitled 'The Days of 1863–1869', which, according to a *Los Angeles Times* article, included 25–50 dancing Arapahoe and Shoshone Indians and Yakama Chief Yowlachie singing traditional songs.[17] The brilliant spectacle, as noted by Charles Beardsley, 'was climaxed by the arrival onstage of two locomotives, there for the driving of the final spike to connect the two great railroads'.[18]

Early reactions to the film fell short of the success for which Fox had hoped. The reviews were largely mixed due in part to its slow pace and recycling of narrative elements from earlier Westerns. While many critics praised the cinematic feat and its celebration of American patriotism, Robert Sherwood of *Life* magazine complained that 'as a whole, the picture makes almost no sense; scenes, episodes and situations (some of them highly meritorious in themselves) are hurled together with utter disregard of continuity'.[19] A month after the premiere, *Film Daily* reported, 'business at the Lyric hasn't been good. In other words, the public isn't going.'[20] Perplexed, the same writer asked why this would be, 'because it certainly is a fine picture. And should be a great box office success.' Business did eventually pick up at the Lyric, where the film continued to pack houses twice daily for its eight-month run. Two months after the New York premiere, *Chicago Daily Tribune* reviewer Mae Tinee boasted: 'Scenery, Indians, acting – everything about *The Iron Horse* satisfies.'[21] By the time it reached Los Angeles, Fox was heralding it as 'The Outstanding Picture of 1925'.[22]

Erno Rapée's score

By the time *The Iron Horse* was released, Rapée was considered the premiere composer, compiler and orchestral conductor of the New York film scene. As music director, Rapée tried to enlighten American audiences on the subject of European classical music. In a *New Yorker* article reviewing his career, he called American audiences 'culturally starved' and claimed to incorporate arrangements from the classical canon whenever possible.[23] When Rapée later became the orchestra conductor at Radio City Music Hall, he explained his music selection process in a *New York Times* article: 'give them what they want but keep the general level high, and keep on improving it'.[24] For Westerns, however, he relied more on popular tunes, because, in his view, 'the Western-movie public was not quite ready for the classics'.[25] His engagement as manager and musical director at Philadelphia's Fox Theatre, from November 1923 to

August 1925, led to his work on numerous Westerns, including the score for *The Iron Horse*.

Rapée was a prolific film composer and arranger and is often remembered for his two instructional books for silent film accompanists: *Motion Picture Moods* (1924) and *Encyclopedia of Music for Pictures* (1925). Prior to these publications, Rapée collaborated with William Axt on a project composing a series of 'moods' for Richmond-Robbins's (later, Robbins-Engel) *Capitol Photoplay Series*. The series contains approximately 100 programs for both small and full orchestras; Rapée contributed only 17 programs to the series (1–16 and 18), while Axt went on to contribute at least 19 additional pieces. Several of Rapée's *Photoplay* contributions appear in his score for *The Iron Horse*; most important are program three, entitled 'Misterioso [*sic*] No. 1: For Horror, Stealth, Conspiracy, and Treachery', and program 13, labeled 'Indian Orgy: For Gatherings, Uprisings, Dances and Festivals'. These two programs, along with a third unidentified work, provide notable insight into Rapée's compositional method and help us understand the Indian characters' narrative function.

Rapée's score to *The Iron Horse* received consistently positive reviews in the press. Fred of *Variety* wrote: '[the score] added considerably to the thrill moments'.[26] The critic for *Film Daily* argued for its importance as an essential component of the work: 'by all means secure Erno Rapée's score to use with the showing. It's very important, and mighty fine.'[27] Unfortunately, beyond these initial reviews few comments on the music exist. Kathryn Kalinak's 2007 book *How The West Was Sung: Music in the Westerns of John Ford* is among the first scholarly considerations of Rapée's music; without access to the score, however, Kalinak is left to make inferences regarding its contents. For her investigation, Kalinak looks at Rapée's separately published title song, 'March of the Iron Horse', as well as a recording from February 1925 entitled 'Echoes from *The Iron Horse*', logically thought to be a distillation of the score. 'Echoes' is a short medley of folk songs that Rapée arranged to accompany the elaborate Grauman's prologue.[28] Most of the medley's songs, however, do not actually appear in the film's score; the only ones that do are 'Pop Goes the Weasel', 'Drill, Ye Tarriers, Drill', and 'Indian Orgy' from the *Capitol Photoplay Series* (labeled below as Indian theme 2).

Ford took an active role in choosing music for *The Iron Horse*. In an era when it was unique for the director and composer to collaborate, Ford asserted himself specifically through the song 'Drill, Ye Tarriers, Drill'. As Kalinak notes, the director included the song's lyrics in several intertitles and even instructed the tracklayers to sing and pound their

146 *New Approaches to Silent Film Music History and Theory*

tools in rhythm – their mouths clearly singing the words – thereby giving Rapée little choice in the matter.[29] The song appears four times in the score, each time accompanying the working tracklayers. Elsewhere the score relies heavily on familiar songs, as in Ford's later Westerns. This tendency in particular reflects Ford's musical taste: Jim Kitses's DVD commentary for *Stagecoach* notes that Ford 'hated over-scoring, but loved folksongs', a musical genre with which he was well acquainted.[30] In an interview with Bogdanovich, Ford joked: 'I don't like to see a man alone in the desert, dying of thirst, with the Philadelphia Orchestra behind him.'[31]

Rapée had little control in the 'over-scoring' but found a compromise by restricting himself to folk songs, Protestant hymns, and patriotic tunes. Quoted throughout the score are arrangements of 'The Battle Hymn of the Republic', 'Tramp, Tramp, Tramp', 'Bonnie Eloise', 'Lead, Kindly Light', 'Drill, Ye Tarriers, Drill', 'O sole mio', 'Garry Own', 'Pop Goes the Weasel', 'The Old Hundredth', 'Oh, My Darling Clementine' and 'St. Patrick's Day'. Occasionally Rapée includes works he composed for various photoplay music series. One piece from the Red Seal Concert Series, 'Dew Drops', is used and at least six pieces are borrowed from the Capitol Photoplay Series: 'Agitato No. 2', 'Agitato No. 3', 'Gruesome Tales', 'Indian Orgy', 'Misterioso No. 1' and 'Recitativo No. 1'. There are eight as yet unidentified pieces, four of which are credited to Rapée, one to Edward Kilenyi and one to Gason Borch. The only original composition for the film is the title song, which was later published in 1925 under the title 'March of the Iron Horse'.

Like the static Western characters, the various musical themes resist development during the film; the iterations of a theme remain exactly the same through its final appearance, save for extensions and truncations. This non-developmental style binds the characters to their musical characterization. For example, 'Garry Owen', an 18th-century Irish quickstep, accompanies the Irish trio led by Corporal Casey. Regardless of a scene's mood, the song always occurs in A major and through its repetition becomes a theme for Casey's group. This fixed quality likewise holds true for the Indian themes. Two interchangeable themes exist for the Indians and both derive from the *Capitol Photoplay Series*: one from 'Indian Orgy: For Indian Gatherings, Uprisings, Dances and Festivals' and the other from an as yet unidentified program. The theme for white-Deroux is also from the photoplay collection: 'Misterioso No. 1: For Horror, Stealth, Conspiracy, Treachery'. As one would expect, Rapée's use of music that he himself specifically designed for preset moods and actions relies heavily on standard musical conventions of the silent era.

Indian musics

As evidenced by Rapée's publications alone, 'Indian music' was already a well-worn stereotype by the 1920s. Even if the music scarcely resembled actual American Indian music, audiences by that time could instantly recognize the intended referent. Claudia Gorbman suggests that the public's familiarization with Indian musics stems from melodramas, fairs, Wild West shows and popular theater during the 19th century – the Indian character being particularly popular in minstrel shows.[32] Music typically found an outlet in all of these arenas and largely consisted of a repetitive tom-tom figure with a modal melody, often played on 'foreign-sounding' instruments. Eventually, a drum and modal melody came to represent the stock 'exotic' music employed in depicting non-Western cultures, particularly the Middle East and Asia.[33] Slight variants helped distinguish between the varied 'exotic' locales, and adding visual elements reinforced the music's 'authenticity'. Through its fusion with clichéd Indian imagery, 'Indian music' thus was widely identifiable by audiences at the turn of the 20th century.

According to Gorbman, the two 'unambiguous musical conventions' for Indian music in pre-World War II Westerns are 'a "tom-tom" rhythmic drumming figure of equal beats, the first of every four beats being accented ... played by actual drums or as a repeated bass note or pair of notes in perfect fifths, played in the low strings', and 'a modal melody ... sometimes monophonically [with the tom-tom], sometimes in parallel fourths, often with a falling third (e.g. F–D) concluding a melodic phrase'.[34] These two rules dominate most Indian music of the 20th century, to which composers add alterations when accompanying different character types. For the 'brutal savage' archetype, the composer might include a descending two-note figure played by a collection of brass instruments with the first note heavily accented and a sustained second.[35] This two-note motif came to characterize 'threatening' Indians and appears in many of Ford's films: *Stagecoach* (1939), *Drums Along the Mohawk* (1939), *Fort Apache* (1948), *Red River* (1948), *She Wore a Yellow Ribbon* (1950) and *The Searchers* (1956). By contrast, typical music for the noble, friendly Indian has slower tempos, diminished tom-tom presence, orchestration of a modal melody with strings or a flute and accompaniment comprised of 'sweet, pastoral harmonies'.[36] *The Iron Horse* relies on many of these conventions – tom-tom figures, modal melodies on foreign-sounding instruments and descending two-note figures – to clearly code the Indian as an exotic Other.

Unmistakable archetypes

The Iron Horse explores a narrative theme common to silent Westerns, depicting good overcoming evil rather than man overcoming self. Dramatic convention required discernible character types that experienced minimal psychological change as the stories unfolded. In *The Iron Horse* characters that are heroic or villainous at the beginning, such as Davy and Deroux, remain so throughout. Even though the music clearly identifies their race, the Indians in the film challenge archetypal clarity by acting as extensions of the good and evil white forces, thus stretching the mold by the very fact that they are carrying out the directions of others. Not acting on their own accord complicates an identity that would otherwise be archetypally sound, as the film visually codes the Pawnee and Cheyenne tribes with two classic Indian types: the noble and brutal savages, respectively.

The Iron Horse continues the practice of 19th-century Western novels and early silent films that permit identifiably 'good' Indian characters; only in the early sound era did savagery become an obligatory convention.[37] The 19th-century literary practice and its replication in film reduced Indians to two basic roles: noble savage (friend) and brutal savage (foe). Generally, the 'noble' roles appear in plots set before the expansion of white civilization, or in stories of assimilated Indians from tribes already conquered by white settlers. Noble Indians, such as Chief John Big Tree's characters in *Stagecoach* and *Drums Along the Mohawk*, often aid the whites as guides or scouts. More common, however, is the 'brutal' character (or characters, as they typically appear in groups), whose violent attempts to halt the westward expansion of civilization is, in the end, thwarted by a white hero. This enemy is an unmistakably evil character who scalps innocent civilians and rapes young women. In both of these roles, as John O'Connor asserts, the Indian remains a one-dimensional character devoid of individuality, thereby keeping moral ambiguities to a minimum.[38]

The Iron Horse invokes both types: the Pawnee tribe represents the noble savage, employed by the Union Pacific to protect the rails from impending attacks by hostile Indians; and the Cheyennes embody the brutal archetype, hired by Deroux to halt the westward progression of the railroad. White men, it appears, are seemingly inadequate in battle and must rely on Indians, whose perceived natural warrior instincts prove essential to either side's victory. Most important, the brutal and noble Indians serve merely as screens upon which the savagery and nobility of their white counterparts are projected. Here, then,

Peter A. Graff 149

additional dimensions complicate the one-dimensionality described by O'Connor: Indian duality within a single film and roles as white surrogates.

Such instances of multidimensionality are easily overlooked by viewers predisposed to reading Indians as obstacles 'standing in the way of civilization's progress'.[39] In his dissertation on John Ford, for example, Peter Lehman avoids these crucial points, identifying all Indians as one force: 'In *The Iron Horse*, he [Ford] depicts Indians as satanic threats to white civilization.'[40] The inclusion of Pawnees alone challenges this reading, and while the Cheyennes may possess a mutual interest in destroying the rails, their lack of explicit dialogue further undermines Lehman's interpretation. Rapée's thematic implementation, however, fills the void created by the absence of dialogue, clarifying the identities and intentions of the hero and villain, Anglo and Other.

Brutal savage: Deroux's façade

Of the many villainous acts presented in the film, Deroux commits the harshest by murdering and scalping Davy's father. In Westerns, scalping is typically reserved for Indian characters; transferring this act to the white-Deroux marks him as the most sinister character of the film. Moreover, Deroux's posing as a member of the Cheyenne tribe during this initial episode suggests that the Indian attacks that occur in his absence are ultimately the responsibility of a white character. Apart from the murder of Davy's father, four additional cases of Indian aggression occur, the last of which mirrors the first as Deroux is involved once again. The most challenging question of the plot, then, surrounds the Cheyennes: do they act on their own accord or are they always acting upon Deroux's commands?

Analysis of the music for each attack identifies Deroux as the root source of aggression. Deroux has multiple themes to match his visual identities. Two Indian themes are employed to match his Indian disguise, and a non-Indian theme later appears for the introduction of his white persona. This departure from Rapée's standard of one theme per character serves a crucial function: it reinforces Deroux's dual visual identity as both an Indian and a white man, using music as a component of his disguise. For example, during the initial attack led by Deroux, one hears the first of the film's two Indian themes. While this is the first time the theme is heard in its entirety, the audience previously encountered a snippet of it during a close-up of an Indian Chief, followed by the intertitle 'And others see it [a great nation pushing westward] – but

150 *New Approaches to Silent Film Music History and Theory*

face it in defiance'. Rapée utilized a conventional technique in which a character's theme always accompanies their filmic entrance. When interviewed by *Roxy Theatre Weekly Review* about his compositional process, Rapée stated: 'When it comes to the characters, I figure out one theme for the villain, one for the lovers, and still another for the comic character who is sure to appear.'[41] Based on this testimony, Indian theme 1 paired with this close-up shot therefore signals that the theme belongs to the Indians and their future actions.

The theme's second iteration draws on its Indian association as a band of nine Cheyennes emerges from the forest to kill Davy's father; this time Deroux is present in buckskin fringe and headband. Following the conventions of Rapée's technique, Deroux – the murderer and orchestrator of the attack – takes over the theme with his filmic entrance: it now belongs to him. As the faux-Indian Deroux dons the clichéd Indian dress, his aural identity is matched with equally stereotypical Indian music. Later, however, Deroux receives a second, non-Indian theme to accompany the introduction of his white identity.

Even though Deroux is not present during the next Indian attack, the use of his Indian theme signals his agency. Heard for the third time, a truncated Indian theme 1 accompanies a small band of Indians on horseback attacking the tracklayers. This sudden raid, and the abrupt entrance of the musical cue, interrupts the laborers working and singing 'Drill, ye Tarriers, Drill'. Once the men fend off the Indian attack, the theme ends and they resume their merry working tune. There is no tribal identification for these rogue Indians, but the use of Indian theme 1 connects them with the earlier Cheyennes, and therefore with Deroux. Shortly thereafter a new Indian theme 2 sounds as a caravan of horseback Indians seize and ravage a train and its inhabitants. Indian theme 2 originates from the *Capitol Photoplay Series* and was intended to accompany 'Indian Gatherings, Uprisings, Dances and Festivals' – used here clearly for an uprising. Initially the new theme and unidentified tribe mark this as an isolated incident; later, however, we find the theme identified with the Cheyennes and Deroux in the final attack.

The musical cue for the next instance of Indian hostility is integral to understanding the overarching Indian motivation. The scene introduces the adult-Davy, now a Pony Express rider, pursued by a dozen mounted Indians. He finds protection after the dare-devilish feat of boarding a moving train containing Thomas Marsh, Miriam, Jesson and Deroux en route to inspect the track's progress. Revealingly, the Indian chase, which is by no means brief, uses white-Deroux's theme – *not* one of the two Indian themes already heard. The thematic borrowing of a musical

marker, well established with white-Deroux, is a technique Rapée uses intermittently to express an extension of Deroux's will.

Deroux controls his world by coercing people, through monetary bribes, into carrying out his bidding. To signal Deroux's influence when he is absent, Rapée shares his themes – both Indian and white – with other characters. The first such instance occurs with the aforementioned Cheyenne murder party; subsequent bribes include Ruby and Jesson, who both act as Deroux's henchmen in the film. Halfway through the story, Deroux instructs Ruby, a saloon girl, to user her 'feminine persuasion' on Jesson, saying, 'Give him anything he wants *not* to find a pass through the hills.' Doing as she is told, Ruby talks her way into Jesson's living quarters and proposes Deroux's offer: 'My friends will make you very rich if you fail to find a shorter pass.' Jesson agrees and the pair kiss passionately, sealing the deal. While Ruby carries out these instructions, Deroux's theme occurs (Rapée borrows this theme from the *Capitol Photoplay Series*, where it was intended for 'horror, stealth, conspiracy, [and] treachery'). Similarly, when Jesson follows Deroux's instruction to murder Davy, the theme appears again. The music tells us, then, that these characters are merely surrogates of Deroux's villainy.

For Rapée, borrowing themes signifies an extension of a character's power. Based on the previous instances of Deroux's bribery, the use of his theme during the Pony Express chase confirms him as the source of the Indian action. Curiously, though, none of the characters knows about adult-Davy or, at this point, his knowledge of the secret passage; therefore the attack cannot be read as a calculated effort to kill Davy. Yet, the use of Deroux's theme suggests there was a purpose for the attack; it was not a random act of aggression. With Deroux onboard the train, it is also doubtful that the Indians intended to destroy the train itself. One explanation remains: Deroux intended to frighten Thomas Marsh into ending his encroachment into Cheyenne territory (land that Deroux owns) through the image of Indians attacking the Pony Express (a symbol of westward-moving civilization) – and while it visibly startled Marsh, the attack failed to halt his steady progression.

Prior to the final and most extensive Indian attack, Deroux visits the Cheyenne camp, 'inciting the hostile Indians to war'. Indian theme 1 reappears at this occasion, echoing the beginning of the film when Deroux worked alongside the Cheyennes. The scene concludes with hoards of Cheyennes mounting their horses and riding away as Deroux says, 'my brother, before many suns we shall stop the iron horse forever – '. The subsequent fight scenes (18 minutes in total) depict a group of tracklayers besieged by the Cheyennes and begin

152 *New Approaches to Silent Film Music History and Theory*

with Indian theme 2. During the first cue, Deroux sports his Indian attire while directing the Cheyenne forces. The Indian music temporarily stalls, however, as Davy escapes on the engine car to gather help from the nearby boomtown. The theme resumes upon his return to the battlefront with a small militia of men and women.

Shortly after Davy's return, the Cheyenne warriors assemble in a line parallel to the train, ready to charge. This particular counterpoint of Indian and white lines produces a literal cultural mirror. As the lines dissolve and fighting ensues, Deroux relocates behind a stack of railroad ties to gain a better aim for shooting at the train. Davy ventures out to defeat this 'Indian sharpshooter' and discovers, to his bewilderment, that it is actually Deroux in disguise. Upon this revelation, we hear an abrupt stinger and the music changes to new material that is modulatory and suspenseful. As the cue continues, Davy exposes Deroux's two-fingered hand, signaling the mark of his father's murderer, and a fistfight occurs resulting in Deroux's death.

Returning once again to the earlier scene in which unidentified Indians decimate a train, the use of Indian theme 2 for the Deroux-orchestrated final attack not only identifies this tribe as Cheyenne but also marks Deroux as its source. Rapée's score binds together events that would otherwise seem unrelated, unlocking the source of the Indian hostility. Through a strict use of themes, the music identifies Deroux as the root of aggression, and therefore unshackles the Cheyennes from their hackneyed villainous characterization. Once Davy discovers that the Indian sharpshooter is actually Deroux, Indian theme 2 abruptly stops. With his physical disguise removed, the music used to conceal his identity loses its power. Neither Indian theme is heard again, which confirms their dependence on Deroux's façade.

Noble Pawnee: Cavalry surrogates

While the 'brutal savage' Cheyennes are the dominant Indian image in the film, the inclusion of Pawnees in the final battle scene provides an important 'noble savage' counterbalance. In the film (as in real life) the Union Pacific enlists Pawnee Indians as scouts and defenders against attack, and it is they who ultimately ride to the rescue and save the day. Toward the end of the monumental battle scene, an intertitle flashes: 'Like a sweeping wind, the Pawnee scouts rush to the rescue'. A tribe on horseback in identifiably different Indian dress rides in a single-file line toward the battlefront. As before, lines demarcate the opposing tribes; this time the Pawnees form a perpendicular line with the Cheyennes.

The tribes personify the individual struggle between Davy and Deroux, and as Davy defeats Deroux the Pawnees rush in and drive off the hostile Cheyennes. Through the nature of their arrival and their function in the plot, the Pawnees fulfill the role of cavalry as defined by later Ford Westerns. In *Stagecoach*, for example, when the coach is besieged by a wild band of Apaches, a group of cavalrymen ride in and drive away the Indians. The cavalrymen, while undeveloped characters, are essential to the plot's turning point. Similarly, in *The Iron Horse* the Pawnees arrive when all hope seems lost and vanquish the evil forces. They ensure conflict resolution even though they occupy the screen for a mere three minutes.

While the Pawnees function as a traditional cavalry, their musical treatment is markedly different. In traditional cavalry depictions, a bugle call and/or a change in musical character signals their arrival, often foretelling the conflict's favorable resolution. Here, however, there is no change in musical character as the Pawnees rush in; rather, the music of Indian theme 2 continues until the end of the fight sequence. With no aural cue to distinguish between tribes, audiences of the time might well have wondered if this was another band of marauders – especially illiterate viewers or those who simply disregarded the single intertitle that identifies them as friendly scouts. There are several possible reasons for this absent musical distinction upon their entrance. First and foremost, the music would need to remain identifiably Indian, yet reflect a peaceful Indian presence. Clearly, the characteristic pastoral melodies of the 'noble savage' would disrupt the energy of the scene. Another possibility is that Rapée, or even Ford himself, wanted to maintain a diminished noble Indian presence, preferring to focus our attention on the savage Cheyennes. This would potentially also explain the lack of female Indians in the film, who often signal peaceable Indians. Then again, a simpler explanation may suffice, namely that live musicians were unable to switch quickly enough to respond to the dramatic revelation and subsequent cross-cuttings.

Many stylistic elements typical of Ford's later Westerns find their roots in *The Iron Horse*: symbolic use of lines; archetypal duality in dramatic characterization (seen here in the function of the Indian); and reliance on cavalry at the climax of the plot. The score itself, comprising mainly folk melodies, provided Ford with a template upon which he built his later Westerns. But more important, Rapée's score for *The Iron Horse* proves essential for an accurate reading of the film. By looking specifically at the narrative function of the Indian characters and their corresponding musical material, we gain a clear understanding of

154 *New Approaches to Silent Film Music History and Theory*

the Cheyennes' hidden motives stemming from Deroux. Through the aid of Rapée's score, the Cheyennes, once considered the villain of the film, gain redemption from their barbaric characterization.

Notes

1. William Fox, 'The Story', in John Ford and Sid Grauman (eds.) *William Fox Presents: The Iron Horse*, Souvenir Program (New York: The Gordon Press, 1924): 5.
2. *Los Angeles Times*, 18 February 1925, 9.
3. Ronald L. Davis, *John Ford: Hollywood's Old Master* (Norman, OK: University of Oklahoma Press, 1995): 52.
4. Tag Gallagher, *John Ford: The Man and His Films* (Berkeley: University of California Press, 1986): 36.
5. Edwin C. Hill, 'The Origin and Completion of the Iron Horse', in John Ford and Sid Grauman (eds.) *William Fox Presents: The Iron Horse, Souvenir Program* (New York: The Gordon Press, 1924): 6–7 (6).
6. Peter Bogdanovich, *John Ford* (Berkeley: University of California Press, 1978): 44.
7. John Baxter, *The Cinema of John Ford* (London: A. Zwemmer, 1971): 40.
8. Kevin Brownlow, *The War, The West, and The Wilderness* (New York: Knopf, 1979): 390.
9. Bogdanovich, *John Ford*, 44.
10. Gallagher, *John Ford*, 31.
11. Bertrand Tavernier, 'John Ford a Paris, Notes d'un Attache de Presse,' *Positif: Revue du cinema* 82 (March 1967): 7–21 (20). [All translations by the author of this chapter.]
12. Davis, *John Ford*, 54.
13. Ibid.
14. Ibid; and Fox, 'The Story', 4.
15. 'Broadway Sees the "Iron Horse": New York Premiere of Picture Given at Lyric Following Heavy Campaign', *Motion Picture News*, 13 September 1924, 1362.
16. Fred, 'Pictures: The Iron Horse', *Variety*, 3 September 1924, 23.
17. *Los Angeles Times*, 22 February 1925, 25.
18. Charles Beardsley, *Hollywood's Master Showman: The Legendary Sid Grauman* (New York: Cornwall Books, 1983): 94.
19. Robert E. Sherwood, 'The Silent Drama: "The Iron Horse" ', *Life*, 25 September 1924, 26.
20. *Film Daily*, 28 September 1924, 10.
21. Mae Tinee, *Chicago Daily Tribune*, 4 November 1924, 13.
22. *Variety*, '22nd Annual Announcement: Fox Film Corporation Independence and Strength', 6 May 1925, 36.
23. Barbara Heggie and Lewis Taylor Robert, 'Idea Flourisher', *New Yorker*, 5 February 1944, 32.
24. *New York Times*, 2 August 1942, X8.
25. Heggie and Taylor, 'Idea Flourisher', 32.
26. Fred, 'Pictures', 23.
27. *Film Daily*, 7 September 1924, 5.

28. H. Marcus Kenneth, *Musical Metropolis: Los Angeles and the Creation of a Music Culture, 1880–1940* (New York: Palgrave Macmillan, 2004): 166.
29. Kathryn Kalinak, *How the West Was Sung: Music in the Westerns of John Ford* (Berkeley: University of California Press, 2007): 16.
30. John Ford, dir. *Stagecoach*. United Artists, 1939. DVD. Criterion Collection, 2010.
31. Bogdanovich, *John Ford*, 99.
32. Claudia Gorbman, 'Scoring the Indian: Music in the Liberal Western', in Georgina Born and David Hesmondhalgh (eds.) *Western Music and Its Others* (Berkeley: University of California Press, 2000): 234–254 (237).
33. Kalinak, *How the West*, 71.
34. Gorbman, 'Scoring the Indian', 235.
35. Ibid.
36. Ibid.
37. John E. O'Connor, 'The White Man's Indian: An Institutional Approach', in Peter C. Rollins and John E. O'Connor (eds.) *Hollywood's Indian: The Portrayal of the Native American in Film* (Lexington: University Press of Kentucky, 1998): 27–38 (28).
38. O'Connor, 'The White Man's Indian', 27, 33.
39. Davis, *John Ford*, 58.
40. Peter Lehman, 'John Ford and the Auteur Theory', PhD. diss., University of Wisconsin-Madison, (1978): 325.
41. Ross Melnick, *American Showman: Samuel 'Roxy' Rothafel and the Birth of the Entertainment Industry, 1908–1935* (New York: Columbia University Press, 2012): 298.

9

'The Hermeneutic Framing of Film Illustration Practice': The *Allgemeines Handbuch der Film-Musik* in the Context of Historico-musicological Traditions

Maria Fuchs

Introduction

As an 'auxiliary', or at any rate complementary, art form, music accompaniment of silent films revitalized old questions about the correlation between music and the representation of extra-musical imagery. With this article, I set out to utilize a crucial concept of music theory at the turn of the century, musical hermeneutics, to 'frame' the arguably most significant cinema music collection and theoretic work of the silent period in the German-speaking world: the *Allgemeines Handbuch der Film-Musik*.

The epistemology of musical affect, known to have started in ancient Greece, has a long tradition and found a striking continuation in the 'musical doctrines of the affects' of the baroque period, which are characterized by a classification of musical structures. The musical representation of (poetic) imagery was particularly conventionalized in the compositional techniques and practices as well as in the theory of opera and program music, musical spheres that were used to a great extent in silent film accompaniment.[1] The silent medium offering 'concrete' (visual) content[2] outright provokes questions about the effectiveness of music.[3] The already tested relationship between music and language is replaced by relations between music and image in the 'art of illustration'.[4] In a sense, music takes over the rhetorical functions of the muted courses of movements.

At the time moving pictures emerged, the semantic orientation of music experienced a boom with regard to general problems of how to 'understand' instrumental music and established itself in concert program introductions, so-called music guidebooks, during the late 19th century until finally gaining a certain methodological foundation with Hermann Kretzschmar's musical hermeneutics.[5] The discussions surrounding musical accompaniment of silent films focused on finding a coherent method for a musico-dramaturgic connection between image and sound: a method that could correspond to the heterogeneous performance practice conditions in silent film exhibition seemed necessary.

Giuseppe Becce, publisher of the *Kinotheken*, which were received with great success after their launch in 1919, is considered to have paved the way for making such methods available to the majority of cinema musicians and musical directors of movie theaters in the German-speaking area. However, elaborate theoretical and methodological approaches within the compilation practice did not appear until the end of the silent film period. With their two-part volume *Allgemeines Handbuch der Film-Musik*, Giuseppe Becce, Hans Erdmann and Ludwig Brav put forward a highly refined testimony of the art of film illustration for the German-speaking context. The first volume of the *Handbuch* consolidates a discourse on film music theory that had been led for many years in specialist magazines. The second volume, the 'Thematisches Skalenregister', initiated a new course with regard to publishing standards as it contained a systematic categorization of music pieces from several film music catalogues that circulated in the 1920s. Works from 34 different music publishers were chosen and edited for cinematic use according to their stylistic suitability.

In the course of this chapter, I shall put into perspective the *Allgemeines Handbuch der Film-Musik* in relation to Kretzschmar's musical hermeneutics. The *Handbuchs*'s proximity to musical hermeneutics is primarily based on biographical backgrounds. Both Erdmann and Brav were graduated musicologists. They were acutely aware of Kretzschmar's attempt to describe and catalogue musical content and this knowledge informed their reflections on film music. In this sense, a musico-historical tradition is carried over into the conception of the *Handbuch* and consequently into German-language film music theory. When compared internationally with Erno Rapée's mood music catalogues, the music-hermeneutic profile of the *Handbuch* becomes even more evident.

158 *New Approaches to Silent Film Music History and Theory*

Becce's *Kinothek* as methodological pioneer

Giuseppe Becce's *Kinotheken*, published by Schlesinger and Lienau between 1919 and 1929, were the first collections of cinematic 'illustration music' in Germany and are considered to have brought the somewhat anarchic period of film accompaniment in Germany to a close.[6] During the first two decades of silent film exhibition, the music for moving images was mainly characterized by arbitrariness; that is to say, there was no widespread recipe for a musico-dramatic unity between image and sound. Robert Lienau's predominant 'formula for film music' – printed on the back of his catalogue – was: F+M = 1.[7]

The reasons for this are found in the poor conditions that movie theaters and film production companies provided for musical accompaniment. These practical parameters, the so-called 'Geländeschwierigkeiten',[8] complicated the advancement of film music. Musical illustration was the only approach that counteracted this, but it required methodical development. Becce's *Kinotheken* provided an answer to these deficiencies, more precisely; they were a methodical reaction to the prevalent practice of film music accompaniment. Due to missing performance norms, it was necessary to compose music that proved flexible and compatible in terms of musical form. Music for illustration practices needed to be shortened or lengthened at will, thus requiring a form that would support the conductor's work.[9] Following the *Kinotheken*, numerous film illustration catalogues sprung up in Germany.[10]

Music historiography in the focus of 1920s German film music discourse

Embedding the *Allgemeines Handbuch der Film-Musik* in the preceding literature appears necessary with respect to the various references to previously published topics and professional articles some of which were incorporated in their entirety in the first volume of the *Handbuch*.[11] Music in cinemas before the 1920s in German-speaking countries was left largely to its own devices, a circumstance which was responsible for film accompaniments' tenacious 'Geländeschwierigkeiten'.[12] Film and music theorists only began to show an interest in cinema music in the last decade of the silent period.[13]

In 1927 Schlesinger and Lienau published *Film-Ton-Kunst: Eine Zeitschrift für die künstlerische Musikillustration des Lichtbildes*.[14] *Film-Ton-Kunst* was to be understood as the continuation of the 1921 *Kinomusikblatt*, issued by the same publishers. The *Kinomusikblatt*

emerged in connection with Becce's Kinotheken and was more or less meant as an advertisement for his film music compositions and for cue sheets. Despite Becce's visions and ideas with regard to practical and theoretical musical questions, he was not cut out to be an editor, as he states himself.[15] Instead, Hans Erdmann was appointed editor of *Film-Ton-Kunst*. The most important medium for film music in German-speaking countries pursued the goal of collecting material specifically for film accompaniment on a broad level. The emergence of the *Handbuch* is connected to the theoretical work of *Film-Ton-Kunst*. The *Film-Ton-Kunst* issue of August 1927 was a special edition devoted to the *Handbuch*'s announcement, and Becce, Brav and Erdmann all contributed to this issue with articles written in an academic fashion.[16] Historical musicological traditions were taken as criteria for film music's aesthetic. The eclecticism of the compiled film accompaniment, which was generally perceived as objectionable, is compared with the Pasticcio-technique of the baroque era (in particular Händel's). A certain unease in combining 'one's own' and 'foreign' musical material is thus valorized through a historical comparison and legitimized as an artistic practice: 'And everything happens again – our musical film illustrator is really just "Mister Pasticcio composer redivivus".'[17]

In terms of form and aesthetic, opera served as a comparative musical genre for references of musical dramaturgy: an opera's plot is schematically divided into active dramatic and passive lyrical parts, as well as in their connection. This abstract construction scheme as well as compositional techniques of opera, such as the possibility of musically and temporally prolonging an action, are used as reference points for film music.[18]

Another tenor within the discussions on the topic is the dissociation of film music from absolute music: 'The compositional technique of opera composition allows itself to be transformed, accelerated and compressed, but the compositional methods of absolute music, whose inner tempo is much more tentative, are less suitable.'[19] Comparing film music as an auxiliary art with opera can ultimately be interpreted as an attempt to legitimize film music as an artistic praxis.

Numerous references to European music history can be found in both of the article series, 'Die Tasteninstrumente im Orchester'[20] and 'Über das Kammer- (Salon-) Orchester und die Bearbeitung von Musikwerken'.[21] Orchestra lineups from the Viennese classical era to the modern orchestra of the early 20th century to the salon orchestra of movie theaters are elaborated upon. Furthermore, the historical development of the keyboard instrument is recounted, from the basso continuo

160 *New Approaches to Silent Film Music History and Theory*

period up to its significance within the salon orchestra. Erdmann displays a high level of knowledge with regard to musical performance practices, especially from the 18th century.[22] The legitimization of arrangements for salon orchestras also references the basso continuo practice of that era.[23]

Within this narration the continuity of European music history tradition becomes apparent: canonical ways of thinking and writing about music are furthered within the realm of film music. Principles were devised and laid out as theoretical thoughts, and music compilation was thus promoted and legitimized as an artistic method by referring to European music traditions.[24]

The *Handbuch* in an international comparison

This international comparison intends for a profiling of the *Handbuch*. Ultimately, the juxtaposition should support the argument that the discourse on film music (aesthetics) within the German-speaking countries derived its parameters from European music history in a striking manner.[25]

For this comparison, I will refer to the illustration catalogues by Hungarian-born composer and conductor Erno Rapée, who emigrated to the US in the mid-teens and became an influential figure in the musical settings of films on Broadway's moving pictures palaces. From 1925 to 1926 he returned to Europe to conduct the orchestra at the Ufa-Palast-Zoo in Berlin. Curiously enough, a relationship between the authors of the *Handbuch* and Erno Rapée can be ascertained. Erdmann and Brav repeatedly commented, often unfavorably, on Rapée's activities in Berlin: 'His skills as a businessman and advertiser are surely obvious and admirable... With regard to film music, he hardly created anything better than what was already being done. He was not ambitious.'[26]

The theory of the *Handbuch*, contained in the first volume, spans over 80 pages including margin notes in small print. The objective was a conceptualization of film music on an aesthetic and practical level. The structure that makes up the material contains a thoroughly summarized previous discourse on film music from magazines, which thereby emphasizes the historical musicological focus.[27]

In comparison, Rapée's musical motive collection *Motion Picture Moods for Pianists and Organists: A Rapid Reference Collection of Selected Pieces* (1924) does not contain any substantial theory. His *Encyclopedia of Music for Pictures* (1925), on the other hand, includes a rather superficial theoretical review of his library that spans around 22 pages.[28] In the

Maria Fuchs 161

first chapter, 'Origin and Development of Musical Accompaniment to Action', the historical development of the effects of music since Greek antiquity is treated on barely one and a half pages, which was noted by the German trade press:

> Everything Rapée says on these thirty pages is virtually self-evident... Chapter one follows the 'good fashion' of starting out with Orpheus, in order to give a kind of line of thought of music history. Now that may be a bit gratuitous, since it is written in every elementary book... Chapter 9 deals with lighting effects on stage and theater. What does that have to do with music?... This thick American book entails no revelations and very much remains within the elementary sphere.[29]

Becce and Brav are also in agreement about the poor quality of the encyclopedia when they write that 'it avoids the issue of film music. The catalogue is lacking a deeper systematization'.[30] Rapée's theory does not contain the same level of diligence with regard to musicology as the *Handbuch*, thus emphasizing the *Handbuch's* great theoretical interest in comparison.

The *Handbuch's* 'Thematisches Skalenregister', the mood catalogue comprising the second volume, stands out for its scope. Preexisting catalogues were extended and enlarged upon therein. This system is valid for the years 1926–1929 in Germany.[31] Existing catalogues for musical illustration, such as Becce's *Kinotheken*, which contained opera fantasies and diverse opera and concert music, were compiled into a superordinate system according to levels of tension and temporal dynamics in the 'Thematisches Skalenregister'.[32] Such a systematization of already published catalogues was not commonplace for publishing houses.[33] The logic of taxonomy follows the classification scheme from Becce's *Kinotheken*.[34] The mood categories 'Dramatic Scene', 'Dramatic Expression', 'Lyrical Expression' and 'Incidence' are maintained as superordinate functional models. Subcategories further organize the music material according to aspects of narration and atmosphere. The 3,050 chosen excerpts of music incipits represent about 211 different composers. The repertoire ranges from the 19th century, in particular operas – numerous verismo operas – and Schauspielmusik (stage music), to pieces from cinema music collections.[35]

With regard to Rapée's anthologies, we can ascertain that in his work the choice of music is not organized according to any mood-related scheme. Various types of scenes or mood categories such as

162 *New Approaches to Silent Film Music History and Theory*

'Andantes', 'Antique Dances', 'Apach', 'Appassionato' and 'Arabian Music' are ordered alphabetically in Rapée's catalogues. The catalogue *Motion Picture Moods* contains parts of the pinao scores. In his *Encyclopedia*, only music titles and the respective composers and publishers are listed alphabetically and systematically according to film scenes and characters. In part, Rapée also based his musical selection on the piece's titles in a superficial manner. The labeling of music pieces by 'programmatic' titles was a common practice, especially in 'illustration art'.[36] Therein, a specific vocabulary for marking contents beside the music had already been developed. Numerous pioneer Hollywood composers emigrated from Europe and their musical background was utterly characterized by European romantic and program music. Rapées modest classification, which supposedly did not correspond to the musical content, was critically noted in the *Handbuch*.[37]

In the 'Skalenregister', by contrast, the detailed interpretations of film images are based on the expressive qualities of the music, not according to programmatic titles.[38] Ludwig Brav harshly criticized this practice of choosing titles in *Film-Ton-Kunst*. On the grounds of this principle, the *Handbuch* 'labeled a large part of the music under consideration according to content and atmosphere in terms of applicability for film'[39]: a clear dissociation from Rapée's work.

Consequently, the basic considerations for classification in the 'Thematisches Skalenregister' follow categories of moods and (musical) expression and are not organized alphabetically by composer or an index of scene types. This implies a profound interest in musical expression. In addition, detailed interpretations of characteristic and recurring film scenes distinguish the taxonomic preparations. As a result, the terminology for film music content was developed with great care and the meticulous approach to this categorization is not found in any other catalogue.

The *Handbuch* in the context of musical hermeneutics

According to the *Handbuch*, the daily requirements of film music called for a musical hermeneutic perspective. The authors state that the entire illustration technique was simply a primitive music hermeneutics. The musical pieces were 'no longer organized alphabetically by composer or music form, but rather by atmospheres. We attempted to attain a literal interpretation of the individual pieces in the most diligent and detailed manner possible.'[40]

With musical hermeneutics, Hermann Kretzschmar formulated a new musicological method – based on a long-standing tradition – that

focused primarily on the interpretation of affect and temper with regard to musical expression. With his *Führer durch den Konzertsaal*, Kretzschmar defined canonical music pieces according to their narrative content.[41] He was aiming for a methodological legitimization of his 'emotional' (interpretative) approaches to music in the face of widespread formal-aesthetic approaches (Hanslick's idea of 'absolute music'). With the introduction of the term 'hermeneutics', Kretzschmar managed to elevate his content-aesthetical theory of interpretation to interpretative theories of social studies and humanities.[42]

The musical doctrine of the affects of the baroque period thus served as a role model and starting point for musical hermeneutics, according to Kretzschmar.[43] The established affect model of the 18th century, which is characterized by a classification of musical structures, offered him secure (scholarly) grounds against allegations of all too noncommittal interpretations. The thematic aesthetics of a musical piece, its main thought or principal mood, should be laid out within a few measures. The aim of musical hermeneutics is then to interpret and verbally communicate musical content such as affect, expressive character and temper in the smallest possible musical units. The musical hermeneutic understanding of the entire composition then follows by way of an additive principle of the singular elements. Kretzschmar attempted to place hermeneutics at the basis of a verbal interpretation of music.

Biographies as key

As the *Handbuch*'s authors mention in their introduction, a general interest is added to the practical interest with the 'Thematische Skalenregister' by attempting to create a system of mood categories, which can be derived from musical hermeneutics.[44] The key for understanding Becce, Brav and Erdmann's venture lies, according to Hartmut Krones, in Erdmann's substantiated historico-musicological knowledge. Siebert[45] pointed out Brav's musical academic background and Erdmann's musical hermeneutic references in the *Reichsfilmblatt*. Giuseppe Becce, surely the most well-known of the three, does not play such a significant role in this respect. According to a rumor spread by Brav's wife, Becce did not contribute to any large extent, but rather provided his famous name to ensure the success of the publication. Brav's musicological and practical knowledge, on the other hand, are relevant for the *Handbuch*'s conception, while secondary literature tends to deem him a shadowy figure.[46]

Ludwig Brav (born 1896 in Berlin, died 1951 in London) graduated in 1921 with a thesis on the historiographic depiction of the Dance Suite, wherein he refers to Kretzschmar. During the silent film period, Brav was

164 *New Approaches to Silent Film Music History and Theory*

mainly active as an arranger. His journalistic pieces in *Film-Ton-Kunst* deal almost exclusively with issues of arrangement and methodological approaches to illustration, such as indexing musical content,[47] which explains the extended linguistical indexing of music pieces in the 'Skalenregister'. In 1928, he published his *Thematischer Führer durch die klassische und moderne Orchester-Musik zum besonderen Gebrauch für die musikalische Illustration*. Individual pieces from this thematic guide are also included in the 'Skalenregister' and were marked as EBB (Erdmann, Becce, Brav) in Brav's publication. This makes Brav's contributions a crucial factor in the conception of the *Handbuch*.

Hans Erdmann Timotheos Guckel (born 1882, died 1942 in Berlin) graduated in 1912 under Otto Kinkeldey in Breslau with a thesis on 'Die Katholische Kirchenmusik in Schlesien'. Kinkeldey was a student of Hermann Kretzschmar. In 1913, Erdmann performed a reopening of Monteverdi's *L'Orfeo* at the Breslau Theater. At the first performance, Kinkeldey and Hermann Kretzschmar were in the audience, as is stated in John Whenham's publication *Claudio Monteverdi. Orfeo*.[48] These biographical entanglements suggest that Erdmann's musicological considerations were informed by Kretzschmar's musical hermeneutics and that they shaped his work and mentality. He referred to Kretzschmar's *Führer durch den Konzertsaal* in his dissertation when discussing masses. Hans Erdmann is to be regarded as the most important exponent of German-language film music theory, as measured by his extensive journalistic activities and his co-authorship of the *Handbuch*. In secondary literature, he is also acknowledged as such.[49]

The hermeneutic framing

The influence of musical hermeneutics becomes apparent throughout the *Handbuch*. It is especially visible in a section where Kretzschmar's 'Musikalische Zeitfragen' are quoted literally.[50] The norms of absolute and of dramatic music provide the criteria for the genre classification of 'illustration music'. The practice of compilation is ultimately defined as 'gesprächige Konzertmusik' (loquacious concert music).[51] This notion indirectly links to Kretzschmar's historical recourse of the musical rhetoric of the 18th century.

The term 'hermeneutics' was included in the 'Register of Uncommon Foreign Words' and defined as the 'interpretation of music through words'.[52] It was also included in the 'Name and Keyword Index' in a 1927 issue of *Film-Ton-Kunst*.[53] A connection between the method of musical accompaniment for films and musical hermeneutics is already apparent in the journal articles: 'The great and widely acknowledged

difficulty of grasping musical moods in words (musical hermeneutics) is well-known; anyhow, a careful weighing of the terms can be helpful.'[54] Erdmann directly refers to Kretzschmar in the *Reichsfilmblatt* in his wish to legitimize film music aesthetics as such: 'The musical accompaniment for film – an "auxiliary art", as Hermann Kretzschmar would have called it – is, in the common sense, just as little a problem as ballet, pantomime, opera, theater music and such.'[55] In 1928, Erdmann was the head of the Film Music Class at the Berlin Klindworth-Scharwenka Conservatory and published the school's curriculum in *Filmtechnik*.[56] Besides an 'Introduction to Film Music', 'Musical Dramaturgy', 'Image Dramaturgy' and many more subjects, film music studies also included the discipline 'Aesthetics and Hermeneutics'.

Knowledge of musical hermeneutics also takes shape in the 'Thematisches Skalenregister', thus the form of illustration methods. The musical pieces in the catalogues were disassembled according to moods and represented by music incipits. The incipits do not necessarily specify the beginning of a composition; they can also describe middle parts, in which new performance indications are dominant and are used to convey a piece's musical character with regard to affect, dynamics and mood. Bibliographical specifications added after the incipits refer to the entire sheet music of a piece, which the conductor could draw upon in compiling the film accompaniment. Nonetheless, the bibliographical specifications, the visual conception,[57] that is, the smallest musical units in the shape of incipits, define the semantic structure of the 'Skalenregister'.[58]

When compared with Brav's solo publication *Thematischer Führer* (thematic guide), whose structure is similar to that of the 'Thematisches Skalenregister', the musical hermeneutic approach becomes even more apparent:

> The layout was arranged so that the works could be disassembled into individual pieces, suitable for illustrative purposes, the themes of which are specified. Along with this, there was an attempt to provide an illustrative interpretation of the music, which should indicate the suitability of a certain piece for the specific purposes of the film.[59]

The specification of meaning with regard to intervals, motifs and themes, available via written indexing, represents the main part of Kretzschmar's hermeneutics.

This illustrative fragmentation of a music piece corresponds to the additive law of musical hermeneutics, even though the aim is a different

166 *New Approaches to Silent Film Music History and Theory*

one. In light of the categorization principle of the 'Skalenregister', namely that the music in consideration be catalogued according to content and mood with regard to its use for film, the hermeneutic approach is signaled emphatically.

In 'Beitrag zur Filmillustration', a film music contemporary writes that the illustration practice is basically 'safe and sensitive empathizing, and, if you will, theoretical mental digging'.[60] The keywords 'empathizing' and 'digging' place the art of illustration within the trichotomy of experience, expression and understanding, which is the methodological keystone of hermeneutics: 'Whoever has the largest "motive catalogue" at hand, will ultimately win.'[61] Expressing music in words that are then systematized in motive catalogues can basically be legitimized as a musical hermeneutic practice. If one also considers the diverse specifications of meaning of the pieces of music in the scale register, it becomes apparent that a hermeneutic musical interest was taken to its extreme. The conception of the 'Thematisches Skalenregister' is doubtlessly to be understood within the context of musical hermeneutics, where the form and content of the music was systematically indexed. In this sense, this undertaking is one that Kretzschmar never fulfilled.

Conclusion

These observations should demonstrate that a tradition and discourse surrounding musical form and content since the mid-17th century was transferred into German-language film music theory. This tradition continued because silent film accompaniment was faced with the difficulty of representing images through music. Due to their musicological education and background, Erdmann and Brav were aware of the historical literature concerning the representational qualities of music. This awareness is reflected in a conversation with Erno Rapée, when Erdmann draws the following conclusion: 'All in all, I had the impression that one can communicate with Rapée, even if one is a historically burdened musician from the occident; determining this is not without value.'[62] The article also intends to highlight Ludwig Brav's substantial involvement in the conception and implementation of the *Handbuch*. The international comparison should emphasize the musical hermeneutic perspective of the work.

Not least, it should be mentioned that the silent medium itself requires a musical hermeneutic approach to the compilation practice that is empathizing, labeling, naming and cataloguing musical meaning.

Maria Fuchs 167

These findings should be of value for the historiography of the *Handbuch* and the practice of musical accompaniment for film in general, as well as for a tradition of musical hermeneutics.

Translation: Sam Osborn

Acknowledgements: I would like to thank PD Dr Tobias Plebuch for his valuable assistance. I would like to thank Univ.-Prof. Dr Christian Thorau for his inspiration and Thomas Herscht for his collegial interest. I appreciate the generous support of my dissertation project on the *Handbuch* by my supervisors in Vienna, Univ.-Prof. Dr Michele Calella and Univ.-Prof. Dr Elisabeth Büttner, MA.

Notes

1. See Manuel Gervink, '(Art.) Programmmusik', in Manuel Gervink and Matthias Bückle (eds.) *Lexikon der Filmmusik* (Regensburg: Laaber, 2012): 404–405; Claudia Bullerjahn, 'Von der Kinomusik zur Filmmusik. Stummfilm-Originalkompositionen der zwanziger Jahre', in Werner Keil (ed.) *Musik der zwanziger* Jahre (Hildesheim/Zürich/New York: Georg Olms Verlag, 1996): 290; and Elmar Budde, 'Filmmusik – Verlust der musikalischen Vernunft?' in Hartmut Krones (ed.) *Bühne, Film, Raum und Zeit in der Musik des 20. Jahrhunderts* (Vienna: Böhlau, 2003): 111–118 (112).
2. Bullerjahn, 'Von der Kinomusik zur Filmmusik', 291.
3. The establishment and various functions of adding music to silent film presentations since the first public screenings have been discussed in a number of works. The differing lines of argumentation are well summarized in Claudia Bullerjahn, 'Musik zum Stummfilm. Von den ersten Anfängen einer Kinomusik zu heutigen Versuchen der Stummfilmillustration', in Josef Kloppenburg (ed.) *Das Handbuch der Filmmusik. Geschichte-Ästhetik-Funktionalität* (Regensburg: Laaber, 2012): 28–38; and Ulrich Eberhard Siebert, *Filmmusik in Theorie und Praxis. Eine Untersuchung der 20er und frühen 30er Jahre anhand des Werkes von Hans Erdmann*, Europäische Hochschulschriften 53 (Frankfurt/M./Bern/New York/Paris, 1990): 93.
4. The terms 'illustration' and 'compilation' are synonymously used in the literature of the 1920s for the techniques of selecting, combining and adapting preexisting music according to musico-dramaturgic considerations. See Hans Erdmann, Giuseppe Becce and Ludwig Brav, *Das Allgemeine Handbuch der Film-Musik* (Berlin-Lichterfelde/Leipzig: Schlesinger'sche Buchund Musikhandlung, 1927): 5–6.
5. See Christian Thorau, *Semantisierte Sinnlichkeit – Studien zu Rezeption und Zeichenstruktur der Leitmotivtechnik Richard Wagners*. Beihefte zum Archiv für Musikwissenschaft 50 (Stuttgart: Steiner, 2003): 161–167.
6. Ulrich Rügner, *Filmmusik in Deutschland zwischen 1924 und 1934* (Hildesheim/Zürich/New York: Georg Olms Verlag, 1988): 74.

7. With his formula 'film+music=1', Lienau advocates a strong unity between film and music; 'Die Schlesinger'sche Buch- und Musikhandlung als führendes Haus der Filmmusik', *Reichsfilmblatt* 9, 1926, 16.

8. Hans Erdmann, 'Filmmusik, ein Problem?', *Reichsfilmblatt* 34, 1924, 28.

9. Hans Erdmann, 'Zur Methodik der musikalischen Film-Illustration', *Reichsfilmblatt* 41, 1924, 26. For the derogatory criticism of contemporaries towards the *Kinotheken*, see Michael Beiche, 'Musik und Film im deutschen Musikjournalismus der 1920er Jahre', *Archiv für Musikwissenschaft* 63 (Stuttgart: Franz Steiner Verlag, 2006): 94–119, (107–108).

10. Konrad Ottenheym, *Film und Musik bis zur Einführung des Tonfilms. Ein Beitrag zur Geschichte des Films*. Phil. Diss. (Berlin 1944): 55–57. Refer to a register of catalogues in the German-speaking world in Erdmann, Becce and Brav, *Das Allgemeine Handbuch*, 58. See also, Siebert and Pauli who criticize the confusing handling of the term *Kinothek*, which soon became a key word and proved useful for pushing sales. Siebert, *Filmmusik in Theorie und Praxis*, 30; Hansjörg Pauli, *Filmmusik: Stummfilm* (Stuttgart: Klett-Cotta, 1981): 41.

11. Hans Siebert has mentioned the references to *Film-Ton-Kunst* in the *Handbuch*. See Siebert, *Filmmusik in Theorie und Praxis*, 59; see also Rügner, *Filmmusik in Deutschland*, 81.

12. Ottenheym points out the fact that film theorists hardly noticed the musical accompaniment in cinemas, while they published numerous books about film aesthetics and dramaturgy. Ottenheym, *Film und Musik*, 18.

13. See Ottenheym, *Film und Musik*, 39–44. First discussions about the music in cinemas were mentioned in the *Kinematograph* in 1911. (*Stummfilmmusik – gestern und heute*. Beiträge und Interviews anläßlich eines Symposiums im Kino Arsenal am 9. Juni 1979 in Berlin. Ed. Stiftung Deutsche Kinemathek Berlin. Berlin 1979). See a list of articles of different authors and media noted by Erdmann as well as a short development in the specialist literature, 'Der künstlerische Spielfilm und seine Musik', in Rudolf Pabst (ed.) *Das deutsche Lichtspieltheater in Vergangenheit, Gegenwart und Zukunft* (Berlin: Prisma-Verlag, 1926): 114–116.

14. The magazine *Film-Ton-Kunst* was published monthly from April 1926 until it was adjusted in 1928. Siebert, *Filmmusik in Theorie und Praxis*, 58.

15. Giuseppe Becce, 'Wie das "Kinomusikblatt" entstand', *Film-Ton-Kunst. Eine Zeitschrift für die künstlerische Musikillustration des Lichtbildes* 1, 1926, 3. The layout of the *Kinomusikblatt* was basic and simple: one to two pages of information from the film music publishing houses, and another one to two pages of publishers' advertisements.

16. The analysis of German-language periodicals of film history journals for this article is based on *Film-Ton-Kunst*, *Reichsfilmblatt*, the *Film-Kurier*, *Der Film* and *Der Kinematograph*.

17. Hans Erdmann, 'Filmmusik, ein Problem', *Reichsfilmblatt* 35, 1924, 31.

18. Hans Erdmann, 'Zur Methodik der musikalischen Film-Illustration', *Reichsfilmblatt* 39, 1924, 28.

19. Erdmann, 'Zur Methodik der musikalischen Film-Illustration', 28.

20. Hans Erdmann, 'Die Tasteninstrumente im Orchester. (Ihre Stellung in Vergangenheit und Gegenwart)', *Reichsfilmblatt* 19, 1925, 25; Hans Erdmann,

'Die Tasteninstrumente im Orchester. (Ihre Stellung in Vergangenheit und Gegenwart)', *Reichsfilmblatt* 20, 1925, 22; Hans Erdmann, 'Die Tasteninstrumente im Orchester. (Ihre Stellung in Vergangenheit und Gegenwart)', *Reichsfilmblatt* 21, 1925, 22; Hans Erdmann, 'Die Tasteninstrumente im Orchester. (Ihre Stellung in Vergangenheit und Gegenwart)', *Reichsfilmblatt* 22, 1925, 21.

21. Hans Erdmann, 'Ueber das Kammer-(Salon)Orchester und die Bearbeitung von Musikwerken', *Reichsfilmblatt* 13, 1925, 32; Hans Erdmann, 'Ueber das Kammer-(Salon)Orchester und die Bearbeitung von Musikwerken', *Reichsfilmblatt* 14, 1925, 26.

22. See Krones' analysis of musicological 'Diction and Thoughts' in the *Handbuch*. Hartmut Krones, 'Optische Konzeption und musikalische Semantik. Zum "Allgemeinen Handbuch der Film-Musik" von Hans Erdman, Giuseppe Becce und Ludwig Brav', in Hartmut Krones (ed.) *Bühne, Film, Raum und Zeit in der Musik des 20. Jahrhunderts* (Vienna: Böhlau, 2003): 119–142 (124).

23. Erdmann, 'Die Tasteninstrumente im Orchester', 25.

24. The practice of composing original film music struggled to establish itself for quite some time because of practical parameters in music accompaniment.

25. It should be noted here that in the article only the music-hermeneutic influence of the illustration method was incorporated. Numerous anthologies for melodrama are surely exemplary for film illustration, see Mervyn Cooke, *A History of Film Music* (Cambridge, MA: University Press, 2010): 10. Spoken drama's incidental music was also an established form of musical illustration. Besides this, ballet, pantomime, opera and program music were important influences and comparative categories for musical accompaniment catalogues; see Erdmann, Becce and Brav, *Das Allgemeine Handbuch*.

26. Hans Erdmann and Ludwig Brav, 'Erno Rapées Abgang', *Film-Ton-Kunst. Eine Zeitschrift für die künstlerische Musikillustration des Lichtbildes* 5 (1926): 49–50.

27. The quoted journals and newspapers of the preceding literature on film music include *Reichsfilmblatt, Filmtechnik, Film-Ton-Kunst, Kinotechnik, Vossische Zeitung, Berliner Tagesblatt, Film-Kurier.*

28. This assessment follows the line of argument of this article, which is reviewing the film music aesthetics within German-speaking context. It is not intended as a general evaluation of Rapée's work and achievements for silent film accompaniment.

29. 'Amerikanische Film-Musik-Theorie', *Reichsfilmblatt* 33, 1925, 42; 'Amerikanische Film-Musik-Theorie', *Reichsfilmblatt* 34, 1925, 32.

30. Erdmann and Brav, 'Erno Rapées Abgang', 50.

31. Rügner, *Filmmusik in Deutschland*, 14.

32. Ibid., 77.

33. Compare the critique of one-sided cataloging of music pieces from only one publisher in Erdmann, Becce and Brav, *Das Allgemeine Handbuch*, 58.

34. Rügner, *Filmmusik in Deutschland*, 78.

35. See Pauli, *Filmmusik: Stummfilm*, 148.

36. Gervink and Bückle, '(Art.) Programmmusik', 404–405, and Ottenheym, *Film und Musik*, 56.

170 *New Approaches to Silent Film Music History and Theory*

37. Erdmann, Becce, and Brav, *Das Allgemeine Handbuch*, 45; 64.
38. See Brav's exemplification on the methodological approaches of indexing. Ludwig Brav, 'Praktisches', *Film-Ton-Kunst. Eine Zeitschrift für die künstlerische Musikillustration des Lichtbildes* 8, 1927, 99.
39. Ludwig Brav, 'Musikalienschau', *Film-Ton-Kunst. Eine Zeitschrift für die künstlerische Musikillustration des Lichtbildes* 10, 1927, 124.
40. Erdmann, Becce and Brav, *Das Allgemeine Handbuch*, 63.
41. Thorau, *Semantisierte Sinnlichkeit*, 161–167.
42. Heinz-Dieter Sommer, *Praxisorientierte Musikwissenschaft. Studien zu Leben und Werk Hermann Kretzschmars*, Freiburger Schriften zur Musikwissenschaft 16 (Munich/Salzburg: Katzbichler, 1985): 65ff.
43. Hartmut Grimm, 'Hermann Kretzschmar: Restitution der Affektenlehre als wissenschaftliche Grundlegung musikalischer Hermeneutik', in Anselm Gerhard (ed.) *Musikwissenschaft – eine verspätete Disziplin? Die akademische Musikforschung zwischen Fortschrittsglauben und Monernitätsverweigerung* (Stuttgart and Weimar: Metzler, 2000): 87ff.
44. Erdmann, Becce and Brav, *Das Allgemeine Handbuch*, XI.
45. Siebert, *Filmmusik in Theorie und Praxis*, 115–116. Also, see the article by Irene Comisso in which she draws a parallel between the principles of musical hermeneutics and the conception of the 'Thematische Skalenregister' in the *Handbuch*. In her statements, she refers to Krones and Sieberts researches. Irene Comisso, 'Theory and Practice in Erdmann/Becce/Brav's *Allgemeines Handbuch der Film-Musik* (1927)', *The Journal of Film Music* 5/1–2 (2012): 93–100.
46. See Siebert's reconstruction, which assigns various parts of the *Handbuch* to the various authors. Siebert, *Filmmusik in Theorie und Praxis*, 49–50.
47. Brav, 'Praktisches', 99–100; Brav, 'Musikalienschau', 124–126.
48. John Whenham, *Claudio Monteverdi. Orfeo* (Cambridge, MA: Cambridge University Press, 1986), 89.
49. See Siebert, *Filmmusik in Theorie und Praxis*.
50. Erdmann, Becce and Brav, *Das Allgemeine Handbuch*, 41.
51. Ibid.
52. Ibid.
53. See *Film-Ton-Kunst. Eine Zeitschrift für die künstlerische Musikillustration des Lichtbildes* 1, 1927.
54. Hans Erdmann, 'Die Preiskino-Bibliothek. Herausgegeben von Ernst Eggert, Heinrichshofens Verlag, Magdeburg', *Reichsfilmblatt* 11, 1926, 14.
55. Erdmann, Hans. 'Filmmusik, ein Problem?', *Reichsfilmblatt* 34, 1924, 28.
56. Siebert, *Filmmusik in Theorie und Praxis*, 70.
57. Hartmut Krones points to the visual conception of the 'Skalenregister' with its musical topos-like structure. Krones, 'Optische Konzeption'.
58. See Ottenheym, who mentions that the 'Thematisches Skalenregister' is conceived in line with the fact that the illustrator could hardly ever realize the whole piece but only a part of it. Conductors were forced to cut the music pieces in order to fit to the length of film scenes. The music incipits in the 'Skalenregister' imply particular themes for characterizing specific film scenes (Ottenheym, *Film und Musik*, 57).
59. Ludwig Brav, 'Die Praxis der Bearbeitung und Besetzung für kleines Orchester', in Ludwig Brav (ed.) *Thematischer Führer durch die klassische*

und moderne Orchester-Musik zum besonderen Gebrauch für die musikalische Illustration (Berlin: Bote & Bock, 1928): III.

60. Kurt Groetschel, 'Horizontale oder vertikale Linie? Ein Beitrag zur Filmillustration', *Film-Ton-Kunst. Eine Zeitschrift für die künstlerische Musikillustration des Lichtbildes* 8, 1926, 90–91.

61. Ibid., 90.

62. Hans Erdmann, 'Eine Unterhaltung mit Erno Rappee', *Reichsfilmblatt* 13, 1926, 17.

10

Sergei Eisenstein and the Music of Landscape: The 'Mists' of *Potemkin* between Metaphor and Illustration

Francesco Finocchiaro

The anomaly of metaphor

As is known, Sergei Eisenstein's artistic course has always proceeded along with his theoretical evolution and aesthetic reflection. In many aspects, the Eisensteinian theory considers music as an aesthetic, linguistic and communicative model: starting from the well-known *Statement on Sound*[1] – gone down in history as *Sound Manifesto* – a polished metaphorical imagination inspired by music guides the thoughts of the Russian filmmaker, within both the theoretical formalization and film analysis. Analyses like the one carried out by Eisenstein on the 'symphony of the mist' in *Bronenosets Potyomkin* (*Battleship Potemkin*, 1925) are the paradigmatic model of a kind of inherently metaphorical treatise, in which a figurative structure, coherent and systematic, is created through the application of musical terminology to the film grammar. The Eisensteinian analysis hosts careful references, never obvious, to basic elements of the musical form, as well as to macro formal structures and even to real compositive procedures, such as polyrhythmicity and the fugue.

Of course, we are not going to linger over a generic penchant for music within the Eisensteinian theory: far from the mere linguistic curiosity, we are going to take the musical metaphor as a privileged point of view for the observation of Eisenstein's thought. In fact, within the theory conceived by the Russian filmmaker, the role played by metaphor is neither superficial nor accidental. The metaphor employment is indeed the 'core of Eisenstein's "mental" poetics',[2] as written by Marco Vallora, which means that 'his reasoning and thought are often guided exactly by the poetic energy of metaphor'.[3]

Upon these bases, we can understand that the musical metaphorization of theoretical concepts can become *systematic* for Eisenstein. The 'music of landscape' theory adopts and composes a 'conceptual system' that – quoting George Lakoff and Mark Johnson – is indeed 'metaphorical in nature'[4]: a linguistic universe systematically structured and defined through metaphorical terms. According to the two American scholars, the systematic aspect – that is, the organization of an entire conceptual system through the methodical use of terms belonging to another system – is typical of those abstract concepts 'which are not clearly delineated in our experience in any direct fashion and therefore must be comprehended primarily indirectly, via metaphor'.[5] Therefore, metaphor is characterized by directionality: even in everyday language, speakers tend to express abstract and vague ideas (emotions, time and so on) through concrete concepts, which are better delineated within our experience (spatial orientation, real objects, etc.). According to the philosopher Hans Blumenberg, metaphor 'is projected in place of what seemed essentially impervious to the theoretical demand for objectivity'[6]; it 'springs into a nonconceptualizable, conceptually unfillable gap and lacuna',[7] projecting itself upon the *horror vacui* and 'on the *tabula rasa* of theoretical unsatisfiability'.[8]

Ontologically, this *horror vacui* belongs to the 'musical talk', due to its manifest inability of verbalizing the nonverbal, if not 'via metaphor'. Basic musical concepts, such as 'pitch', 'timbre', 'scale', 'measure', 'cadenza' and so on, which seem to refer to the essence of musical facts, are only minimally understood through their intrinsic features, and are mostly founded on metaphors strongly characterized by visual, spatial or tactile elements.

Herein lies the ostensible anomaly of the Eisensteinian metaphorical deed: that intrinsic directionality supposed to belong to metaphor – talking about music in visual and spatial terms – is overturned within the thought of the Russian filmmaker, which conceptualizes concrete fields of experience, such as the visual and spatial, utilizing abstract and ineffable terms from aural and musical experience. In order to understand the reasons behind this presumed anomaly, we need to contextualize the Eisensteinian metaphor within its historical background, putting it in connection with its intertextual tradition and with the appropriate cultural and metaphorical repertoire.

It is crucial to note that this 'musical vocation' within cinematographic theory is not an isolated incident, but the fulfillment of a historically determined trend, which refers equally to the theories on silent cinema elaborated during the twenties, and to abstract films

174 *New Approaches to Silent Film Music History and Theory*

experiments of the same period. In fact, within the second decade of the 20th century, European filmmakers and cinema theorists have been drawing inspiration from music, from its syntactical structures, in order to formalize a 'still-under-construction language', as the cinema language was in those years. In the German-speaking area, the assumption of an 'elective affinity' between cinema and music already had a well-established theoretical basis within the writings of Georg Otto Stindt,[9] Rudolf Harms[10] and Hans Erdmann,[11] who firmly claimed not only the essential role of music for cinema, but also the mother–son relation between the ancient noble 'art of sounds' and the newborn 'tenth muse', putting the rhythmic dimension as the *trait d'union* between the two arts.

During the twenties, the same musical vocation engages in a creative evolution within the abstract cinema. Filmmakers like Walter Ruttmann, Viking Eggeling, Hans Richter and Ludwig Hirschfeld-Mack were deeply influenced by music. The reference to music, to its laws and terminology, is a permanent feature within their poetics: so, for example, the chromatic interactions between black and white are likened to *counterpoint*, while *timbre* and *instruments* are involved within the construction of lines, figures and so on. The central idea in the abstract short films by Ruttmann (*Lichtspiel Opus I, Opus II, Opus III, Opus IV*), Eggeling (*Horizontal-vertical Orchestra, Symphonie diagonale*), Richter (*Film ist Rhythmus, Vormittagsspuk*) and Hirschfeld-Mack (*Dreiteilige Farbensonatine*) is to 'musically' conceive imagery and its flux, by giving acoustic, auditory, musical arrangement to an absolutely visual fact. To describe his films, Ruttmann talks about 'painting with time' (*Malerei mit Zeit*):[12] a visual art in the first place, since it is composed of shapes, lines, figures, colors, not only organized in the spatial dimension, but also in temporal forms, regulated by relations of symmetry, alternation, correspondence. A visual art that settles and proceeds through time, following syntactic mechanisms borrowed from music: in this way, it emancipates from narrative fiction, from the reproduction of nature and referents, to become art, autonomous and completely formal.

In this search for an autonomous and self-sufficient language with a highly formalized syntax, no other artistic discipline but music could offer a richer lexical source and a more effective conceptual model. Hence, the maelstrom towards abstraction explains the frequent use of titles that may recall music; but even more meaningful is the title of the Berliner *Filmmatinee* 'Der absolute Film', which took place on 3 and 10 May 1925 at the Ufa-Theater am Kurfürstendamm. During this event, exponents of abstract cinema from Germany (Ruttmann,

Eggeling, Richter and Hirschfeld-Mack) and France (Léger, Murphy, Picabia and Clair) presented the results of their experimentations. The concept 'absolute cinema' recalls, and not by chance, the notion of 'absolute music', a music not hindered by any external reference; just like purely instrumental music, abstract cinema aspires to a language exclusively based upon its own features, which – as an extreme consequence – produces the pure unfolding of lines, colors, shapes and figures through time.

The music of landscape

The opening assumption of Eisenstein's essay *Neravnodushnaja priroda* (*Nonindifferent Nature*, 1945)[13] is in affinity with the theories by Stindt and Harms as well as with abstractionist research: in silent cinema there is an area of 'being beside oneself', in which 'the passage of representation into music' can take place.[14]

Here, the Eisensteinian theory brings a remarkable new improvement to this theoretical tradition. For Eisenstein, this 'access' towards music can be unlocked not only by the rhythmic element, but also by a more complex narrative unit: the landscape. With landscape – 'the freest element of film', and for this reason 'the most flexible in conveying moods, emotional states, and spiritual experiences'[15] – silent cinema can autonomously compose its own music, going beyond its limits, to become 'plastic music' (*plasticheskaya muzyka*).[16] Landscape is an 'emotional' element, 'functioning in the film as a musical component': here resides the deep sense of the expression 'non-indifferent nature'.[17]

Taking inspiration from Wagner[18] (1852) and Schönberg[19] (1912), Eisenstein asserts that the duty of landscape is 'expressing emotionally what only music is able to express completely',[20] and that cannot be expressed through other means. This is made possible by inserting 'landscape sequences'[21] within the narrative course of the film (like an interlude), or by interposing them before or after the narrative sections (like a prelude or a postlude). By doing this, the director reasserts a *topos* of soviet silent and early talking cinema, which takes inspiration from romantic painting. Referring to Anatoliy Dmitrievich Golovnya, a long-time collaborator of Vsevolod Pudovkin, Eisenstein talks about a 'literary treatment'[22] of the landscape, in lieu of a merely pictorial one. In other terms, the pictorial shape of landscape becomes a component of the cinematographic dramaturgy. As a descriptive element, it complements the development of action within the movie narration: 'For landscape...is least of all a catalog of trees, lakes, and mountain tops. Landscape is

176 *New Approaches to Silent Film Music History and Theory*

a complex bearer of the possibilities of a plastic interpretation of emotion'[23]; moreover, it 'can serve as a concrete image of the embodiment of whole cosmic conceptions, whole philosophic systems'.[24]

Now, the innovative contribution of the Eisensteinian theory resides in assuming that landscape can penetrate, thanks to its *musical* elements, within the development of the scene 'thematically resounding in the same key'.[25] Therefore, the landscape scene is 'built according to the same rhythmic and audiomelodic structure',[26] which decides also 'the structure and montage of representation'.[27] In this way, Eisenstein proposes to overtake literary treatments of the landscape, in order to consider its musical value: landscape has got not only an 'emotional effect' (*emotsional'nost'*), but also a 'musical effect' (*muzykal'nost'*),[28] and indeed it obtains the former through the latter. Landscape is 'emotional' in virtue of a 'set of representational elements of nature'[29]: in this way, each landscape can rouse psychological and emotional states through 'the compositional arrangement of the objects'.[30] Nevertheless, landscape is 'musical' in virtue of the 'development and composition'[31] of elements represented via strictly musical principles.

The distance between these two moments – the starting 'set of representational elements' on the one hand, and their 'development and composition' on the other – unequivocally recalls the distinction between *fabula* (story) and *sjuzet* (plot), one of the main assumptions of formalist theory in literature, which unquestionably influenced the Eisensteinian cinema aesthetics. Referring to the *Teoriya literatury* (*Theory of Literature*) by Boris Tomashevsky, the landscape 'system of motives,'[32] containing the minimum and indivisible narrative units that 'form the thematic bonds of the work'[33] through their reciprocal relations, belongs to the *fabula*. The *musical* elaboration of the 'thematic material',[34] instead, is a feature of the *sjuzet*, that is the narration as an 'artistic creation'.[35]

The symphony of the mists

Eisenstein illustrates the music of landscape theory through the analysis of a memorable film sequence from *Battleship Potemkin*: the mists in the port of Odessa, third act. The title given to the sequence by Eisenstein – 'symphony of the mist' (*simfoniya tumanov*)[36] or sometimes 'suite of lyrical mourning of mists' (*liricheski-traurnaya syuita tumanov*)[37] – introduces an inherently metaphorical analysis in which, as mentioned above, music terminology is systematically applied to film aspects.[38]

The composition consists of three elements:

1. The mists
2. The water
3. The shapes of the objects (the port cranes, the docked ships, etc.)

All these components belong to the system of the four natural elements: air, water, earth, fire. The latter is not immediately present, but it becomes clearly recognizable during the collective march generated by the funeral wake over Vakulinchuk's corpse.

In every single frame, each one of the three elements mingles with the other two in a different and peculiar way. Initially the picture is completely dominated by a gray veil of mist [Figure 10.1]. The shapes of trees and ships are barely visible. Then here is the silvern surface of water [Figure 10.2] and somewhere, far away upon the horizon, the boats take their blurred shape [Figure 10.3].

Here the black mass of a buoy [Figure 10.4], like a massive chord of 'Solidity', bursts out into the elemental water and calmly rolls on the silvery surface of the sea.

And here the black mass of the hulks of ships [Figure 10.5] swallows the whole expanse of the screen and slowly floats past the camera...

The general combination of motifs moves from the airiness of the mist through the barely perceptible outline of objects – through the lead-gray surface of the water and gray sails – the velvety black hulks of the ships and the hard rock of the embankment.

The dynamic combination of the separate lines of these elements flows together into a final static chord.

They merge together into a motionless shot, where the gray sail becomes a tent; the black hulks of the ships, the crêpe of the mourning bow; the water, the tears of women's bowed heads; the mist, the softness of the outlines of the – out of focus – shot; and the hard rock becomes the corpse lying prostrate on the paved, cobblestone embankment [Figure 10.6].

And now – almost inaudibly – the theme of fire enters.

It enters as the flickering candle in the hands of Vakulinchuk [Figure 10.7], so it may grow into the flaming wrath of the meeting held over the corpse, and it flares up with the scarlet flame of the red flag on the mast of the mutinying battleship.

The movement goes from hazy, almost ethereal moods of sorrow and mourning in general to a real victim, who perished for the cause of freedom, from the gloomy surface of the sea to the ocean of human

178 *New Approaches to Silent Film Music History and Theory*

sorrow, from the trembling candle in the hands of the murdered fighter through the mourning of the grieving masses to the uprising, seizing the whole city.

Thus, interweaving, the separate lines of these 'elements' move into the opening part, now floating into the foreground, now giving place to others and becoming lost in the depths of the background, now emphasizing each other, now setting each other off, now opposing each other.

In addition, each line passes along its own path of movement.

Thus the mist thins out from shot to shot:

concreteness becomes more and more transparent.

And on the contrary, before our eye the hard rock thickens and grows heavier: At first this is a black haze merging with the mist, then it is the bony skeletons of the masts and yard arms or silhouettes of cranes, resembling huge insects.

Later these bows and masts, jutting out of the shroud of the mist, grow before our eyes into whole launches and schooners.

The impact of the *Vorschlag* of the black buoy – and now the massive hulks of large ships enter.

And the theme of the water turning silver passes into the white sail, dreamily rolling on the sea's smooth surface...

I have touched here only on the mutual play of *concrete* principles, that is, the actual 'elements' – water, air, and earth.

But they are all also strictly echoed by the mutual play of purely *tonal* and *textural* combinations: dull gray, the mellow atmosphere of the mist, the silvery gray smoothness of the glittering surface of the water, the velvety sides of the black masses of concrete details.

All this is rhythmically echoed by the *measured length of duration of the pieces* and the barely caught *'melodic' rocking of photographed objects*.

The sea gull in the air – seems to be part of the mist and sky.

The sea gull, alighting down like a black silhouette on the buoy – is an element of solid earth.

And among them – as if the sea gull's wing grew enormously – the whiteness of the sail of a yacht slumbering on the water.

And it seems that the textures of the separate elements, just as the elements among themselves, form the same combination as an orchestra does, unifying into the *simultaneity* and the *sequence* of the action – the winds and strings, wood an brass![39]

Figures 10.1–10.7 Screen shots, *Panzerkreuzer Potemkin – Das Jahr 1905* (Berlin: Deutsche Kinemathek – Museum für Film und Fernsehen, Transit Classics, 2005), DVD. Courtesy of the Deutsche Kinemathek, Berlin

Figures 10.1–10.7 (Continued)

Figures 10.1–10.7 (Continued)

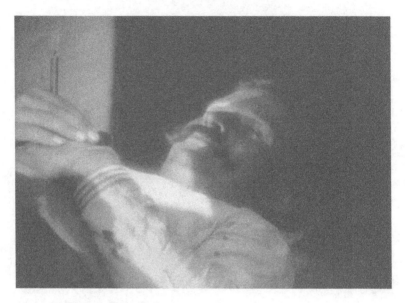

Figures 10.1–10.7 (Continued)

Eisenstein's discourse can be deconstructed and reassembled. If we examine the musical metaphors that substantiate the Eisensteinian analysis one by one, we see that they are neither ornamental nor gratuitous; on the contrary, they are part of a systematically structured metaphoric field. Within the Eisensteinian analysis, references to music, never featureless, are so coherent and circumstantial that the reader can imagine a real musical execution. The Eisensteinian description resounds with an acoustic form as if it were directly propagated by the images.

Those metaphors assimilating elements of film narration to musical form units can be included into a first category. For example, the black buoy is described as an *acciaccatura* (*Vorschlag*) and the seagull flight is described as a *trill*, due to an implied comparison between the flapping wings and the rapid oscillation of high pitches. Three out of four nature elements – air, water and earth – are considered *motifs*: concrete rhythmic-melodic units. These three motifs operate within the introduction of the third act; in the course of the narration, the fire element will become so important that it can be likened to a *theme*, instead of a mere motif. In addition to these elements, the motif of the ships and the black motif of the buoy form a motivic chain. We should note that these

metaphors are amply used within formalist theory, so as to intertwine its linguistic texture: the concepts of 'motif' as a synonym of minimum narrative unit, the *Leitmotiv* as recurring narrative subject, the 'thematic material' as logical set of story elements, and so on are well represented in the *Teoriya literatury* by Tomashevsky (1928). Nevertheless, they are also fundamental for the method of literary analysis proposed by Viktor Shklovsky (1925)[40] and, before that, for Alexander Veselovsky's work (1906).[41]

Metaphors which, alluding to syntactical musical phenomena, suggest formal caesuras belong to a second category and can be seen as a logical development of this metaphoric field. The three motifs air, water and earth harmonize through their overlapping, forming vertical *chords*. For example, with its rush between air and water elements, the black mass of the buoy creates a 'massive chord of "Solidity" '. Then the 'static chord', in which the three motifs finally come together, establishes a formal caesura. It defines a cadenza, an ending point of a movement, which closes the introduction, while at the same time forming a prelude to the next episode.

We can classify those most frequent metaphors, which describe a polyphonic structure, under a third category. Here, the nature elements are still compared with motifs, but in addition they are imagined as separate lines, each one with an autonomous development; the lines of the three elements get along and intertwine with each other as if they were voices within a polyphonic texture:

> Thus the mist thins out from shot to shot: concreteness becomes more and more transparent. And on the contrary, before our eye the hard rock thickens and grows heavier: At first this is a black haze merging with the mist, then it is the bony skeletons of the masts and yard arms or silhouettes of cranes, resembling huge insects. Later these bows and masts, jutting out of the shroud of the mist, grow before our eyes into whole launches and schooners. The impact of the *Vorschlag* of the black buoy – and now the massive hulks of large ships enter. And the theme of the water turning silver passes into the white sail, dreamily rolling on the sea's smooth surface...

The texture is further enriched by other 'voices', which do not consist of melodic lines but of '*tonal* and *textural*' lines, the former produced by chromatic variations, the latter by timbric ones. The chromatic variations entail trichromatic combinations, hence three lines result in three elements: the shade of the mists, the silvery sea and the ships in black.

184 *New Approaches to Silent Film Music History and Theory*

Variations in timbre create a timbric-material impasto – the softness of the fog, the brilliance of the water, the velvety sides of the ships – that the director compares to the timbric combination of strings, woodwinds and brass.

Finally, other metaphors reinforce the metaphoric field, even without bringing substantial semantic changes: the movement of the filmed objects is at some times assimilated to a melodic variation, in other circumstances to a rhythmic rocking. Most of all, the rhythmic feature traditionally attributed to the framings is due to their disposition upon the film: 'All this is rhythmically echoed by the *measured length of duration of the pieces* and the barely caught *"melodic" rocking of photographed objects*.'

The latter allusion to the rhythm of montage delimits what the Eisensteinian thought takes from the previously mentioned theories by Stindt, Harms and Erdmann: after all, the rhythm of the images (*Bildrhythmus*), particularly important for Stindt and Harms, has limited significance within the filmmaker's reasoning and it comes up but marginally in the mists analysis of *Potemkin*.

Musica mundana and *musica instrumentalis*

Finally, the musicality of landscape consists in its 'counterpoint structure'[42]: the 'orchestration' of physical elements, compared with melodic lines, is enriched through the simultaneous '*tonal* and *textural* combinations', which produce further chromatic and timbric polyphonies. Obviously, the recourse to polyphony as a metaphor of the scenic construction points out both the formalist and the abstractionist accents within Eisensteinian cinema: musical polyphony offers a syntactical and formal model for a film language unhooked from the mere referential representation and almost tending towards autotelism. Therefore, the music of landscape theory can be considered as a theoretic product consistent with Russian Formalism, and with modernist aesthetics as well, since it is in intense opposition to the idea that art can be a merely imaginative activity and that querying the images evoked by art is equivalent to querying the sense of the artwork. Essentially, Shklovsky (1925) considers art itself as a procedure, an aesthetic construction, and not as a thought proceeding by images. This is particularly relevant within music, which cannot be understood through images and which is even closer to the idea of aesthetic construction via abstraction to the point where even plastic arts – including painting and filmmaking – 'become musical', when they want to reach the sphere of the abstract.

Nevertheless, this compositional conception – based on a well-grounded analogy with music, if not on an authentic schematic equivalence – does not correspond with an appropriate reflection on 'actual' music. Even if the Eisensteinian analysis bears elective conceptual referents to music, it relegates music itself to silence, overlooking the accompaniment score composed by Edmund Meisel for the Berliner premiere of *Potemkin* at the Apollo Theater on 29 April 1926.

Meisel's commission for the score did not come from Eisenstein but from the German distribution company Prometheus, which distributed the film in Europe and in the US. However, Eisenstein went to Berlin in March 1926 to meet the composer, with whom he worked 'as *one should work* with the sound track, always and everywhere, with the creative cooperation and friendly cocreation of the composer and the director'.[43] The essay *O stroyenii veschey* (*On the structure of things*) (1947) hosts many noteworthy observations about Meisel's music. Most of all, the assumption that *Potemkin*, by placing a structural principle derived from imagery as foundation for its musical component, 'stylistically explodes beyond the limits of the system of "silent picture with musical illustration" ', so to anticipate also '*the possibility of the inner nature of the composition of sound film*'.[44] The director makes reference to two famous scenes: the massacre on the Odessa Steps during act IV, and the 'music of the machines' during act V. Meisel made use of a percussive ostinato, barbaric and unstoppable in its strut, as an acoustic correspondence to the murderous squad of Cossacks in the massacre scene and to the full-speed rush of the battleship later in act V.

Equally interesting, if not the most suggestive part in the score, are the solutions chosen by Meisel at the beginning of act III. In the first 19 measures, which correspond to the first ten framings (plus the first two intertitles), the music proceeds horizontally, following a heterophonic texture, through the alternation and overlapping of two melodic lines, assigned to English horn (Figure 10.8, measures 3–8) and harmonium (Figure 10.9, measures 5–8).[45]

Both have an irregular profile, fraught with semitones and broad intervals, which excludes a tonal orientation. Without tonal expectations in the music score the entire sequence turns out to be absolutely static. In measures 9–10 a third motif emerges in the strings, a three-fold semitonal progression. In measure 11 (Figure 10.10), all voices stop in a fermata on the notes of a vertical aggregate, based on the empty fifth D–A, 'marked' by the emancipated dissonances D flat – E flat. Synchronously with the black buoy framing begins the repetition of the two themes – the first one is now doubled by the first violins – which finishes with a fourth and last trombone motif (Figure 10.10, measures 17–19).

186 New Approaches to Silent Film Music History and Theory

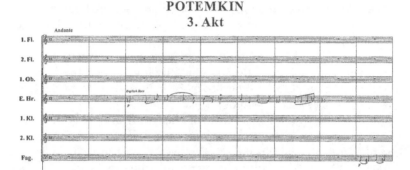

Figure 10.8 Music score of *Panzerkreuzer Potemkin* by Edmund Meisel, Music Publisher Ries & Erler, 2005

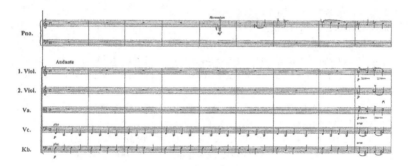

Figure 10.9 Music score of *Panzerkreuzer Potemkin* by Edmund Meisel, Music Publisher Ries & Erler, 2005

Until this point, a very slight accompaniment of cello and double bass pizzicato has been in the background, supported by timpani and entirely formed on the fourth descending ostinato F–C. On the upbeat of measure 19, in correspondence to the framing of the majestic ships in the port of Odessa, a new theme emerges within the strings (Figure 10.11, measures 19–27), directly taken from the revolutionary chant 'Immortal Victims'. The popular song accompanies the vigil on Vakulinchuk's corpse as a mourning chant, to be finally replaced by a marching theme, which will dominate the third act prosecution.

Without any doubt, the temptation of comparing Meisel's heterophony with the Eisensteinian aspiration towards a 'counterpoint structure' of this visual sequence is strong. Similarly, within the aggregate in measure 11 we recognize the 'massive chord of "Solidity"';

Francesco Finocchiaro 187

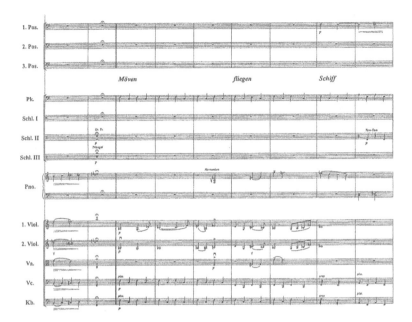

Figure 10.10 Music score of *Panzerkreuzer Potemkin* by Edmund Meisel, Music Publisher Ries & Erler, 2005

the 'tonal and textural combinations' could materialize in the timbric alternation, already considered by Meisel; the 'theme of fire' could be detected within the march, and so on. However, this not only could result in an *ex post facto* interpretation, but it would force us to take for granted the unsupported fact that during the director's stay in Berlin, between March and April 1926, he gave Meisel a precise formal idea about the musical composition. This, however, was only *in nuce* within Eisenstein's thoughts at that moment and he would theoretically organize it 20 years later.

Surely, Meisel's musical choices are absolutely coherent with his creative course, and they do not require heteronomic explanations, least of all when they are based on retrospective analyses: avant-garde techniques like ostinato, heterophony or dissonance emancipation represent the peculiar stylistic traits of the German composer (Figure 10.12). Similarly, we can explain the adaptation of the musical matter to imagery elements in light of the 'illustration' ideal, which is the aesthetical rule of film music praxis during the 'silent' era.

It is surprising that Eisenstein does not spend a single line on the musical accompaniment of the 'symphony of the mist' in his almost

Figure 10.11 Music score of *Panzerkreuzer Potemkin* by Edmund Meisel, Music Publisher Ries & Erler, 2005

2,000 pages of *Neravnodushnaya priroda*, seemingly as if the cinema landscape had an inherent musicality so preponderant that the union with an actual sounding music would have been excessive.

Lastly, this paradox hides the real existence of a contradictory and ambivalent approach towards music, which places Eisenstein in the company of other theorists of silent cinema such as the already mentioned Stindt and Harms. Even hoping for a union between the art forms film and music, Eisenstein seemed to theorize a kind of inner music, purely imaginary, such as the *musica mundana* imagined by Boethius, produced by a numerical and proportional abstract play, articulated by the 'great celestial movement' of the spheres, which has nothing to do with the concrete and deciduous *musica instrumentalis*.

The dichotomy between *musica mundana*, the abstract music of the images rooted within the cinematographic text composition, and the *musica instrumentalis*, the deciduous complementary element for the film projection, permeates Eisenstein's thoughts, at least as far as his presumed 'musical vocation' is concerned, and it is one of the conceptual premises for the music of landscape theory.

Figure 10.12 Manuscript page of the original piano reduction by E. Meisel, Courtesy of the DAMS Library in Turin

Due to a strange paradox, 'plastic music' is allowed to represent every aspect of the musical universe, but it is not allowed to join with the 'real' music. This paradox condemns musical landscape to silence.

Notes

1. Sergei Eisenstein, Vsevolod Pudovkin, and Grigori Aleksandrov, 'Budushchee zvukovoi il'my: Zaiavka' [The Statement on Sound], *Zhizn' iskusstva* 32, (August 5, 1928); translated in Richard Taylor and Ian Christie (eds.), *The*

190 *New Approaches to Silent Film Music History and Theory*

 Film Factory: Russian and Soviet Cinema in Documents 1896–1939 (London and New York: Routledge, 1988): 234–235.

2. Marco Vallora, 'Il nipote di Diderot: Ejzenštejn o la scrittura delle emozioni', in Sergej Ejzenštejn and P. Gobetti (eds.) *La forma cinematografica* (Torino: Einaudi, 1986): VIII.

3. Ibid., XII.

4. George Lakoff and Mark Johnson, *Metaphors We Live By* (Chigaco–London: University of Chicago Press, 1981): 4.

5. Lakoff and Johnson, *Metaphors*, 85.

6. Hans Blumenberg, *Paradigmen zu einer Metaphorologie* (Bonn: Bouvier, 1960); English translation *Paradigms for a Metaphorology*, ed. R. Savage (Ithaca: Cornell University Press, 2010): 67.

7. Blumenberg, *Paradigmen*, 122.

8. Ibid., 132.

9. Georg Otto Stindt, *Das Lichtspiel als Kunstform* (Bremerhaven: Atlantis, 1924).

10. Rudolf Harms, *Philosophie des Films* (Leipzig: Meiner, 1926).

11. Hans Erdmann, Giuseppe Becce and Ludwig Brav, *Allgemeines Handbuch der Film-Musik*, 2 Vol. (Berlin-Lichterfelde/Leipzig: Schlesinger'sche Buch- und Musikhandlung, 1927).

12. *Malerei mit Zeit* is the title of a famous writing by Ruttmann, *c*. 1919. The document is now reproduced in *Berlin, die Sinfonie der Großstadt & Melodie der Welt*, directed by Walter Ruttmann (1927; Edition Filmmuseum München in collaboration with Bundesarchiv Berlin and ZDF/ARTE, 2010), 2 DVDs.

13. The essay *Neravnodushnaya priroda* [*Nonindifferent nature*], edited by Eisenstein in 1945, should have been occupying the fourth and last part of a vast theoretical work that was left unfinished. These are the remaining parts: I. *O stroyenii veschey* [*On the structure of things*]; II. *Pafos* [*Pathos*]; III. *Yeschyo raz o stroyenii veschey* [*Once again on the structure of things*]. This segment of the work has been published in Russian language in 1964, in L.A. Il'ina (ed.) Sergei Eisenstein, 'Neravnodushnaya priroda', Id. *Izbrannye proizvedeniya v shesti tomakh* (Moskva: Iskusstvo, 1963–1970) III: *Teoreticheskie issledovaniya (1945–1948)* (1964): 251–432; English translation 'Nonindifferent Nature', in H. Marshall (ed.) Sergei Eisenstein, *Nonindifferent Nature* (Cambridge, MA: Cambridge University Press, 1987): 216–396.

14. Eisenstein, 'Neravnodushnaya', 216.

15. Ibid., 217.

16. Ibid., 216.

17. Ibid.

18. Richard Wagner, *Oper und Drama* (Leipzig: Weber, 1852); English translation *Opera & Drama*, ed. E. Evans (London: Reeves, 1913).

19. Schoenberg, Arnold. 'Das Verhältnis zum Text', in W. Kandinsky and F. Marc (eds.), *Der blaue Reiter* (Munich: Piper, 1912): 27–33; English translation as 'The Relationship to the Text', in Arnold Schoenberg, *Style and Idea: Selected Writings of Arnold Schoenberg*, ed. Leonard Stein, trans. Leo Black (New York: St. Martins Press; London: Faber & Faber, 1975): 141–145.

20. Eisenstein, 'Neravnodushnaya', 218.

21. Ibid.

22. Ibid., 219.

23. Ibid., 355.

Francesco Finocchiaro 191

24. Ibid., 355.
25. Ibid., 218.
26. Ibid., 218.
27. Ibid., 217.
28. Ibid., 225.
29. Ibid., 226.
30. Ibid.
31. Ibid.
32. Boris Tomashevsky, *Teoriya literatury. Poetika* (Moskva–Leningrad: Gosudarst-vennoe izd-vo, 1928); partial translation *Thematics*, in *Russian Formalist Criticism. Four Essays*. ed. L.T. Lemon and M.J. Reis (Lincoln: University of Nebraska Press, 1965): 61–95 (78).
33. Tomashevsky, *Teoriya*, 68.
34. Ibid., 67.
35. Ibid., 68.
36. Eisenstein, 'Neravnodushnaya', 219.
37. Ibid., 238.
38. The initial section in brackets translates the first part of Eisenstein's discourse, since the English edition (Eisenstein 1945, 228–229) seems to omit the original incipit.
39. Eisenstein, 'Neravnodushnaya', 228–229.
40. Viktor Shklovsky, *O teorii prozy* (Moskva–Leningrad: Krug, 1925); English translation *Theory of Prose*, ed. B. Sher (Elmwood Park: Dalkey Archive Press, 1990).
41. Veselovsky, Alexander. *Sobranie sochineniy* (Poetika), II Vol.: Poetika syuzhetov (Sankt Petersburg: Tipogr. Imperat. Akad. Nauk, 1913).
42. Eisenstein, 'Neravnodushnaya', 253.
43. Sergei Eisenstein, 'O stroyenii veschey', in L.A. Il'ina (ed.) Id. *Izbrannye proizvedeniya v shesti tomakh* (Moskva: Iskusstvo, 1963–1970), III: *Teoreticheskie issledovaniya (1945–1948)*, (1964): 37–71; English translation 'On the Structure of Things', in H. Marshall (ed.) Sergei Eisenstein, *Nonindifferent Nature* (Cambridge, MA: Cambridge University Press, 1987): 3–37 (32).
44. Eisenstein, 'O stroyenii', 33.
45. Here we refer to the score reworked by Helmut Imig in 2005, in concomitance with the film restoration by the Deutsche Kinemathek in *Panzerkreuzer Potemkin – Das Jahr 1905*, directed by Sergei Eisenstein (1926; Berlin: Deutsche Kinemathek – Museum für Film und Fernsehen, Transit Classics, 2005), DVD. The score, published in 2005 by Ries & Erler, Berlin, was orchestrated and adapted by Helmut Imig, following the indications found in the original piano reduction and the few still intact instrumental parts. The timbric choices are a result of the editor's work. For the rest, the Meiselian original dictation has been reconstructed in a fairly accurate way, as can be verified by comparing it with the piano reduction (Figure 10.12), kindly provided by the DAMS Library in Turin.

11
Paradoxes of Autonomy: Bernd Thewes's Compositions to the *Rhythmus-films* of Hans Richter

Marion Saxer

> Wie wir wieder und wieder gesehen haben, verringern Bindungen nicht die Autonomie, sondern fördern sie.[1]
>
> *Die Hoffnung der Pandora*, Bruno Latour

Film history on ARTE – cinematic art in restored versions

The Franco-German TV network ARTE is the only European TV network that has dedicated a regular TV slot to showing early contributions from film history. Its monthly series *Stummfilm-Rendezvous* has been shown since 1997 by both Arte France and Arte Deutschland, a subsidiary of the two main public German TV networks ZDF (*Zweites Deutsches Fernsehen*) and ARD (*Arbeitsgemeinschaft der öffentlich-rechtlichen Rundfunkanstalten der Bundesrepublik Deutschland*). In these broadcasts, ARTE presents film history in its most beautiful form: by showing restored copies from the stock of international film archives. These activities are financially supported by ARTE and offer a wide public access to such films. Thanks to increasingly close cooperation, the channel is able to present trouvailles from film history – for example, films that were thought to have been lost or newly restored film classics as well as rarities which show how innovative and unorthodox early cinema really was.

The ZDF with its numerous own productions is an active collaborator within this project and it's commitment to early cinematic history is part of a long tradition. Jürgen Labenski and his colleague Gerd Luft initiated the renaissance of silent films within this TV network in the 1980s and both deserve great credit for this achievement. Nowadays it is the new generation of cineastes in film editing and in the archives who

seek cooperations and try out new restoration techniques – in this way they not only ensure film stocks are safeguarded but also offer valuable programs about film history.

A second emphasis of ARTE's film program is the production of new film music. The program not only includes new compositions for silent films but is also involved in the reconstruction and recording of original film scores. Within the past few years, the many new recordings of film music which have been preferentially realized for its silent film program have put ARTE into the unique position of being the only TV channel producing film music. In doing so, ARTE helps to preserve and cultivate the genre of historical film music which, because of the time-consuming and cost-intensive reconstruction work, could not be financed otherwise.

In the last 15 years, 230 productions have been realized, among these such prominent films as *Die freudlose Gasse* (Georg Wilhelm Pabst, 1925, music: new composition by Aljoscha Zimmermann), *Menschen am Sonntag* (Robert Siodmak, 1929/1930, music: new composition by Elena Kats-Chernin), *Die Nibelungen* (Fritz Lang, 1924, music: reconstruction of the historical compilation score including themes by Debussy, Honegger, Milhaud, Satie and others, compiled by Gottfried Huppertz) and *Intolerance* (David W. Griffith, US 1916, music: new composition by Antoine Duhamel and Pierre Jansen), just to mention a few examples. New soundtracks were produced for about 70% of the 230 productions (among these were orchestral scores by Carl Davis, piano accompaniments and ensemble scores). In addition, 40 (15%) of the recorded scores were historical ones, and a number of compositions for 20th- and 21st-century new music and jazz were also commissioned.[2]

'Der absolute Film' and the commission of Bernd Thewes

On 3 May 1925 the so-called 'Novembergruppe' (named after the German Revolution that began in November 1918/1919 and overthrew the monarchy), formed around Max Pechstein, Hanns Eisler and Lyonel Feininger, arranged a matinee at the Ufa Theater am Kurfürstendamm in Berlin in which they presented ten short silent films each lasting between 3 and 19 minutes. It was a compilation of works from seven German and French artists with very different artistic techniques and concepts that all had one thing in common: they all avoided narrative structures.

The idea of art without references to the representational world stems from the 19th century. Richard Wagner coined the term 'absolute

music' as a pejorative expression with the aim of denigrating music arising of its own accord – music composed without any connection to extra-musical elements and references. In juxtaposition to absolute music he set program music and his own all-encompassing musical concept – *Musikdrama* – which he considered superior. Both terms have been the subject of controversial debates since the middle of the 19th century.

While the medium film was going through a period of self-discovery, the avantgardists, with the idea of 'absolute music' in mind, attempted to find its equivalent in the art form of moving images. The artists of the November Group tried to transfer the idea of 'absolute music' to the new film medium and entitled their matinee 'Der absolute Film'.[3]

The Swedish filmmaker Viking Eggeling, who had immigrated to Germany, animated approximately 6,700 of his pictures of two-dimensional, white, silhouette-like reliefs on black background to a gently flowing drawing (*Symphonische Diagonale*, 1924). His friend, the constructivist Hans Richter from Berlin, made his contributions *Rhythmus 21* (1921) and *Rhythmus 23* (1923) under the title 'Film ist Rhythmus' by using geometric figures that seemingly randomly grow, recede, intersect and displace each other. The painter and architect Walter Ruttmann from Frankfurt, who became famous in 1927 for the city film *Berlin – Die Sinfonie der Großstadt*, did the same thing as Richter in *Opus 2*, *Opus 3* and *Opus 4* (1921/24/25), though his animations were more intricate in shades of gray with a smoother sequence of movements which he ingeniously tinted in color. In Ludwig Hirschfeld-Mack's *Sonate und Kreuzspiel* (1922/23), the red, blue and yellow light projections resembled a Kandinsky painting that had been elaborately brought to life. More figurative were René Clair's *Entr'acte* (1924) and *Ballet Mécanique* (1924) by Ferdinand Léger and Dudley Murphy. In the last two works mentioned, an absurd playground of technical possibilities was presented: slow motion, dissolves, reverse playback, duplicated pictures and freeze frames devoid of any contextual meaning whatsoever celebrated Dada in its purest form.

These film screenings in May 1925 took place largely in their silent versions; only a few films, for instance Hans Richter's contributions, had a musical concept, though today this has been lost. In 2008 ARTE broadcast all the films of the legendary matinee complete with music. In this program Ruttmann's *Opus 3* was furnished with the atonal music of Hanns Eisler (completed two years after the matinee). Léger's *Ballet Mécanique* was set to George Antheil's stirring composition for 16 pianolas, 8 pianos, xylophone, orchestral percussion, bells, propellers and sirens, written for the film in 1926. René Clair's *Entr'Acte*

was complemented by Erik Satie's original orchestral music. For some films, ARTE commissioned composers of contemporary music to create new compositions: Austrian composer Olga Neuwirth wrote the music for Eggeling's *Symphonie Diagonale*, and German composers Ludger Brümmer and Sven Ingo Koch contributed the music to Ruttmann's *Opus 2* and *Opus 4*. Another composer was the German Bernd Thewes. He wrote the scores for the films of Hans Richter, which were interpreted by the *Ensemble Ascolta*.

Thewes has been artistically involved with silent films in many ways. He participated in the restoration of several silent movies; that is, he arranged the film music for the very successful reproduction of Robert Wiene's *Rosenkavalier* (1926) in Dresden in 2006, and for Ruttmann's *Berlin – Die Sinfonie der Großstadt* (1927) he arranged the orchestral score of the music by Edmund Meisel. His recent arrangement – the orchestral version of the piano music by Adolph Weiss to the silent movie classic *Der Student von Prag* (1913) – was staged with great success on 15 February 2013 at the Volksbühne Berlin in the course of the renowned film festival Berlinale.

Furthermore, he has composed music for several silent movies such as *Die Schwarze Kugel oder die geheimnisvollen Schwestern* (Franz Hofer, 1913) and for Carl Dreyer's *Die Gezeichneten* (1922), which was interpreted by members of the *Ensemble Modern*. Besides his work as a composer of film music, Thewes is also an established composer of music in his own right and has composed numerous pieces commissioned for orchestra and ensemble. In his experimental pieces he often explores the possibilities of unusual scoring as, for example, in his *Streichquartett – Wait for the Richochet* adapted from Deep Purple's song 'Child In Time für Streichquartett, Klangmaschine "Pressluftgeiger" und 5-kanalige Zuspielmusik' (2006).[4] In his orchestral works he establishes a link to literature, as in *abwendigMACHT* (2006). Another aspect of his compositions is his very conscious approach to the medial transfer process, as in the orchestral piece *Die siebende Gestalt. SPEECH REMIX nach Jakob Böhme für Orchester (2007)*.[5]

Thewes's fundamental considerations on silent film music

The work of Bernd Thewes is of special interest because he links being a composer of music in his own right to arranging original music for silent films by commission, and the two kinds of work influence each other. First I would like to describe some of Thewes's basic considerations, which apply to the compositions for both films of Hans Richter.

196 *New Approaches to Silent Film Music History and Theory*

Thewes acts under the assumption that the temporality of the film medium differs in principle from the temporality of music. While moving images work with an inevitable spatialized time, music has, in contrast, a more fluid time character. The *Rhythmus-films* of Hans Richter are therefore of great interest to Thewes as they focus on the articulation of time – which results in an intermedial relationship to the time-based art of music. Richter understood his films as a bridge between abstract painting and film. He had abandoned the narrative story in his films in order to show visual rhythms with abstract moving forms. His *Rhythmus-films* offer a high-contrast alternation between light/dark, horizontal/vertical, large/small and fast/slow shapes of white, gray and black squares; rectangles and bars which 'grow and recede and jump or slide in well-articulated time-intervals and planned rhythms' (Hans Richter). The basic form of this 'light pattern' is the rectangular screen. Richter systematically develops his figures out of the whole area of the film frame by recognizing that the frame itself is a formal element that is orchestrated at rhythmic intervals. Richter remarked that he wanted to replace an 'orchestration of form' – which is painting – through an 'orchestration of time' – which is film.[6]

It is an important compositional concern of Thewes not to reconcile the two different media film and music by compulsion (what he calls 'zwangsversöhnen'). In fact, he wants to treat them as a non-hierarchical, level media combination. The music is not supposed to document or illustrate the film rhythm, but should rather be composed as a discrete musical articulation, which merges with the visual pictures to create something singular and new. In striving for this aesthetic goal, the composing situation becomes in a sense a paradox: Thewes has to react to the film rhythm *and* to compose an autonomous piece of music at the same time.

In his compositional approach, Thewes is also conscious of the historical gap that separates the present from Richter's films. In the early 1920s, Richter's films were considered among the pioneering works of avant-garde film experiments. Although the formerly brand new découpage technique looks outdated today, the film's renown still adds glamor to the dusty old flickering pictures. As experiments in perception, their relevance remains unchanged. Thewes musically takes account of the historicity of the films with a specific jazz sound character. On the one hand he pays homage to Hans Richter, who was a great jazz fan – and jazz can be regarded as *the* sound of the twenties, after all. On the other hand, the sound material that is typical for jazz – for example, scales and repetitions – has a certain expressive neutrality more affine to the

abstract forms of the films as a more individually shaped, expressive melodic style. The third important point is that Thewes manages to create a musical language of his own while following the jazz idiom – a further paradox, similar to the above-mentioned one.

Thewes achieves this special sound quality with some compositional strategies that modify the jazz idiom in an original way. At first he superimposes contrapuntal layers, which produce a more dense sound complexity than generally used in jazz. Then, as a further differentiation, he turns away from modal scales. Thewes's exposure with pitches is completely free, without tonal echoes; that is, in *ad Rhythmus 21* there is a sort of 'walking bass' but Thewes uses predominantly chromatic or irregular scales for it.

Thewes varies typical jazz practice particularly with regard to the time articulation. He continuously uses changes of meter, which generate a complex time structure outside of musical measure. Figure 11.1 shows an example of a scale structure from *ad Rhythmus 21*.

Figure 11.1 Score example of *ad Rhythmus 21*, bars 25f., courtesy of Bernd Thewes (composer)

198 *New Approaches to Silent Film Music History and Theory*

The chromatic scale of the cello illustrates the irregularity of the time structure. The same part of an ascending and descending chromatic scale is only varied through changes of meter from nine/semiquaver to two/quaver to seven/semiquaver to six/semiquaver to five/semiquaver. This irregular time structure is a main component of the equal status between film and music and might also be an underlying motivation for the subtitle given to the piece by Thewes, that is *add rhythm to rhythm 21*. The flow of musical motion follows its own laws. A measured musical stream tends more to be perceived as subordinate, because the metrical pulse generates a hierarchy, in which the rhythm of moving images is permanently related to the simple structure of constant, equal time intervals.

The time structure of both scores is based on a very precise digital time analysis of the film images (see Figure 11.1). This does not weaken the autonomy of film and music, as I will attempt to demonstrate with more concrete examples of the two pieces, which use different compositional strategies of combining film and music.

Strategies of combining film and music in *ad Rhythmus 21 by Hans Richter*[7]

This composition has its own musically based form, which can be described as a process. Thewes marked the different sections in the score with titles designating the main instrument of the part. Such a denotation is related to jazz practices, where instrumental solo parts are common. In *ad Rhythmus 21* there are seven sections (Figure 11.2). The musical process is a gradual agglomeration and increase to a phase of culmination in part E. Then follows a phase of sedation and rhythmic resolution until the end of the piece.

In the following, two characteristic strategies will be explained in detail. In sections A to D, Thewes places a lot of precise synchronic points between the two media, which bind them together in a sort of artificial intermodal linkage. Intermodality is the ability to interrelate sensations from different senses; for example, in every day life we automatically connect the image of a book falling down onto a wooden table with the sound this produces – and we are very confused if we hear nothing. Because of this intermodal routine, it is virtually impossible for the human apperception not to relate visual and aural sensations, which are synchronic and gradually changing – even if they are completely simulated.

Figure 11.2 Process *ad Rhythmus 21 von Hans Richter* [author's illustration]

Thewes toys with this automatism of apperception by establishing artificial intermodal connections and suddenly suspending them (Figures 11.3 and 11.4).[8] In the cello-part (Figure 11.4, bar 25 ff.), Thewes relates the appearance of a big white square four times in succession very precisely with a cue of a trumpet-sliding combined with a high signal by the vibraphone, so that the apperception is adjusted to link visual and aural sensations. This is confirmed in the following phase, where ascending and descending chromatic scales in the trumpet are bound to increasing and decreasing rectangles. As soon as such a system of correlation is established, Thewes then cuts off this new 'routine' and connects an ascending scale with a decreasing rectangle and leads the whole phase to an end. Hence, the recipient again and again couples film and music automatically and then loses the sensuous criteria of this coupling. In the process of apperception, it is impossible to build a hierarchy between the two media.

The routine of intermodal apperception is mostly disrupted towards the end of the film. While the music becomes more and more even-tempered, the energy of the film rhythm remains continuously high. There is even a kind of visual recapitulation with the recurrence of the large black and white squares, which opened the film. The music ignores this formal regress completely with the result that the formal process of moving images and music is now perceived more separately. Hence both media are perceivable in their own motion and discreteness (Figure 11.5).

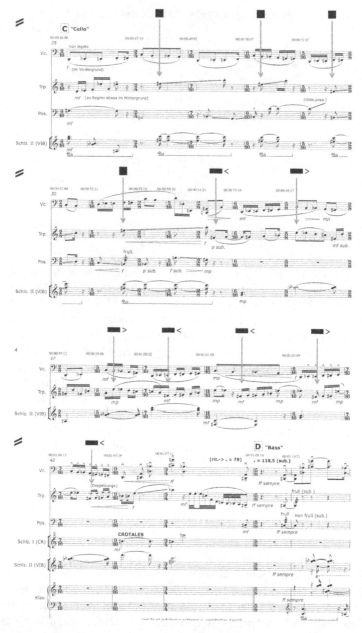

Figures 11.3 and 11.4 Music example, *ad Rhythmus 21 von Hans Richter*, courtesy of Bernd Thewes (composer)

Process ad RHYTHMUS 21 von Hans Richter

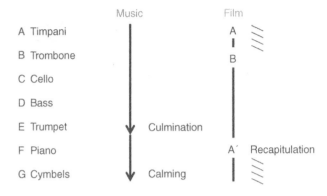

Figure 11.5 Counter Movement (*Gegenläufigkeit*) [author's illustration]

Strategies of combining film and music in ... *alles weg mit klein explo* ...

In Thewes's second piece, ...*alles weg mit klein explo*...*Musik zum Film Rhythmus 23 von Hans Richter (1923) für Violoncello, Flügelhorn, Posaune, 2 Schlagzeuger, Klavier und E-Bass (2007)*, the compositional approach is completely different. Thewes started off with a very individual analysis of Richter's film. He translated the non-narrative, abstract film images in a sort of retransfer into a new, fragmented story, which he calls 'imaginary level of narration' (*imaginäre Erzählebene*). For this purpose, he divided the film into 15 sections with descriptive titles such as 'coalition and separation' (*Vereinigung und Trennung*...) or 'there they roll about, the diagonals' (*da rollen sie übereinander, die Diagonalen*...) (Figure 11.6).

He then segmented the sections again into small, precisely measured chapters, which follow the transition of the film images. All these short parts, which sometimes last only one second or less, are labeled with words that mark either the motion and spatial organization like 'one from the back' (*einer von hinten*), or the time character like 'suddenly the black square' (*plötzlich das schwarze Quadrat*), or representational or fantastic associations like 'city landscape in motion' (*Stadtlandschaft in Bewegung*) and 'even cut doors of the other world' (*sogar geschnittene Jenseitstore*). These narrative fragments finally remain abstract because there is no continuous storyline in a traditional sense. It is a subjective decision of the artist to articulate in words his impressions of the film.

202 New Approaches to Silent Film Music History and Theory

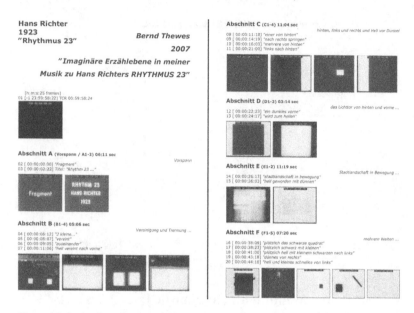

Figure 11.6 Analysis by Bernd Thewes, courtesy of Bernd Thewes (composer)

In his analysis Thewes furthermore visualized the chapters with screenshots, which means to transfer the in-time structure of the film images to the analyzed outside-time structure of numbers, pictures and words (Figure 11.7).[9]

Section M has especially fast changes of images (see Figure 11.7). This outside-time structure serves as the basis for the composition. But, as in the first piece, Thewes does not want to follow the form of the film; he rather wants to contrast it with something like a musical counterpoint. The score of the piece shows the idea of a visual/aural counterpoint very well. Thewes's score contains its own system for the film, where he precisely notates the transition of the images. The rhythm of the click-track has its own system too. Some sections look like a very balanced classical style (*durchbrochener Satz*) (Figure 11.8). The visual rhythm becomes perceivable as a discrete 'voice', which articulates vivid rhythmic gestures with the musical motion. Film and music melt to an overall audiovisual impression, where it is difficult to differentiate between hearing and seeing.

For the music to *Rhythmus 23* Thewes decided not to exclude sound associations that were evoked by the film, which even led to a musical quotation: in section I 'the nice diagonals' (*die schönen Diagonalen*),

Marion Saxer 203

Abschnitt M (M1-12) 06:04 sec

 cut, cut, cut ...

50 [00:02:10:16] "<01> kipp rechts"
51 [00:02:11:02] "<02> klein rechts"
52 [00:02:11:12] "<03> plong groß"
53 [00:02:11:23] "<04> klein"
54 [00:02:12:09] "<05> rechts"
55 [00:02:12:18] "<06> klein"
56 [00:02:13:04] "<07> mitte"
57 [00:02:13:15] "<08> plong groß"
58 [00:02:14:00] "<09> klein"
59 [00:02:14:19] "<10> plong groß"
60 [00:02:15:05] "<11> klein"
61 [00:02:15:13] "<12> rechts wächst"

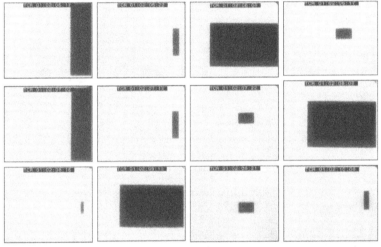

Figure 11.7 Analysis by Bernd Thewes, Section M, courtesy of Bernd Thewes (composer)

while two diagonals continue to draw closer until they overlap, Thewes's composition contains a harmonic turn which sounds like a dreamed Tristan-chord. This is the most programmatic moment in the otherwise abstract event.[10]

Composing music to a film is always a kind of collaboration with a machine. Film as a completely technical medium has its own terms of use and characteristics. Not only the composer, but also the film as a medium, composes. Hence one could speak of a sort of distributed agency between the film and the composer. The abstract silent films of Hans Richter enabled Bernd Thewes to articulate very concentrated apperception experiments. Situated in the paradox of autonomy – as I hope to have demonstrated – Thewes composed, in interaction with

204 *New Approaches to Silent Film Music History and Theory*

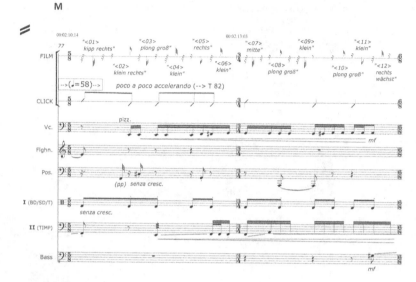

Figure 11.8 Score to *Rhythmus 23*, Section M, Courtesy of Bernd Thewes (composer)

the film images and rhythms, musical structures that equate hearing with seeing.

Silent movies and live music

Furthermore, Bernd Thewes specifically intends that musicians perform his compositions live at the same time as the films. This might initially appear as if he wanted to recreate the historical performance context of the silent film era. However, the whole setting of the pieces – most notably the artistic issues involved – have changed so drastically that a completely new set of circumstances of media combination is the result. In order to realize Thewes's artistic concept the musicians' timing has to be extremely precise, which in the era of silent films was generally not a great priority. The use of the click-track, a technical development that originates in the early years of sound films, guarantees the precise synchronization of image and sound intended by Thewes. Whereas during the silent film era the projection speed was controlled by a lever so that the film could be adjusted to the live music in the moment, Thewes's compositions oblige the musicians to strictly keep in time with the film.

By including live music in his pieces, Thewes is nevertheless able to share a feature of the historical combination of media in the silent film era, though today it is handled more consciously than at the time when Richter produced his films. Showing the musicians as performers on a stage is a form of 'hypermediacy', which Bolter and Grusin describe as a 'style of...representation, whose goal is to remind the viewer of the medium'.[11] While film as a purely technical medium cannot provide anything tangible about the process of its making, live music allows its audience to directly experience the origin of the sounds and so complements the cinematic events, giving them a specific form of authenticity or immediacy which is cinematically not possible in this way. Live music shifts the mediation of the whole media combination into the foreground as it 'create[s] a feeling of fullness, a satiety of experience, which can be taken as reality'.[12] In addition, the media combination of film and live music is a technically supported form of live experience, typical of 20th-century media.[13]

The special form of hypermediacy that is obtained when combining silent films with live music can provide a reason for the increasing interest in this historical mixed-media practice. In particular, concerts that are performed with not only a restored version of a silent film but also with reconstructed original scores are extraordinarily popular and have met with great success. The fall-back on the original media combination of silent film and live music provides us with two forms of authenticity: first, it has the character of a historically-documented reconstruction; and second, it evokes feelings of immediacy and experience that are coupled to hypermediacy. This doubled authenticity guarantees part of the attraction of the 'new-old' media format.

This phenomenon can be found in current digital culture in two respects. On the one hand both cinematic and musical reconstructions of present-day standards are only realizable with the aid of digital means and are therefore based on the latest technology. On the other hand, contemporary digital culture is, however, also characterized by the fall-back on older media situations, as well as new combinations of media formats.

As a side note, the current success of the combination of film and live music is of great relevance with regard to media-historical considerations. The process of reciprocal influence of older and newer media has already been described by Bolter/Grusin: 'Newer media do not necessarily supersede older media because the process of reform and refashioning is mutual.'[14] And Jonathan Sterne suggests conceiving of such processes of cross-references between media as a typical routine. He tries to

206 *New Approaches to Silent Film Music History and Theory*

describe media history as 'a nonlinear, relational causality, a movement from one set of relations to another'.[15]

While the combination of silent film and live music is already a form of hypermediacy because it reminds the public of the media that are used, Bernd Thewes extends hypermediacy into the structure of the composition itself: as apperception experiments, he puts the relationships of moving images and music in a meta-reflexive state. Not least, in doing so he widens the compositional options of film music through the paradoxes of autonomy.

Notes

1. 'As we have seen again and again, bonds do not reduce autonomy, but they foster it.' [Translation by the editors of this volume.] Bruno Latour, *Die Hoffnung der Pandora* (Frankfurt am Main: Suhrkamp 2002): 338.
2. Thanks to Nina Goslar, producer of the ARTE silent film program, for providing this information.
3. Christian Kiening and Adolf Heinrich, *Der absolute Film. Dokumente der Medienavantgarde (1912–1936)* (Zürich: Chronos 2011).
4. Achim Heidenreich, 'Zwischen Klanginstallation und Konzert – Der Komponist Bernd Thewes', *MusikTexte* 95 (November 2002): 13–18.
5. Marion Saxer, 'Komposition im Medienwandel. Operationsketten als kompositorische Strategien bei Peter Ablinger, Bernd Thewes und Isabel Mundry', in Christian Utz (ed.) *Musiktheorie als interdisziplinäres Fach. 8. Kongress der Gesellschaft für Musiktheorie Graz 2008* (musik.theorien der gegenwart 4) (Saarbrücken: Pfau, 2010): 481–495.
6. For details on the cultural-historical meaning of Richter's films, see Christoph Bareither (ed.), *Hans Richters 'Rhythmus 21': Schlüsselfilm der Moderne* (Würzburg: Königshausen & Neumann, 2012).
7. The full title of Thewes's piece for this film is *ad Rhythmus 21 von Hans Richter oder add rhythm to rhythm 21. Musik zum Film Rhythmus 21 von Hans Richter (1921) für Violoncello, Trompete, Posaune, 2 Schlagzeuger, Klavier, E-Bass und Dirigenten mit Click-Track (2006)*.
8. For other examples for composing with intermodal irritations, see Marion Saxer, 'Komponierte Sichtbarkeit. Intermodale Strategien in Annesley Blacks Video-Komposition 4238 De Bullion für Klavier solo und live-elektronische Klang- und Videobearbeitung (2007/2008)', in Marion Saxer (ed.) *Mind the Gap! Medienkonstellationen zwischen zeitgenössischer Musik und Klangkunst* (Saarbrücken: Pfau, 2011): 50–66.
9. The terms 'in-time structure' and 'outside-time structure' stem from Iannis Xenakis's elaborations on musical architecture and categories. Iannis Xenakis, *Formalized Music. Thought and Mathematics in Composition*. 2nd revised English Ed. Harmonologia Series 6 (Stuyvesant, NY: Pendragon Press, 1992).
10. We should not forget that the Tristan-chord is a musical articulation of *seeing*. It can be heard in the moment of love at first sight between Tristan and Isolde.

11. Jay David Bolter and Richard Grusin, *Remediation. Understanding New Media* (Cambridge, MA: MIT Press, 2000): 272.
12. Ibid., 53.
13. Philip Auslander, *Liveness: Performance in a Mediatized Culture* (New York: Routledge, 2008).
14. Bolter and Grusin, *Remediation*, 59.
15. Jonathan Sterne, *MP3: The Meaning of a Format* (Durham: Duke University Press, 2012): 9.

12
The Tradition of Novelty – Comparative Studies of Silent Film Scores: Perspectives, Challenges, Proposals

Marco Bellano

'Music for the silent film was an independent, ever-changing accompaniment'[1]: from theater to theater, many different musicians worked on the same single silent picture. As a result, each film could have many different 'scores'. Even when original compositions started to spread around 1908,[2] only the big theaters in the most important cities in Europe or in the US were likely to benefit from that music: the smaller towns (with lesser artistic resources) often preferred to continue with compilation/improvisation practices.[3] The existence of multiple interpretations created a tradition based on the continuous renovation of film music: a tradition of novelty.

In the contemporary age, especially since the Thames Television presentation of Abel Gance's *Napoléon* (1927) with music by Carl Davis (1980), the musical repertoire for 'the Silents' has started to increase again. In the past 30 years, the venues where silent films are screened with the aim to represent and reflect historical performance practices have multiplied, as has the production of music especially conceived for those screenings.

While studies on silent film music have dealt with the analysis of single scores, they have seldom tried to take advantage of the availability of alternative musical interpretations of the same film. A comparative approach to silent film music analysis could be a knowledge-producing method. Studying how composers gave different or equal importance to certain elements of a film might impart a deeper knowledge of the communicative potentials of the director's work. A comparison between a

historical score and a contemporary one can provide scholars with great insights into the transformation of the audiovisual language. In this chapter, I will outline problems and purposes of a comparative study of music for silent film. The exposition will rest on examples from different interpretations of Fritz Lang's *Metropolis* (1927) (Gottfried Huppertz, 1927; Bernd Schultheis, 2001) and Buster Keaton's *The General* (1926) (Robert Israel, 1995; Joe Hisaishi, 2004; Alloy Orchestra, 2004).

General film music studies have not felt the urge to develop comparative analyses of this kind, as it is obvious how, since the advent of sound cinema, each film receives a unique and unchanging synchronized soundtrack. The exceptional cases of alternative scores for sound films were too few to lure researchers into analytically comparing the efforts of different composers on the same film on a larger scale. Moreover, even if an alternate score is commercially available – as in the case of Alex North's unused music for *2001: A Space Odyssey* (Stanley Kubrick, 1968) and Bernard Herrmann's score for *Torn Curtain* (Alfred Hitchcock, 1966) – there is usually no version of the actual film featuring it. So, it would not be possible to work on defined audiovisual relationships, but just on hypotheses.[4] In addition to that, it is necessary to remark how the expression 'comparative studies' should always be used with great care and be properly explained. In fact, comparative research is generally understood as a research method mostly applied in literary criticism, or in sociology and cultural studies. On the one hand, 'Comparative literature...in brief...is the comparison of one literature with another or others, and the comparison of literature with other spheres of human expression.'[5] On the other hand, 'Comparative research or analysis is a broad term that includes both quantitative and qualitative comparison of social entities.'[6] Even when used with regard to other disciplines, comparative research is usually associated with a social and cultural point of view and often with a comparison between relevantly different objects. This is not, however, a strict rule: as an example, comparative literature is of course entitled to study a text and its transcription, even when they both use the same linguistic code and they come from the same age.[7] The comparative study of cultural objects with a high grade of affinity is thus a reasonable option. In the area of music, comparative musicology was the first denomination of ethnomusicology (up to the 1950s), and it mostly referred to the cross-cultural study of the musical expression.[8] As for cinema, nowadays we can still quote Paul Willemen: '...It must be acknowledged that comparative studies in cinema do not as yet exist'.[9]

210 *New Approaches to Silent Film Music History and Theory*

Comparative studies in silent film music are non-existent, too. And if they did exist, they would certainly need a reasonably different approach from the sociological/cross-cultural one. In fact, the comparison would not be made between two different techniques or languages. Moreover, cross-cultural issues would be addressed only in circumscribed cases, for example in a synchronic comparison (two silent film scores from the same period) and if the authors come from a meaningfully different cultural background, or in a diachronic comparison (scores from different periods) when the time gap between the objects of study is significantly wide. In any case, the objects of a silent film music comparative research would mostly be two or more musical interpretations of a film, which is supposed to remain exactly the same. It is necessary to underline the expression 'supposed to': in fact, the issue of possible differences between alternate prints of the same film is one that needs to be seriously taken into account if scholars want to give a firm grounding to this comparative discipline. This kind of research would need to be especially focused, because it would deal with musical creations stemming from a shared visual source. That is to say, while the study of a text and its variants, for example, is only an option within comparative literature, the comparison of variants of a single film would be at the core of comparative research about silent film music (those 'variants' are actually different audiovisual outcomes of the same film; as will be explained later. What the researcher studies is not only the film or a performance, but the final and *fixed* result of a performance based on a film).[10]

A similar approach to the first proposed instance of comparative research can be found in a few recent musicological studies, dedicated, for example, to the comparison of different interpretations of a same musical piece[11] or of different *Lieder* based on the same poetic text.[12] The method is different, however: Sapp uses a computerized quantitative approach, transforming the performances into numeric data, whereas Cheng bases the comparison on the formal and harmonic structure.

Scholars who carry out comparative silent film music research would thus have many different methodological options at their disposal. However, it is nonetheless recommendable to use an approach that implements analytical devices already tested in film music analysis in order to assure continuity within film music (analysis and) literature. A key feature to be considered is the use of audiovisual functions: the description of the purpose of the music in relation to a certain film

sequence. Even in the comparative field, it would be fruitful to keep in mind Sergio Miceli's warning:

> To isolate an audiovisual object within the narrow borders of the event under analysis might entail a sensible distortion of its dramaturgical values since the events that precede and follow the segment taken into account might modify its reach, its meaning and, eventually, its evaluation.[13]

So, a reasonable model for comparative analysis could be a contextualized comparison of audiovisual functions as they appear in different musical versions of the same film.

Before attempting such an analysis, however, a further warning is necessary. It concerns the objects of this comparative research. Because of the situation with regard to the historical sources on silent film music, the comparative approach should not aim to extract general rules or patterns describing the sound practices during the silent age. As Altman reminds us in 2004:

> Not only are the performances themselves forever lost, but even their traces... Many original performances were improvised and thus from the start lacked a written record. Where sheet music was used, it has by and large gone the way of other cheaply produced century-old paper documents. Even when the printed music remains, we rarely know when it was used, how it was performed and what its relationship was to which film(s).[14]

The consequences of those unfortunate premises are evident. In order to compare audiovisual functions, it is necessary to deal with a fixed, unchangeable synchronization between images and sounds, as a specific music can generate a function only when joined with a certain sequence. An alteration of the match between music and film scenes can generate a completely different set of audiovisual functions. In order to grant consistency to the comparative approach, the ideal study object would be a fixed and unchangeable combination of sound and image so that scholars could work with materials that give them an unmistakable comprehension of the film–music synchronization. Those materials would be:

– cue sheets complete with detailed indications about the joining between music selection and scenes;

212 *New Approaches to Silent Film Music History and Theory*

- musical scores where the composer or some other author noted verbal cues to create an exact match between the music and the film;
- DVD or video releases of silent films synchronized with music;
- audiovisual recordings of silent film music performances.

The largest number of comparable items presents itself to the contemporary researcher in the form of original compositions, compilations and musical settings that followed the silent film renaissance of the 1980s. By contrast, the amount of historical documents that provide a fixed synchronization between music and images is very small. But even the most recent materials are not devoid of difficulties: a relevant number of new silent film scores have not been published and released on video. Improvisations are still unrecorded in most cases: two laudable exceptions are the Italian film festivals *Le Giornate del cinema muto* in Pordenone and *Il Cinema ritrovato* in Bologna. Both keep track of almost every improvisation and musical performance they host; in particular, *Le Giornate del cinema muto* started their archive in 1991. However, the recordings (on videocassette first and on DVD since 2005), stored at the Cineteca del Friuli in Gemona, are not accessible to the public. The same goes for the audiovisual documents pertaining to *Il Cinema ritrovato*, preserved at the Cineteca di Bologna.

Because of this current state, the only possibility for comparative silent film music studies is to develop empirical research without historical implications: the 'tradition of novelty' in the original age of silent cinema is largely inaccessible to the kind of comparative study at issue here. As already pointed out, the basic strategy would be the comparison of audiovisual functions. What, then, would be the aim of this kind of approach? A deeper comprehension of film language, I would argue. In fact, audiovisual functions can bring into focus both the visual and the narrative content. An audiovisual function works like a gloss on the director's work: it is the result of a musical interpretation of the images. It conveys a composer's point of view on a certain fragment of a film. It is, of course, the point of view of an individual; a different musician could see the same fragment in a completely different way – and completely different would be the audiovisual message that reaches the audience, too. To compare two different musical readings of the same sequence is like starting to draw a map of the hidden potential of a film, better rationalizing its dramaturgical value. It is relevant to observe that this rationalization does not necessarily derive from a conscious intention of a certain author. Just as during the silent film era a careless film accompanist could reveal the hidden meaning of a scene

Marco Bellano 213

just by playing some random piece from his/her repertory, a contemporary video release of a silent film, sleazily joined with archive music, could equally provide, by chance, interesting research material. With this approach, it is not the intention that counts, but rather the final audiovisual relationship.

It is important to note that this suggested research strategy does not betray one of the fundamental traits of silent film music practice, the 'tradition of novelty': the continued mutation of music from film screening to film screening. However, as it is impossible to reconstruct the complete 'tradition' of different musical interpretations pertaining to each silent film, it must be stressed once again that the term 'tradition' needs to be understood without historical implications: what is 'traditional', in this case, is not a certain repertoire of silent film scores, but a practice that continued until the present days. The idea of the 'tradition of novelty' does not identify a historical series of musical documents, but a way of looking at a silent film as a potentially perennial source of musical inspiration. As Zofia Lissa noted as early as 1965: 'In silent cinema ... [music] was a device connected with the image itself in a purely external way.'[15] This 'external connection' is a key element of silent film music language, which enables the emergence of unique audiovisual functions. It is true that to achieve results in a comparative analysis of functions, as stated above, it is necessary to use objects of study for which the film/music relationship is solid and unchanging: the recorded results of a performance. But this does not mean regarding silent films as if they were synchronized sound films. As I implied when describing the research materials, even improvisations can be used if they are recorded. When fixed on video, the performance becomes an audiovisual text: every match between audio and video is definitive. The time span is determined once and for all, and the temporality is potentially reversible and repeatable at will. This makes it possible to describe and measure minutely each audiovisual function. By achieving 'measurability', however, the improvisation gives up its 'aura': it is no more an event, but a reproducible artifact. The Heisenberg principle of quantum dynamics, which tells that it is impossible to know both the position and the momentum of a particle at once, could be a metaphor for the dilemma of silent film music analysis: audiovisual functions can be understood and described only when a silent film performance is accessed through the filter of a video recording. It is a proper silent film no more; however, the researcher should keep in mind the aesthetics of the original event. After all, even if only its position or its momentum is known, a particle remains a particle; and a silent film should be always

214 *New Approaches to Silent Film Music History and Theory*

understood as a silent film, even if it is accessed through a medium that conceals its nature under a veil of synchronicity and reversibility.

In order to point out some of the possibilities and potential results of comparative silent film music analysis, some short examples will now be examined. The reasons behind the choice of those examples are not related to the artistic value of the music–image relationship, or of the music in itself. The fact that some of the examples are from contemporary scores and one is from a historical score is not going to influence the present discourse either, as it deliberately focuses on just the comparison itself. The selection has been constructed on the basis of three practical principles:

1) availability: as the aim of this chapter is to show how a methodology of comparative studies on silent film music could work and how it could benefit present-day research (and not to propose a systematic study of certain scores written for silent films), the examples come from renowned silent films, whose alternate musical versions are easily attainable by the reader;
2) compatibility: the selected musical interpretations are sufficiently different from each other, but their differences are by no means radical. This simplifies the present discourse as the comparison can be commented on a common aesthetic and stylistic ground;
3) consistency: the alternate scores refer to video transfers of the same film print, and not to transfers showing relevant reciprocal differences. This is to avoid difficult methodological questions; those questions, however, should by no means be avoided by more general and systematic studies in silent film music comparison.[16]

A fundamental source for this kind of study is certainly the German silent film classic *Metropolis* (Fritz Lang, 1927),[17] one of the films whose shortened and then progressively restored versions have been the object of the efforts of a relevant number of composers and music compilers for decades. As Thomas Elsaesser affirms:

> The desire to 'perform' *Metropolis*, instead of putting it in a critical or historical perspective, is largely responsible for lending new life to the vision of Lang and von Harbou. The key element is probably the changing place of music and sound not only in this film, but in popular visual culture generally... There have been several attempts – including a stage musical – to... turn *Metropolis* into a kind of visual score, ready to be performed in very different musical idioms. Full

orchestra and chamber music archive screenings – whether with the Munich print or another version – have become staple repertoire attractions, possibly also in order to claw back some of the prestige of a high-culture vent for a film that first came back from the dead in Moroder's downmarket version... But Lang also understood that cinema would exercise its power of fascination through exhibitionist spectacle as well as voyeuristic surveillance. In both respects, Metropolis has become 'more like itself' in the uncanny guise that Moroder gave it than it had even been before. As a film that one now inhabits rather than interprets, it is as much an experience to dress up and be seen in, as it is a film to be seen and be addressed by.[18]

In addition, *Metropolis* is one of the few silent films for which we have a full original score (by Gottfried Huppertz), complete with detailed indications about the matching between images and sound.

There is a lot of material to choose from when approaching a comparative analysis of *Metropolis*. I will compare two musical renderings created for the same version of the film: the 2001 restoration, which premiered at the Berlinale on 15 February of that same year. For the DVD release of that version, conductor and silent film music scholar Berndt Heller prepared an arrangement of Huppertz's score. However, because of some copyright issues, the live performance at the Berlin film festival used an original composition for orchestra and electronic instruments by the contemporary author Bernd Schultheis. Schultheis's score has never been released with a home video version of *Metropolis*. However, the composer's website contains some audio files of his music,[19] complete with indication on the relationship with the film sequences. I downloaded those samples and synchronized them with the 2001 version of *Metropolis*.

I will focus on a short excerpt from the presentation of the character of Maria. In Huppertz's version, the appearance of the girl coincides with a musical transition, which leads from the previous waltz, which commented upon Freder's frivolous flirts with the girls of the 'Eternal Gardens', to a more serious and passionate theme, which is completely exposed during Maria's speech in front of a love-struck Freder. Here, there are two important features, which give way to relevant audiovisual functions. The first one is simply the mood of the music: by following Miceli's terminology, the music here has a *commentary* function, interpreting the emotive meaning of the sequence by offering the spectator a series of appropriate musical clichés, which in this case include the quieter pace and the timbre of the orchestra, dominated by the violins.

216 *New Approaches to Silent Film Music History and Theory*

The commentary function goes together with a *leitmotivic* function: the music, which describes the emotional atmosphere, is also the theme that will be linked to Maria for the duration of the film.

In Schultheis's version, the musical language shifts from the late romantic reminiscences of Huppertz's music closer to some 20th-century composers like Igor Stravinsky or Dmitri Shostakovic. Surely, there is still a commentary function at work here, as the music suddenly slows down in tempo when Freder notices the opening of the Gardens' doors, and, on a long note of the clarinet, it changes into an episode interwoven with apparently incomplete melodic fragments. Those fragments keep moving on long notes, sometimes punctuated by irregular rhythmic interventions of the triangle. The mood here is not serious and tenderly passionate anymore, but it is expressing the disconcertment of the inhabitants of the Gardens witnessing Maria's arrival. As for the other function to be compared, the leitmotivic one, it is not possible to identify it because the rest of the film score is currently unavailable: so, we cannot ascertain whether Maria is going to be associated with that musical episode again. However, it is instead possible to recognize another, subtler function that only a comparison with Huppertz's original music can reveal.

The first melodic fragment that Schultheis introduces in Maria's episode is in fact directly inspired by Huppertz's introduction and transition to Maria's *leitmotiv*. It is exposed by a trumpet while in Huppertz it was enunciated by the string section in a more polyphonic way, but the resulting melodic profile (B flat–E flat–D–F) is the same, even alluding to the area of the dominant of E flat major (the tonality of Maria's theme in Huppertz's music). Thus, we witness a particular type of a *signaling* function. The Schultheis fragment from Maria's theme signals the place of the original Maria's theme to anyone who is closely familiar with Huppertz's *Metropolis* score. At the same time, I would argue that it signals also, more generally, the rich musical tradition related with *Metropolis* itself, acknowledging the existence of at least one other score.

A second film that offers a rich set of alternate scores for comparison is Buster Keaton's *The General*[20] (Buster Keaton and Clyde Bruckman, 1926). In this case, however, an 'original' score never existed. There have been instead multiple musical interpretations, of which I would like to consider three: the 1995 score by Robert Israel, and two scores from 2004 rendered respectively by the Alloy Orchestra and by Joe Hisaishi.

Each one of those scores applies slightly different film functions, pointing out alternate potentials of the visuals. All three of them are,

however, equally concerned about one quality of Keaton's work: the dynamism. Ken Winokur, member of the Alloy Orchestra, explicitly refers to this:

> There's such a kinetic quality to the film, with the train chugging back and forth throughout the story that we thought we could be particularly effective in writing music that mirrored the movie's rhythm. We felt that our style of music, with its strong emphasis on percussion, would be ideal for the film...Even though it was the mechanical rhythms of the train that attracted us to this project, it is Keaton's subtle emotions that make this film so satisfying.[21]

The take on the dynamism is the shared starting point, which each musician or musical formation developed in a different way.

In order to underline some key differences, it is useful to consider a short excerpt from the sequence of the abduction of both Annabelle and the engine 'General'. The bold and ample gesture of the Union General in the scene serves as a visual hint that is identified as an audiovisual marker by all three different scores: at this marker, the tension built up by the previous music ends and a new musical episode starts.

In Robert Israel's music the man's gesture is the only place where a kind of synchronization occurs: however, it is not an accompaniment function. The music, in fact, does not try to describe other movements or trajectories seen on screen. The excitement within the scene is commented only by a fast-paced music played by a small ensemble: it is a simple commentary function. The music mirrors the frenetic mood of the episode, but does not try to take advantage of other visual suggestions: actually, it continues almost independently of the images, sounding as if it were a chamber music piece from the middle of the 19th century. This stylistic trait could be read at most as a signaling function, because it recalls the time period in which the story of the film is set. Consistent with this, we could point out that throughout the whole score Israel actually quotes melodies from songs dating back to the American Civil War. The loose connection between music and image in this excerpt, with the music developing on its own, might also suggest the presence of a typical silent film music 'bridge' function, which can be described as a musical episode that starts off from a clear function (a commentary function, in this case), and then keeps presenting a certain musical pattern until a new possibility of a strong audiovisual function appears, disregarding other features of the visuals between the two main functions.[22]

Both Hisaishi and the Alloy Orchestra do not try to emphasize the historical period of the story through their style or with song quotations. As anticipated, the Alloy Orchestra focuses the attention on rhythm: they treat the film somewhat as a visual canvas on which to play out clever musical synchronizations, underlining Keaton's taste for mechanical and dynamic slapstick gags. The main ideas by the Alloy Orchestra revolve around the imitation of the noise of the steam engine with a prevalent function of accompaniment. In the sequence of the double abduction, the steady 4/4 rhythm of the percussion, which functions also as a basis for repetitive ostinato fragments played by other instruments, is actually derived from the rhythmic pattern associated with the train, as becomes clear when the drum set starts playing the almost onomatopoeic imitation of the engine noise. This onomatopoeic intention of the accompaniment is further reinforced when we hear it slowing down as the train decelerates.

Hisaishi's version presents a sort of mediation between the choices of Israel and the Alloy Orchestra. It adds a clear leitmotivic function in its own right, which shifts the focus to characters and situations: during the 'abduction' sequence we hear, for example, the Union theme, played by a trumpet, and then the leitmotiv for the General engine itself. This same leitmotiv is the place for a singular 'mediation' between a commentary and an accompaniment function. The introductory section of the theme features in fact a second semiphrase with a cadenced 4/4 motif. This cadenced pattern returns when the music reprises the main melody of the theme. In some way, it is reminiscent of the Alloy Orchestra's sound device to imitate the engine noise: in this case, however, the onomatopoeic hint is structurally part of a longer theme with a leitmotivic function. The movement of the locomotive is embedded into the theme: the ostinato melodic pattern draws on the score the points of a cycloid curve, which is the curve described by a fixed point on the circumference of a wheel advancing on a straight surface (Figure 12.1).

Figure 12.1 A cycloid curve drawn by musical notes in Joe Hisaishi's theme for the 'General' locomotive

Those were only very partial examples. A complete comparative analysis should be developed for a whole film, in order for us to become more aware of the context of each function, as noticed before when quoting Miceli's caution. Moreover, I did not consider another relevant and possible approach: the study of the same music used in different films. Documents such as the *Allgemeines Handbuch der Film-Musik* testify that it was actually recommended to have pieces from a selected repertoire used over and over again through different films, in comparable narrative situations. This second approach might shed more light not on the potentials of the visuals, but rather on the dramatic versatility of the music. This reverse and complementary approach would require an in-depth study of its own, and will not be discussed now: but just being aware of such alternate approaches is useful to reveal yet another hint about how rich and multifaceted this field of analysis can be.

Notes

1. Martin M. Marks, *Music and the Silent Film* (New York/Oxford: Oxford University Press, 1997): 6.
2. Rick Altman, *Silent Film Sound* (New York: Columbia University Press, 2004): 251–252.
3. Ennio Simeon, 'Appunti sulla teoria e prassi musicale nel cinema muto Tedesco', *Trento Cinema. Incontri Internazionali con il film d'autore* (Trento: Servizio Attività Culturali della Provincia Autonoma di Trento, 1987): 74–80.
4. Very few films thus offer solid ground for a comparative analysis of this kind. One of them is *Castle in the Sky* (*Tenkuu no Shiro Rapyuta*, Hayao Miyazaki, 1986), which was released in the US in 2002 with an expanded and largely rescored music by the composer of the first version, Joe Hisaishi. Other valuable possibilities of comparison are found in Danny Elfman's reworking of Herrmann's score for *Psycho* (1960) for the scene-by-scene remake of that film directed by Gus Van Sant in 1998.
5. Henry H.H. Remak, 'Comparative Literature: Its Definition and Function', in Horst Frenz and Newton P. Stallknecht (eds.) *Comparative Literature: Method and Perspective* (Carbondale, IL: Southern Illinois University Press, 1961): 3–37 (3).
6. Melinda Mills, Gerhard G. Van de Bunt and Jeanne De Brujin, 'Comparative Research. Persistent Problems and Promising Solutions', *International Sociology* 21/5 (2006): 619–631 (621).
7. Cesare Segre, *Semiotica filologica. Testo e modelli culturali* (Torino: Einaudi, 1979): 64–70.
8. Bruno Nettl, *The Study of Ethnomusicology: Thirty-One Issues and Concepts* (Urbana: University of Illinois Press, 2005): 3–15.
9. Paul Willemen in Yingjin Zhang, *Cinema, Space, and Polylocality in a Globalizing China* (Honolulu: University of Hawai'i Press, 2010): 29.
10. The only conceivable alternative to this model would be the comparison between different scores for silents written by the same composer; however,

220 *New Approaches to Silent Film Music History and Theory*

here the focus would considerably shift from the image–sound relationships (audiovisual functions) to questions of musical style. It would generate a parallel branch within comparative silent film music research.

11. Craig Stuart Sapp, 'Comparative Analysis of Multiple Musical Performances', in *Proceedings of the 8th International Conference on Music Information Retrieval (ISMIR)* (Vienna: Österreichische Computer Gesellschaft, 2007): 497–500.

12. Vickie Wing Yee Cheng, 'Comparative Analyses of Different Musical Settings of the Same Text in the Genre of German Lieder', MA thesis, Wesleyan University, 2010.

13. Sergio Miceli, *Film Music. History, Aesthetic-Analysis, Typologies*, Marco Alunno and Braunwin Sheldrick (trans. and ed.) (Milano/Lucca: Ricordi LIM, 2013): 499.

14. Altman, *Silent Film Sound*, 8.

15. 'Im Stummfilm stand die Musik in zweierlei Beziehung zur visuellen Schicht...andererseits war sie ein Hilfsmittel, das mit dem Bild selbst nur rein äußerlich verbunden war'. Zofia Lissa, *Ästhetik der Filmmusik* (Berlin: Henschelverlag, 1965): 99–100.

16. It would be interesting to compare the different prints and video editions and to discuss, for example, where the limit between 'significant' and 'acceptable' differences lies. Probably, even if it is possible to point out some general rules (about the running time, the presence of censorship, etc.), every case should be evaluated individually.

17. The version that includes Gottfried Huppertz's original score and that is used in this chapter is *Metropolis* (1927; Bologna: Ermitage Cinema, 2006), DVD.

18. Thomas Elsaesser, *Metropolis* (London: British Film Institute, 2000): 58, 62–63.

19. http://www.bernd-schultheis.de/B_DE/p4.html. (Accessed 10 February 2013).

20. The two versions considered for this chapter are *The General* (1926; Chatsworth, CA: Image Entertainment, 2003), DVD, featuring the score by the Alloy Orchestra and *The General* (1926; Paris: MK2 Éditions, 2004), DVD, which comprises both the scores by Robert Israel and Joe Hisaishi.

21. Ken Winokur, 'Alloy Orchestra's Score for *The General*', in *Le Giornate del Cinema Muto 2004* (Pordenone, Le Giornate del Cinema Muto: 2004), http://www.cinetecadelfriuli.org/gcm/ed_precedenti/edizione2004/General.html#note (Accessed 10 February 2013).

22. Marco Bellano, 'Silent Strategies: Audiovisual Functions of the Music for Silent Cinema', *Kieler Beiträge zur Filmmusikforschung* 9 (2013): 46–76, http://www.filmmusik.uni-kiel.de/KB9/KB9-Bellano.pdf: 58–61.

13

Germaine Dulac's *La Souriante Madame Beudet* (1923) and the Film Scores by Arthur Kleiner and Manfred Knaak

Jürg Stenzl

Germaine Dulac's *La Souriante Madame Beudet*

Germaine Dulac (1882–1942) must have been an uncommonly impressive figure: a DVD released in 2007 introduces her as 'a chain smoker with short hair, a theater and film critic, feminist, film producer, silent movie director, cinematic theorist, head of the French Film Club Federation and a leading member of the Committee against Film Censorship' – and, I might add, a musical connoisseur with a performance degree in piano. After her death during World War II, she was long consigned to oblivion, only to resurface in the final decades of the 20th century as a feminist and a major avant-garde film director. True, there is still not a trace of her to be found in Germany's *Lexikon des Internationalen Films* (2002), but three of the many films she made in France between 1915 and 1929 have become established 'classics': first and foremost *La Souriante Madame Beudet* (*The smiling Madame Beudet*, 1923, 38'), now considered the 'first feminist film'; then *L'Invitation au voyage* (*The invitation to a journey*, 1927, 39'); and finally the surrealist *La Coquille et le clergyman* (*The seashell and the clergyman*, 1928, 40'), already legendary at the time of its creation because of the quarrels that ensued between Dulac and screenwriter Antonin Artaud. Thanks to Germany's Second Broadcasting Corporation (ZDF) and Arte (ARTE Edition), all three films have now been restored and released on DVD (Absolut Medien) with newly composed music. But before that Dulac's writings on film between 1919 and 1937, edited by Prosper Hillairet, had already been published by Éditions Paris Expérimental (1994).[1] In recent years

221

222 New Approaches to Silent Film Music History and Theory

the significance of the four music-related films she made in 1928–1929 – a sort of counterweight to Germany's '*absoluter Film*' – has likewise been recognized.[2]

The crucial point is what Richard Abel and Oliver Fahle singled out as the outstanding quality of her films: 'the form of an opening inward, a sustained exploration of the inner life or the subjective experience of Madame Beudet',[3] or to quote Oliver Fahle, the 'introduction of the subjective view into cinematic narrative', where

> vision, hallucinations, dream or memory... assume cardinal importance. In this respect *La Souriante Mme Beudet* [abbreviated hereafter as *Mme Beudet*] and *La Fille de l'eau* [by Jean Renoir, 1925] serve as prime examples, for they provide narratives in which the subjective element is an essential component clearly distinct from the objectively narrative cinematic reality.[4]

In her theoretical writings Dulac stressed the autonomy of film as an independent art form and set it sharply apart from theater and literature. In this light it is surprising that *Mme Beudet* is based on a two-act play of the same title by Denys Amiel (1884–1977) and André Obey (1892–1975).[5] The play was successfully premièred at the Nouveau Théâtre on 16 April 1921 by a circle of young actors, the Groupe du Canard Sauvage, to which both men belonged. Judging from its genre, if not from its critique of society, *Mme Beudet* should be categorized as realistic boulevard theater and not, as has often happened, as avant-garde theater; otherwise it would hardly have been awarded the Paul Hervieux Literature Prize by the Académie Française in 1922.

Mme Beudet was Obey's first play, following upon two novels published in 1918 and 1920. It was based on his own short story; the writer Colette, who had just published her best-selling novella *Chérie*, drew the story and its dramatic potential to the attention of Amiel, who asked Obey to adapt the material for the stage. The resultant drama was first published in the periodical *L'Information théâtrale* in 1920;[6] it also appeared as supplement no. 7 in *La Revue hébdomadaire* on 5 August 1922, where it formed part of a '*Collection nouvelle de la France dramatique (Répertoire choisi du théâtre moderne)*'. *La Souriante Madame Beudet* is dedicated to the actors who created the roles of Monsieur and Madame Beudet: Jacques Baumer (1885–1951), who took the part of the husband and later became a well-known film actor beginning in 1932, and the celebrated Ibsen actress Gréta Prozor (1885–1978), who took the part of his wife and is better known today for the portrait Henri Matisse painted of her in 1916 (Centre Pompidou, Paris).[7]

Dulac's film is noteworthy for two distinctive features. First, it transposes a prolix and uneventful play in the boulevard tradition to a *silent* film with relatively few short intertitles. More important, however, is the above-mentioned superposition of a psychological and subjective view onto the contents, a view lacking entirely in the original play. For the film version, one can draw up a continuous pictorial spectrum ranging from realistic imagery via stage acting to unusual cutouts, camera movements, montages, dissolves and double exposures. But even in the quite realistic images the actors, especially the husband (Alexandre Arquillière), act with theatrical caricature, distortion and exaggeration against a décor only moderately more lavish than in the theater. The play's cast of characters describes Monsieur Beudet as a 'good, overweight 45-year-old parvenu, trivial, not evil, but brusque, rotund, all of a piece'.[8] His main method for bullying his wife is to press a revolver to his temple and to feign suicide, though he keeps the revolver and the bullets neatly separated in two drawers of his desk.

Quite distinct from the satirical and realistic depiction of the husband are the thoughts, fantasies and dreams of Madame Beudet (Germaine Dermoz), unhappily married and living in a provincial town. They are presented in a special way: the transitions from outwardly realistic pictures to the mental images of her imagination are blurred so as to display her subjugation at the hands of a tyrannical, provincial, materialistic, cynical and dull-witted husband in the strongest possible terms. Dulac also creates two new avenues of escape for Madame Beudet. The first, presented at the very opening of the film (2'02), is her piano playing, explicitly the music of Debussy, on whose sheet music she writes her name. Monsieur Beudet dismisses the title of Debussy's piano piece *Jardins sous la pluie* (from *Estampes*, 1903) as meaningless gibberish (29'34). Her second avenue of escape lies in reading, whether magazines or a poem by Baudelaire, *La Mort des amants*. Both are 'artificial paradises'. The opening three lines of the poem appear twice in succession as intertitles to impart a programmatic emphasis:

> *Nous aurons des lits pleins d'odeurs légères,*
> *Des divans profonds comme des tombeaux,*
> *Et d'étranges fleurs sur des étagères,*
> *[Écloses pour nous sous des cieux plus beaux.]*

> We will have beds which exhale odours soft,
> We will have divans profound as the tomb,
> And delicate plants on the ledges aloft,
> [Which under the bluest of skies for us bloom.][9]

224 *New Approaches to Silent Film Music History and Theory*

But Madame Beudet is ultimately unable to exact revenge and free herself: the bullet intended for her husband misses her by a hair's breadth (only in the play does she seek a divorce). The film opens with an intertitle *'En province...'* and ends with the same words [37'17–28]: *'En province. Dans les rues calmes, sans horizon, sous le ciel bas...Unis par l'habitude...'* ('In a provincial town. On the quiet streets, without a horizon, beneath the low sky...United by force of habit...').

French avant-garde filmmaking of the 1920s is often referred to as Impressionism. Despite the incontrovertible findings of Stefan Jaročinski and Johannes Trillig,[10] it is evidently impossible to 'strike the term Impressionism from the general musical vocabulary' (Trillig) as applied to the music of Debussy (and usually that of Ravel as well). It is thus futile to try to expunge this same skewed tag for French avant-garde cinema of the 1920s, where Dulac's work is situated. The term *impressionisme* occurs only twice in her writings (1927 and 1932), and then only in passing, when she claims that Louis Delluc's *Fièvre* (1921) begins with an *'ère de l'impressionisme'* and speaks of those who combated *'l'impressionisme et l'expressionisme'*.[11] She does not use these terms to indicate artistic styles, but simply to denote 'impression' and 'expression'.

The special technical devices used by such filmmakers as Louis Delluc and Germaine Dulac are thus resources in an aesthetic that elevated film to an independent art form. Whenever Dulac compares the cinema to another art form it is invariably instrumental music, contrasting the art of listening with the art of seeing.[12] Here she discusses the techniques she employed in *Mme Beudet*:

> To make the life of the mind perceivable through images: this, along with motion, is the entire art of film-making...Movement and inner life: there is, incidentally, nothing contradictory about these two concepts. What can be more mobile than the life of the mind, with its reactions, multiple impressions, leaps, dreams [and] memories? The cinema is wonderfully suited to express these manifestations of our thought, our heart, our memory.

She also singles out one particular moment in her film:

> In *Mme Beudet* the poor wife, outraged at her loudmouthed husband, dreams of a powerful and strong man who will free her from her bookkeeper-spouse...The man she seeks is visible only in her dreams. He is intangible and blurred. It is a phantasm that wages battle with

Figure 13.1 La Souriante Madame Beudet: 'Charlie Adden, Tennis Champion', from the illustrated magazine, carries off Monsieur Beudet (7'06), *Germaine Dulac (1922–1928)* (Berlin: Absolut Medien, 2007), DVD

the cowardly soul of Monsieur Beudet. A transparent scene is superimposed on the real scene, the one that Madame Beudet sees with the eyes of her imagination. The superposition is thought, the workings of the mind... It is achieved by combining two photographs.[13]

This scene is immediately followed by the first of Monsieur Beudet's 'revolver games' (Figures 13.1 and 13.2).

The music for *La Souriante Madame Beudet* (1): Arthur Kleiner

We know of Germaine Dulac's surrealistic film *La Coquille et le clergyman* (1927) that it was first screened at the Studio of the Ursulines *without* musical accompaniment at the express request of the filmmaker.[14] But nothing is known about the musical accompaniment to *Mme Beudet*, which was shot in 1922 but not premiered until 27 November 1923. At the very least Madame Beudet's visible playing of the piano makes it most unlikely that the film was shown without music.

Figure 13.2 Monsieur Beudet's 'revolver game' (12'06), *Germaine Dulac (1922–1928)* (Berlin: Absolut Medien, 2007), DVD

A copy of the film found its way to New York's Museum of Modern Art (MoMA) in 1936. In 1937 MoMA compiled five programs 'for circulation to museums, colleges and film study groups throughout the country'. One of them was *Program 5: The Film in France: The Advance-Guard*, which included three films: *The Smiling Madame Beudet*, Dmitri Kirsanov's *Ménilmontant* (1926) and Man Ray's *Star of the Sea* (*Étoile de Mer*, 1928). All three films were screened at MoMA on 24 September 1939. In the same year Arthur Kleiner (1903–1980), an Austrian composer and pianist who emigrated to America in 1938, was appointed Music Director of MoMA's Department of Film. While still in Europe he had been a successful silent movie pianist and composer who collected 'special scores' on the side. When he couldn't find any such scores, he composed and arranged new ones himself. Some 700 scores are preserved among his posthumous papers in Minnesota.[15] When the film programs went on tour MoMA also lent copies of these piano scores for the films. Further copies of Kleiner's score for *Mme Beudet* are at MoMA and in the archive of the Féderation Internationale des Archives du Film (FIAF) in Brussels.[16]

In 2005 Manfred Knaak composed a new musical accompaniment to *Mme Beudet* for the Nuremberg Silent Film Festival and Ensemble Kontraste. Given the film's dramatic structure and special visual devices, it is natural to compare the two scores and to ask how two composers 60 years apart saw the film and provided it with music long after its French premiere and independently of its director. I regard the music of these two scores as evidence of two contrasting *views*, and thus *interpretations*, of *La Souriante Madame Beudet*, and attempt to shed light on its reception by employing the methods of musical analysis (e.g. for settings of lyric poetry). It need hardly be stressed that the conventions of silent movie music in the 1920s, those at the end of the first decade of sound film (when Kleiner's score probably originated) and the entirely different circumstances faced by a composer of music for a restored silent film already 80 years old, must be taken into account from the standpoint of both film and music history.[17]

While working on these two scores I also discovered a 16mm copy of *Mme Beudet* (with English subtitles by George Tamarelle) in the Harvard Film Archive in Cambridge, MA.[18] It bears a copyright of 1978 to Kit Parker Films and has an 'optical soundtrack' of a 'Piano Score by Carl Schrager recorded at Directors Studio of Carmel'.[19] Schrager, after an early training as a classical pianist, became a jazz and folk musician who drew attention in 1964–1965 as a member of the Berkeley String Quartet and later of The Instant Action Jug Band, from which the successful folk-rock group Country Joe & the Fish emerged in 1965.[20] In the early 1970s, he played piano accompaniment to silent movies screened at the Mendocino Art Center in the like-named town on the coast of northern California.

Kleiner's score, as was typical of the 1920s, consists of 30 self-contained pieces of music. They are listed in Appendix 1 with duration, cues, number of bars and the music used for each segment. Only one of the pieces was newly composed by Kleiner himself (it appears seven times in varying lengths).[21] It is the only piece associated with Monsieur Beudet, somewhat as a leitmotif. This 'Beudet theme' from no. 7 is reproduced in its longest form in Figure 13.3 (with 32 mm of da capo).[22]

The other 29 pieces make use of preexisting 'production music' or 'stock music'. The best-known and most frequently quoted composers are:

Claude Debussy	four works in six numbers
Eric Satie	one work in four numbers
Jan Sibelius	two works in three numbers
Darius Milhaud	one work in two numbers

BEUDET ANGRY [1]

DVD [5'29]

[1] Bei Nr. 3 im Register „Used Music" bezeichnet als „(Beudet theme)".
Das Tempo ♩. = 64-76.

Figure 13.3 Arthur Kleiner: Film music for *La Souriante Madame Beudet,* No. 7:
'Beudet angry'

The score also includes, for a single number, one work each by Maurice Baron (no. 8 and excerpts for no. 17), Albert Dupuis (no. 15), Igor Stravinsky (no. 24), Marc Roland (no. 19) and an otherwise unidentified 'Kroener' or 'Kraemer' (no. 20).[23] The most remarkable of the quotations are no. 24, the 'Valse' from Stravinsky's *L'Histoire du soldat*, and especially no. 14, a very late piano piece by Debussy: *Page d'Album: Pièce pour piano pour l'oeuvre du 'Vêtement du blessé'*, L. 141/(133), composed in 1915 for a charity event. As this piece was not published until 1933, when it appeared in the March issue of the New York journal *The Etude* (p. 169),[24] the year 1933 forms a *terminus post quem* for Kleiner's score. Among the numbers used more than once, it is surprising to find the first of Eric Satie's *Trois pièces montées* (nos. 1, 11, 21 and 30) and a piano piece by Darius Milhaud (nos. 10 and 12). Debussy's very successful early song *Romance (L'âme évaporée et souffrante)* appears in a transcription for solo piano.[25] Moreover, two interpolated scenes from Gounod's *Faust* are accompanied by musical quotations from that opera (nos. 5–6).

The broad-mindedness of this selection – conspicuously Francophile with several obviously American titles (nos. 8, 19 and 20) – is astonishing. Particularly striking are no. 15 (*Modé Rêve*) by Albert Dupuis (1877–1967), a Belgian pupil of d'Indy, and no. 8 (or no. 17, Figure 13.4), *Seduction*, published in 1927 by Maurice Baron (1889–1964), a French theater and film composer who emigrated to the US. Still more astonishing is the systematic way that this eclectic hodgepodge of pieces is employed in the film. Kleiner was not intent on stringing together 'mood-related' pieces of music for the film's segments or proceeding symphonically with leitmotifs. The lesser or greater number of repeats resulted from the way he apportioned the music in the film. We have already mentioned Kleiner's own music for Monsieur Beudet (Figure 13.3). The seven numbers containing this music range from 8 bars (no. 25) and 9 bars (no. 3) to 32 bars (nos. 7 and 13). The fact that the character is given a single item of music, and this one in particular, leads to his sharp musical delineation. An extreme contrast to the one-dimensionality of Monsieur Beudet is the music assigned to his wife. Here uniformity and variety prevail in no fewer than nine numbers – uniformity because six of them are by Debussy, albeit from four different works. Joining them in the second part of the film are three numbers from two character pieces by Jan Sibelius with the revealing titles *In Mournful Mood* (nos. 16 and 23) and *Barcarola* (no. 27). That Madame Beudet herself plays music by Debussy is demonstrated at the very opening of the film (2'09). The sections marked with the intertitle

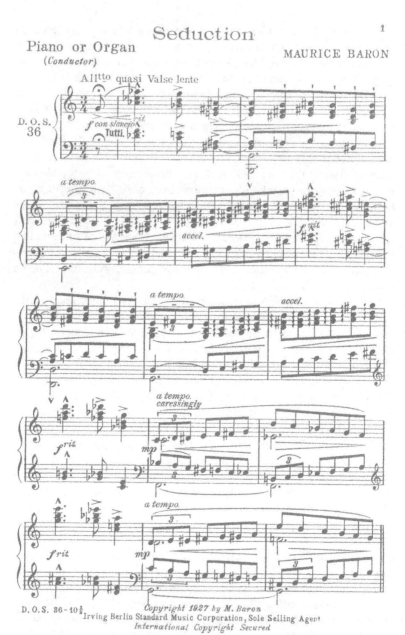

Figure 13.4 Film music, No. 8: *The tennis player comes to life* = Maurice Baron, *Seduction* (New York: Irving Berlin Standard Music Corporation, 1927); copy from the author's private collection

'En province' at the beginning (no. 1) and the end (no. 30), as well as nos. 11 and 21, are serviced by Satie's *Rêverie: De l'enfance de Pantagruel*, the main character in François Rabelais's satirical novel of 1532. Another part of the provincial milieu is a good-natured petty-bourgeois married couple named Lebas whom Kleiner depicts with a soft, undulating piano piece by Milhaud, marked *'souple'*.

Especially interesting is the musical treatment of the visions and dreams, as well as the above-mentioned tennis champion who carries off Monsieur Beudet (6'15–7'32). Here Kleiner makes use of nos. 7, 8 and 9. No. 7 (5'29–6'33) is the 'Beudet theme' (Figure 13.3). For No. 8 (6'34–7'15) he uses Maurice Baron's film music piece *Seduction*, issued in 1927 by the publishing house founded by the celebrated songwriter Irving Berlin in 1919.[26]

Following Madame Beudet's laughter (7'07), we see Monsieur Beudet sitting at his desk and playing his 'pistol game' for the first time (7'16). For this Kleiner uses an excerpt from Beudet's theme as no. 9 (7'16–59). The stylistic contrast between the *martellato* of Beudet's music (nos. 7 and 9) and Maurice Baron's 'romantic' *Valse lente* (no. 8), which appears here for the only time in the film, is plain to hear, underscoring the cinematic depiction of satiric reality vs. Madame Beudet's daydream. A similar use is made of Marc Roland's *Nightmare* (no. 19) when Beudet appears before his wife (20'04–21'14).[27] But when the pistol shot actually goes off (no. 28), we again hear 'Beudet's theme'. A short while earlier (25'40–43), when she imagines him with the pistol pressed to his forehead, we hear her music, the transcription of Debussy's *Romance* (no. 22).

The music for *La Souriante Madame Beudet* (2): Manfred Knaak (2005)

Manfred Knaak is a freelance conductor, composer, arranger and producer who has worked at a large number of German theaters since 1987 and has also functioned as a jazz composer, jazz pianist and music producer. Since 1998 he has been an instructor in musical production at Würzburg University of Music. He devotes an increasing amount of his time to composing scores for silent films, including *Der müde Tod* (Fritz Lang, 1921) and *La Souriante Madame Beudet* for Nuremberg's Ensemble Kontraste and the local silent film festival.[28] He also collaborated with the German singer-songwriter Konstantin Wecker on *Hundertwasser – Das Musical* (2004) and *WeckErlebnisse* (2006).

The ensemble is scored for flute (doubling alto flute and piccolo), clarinet (doubling bass clarinet and alto saxophone), percussion

232 *New Approaches to Silent Film Music History and Theory*

(cymbals, triangle and chimes), vibraphone and marimba, electric guitar, piano and Fender Rhodes electric piano, accordion, cello, double bass and voice, eight instrumentalists, singer and conductor (Frank Strobel). The result is a distinctive sound caused not only by the absence of high strings and brass, but also by the reduced percussion section and the special timbres of the electric instruments plus vibraphone and marimba.

The film falls into two sections corresponding to the first day (including the evening visit to Gounod's *Faust*, when Madame Beudet remains alone at home) and the day after. The sections are roughly equal in length at, respectively, 18'25 (incl. 1'12 of opening credits) and 19'46 (incl. 27' of new closing credits), corresponding to the two-act division of the play.

Manfred Knaak's music, summarized in Appendix 2, consists of four movements of 327, 108, 79 and 359 bars each with durations of 14'14, 4'11, 4'18 and 15'28, or a total duration of 38'11. The first two movements correspond to Part I of the film, the last two to Part II. The caesura after the first movement (followed *attacca* by the second) occurs as Beudet leaves the flat with Monsieur and Madame Lebas and goes to the opera to see *Faust* while his wife remains behind of her own accord. The second movement, Madame Beudet alone at home with her dreams and fantasies, is roughly one-third as long as the first.

In Part II of the film, the third movement ends at the decisive moment when Madame Beudet loads a round of ammunition into her husband's pistol. It is 4'18 long, approximately equal in length to the second movement. The duration of the final movement is roughly the same as that of the first.

Surprisingly, both Dulac and Knaak adopt a proportion of 3:2 (more precisely 59.5–40.5%) for the 'day ratio' between movements I to III and movement IV (including the opening and closing credits). The bipartite subdivision adopted from the play is predetermined by the exigencies of the theater and the principles of two-act dramas, where acts are approximately equal in length. With regard to content, however, the quadripartite subdivision of the music into first day and second day is more logical, especially since Madame Beudet's 'solo scene' takes us to the end of the evening, the loading of the pistol, and thus to her resolution to put a dramatic end to her marital torment by bringing about Monsieur Beudet's suicide in a way that leaves no trace of her involvement. (She envisions it briefly in movement IV at 25'40.) Nevertheless, she revokes her decision on the second day owing to her pangs of conscience ('*remords*', as we are told in an intertitle). Her plan

of vengeance was real enough (she actually did load the revolver, well aware of her husband's longstanding cynical penchant for this 'serious joke'), but it was also a daydream, both in reality and in the cinematic depiction. The absurd consequence is that Beudet, as the shot is released from his revolver and only accidentally misses his wife, assumes that she wanted to kill herself – a conclusion fully in line with his egotistical bearing. In fact the play is dramaturgically lopsided: its contents divide it into three parts, with Madame Beudet's solo scene of self-imposed solitude forming the central second part. The formal, musical and expressive subdivisions of Knaak's score show that he fully realized this point and made it audible by taking into account the two-act design (the end of movement II) while underscoring the internal dramatic structure by compressing the end of movement III and its conclusion and allowing movement IV to open in the manner of a fresh start (a slightly varied reprise of the opening of movement I).

Knaak's score is noteworthy for its unbroken 'basic undertone', and thus for its consistency from the very beginning, where provincial life is broached in text and image, as it is at the very end. This is its major difference vis-à-vis Kleiner's mosaic of 30 short pieces of highly contrasting music. Knaak's score is a subtly differentiated *grisaille* in the middle and low registers, a blended but gently undulating instrumental backdrop (rarely does an instrument stand out melodically) with subdued tempos and a circularity intended primarily to place appropriately jolting accents on the husband's agitation. Every contrast seems like an alien element compared to the drab provincial melancholy of the heroine. Particularly distinctive are the dry, isolated, repeated staccato chords for Beudet's revolver game (first heard at 7'14–32; see Figure 13.5)[29] and the brief, soft trill in the bottom register of the bass clarinet for his blustering (6'03–11). A crucial factor contributing to the music's consistency is the predominantly veiled melodic writing, descending in small legato intervals and frequently tied over the bar line.

At the same time, however, Knaak responds to many details with thoroughly 'realistic' sounds. We hear Madame Beudet's piano playing (I, 1'52–2'22, 13'55–14'01); and when Beudet invites his wife to attend *Faust*, accompanied by two visual quotations from the opera, we hear 'a horn call' and, for Mephistopheles and Gretchen, a chord repeated *ppp* four times with a *flautando* motif in the cello (5'07–12 and 5'19–24). Monsieur Lebas's telephone rings in the vibraphone (8'05–11), and the clock and a bell are audibly rendered with triangle and chime (III, 20'27; IV, 23'41–50). 'Sonic realism' of this sort was standard practice in the age of silent film.

Figure 13.5 Manfred Knaak: Music for Monsieur Beudet's revolver game, I, mm. 161–65, p. 23 (7'14–32). Full score, author's edition, © 2005

In the 1920s a wordless female vocalize was occasionally employed in the manner of an instrument to indicate 'dream material' or memories (Arthur Honegger produced the same effect with the ethereal ondes Martenot).[30] Knaak also adopts this practice in his music for the sequences in which Dulac shows Madame Beudet's dreams, visions, and fears using experimental cinematic techniques: double exposures, distortions, slow motion and the like. They first occur as she leafs through the magazine and discovers the tennis champion Charlie Adden (5'42); they end when the champion, in Madame Beudet's vision, has carried off Monsieur Beudet (7'09). The female voice makes audible the unreal and intangible aspect of this vision, but it also conveys Madame Beudet's depression, despair and remorse.

Yet it is not only for episodes of this sort that Knaak uses the voice: instrumental song also plays a part in Madame Beudet's uncomprehending reaction to her husband's 'revolver game' – a gesture lasting only two bars (7'32–37). Finally, as already mentioned, the voice specially emphasizes the end of movement III, when Madame Beudet loads the revolver (end of III, 22'27–43). In its final occurrence, it is even heard twice during the real argument with her husband after he grabs the (now loaded) revolver one final time – a dramatic climax to a film otherwise not exactly abounding in action (35'19 to just before the shot, 35'49).

The sharp delineation of character that Dulac attempts at the first entrance of each figure finds musical equivalents in Knaak's score, though the traditional technique of 'personal leitmotifs' is of secondary importance in what is essentially a two-character play. Knaak's main concern is to express provincial emptiness, as comes especially to the fore at the beginning of movements I and IV and at the end of the latter movement (36′59–37′16) (Figure 13.6).

Elements of Madame Beudet's theme can be heard from the very first bar of movement I when the intertitle announces 'Germaine Dermoz in the role of Madame Beudet'. It pervades the entire score in a multitude of variants (Figure 13.7).

Monsieur Lebas, an employee in Monsieur Beudet's business, and his wife are given a highly ironic depiction both rhythmically and melodically with a *Tempo di Habanera*. It is first heard in movement I, beginning with the telephone call from Monsieur Beudet (7′55–9′47, including an unmistakably Weill-esque alto saxophone at 8′58); again when they

Figure 13.6 Province theme: I, mm. 26–40 (1′26–2′02), analogous to IV, mm. 1–24 (22′44–23′46)

Figure 13.7 Madame Beudet's theme: I, mm. 19–25 (1′05–1′24). Used at the end of I, mm. 349–59, and IV, mm. 349–59 (37′17–38′11) for the intertitle *'En province...'*

236 *New Approaches to Silent Film Music History and Theory*

make their appearance at the Beudets' home (10′39–55); and one final time for a brief theater insert with Gretchen and a trombone player in movement III (22′03–27).

Arthur Kleiner's and Manfred Knaak's 'musical interpretations' of Germaine Dulac's *La Souriante Madame Beudet*

It is hardly surprising that both Kleiner's and Knaak's music for *Mme Beudet* respond with different devices to the distinguishing features of Dulac's film: the satirical critique in her depiction of Monsieur Beudet, and the special cinematic resources she employs for the visions and dreams of his wife. In Kleiner's case the restriction to a single piece of music for the husband contrasts with the variety and stylistic consistency of his musical delineation of the wife. In Knaak's score Madame Beudet is far more deeply embedded in the 'tone' of the music, which projects the emptiness of provincial life. The stylistic variety of the pieces that Kleiner employed, in keeping with the 'classical' approach of silent movie 'cue sheets', contrasts with the timbral and thematic unity of Knaak's music, within which he is able to respond to details in the imagery. His approach is unmistakably imbued with a subtle command of 'symphonic' film scores, which help the film to achieve a unity by no means easy to achieve, given its rapid cuts and changes of camera perspective.

The pieces Kleiner employed are mainly short, seldom more than two minutes long, and they are used repeatedly, generally in excerpt. His music is thus far more closely allied with the rhythm of the cinematic images. The special aspect in his use of music is that the stylistic variety of the pieces he employed to delineate the personalities, attitudes, mindsets and provincial setting of the film must be subtly stitched into the composition. Kleiner represents a pluralism typical of French interwar music but unusual for a musician from Austria (Ernst Krenek aside). In contrast Knaak, writing at the onset of the 21st century in a post-postmodernist age, relies on stylistic unity even when he draws on models with highly contrasting melody, rhythm and orchestration, which he nevertheless manages to blend. Especially important in his score for *Mme Beudet* is that the larger instrumental ensemble gives him a timbral spectrum offering a far greater expressive range than is possible with a plain piano score, if only through the changing combinations of instruments. Yet we should not forget that even a solo

piano accompaniment to a silent film imparts a timbral unity predefined by the instrument (albeit a conditional unity), and that it does so in a manner quite different from Knaak's score.[31] For all the differences in their music for *Mme Beudet*, our conclusion is surprisingly close to the one that Francesco Finocchiaro draws at the end of his study of the 'Odessa Steps' sequence from *Battleship Potemkin* with regard to the scores written half a century apart by Edmund Meisel and Dmitri Shostakovich: the relation between image and sound – a relation fundamental to the perception of silent film music, and one that Michel Chion refers to as '*synchrèse*' (a hybrid between synchronism and synthesis);[32] and, in Shostakovich's later music (from Symphonies nos. 5 and 11 in Finocchiaro's example), a '*valeur ajouté*' or enriching 'commentary' on a detached, extradiegetic plane that 'avoids supporting the visual level'.[33] Knaak's score, too, declines to 'follow the narrative word for word', preferring instead to appear 'in striking concord with the underlying mood of the narrative'. Or, as Finocchiaro puts it, it is music that functions 'as a fourth dimension to the images, as reality made audible', even when it lends tangible form to the visual imagery, as in Madame Beudet's piano playing or the ringing of the telephone.

Finally, it should be borne in mind that *La Souriante Madame Beudet* is a film with a total duration of less than 40 minutes. Music for such a comparatively short film requires a special approach to musical time. Just how differently this was accomplished by Kleiner and Knaak for this single film by Germaine Dulac (most impressively in both cases, I feel) at a distance of some 70 years apart is proof that the range and the messages of her film still have an impact and relevance today.

Our comparison of Kleiner's and Knaak's scores for *La Souriante Madame Beudet* points beyond the history of the film's reception. Above all it shows that, unlike sound films, silent films have a *history of musical interpretation* in the same way as works of pure music[34] – a history that Finocchiaro goes so far as to call a 'measure of the historicity of the dramaturgy of film music'.

Translation: J. Bradford Robinson

Appendix 1

La Souriante Madame Beudet: Piano Score by Arthur Kleiner

Time Code[35]	Part. S.	Title T.	Key Words	Meter Key	Numbers of Bars	Music Used
[00′00–0′07 new DVD opening credits]						
1 0′08	2f.	Introduction. *Moderato*		3/4	37	Eric Satie, *Rêverie*[36] [= KlA from *Trois*
1′10		18/19	White Title	F		*pièces montées*, no. 1: *De l'enfance de*
1′22		30	Picture starts ('En Pro-vence' [*sic!*])			*Pantagruel* (1919), T. 1–27][37] (see no. **11 21, 30**)
2 1′43	4	'Derrière la façade'.[38] (Hands playing piano). *Andante très expressif*		9/8 Des	14	C. Debussy, *Clair de lune,* [from *Suite bergamasque*, L. 82/(75), no. 3, T. 1–14]
1′55		7	Madame Beudet			(see no. **4**, 29)
2′01		11	playing			
3 2′28	5	Office of Beudet		[6/8] d	9	[A. Kleiner], *Beudet theme.* (part from no. **7**) (see no. **9, 13, 18, 25, 28**)
4 2′47	6–9	Madame Beaudet [*sic!*] reading. *Andante très expressif*		9/8 Des	45	= no. **2**, T. 1–45 (see no. **29***)*
2′59		7	Beudet enters			
3′10		12/13	sits			
3′24		19	Maid with mail			
3′51		28	Letters			
4′43		41	He shows ticket			
5 5′01	10	Beudet sings. *Tempo di* marcia (*burlesque*)		12/8 G	8	Soldiers chorus 'Faust', [quote from C. Gounod, *Faust*, 3rd act, no. 21, Zf. 42 (*Tempo marziale*)]
5′07		5/6	Scene from 'Faust'			
5′15		8	She shakes head			

6	5'20	10	Second Faust Scene		6/8	4	Holy angels 'Faust' short, [quote ibid.,
		1	Second Faust scene		Es		4th act, no. 31, 3. T. p. Zf. 104: 'Anges purs, anges radieux']
7	5'29	11	Beudet angry.		6/8	32,	[A. Kleiner], *Beudet theme* (see no. **3**,
	5'48	13	Auto		d	m. da	**9,13**, **18,25**, **28**)
	6'01	18–20	Pounding desk			ca-po	
8	6'34	12f.	The Tennis player comes to life. – [*Allegretto quasi Valse lente*]		3/4 (E)	21	[M.] Baron, *Seduction*, [p. 1–14 and shortened da capo. I. Berlin Standard M. Corp. 1927] (see no. **17**)
	6'48		10	To Beudet			
	7'05		16	Carries him off			
	7'07		19	She laughs			
	7'13		20/21	Opens dark drawer			
9	7'16	14	Beudet takes pistol		6/8 d	24, m. repeat	= no. **7** T. 9–12 (see no. **3,13**, **18**, **25**, **28**)
10	8'00	15–17	To telephone – calls friend		12/8 (D)	46	Darius Milhaud, *Deuxième Printemps*, [= *Printemps*, Livre I, op. 25 (1915–19),
	8'35		16	Dress suit			no. 2 [30 T., here with repeat of
	8'58		25	Wife enters			T. 1–15][39] (see no. **12**)
	9'07		32/33	Wife on telephone			

(Continued)

Time Code[35]	Part. S.	Title T.	Key Words	Meter Key	Numbers of Bars	Music Used
11 9'48	18f.	Back to Beudets		3 /4	37	= no. **1** (see no. **11, 21, 30**)
10'06		9/10	He moves vase	F		
10'21		16/17	She moves vase back			
10'27		19	Eating			
10'40		24/25	Other couple enters			
10'57		32/33	At table			
12 ~11'30	20	Meet other couple		12/8	19	= no. **10**, T. 1–18
11'34		5	Clock	(D)		
13 ~11'56	21	Beudet with pistol		6/8	32	= no. **7** (see no. **3,9,18,25,28**)
12'12		13/14	Other man [M. Lebas] laughs	d		
14 ~12'47	22f.	People laugh – (Get ready to go out). *Moderato*		3 /4 F	50, m.	C. Debussy, *Page d'Album* [=*Pièce* repeat *pour piano pour l'œuvre du 'Vêtement du blessé'*, L. 141/(133) (1915)]
15 14'15	24–27	Madame Beudet alone. – *Lento*		9/8	58	A. Dupuis, *Modé Rêve*, [in *Les chefs-d'œuvres des gr. maîtres contemp.*, Paris, Salabert © 1929, 70–73[40]]
14'44		14	Finds piano locked	C		
15'05		17	Beudet on screen			
15'24		21	Bed			
16'02		29	Flowers			
16'15		35	Maid enters			T. 35ff.: music corresponds to beginning

	16'45	44/45		Man kisses maid			
	16'59	51		Maid goes			
16	~17'02	28f.	After Maid leaves. – *Moderato*		C	35	J. Sibelius, *In Mournful Mood* [= *Five characteristic Impressions for piano*,op. 103, no. 5 (1924)] (see no. 23)
	17'33		10	Bell ringing	c		
	17'50		17/18	Looks in mirror			
	18'37		30	Weeping			
17	18'50	30	She sits – Dreams. – *Valse lente*		3/4	7	= no. 8, T. 1–7
	19'05		4/5	Man through window	(G)		
18	19'17	31	'Mais' – Her husband		6/8	20	= no. 7, without da capo (see no.3, 7, 9, 13, 25, 28)
	19'36		10	Wedding Ring	d		
	19'58		20	Looks up			
19	20'04	32–34	Beudet creeping through window. – *Adagio – Moderato – Adagio – Allegretto*		C modul.	65	[Marc] Roland, *Nightmare* [= *Alpdruck*, Magdeburg, Heinrichshofen's Verlag 1927, (*Preis-Kino-Bibliothek*, Nr. 52)]
	20'28		14	Bell ringing			
	20'51		30	Moves flowers			
	21'18		43	Beudet smiling			
	21'36		50	Gun out			
	21'56		54	Mad B. to desk			
	22'04		58/59	Box at opera[41]			
20	22'34	35–36	Le lendemain (bedroom of Beudets). – *Slow (dreamily)*		fis/T. 17–28	53	Kraemer (od. Kroener?), *Twilight* [not identified][42]
	22'35						
	23'15		33/34	Mme tossing in bed	Des/ab		
	23'53		43/44	Pendulum swinging	T.29 fis		

(Continued)

Time Code[35]	Part. S.	Title T.	Key Words	Meter Key	Numbers of Bars	Music Used
		Music example 7: No. 20: *Twilight* (Incipit)				
21 24'11	37f.	−. *Moderato*		3/4	37	= no. **1** (see no. **11**, **21**,30)
24'33		13	Wagon	F		
24'43		18/19	People at work			
25'06		30	Leans over her			
25'16		34/35	Downstairs			
22 25'30	39–41	'Remords' (Mme Beudet at window). – *Lento moderato e pensieroso*		4/4 D	28	C. Debussy, *Romance* [= Mélodie *L'âme évaporée et souffrante* (Paul Bourget), L. 65 /(79.1), transcribed by Anonymous for piano, here complete]
23 26'16	42f.	Upstairs again. – *Moderato*		C	48	= no. **16**, with additional repeat of T. 19–31
27'44		12	Sits in bed	c		
28'33 [od. 28'37]		19/20 d. Whlg	Combing hair			
24 28'56	44–46	Beudet and assistant searching for paper		3/4 in C/D	70	I. Strawinsky, *Valse* [from *L'Histoire du Soldat* (1918), *Trois Dances*, KlA Chester © 1924, 38–42, here T. 1–70 (= Zf, 10–18)]
29'26		23	To piano			
29'30		26	Picks up music on piano			
29'35		32/33	He laughs			

25	30'41	47	Beudet angry, picks up doll	6/8 d	8	T. 5–12[43] from no. **7** (see no. **3, 9, 13, 18, 28**)
26	30'45	47–53	Segue. – *Andantino con moto*	C (F)	57	C. Debussy, *Ballade [(slave) pour piano*, (1890), L. 78/(70), from T. 5–62]
			4 Other man speaking			
	31'54		20 Mme B. runs out			
	31'58		23 downstairs			
	32'08		26 to desk			
	32'50		40 Beudet returns			
	33'07		45 pulls out doll – Sorry			
27	34'00	54–56	Beudet sits at desk – studies bills. – *Moderato assai*	3/4 d	66	J. Sibelius, *Barcarola* [= *Ten pieces for piano*, op. 24, no. 10 (1903)]
	34'06		11 bills			
	34'19		23/24 Maid called in			
	34'19		40/41 Counting			
	35'02		48 Mme B. enters			
	35'11		62 Scolds her, etc.			
28	35'30	57	Beudet pounds desk – takes pistol out	6/8 d	12	= no. **7**, T. 1–12 (see. no. **3, 9, 13, 18, 25**)
	35'51		10 Lifts pistol			
29	36'02	58f.	He aims pistol at her	9/8 Des	30	= no. **4**, T. 15–26 and 1–18 (see no. **2**)
30	37'17	60	'En Provence' [sic!]	3/4 F	12	= no. **1**, T. 1–8, 34–37 (see no. **11, 21**)

FIN = 37'46–47

244 *New Approaches to Silent Film Music History and Theory*

Appendix 2

Madame Beudet: Score by Manfred Knaak

T.	Meter	Tempo	Time	Tempo Indication	Content
I					
1	4/4,	♩ ~72	0'00	moderato lent	Vorspann
26	3/2	Halbe = ♩	1'26		'Provinz'
36	2/2 ua		1'52		Mme Beudet am Klavier
51		tempo primo	2'22		M. Beudets Geschäft
74	5/4	♩ ca 147	3'22		Post
111	6/4	♩ ca 160	4'49	wenig voran	M. Beudet: Erregung
126	5/4	♩ ca 180	5'26	weiter voran	M. Beudet wettert
134	4/4	♩ ca 72	5'42	wieder wie am Anfang	Vision Tennisspieler
161	4/4	♩ ca 60	7'14		Revolver-Rhythmen
166	4/4	♩ ca 72	7'32		Ihre/seine Reaktion
169	4/4	♩ ca 60	7'45		Er/sie
172	9/4	♩ ca 110	7'55	*Tempo di Habanera*	Telefon mit Lebas
186	2/4	Generalpause			
187	4/4		8'53	[weiter *Habanera*]	Lebas am Telefon
212	3/2	[♩] ca 72	9'47	wieder wie am Anfang	Lebas, 1. Blume
220		[♩] ca 80	10'09	wenig voran	Essen
224	3/2			wieder wie vorher	2. Blume
227		[♩] ca. 80		wenig voran	Essen
233	8/4	[♩ ca 110]	10'39	*Tempo di Habanera*	Lebas
237	3/2	[♩] ca 80	10'55	wieder wie vorher	Essen
248	5/4	♩ ca 160	11'22		Thema Beudet: Erregung
266	4/4	♩ ca 60	11'56		Revolver-Rhythmen
269	4/4	♩ ca 72			Lebas
271			12'14	etwas langsamer	Mme Beudet

272			12'18	a tempo	Kommentar zu Rev.-Rhythmen
275	4/4	♩ ca 60	12'29		Revolver-Rhythmen
279			12'44	wieder wie vorher	
281–327	5/4	♩ ca 160	12'54–14'14		Er umziehen
II					
1	wechs.	♩ ca 60	14'14	langsam	
15	3/4	♩ ca 85	14'55	*Valse lente*	Baudelaire
52	3/4	♩ ca 108	16'08		
55	3/4	♩ ca 147	Bonne		
79	3/4	♩ ca 108	17'04		Verzweiflung
83	4/4	♩ ca 85	17'12		Uhr
92–108	3/4	♩ ca 85	17'44 18'25	*Valse lente*	Spiegelblick
III					
1	3/4	♩ ca 60	18'25	langsam	
11	4/4	♩ ca 72	18'54	moderato lent	Träume
21	3/4	♩ ca 60	19'30	langsam	Depression/Ehering
71	8/4	♩ ca 110	22'03	*Tempo di Habanera*	Im Theater
77–79	3/4	halbes Tempo	22'27–22'43		Revolver laden
IV					
1	3/2	♩ ca 72	22'44	moderato lent	Erwachen früher Morgen
23	3/4	♩ ca 60	23'44	etwas langsamer	Glocke
31	4/4	♩ ca 68	24'10	wenig voran	Traum
37			24'32	a tempo	Außenwelt
41	3/4	♩ ca 62	24'46	etwas zurückhalten	
49	4/4	♩ ca 120	25'11	lebhaft	7 Uhr
57		♩ ca 65	25'28	langsam	
61	4/4		25'44	wie vorher	sein ruhiges Gewissen
72		♩ ca 65	26'05	langsam	Morgentoilette

246

(Continued)

T.	Meter	Tempo	Time	Tempo Indication	Content
75	5/4 u.a.	♩ ca 165	26'15		Mme, z.T. mit Bonne
113	4/4	♩ ca 60	27'31	langsam	Mme auf Bett
121	4/4	♩ ca 120	28'04	doppeltes Tempo	Geschäft
128			28'17	halbes Tempo	Depression, Spiegel
139	4/4	♩ ca 120	28'56	lebhafter	Geschäft
148			29'14	misterioso	Revolver
150			29'18	wieder wie vorher	
159	4/4	♩ ca 60	29'35	langsam	Fratze, Revolver-Rhythmen
163				wieder wie vorher	MM. Beudet + Lebas
192			30'47	halbes Tempo	M. Beudet/Puppe, Revolver
195	3/4		30'59	dasselbe Tempo	
208	5/4	♩ ca 180	31'39	sehr fließend	Mme Beudet Unruhe
226	4/4	♩ ca 60	32'12	langsam	1. Störung
229	3/4	♩ ca 180	32'25	wieder wie vorher	nächster Versuch
231	4/4	♩ ca 60		langsam	2. Störung
234	2/4	♩ ca 180	32'38	wieder wie vorher	3. Versuch
236	4/4	♩ ca 120			M. Beudet kommt
243			32'57	halbes Tempo	Er nachdenklich
252		♩ ca 120	33'31	lebhfter	Er am Schreibtisch
327	4/4	♩ ca 60	35'49	langsam	Revolver
331	4/4	♩ ca 60	36'04	precipitando	Schuss
335	3/2	[♩] ca 60	36'19	dasselbe Tempo	
341	9/4	♩ ca 54	36'39	langsam	Ihr Blick
343	3/2	[♩] ca 72	36'59	moderato lent	Im Spiegel: 'Theater'
349	4/4		37'17	dasselbe Tempo	'In der Provinz...'
355			37'44-		neuer Abspann
bis 359			38'11		

Notes

1. Germaine Dulac, *Écrits sur le cinéma (1919–1937): Textes réunis et présentés par Prosper Hillairet* (Paris: Éditions Paris Expérimental, 1994).
2. These are *Thèmes et variations, Disque 957, Danses espagnoles* (all 1928) and *Étude cinégraphique sur une arabesque* (1929). Important recent monographs include William Van Wert, 'Germaine Dulac: Die erste Feministin des Films', *[Program] 7. Internationales Forum des Jungen Films, Berlin, 26.6.–3.7.1977*, no. 2 [1–7]; Eng. trans. in *Women and Film* 5–6 (Santa Monica, 1974): 55–58; *L'Invitation au Voyage. Germaine Dulac* (see endnote 1) with comprehensive bibliography on 149–160; and *Germaine Dulac, au delà des impressions, sous la direction de Tami Williams*, 1895: Revue de l'association française sur l'histoire du cinema [no vol. no.] (Paris: Laurent Véray, 2006). Still essential reading is Richard Abel, *French Cinema: The First Wave, 1915–1929* (Princeton University Press, 1984): 340–344.
3. Abel, *French Cinema* (see endnote 2): 341.
4. Oliver Fahle, *Jenseits des Bildes: Poetik des französischen Films der zwanziger Jahre* (Mainz: Bender, 2000): 110.
5. On Obey's early stage plays, see Joachim Kwaysser: *Untersuchungen zur Struktur der frühen Theaterstücke André Obeys* (Diss., Hamburg, 2007), with further reading and bibliography, though he merely summarizes *La Souriante Madame Beudet* on 5 and 7–8. The play was last published in Paris by Albin Michel in 1926 and has not yet appeared in the complete edition launched in 1977.
6. With illustrations and photographs in two quarto volumes: *L'illustration: Receuil de Pièces de Théâtre extraits de 'L'illustration', Année 1920* (Paris, 1920).
7. See Joël Aguet's entry on her in *Dictionnaire du théâtre en Suisse*, Andreas Kotte (ed.) (Zurich: Chronos, 2005): 2, 1437–1438. From 1915 on, Prozor spent decades working in French-speaking Switzerland. Her only film appearance was in the Swiss production *La Croix du Cervin* (1922), where she was the only professional actor in a work crucial to the history of the 'mountain film'. See discussion with illustration in Hervé Dumont, *Histoire du cinéma suisse* (Lausanne: Cinémathèque Suisse, 1987): 69, Ill. 49a.
8. This dichotomy between theory and cinematic practice up to Dulac's *L'Invitation du Voyage* (1927) was pointed out by Laurence Schifano in 'Trois scènes du féminin (*la Souriante Madame Beudet, Âme d'artiste, l'Invitation au voyage*): Dulac avant Dulac', Williams, *Dulac* (see endnote 2), 59–72, esp. 60–65.
9. Charles Baudelaire, *Les Fleurs du mal*, CXXI. Eng. trans. by Cyril Scott as *The Flowers of Evil* (London: Elkin Mathews, 1909). A Baudelaire poem has a similar function (as a title and as the name of a nightclub) in Dulac's film *L'Invitation au voyage. La Mort des amants* was also set to music by Debussy in his *Cinq poèmes de Baudelaire*, L. 70 (64), no. 5 (1887).
10. Stefan Jaročinski, *Debussy – Impressionisme et Symbolisme* (Paris, 1970), orig. Polish edn. (Warsaw, 1966); and Johannes Trillig, 'Das Klischee vom "Impressionisten" Debussy', idem: *Untersuchungen zur Rezeption Claude Debussys in der zeitgenössischen Musikkritik*, Frankfurter Beiträge zur Musikwissenschaft 13 (Tutzing: Schneider, 1983): 393–407, quote on 407.

248 *New Approaches to Silent Film Music History and Theory*

See also the section 'In der Moderne' in Fahle, *Jenseits des Bildes* (see endnote 4), 18–29.

11. Dulac, *Écrits* (see endnote 1), 102 and 185.
12. Dulac, *Écrits*, 66, (1925).
13. Dulac, *Écrits*, 37, (1924).
14. Dulac, *Écrits*, 96, (1927).
15. Located in the Arthur Kleiner Collection at the University of Minnesota. The piano score of *Mme Beudet* is in Box 7, File 9. The collection does not contain a score for Man Ray's *Star of the Sea*; MoMA has only a cue sheet without music. See Gillian B. Anderson, *Music for Silent Films 1894–1929: A Guide* (Washington, DC: Library of Congress, 1988): 119, no. 858.
16. The catalogues of these three archives are in Anderson's indispensable *Music for Silent Films* (see endnote 15); the catalogue of the Kleiner Collection can also be found at https://www.lib.umn.edu/scrbm/kleiner-inventory (accessed 1 November 2012). In October 2012, I was able to consult the copy in the FIAF archive in Brussels, for which I wish to express my thanks to Christophe Dupin and Jacqueline Renaut for their assistance. On Arthur Kleiner and his score for Dmitri Kirsanov's *Ménilmontant*, see chapter 1 of Jürg Stenzl, *Dmitri Kirsanov (1899–1957) – ein verschollener Filmregisseur* (Munich: Edition Text + Kritik, 2013).
17. This same question has just been convincingly posed by Francesco Finocchiaro in '*Panzerkreuzer Potemkin* zwischen Moskau und Berlin: Parallele Leben eines Meisterwerks', *MusikTheorie* 27 (2012): 213–228, using two settings of the legendary 'Odessa Steps' sequence from Sergey Eisenstein's silent film *Battleship Potemkin* (with music by Edmund Meisel and Dmitri Shostakovich). See especially his resumé on 226–227.
18. Admittedly this copy is only 962 feet (293 m) long, whereas the Centre Pompidou copy, evidently congruent with the DVD, has a length of 727m (39'45 at 16 fps). I wish to thank Isabelle Daire for kindly providing this information.
19. I extend my warm thanks to director Haden Guest and especially his co-worker Amy Sloper of the Harvard Film Archive for their suggestions and longstanding assistance. I was unable to ascertain whether this music was already used in the VHS edition.
20. See http://www.countryjoe.com/bsq.htm (accessed 6 November 2012): 'Carl Shrager was formerly a classical pianist, performing with the Philadelphia Orchestra at the age of 15. He attended Oberlin College Conservatory of Music, where he discovered folk music. The discovery led him from Oberlin to Berkeley, and then to some 50,000 miles of travel through every state and nearly every city in America. He performs on guitar, autoharp and assorted home-made rhythm instruments, and has composed original ballads and love songs.'

 See the poster by Charles Marchant Stevenson in http://www.williamzacha.com/ gallery/product.php?productid = 284&page = 1 (accessed 4 November 2012).
21. The catalogue of scores in the Arthur Kleiner Collection in Anderson, *Music for Silent Films* (see endnote 15), 152, explicitly lists that for *Mme Beudet* as one of 106 'Arthur Kleiner score[s]'.

22. If calculated by the coordinating information in the score and the duration of the film, the tempo must lie between ♩. = 64 and 76.
23. It was relatively easy to identify the 'stock music' in the *Mme Beudet* score preserved in the FIAF archive in Brussels. The verso of the front dustcover has a pencilled list of 'Used Music', a sort of cue sheet containing the titles and the names of the composers concerned. It can only have been prepared by the compiler-composer himself, Arthur Kleiner. These references have been incorporated in the rightmost column of the overview in Appendix 1. With regard to no. 20, I am unable to find a title *Twilight* by the American composer Arthur Walter Kramer (1890–1969).
24. Discussed at length in Marianne Wheeldon, *Debussy's Late Style*, Musical Meaning and Interpretation [no vol. no.] (Bloomington, IN, 2009): 38–40. A new edition appeared in Ernst-Günter Heinemann (ed.) Claude Debussy, *Klavierstücke* (Munich: Henle, 1997): 41/11. It is unlikely that the first edition was known in Europe and accessible to Kleiner in Vienna before his emigration to the US.
25. Though published today in a wide range of transcriptions, the only pre-1939 print was the version for cello and piano prepared for Durand in 1911 by F[erdinando] Ronchini (1865–1932), who turned out many such successful arrangements. It was issued together with *Les Cloches*, L. 66/(79).
26. This piece by Maurice Baron (1889–1964), published separately in New York in 1927, is headed 'Piano or Organ (Conductor)'. The marks 'Tutti', 'Cello, Cl.' and cue notes prove that it is a piano reduction of an orchestral piece. The term 'D.O.S. 36', or 'D.O.S. 36–10½', suggests that it was taken from a printed score or collection. Expression marks such as 'caressingly', 'seductive', '*incalzando*' (urgent), '*con passione*' and '*impetuoso*' point to a 'programmatic' subtext, for example in a feature film. I consulted the copy in my own private collection. The Music Division of the Library of Congress in Washington, DC, preserves the Maurice Baron Collection with five of his silent film scores. *Seduction* was recorded on 10' disc in 1928 by the Victor Orchestra under Josef Pasternack (Victor BVE-47879); see http://victor.library.ucsb.edu/index.php/matrix/detail/800021721/BVE-47879-Seduction (accessed 19 November 2012). Another eight similar cue sheets by Maurice Baron, dated 1923–1927, were on sale on the internet in 2012 at http://www.sheetmusicwarehouse.co.uk/ with their first pages on display (accessed 19 November 2012). On half of them the duration of the sections was precisely notated. One number, *Neutral Society Drama*, was published by Irving Berlin's firm in 1924 (like *Seduction*) with the no. D.O.S. 9; the other seven were issued by Belwin Inc., New York.
27. I owe the identification to Isobel Johnstone of the Pictures and Manuscript Branch of the National Library of Australia, to whom I express my gratitude for her assistance. One film score from the Australian State Theatre, Sydney, contains a printed edition of this piece with the title 'Alpdruck/Nightmare' and the subtitle 'Great Anxiety. Dreams of Terror' with a duration of four minutes; see http://catalogue.nla.gov.au/Record/4357364 (accessed 2 December 2012). The music was printed in 1927 by Heinrichshofen in Magdeburg as No. 52 in its 'Preis-Kino-Bibliothek' series. The Pfälzische Landesbibliothek in Speyer has a complete set of parts for this title (shelf mark: Mus. 17 998, 1–13), proving that it was

250 *New Approaches to Silent Film Music History and Theory*

indeed written by the German composer Marc Roland (1894–1975). Further information on Roland in Fred K. Prieberg, *Handbuch Deutsche Musiker 1922–1945*, CD-ROM (Kiel, 2004), 5829–5830, http://de.wikipedia.org/wiki/Marc_Roland (accessed 11 December 2012).

28. Manfred Knaak earned my gratitude by generously placing a copy of his score at my disposal.

29. All times are taken from the DVD and consistently differ from those in the score by one or two seconds. I use roman numerals to indicate the four movements of the score. The staccato chords, a remarkable 'musical characterization', are also heard when Monsieur Beudet twists the head off a doll (IV, 30′47–58) and before then (29′40–44) when he scoffs at the title of Debussy's *Jardins sous la pluie*.

30. In *L'Idée* (Berthold Bartosch, F., 1932), *Rapt* (Dmitri Kirsanov, CH, 1934) and *Der Dämon des Himalaya* (Ende/Andrew Marton, CH/D, 1935). Honegger's music in *L'Idée* is discussed in Jacques Tchamkerten, 'De Frans Masereel à Arthur Honegger, ou comment *L'Idée* devient musique', in Peter Jost (ed.) *Arthur Honegger: Werk und Rezeption/L'œuvre et sa reception* (Bern: Lang, 2009): 229–251.

31. In November 2009, *Mme Beudet* was screened at the 23rd Leeds International Film Festival with alternative experimental jazz performed by the Leeds Improvised Music Association (LIMA). It might be illuminating to expand the present discussion by comparing the Kleiner and Knaak scores with Carl Shrager's (see endnote 20) and the improvizations of LIMA.

32. Michel Chion, *Audio–Vision: Son et image au cinéma* (Paris: Nathan, 1990): 55; Eng. trans. as *Audio–Vision: Sound on Screen*, Walter Murch (ed.) (New York: Columbia University Press, 1994).

33. Finocchiaro, '*Panzerkreuzer Potemkin*' (see endnote 17), 225–227.

34. See Jürg Stenzl, *Auf der Suche nach Geschichte(n) der musikalischen Interpretation*, Salzburger Stier 7 (Würzburg: Königshausen & Neumann, 2012).

35. All time codes refer to the DVD version *Germaine Dulac (1922–1928)* (Berlin: Absolut Medien, 2007), DVD. The initial time codes refer to the beginning of a piece; the consecutive codes aim to localize the synchronization points in the score.

36. Firstly the indications in the column 'Used Music' of the *FIAF* score, Bruxelles, then in [] the identifying additions.

37. In this version in *Les Chefs-d'œuvres des grands maîtres contemporains*, Paris, Salabert © 1919, 22–23, with the title 'RÊVERIE de l'Enfance de Pantagruel'.

38. Titles in quotation marks are congruent with film intertitles.

39. In this version in *Les chefs-d'œuvres des grands maîtres contemporains*, Paris, Salabert © 1919, 24–25.

40. In the intertitle: Extrait de 'Trois Improvisations'. – The copyright for this piece: Maurice Senart 1914.

41. Added in ink by hand.

42. The music is not identical with the A flat major piano piece by D[omenico] Savino (1882–1973), *Twilight Hour*, New York, Schirmer 1925, an Italian-born composer who emigrated to the US and worked in silent and sound film productions.

43. In the column 'Music used', 25 (Nr. 3): '+ insert "Jardins sous la pluie" (Debussy)' [concerns 29′45].

Bibliography

Abel, Richard. *French Cinema: The First Wave, 1915–1929* (Princeton, N.J: Princeton University Press, 1984).

Abel, Richard. *The Red Rooster Scare: Making Cinema American, 1900–1910* (Berkeley: University of California Press, 1999).

Abel, Richard. 'That Most American of Attractions, the Illustrated Song', in Richard Abel and Rick Altman (eds.) *The Sounds of Early Cinema* (Bloomington: Indiana University Press, 2001): 143–155.

Abel, Richard. 'Illustrated Songs', in Richard Abel (ed.) *Encyclopedia of Early Cinema* (London: Routledge, 2005): 310–312.

Abel, Richard. 'A "Forgotten" Part of the Program: Illustrated Songs', in Richard Abel (ed.) *Americanizing the Movies and 'Movie-Mad' Audiences, 1910–1914* (Berkeley: University of California Press, 2006): 127–138.

Abel, Richard and Rick Altman (eds.) *The Sounds of Early Cinema* (Bloomington: Indiana University Press, 2001).

Achenbach, Michael, Paolo Caneppele and Ernst Kieninger (eds.) *Projektionen der Sehnsucht. Saturn – die erotischen Anfänge der österreichischen Kinematografie* (Vienna: Edition Film + Text, 1999).

Alovisio, Silvio. 'I libri e le riviste', in Carla Ceresa and Donata Pesenti Campagnoni (eds.) *Tracce. Documenti del cinema muto torinese nelle collezioni del Museo Nazionale del Cinema* (Torino: Il castoro, 2007): 171–187.

Altman, Rick. 'Introduction', *Yale French Studies: Cinema/Sound* 60 (1980): 1–15.

Altman, Rick, (ed.) *Yale French Studies: Cinema/Sound* 60 (1980).

Altman, Rick, (ed.) *Sound Theory, Sound Practice* (London, New York: Routledge, 1992).

Altman, Rick. 'The Silence of the Silents', *Musical Quarterly* 80/4 (Winter 1996): 648–718.

Altman, Rick. 'Film Sound – All of It', *Iris* 27 (Spring 1999): 31–48.

Altman, Rick. *Silent Film Sound* (New York: Columbia University Press, 2004).

Ament, Vanessa Theme. *The Foley Grail* (Oxford: Focal Press, 2009).

Anderson, Gillian B. *Music for Silent Films, 1894–1929: A Guide* (Washington, DC: Library of Congress, 1988).

Anderson, Gillian B. 'D.W. Griffith's *Intolerance*: Revisiting a Reconstructed Text', *Film History* 25/3 (2013): 57–89.

Anderson, Tim. 'Reforming "Jackass Music": The Problematic Aesthetics of Early American Film Music Accompaniment', *Cinema Journal* 37/1 (1997): 3–22.

Auslander, Philip. *Liveness: Performance in a Mediatized Culture* (New York: Routledge, 2008).

Bakhle, Janaki. *Two Men and Music: Nationalism in the Making of an Indian Classical Tradition* (Delhi: Permanent Black, 2005).

Bareither, Christoph (ed.) *Hans Richters 'Rhythmus 21': Schlüsselfilm der Moderne* (Würzburg: Königshausen & Neumann, 2012).

252 Bibliography

Barnier, Martin. *Bruits, Cris, Musiques de Films. Les Projections avant 1914* (Rennes: Press Universitaires des Rennes, 2011).

Baudelaire, Charles. *Les Fleurs du mal*, CXXI. English translation by Cyril Scott as *The Flowers of Evil* (London: Elkin Mathews, 1909).

Baxter, John. *The Cinema of John Ford* (London: A. Zwemmer, 1971).

Beardsley, Charles. *Hollywood's Master Showman: The Legendary Sid Grauman* (New York: Cornwall Books, 1983).

Beck, Jay and Tony Grajeda (eds.) *Lowering the Boom: Critical Studies in Film Sound* (Champaign: University of Illinois Press, 2008).

Bellano, Marco. 'Silent Strategies: Audiovisual Functions of the Music for Silent Cinema', *Kieler Beiträge zur Filmmusikforschung* 9 (2013): 46–76.

Belton, John. '1950's Magnetic Sound: The Frozen Revolution', in Rick Altman (ed.) *Sound Theory, Sound Practice* (New York: Routledge, 1992): 154–167.

Beynon, George. *Musical Presentation of Motion Pictures* (New York: Schirmer, 1921).

Bhaumik, Kaushik. *The Emergence of the Bombay Film Industry, 1913–1936* (Oxford: University of Oxford, 2001).

Bhirdikar, Urmila. 'The Spread of North Indian Music in Maharashtra in the Late Nineteenth and Early Twentieth Century: Sociocultural Conditions of Production and Consumption', in Amlan Dasgupta (ed.) *Music and Modernity: North Indian Classical Music in an Age of Mechanical Reproduction* (Calcutta: Thema, 2007): 220–238.

Biel, Urszula. 'Niemiecka reforma kinowa na Górnym Śląsku', in Andrzej Dębski and Marek Zybura (eds.) *Wrocław będzie miastem filmowym ... Z dziejów kina w stolicy Dolnego Śląska* (Wrocław: Wydawnictwo GAJT, 2008): 109–126.

Blumenberg, Hans. *Paradigmen zu einer Metaphorologie* (Bonn: Bouvier, 1960); English translation *Paradigms for a Metaphorology*, ed. by R. Savage (Ithaca: Cornell University Press, 2010).

Bogdanovich, Peter. *John Ford* (Berkeley: University of California Press, 1978).

Boillat, Alain. *Du bonimenteur à la voix-over. Voix-attraction et voix-narration au cinema* (Lausanne: Antipodes, 2007).

Bolter, Jay David and Richard Grusin. *Remediation. Understanding New Media* (Boston: MIT Press, 2000).

Bono, Francesco, Paolo Caneppele and Günther Krenn (eds.) *Elektrische Schatten: Beiträge zur österreichischen Stummfilmgeschichte* (Vienna: Verlag Filmarchiv Austria, 1999).

Bottomore, Stephen. 'An International Survey of Sound Effects in Early Cinema', *Film History* 11/4 (1999): 485–498.

Bottomore, Stephen. 'The Story of Percy Peashaker: Debates about Sound Effects in Early Cinema', in Richard Abel and Rick Altman (eds.) *The Sounds of Early Cinema* (Bloomington: Indiana University Press, 2001): 129–142.

Bowser, Eileen. *The Transformation of Cinema, 1907–1915* (New York: Scribner, 1990).

Brown, Julie and Annette Davison (eds.) *The Sounds of the Silents in Britain* (New York: Oxford University Press, 2012).

Brownlow, Kevin. *The War, the West, and the Wilderness* (New York: Knopf, 1979).

Brown, Royal. *Overtones and Undertones: Reading Film Music* (Berkeley: University of California Press, 1994).

Budde, Elmar. 'Filmmusik – Verlust der musikalischen Vernunft?', in Hartmut Krones (ed.) *Bühne, Film, Raum und Zeit in der Musik des 20. Jahrhunderts* (Vienna: Böhlau, 2003): 111–118.

Buhler, James. 'The Reception of British Exhibition Practices in *Moving Picture World, 1907–1914*', in Julie Brown and Annette Davison (eds.) *The Sounds of the Silents in Britain* (New York: Oxford University Press, 2012): 144–160.

Buhler, James, Caryl Flinn and David Neumeyer (eds.) *Music and Cinema* (Middletown: Wesleyan University Press, 2000).

Buhler, James, David Neumeyer and Rob Deemer. *Hearing the Movies: Music and Sound in Film History* (New York: Oxford University Press, 2009).

Bullerjahn, Claudia. 'Von der Kinomusik zur Filmmusik. Stummfilm-Originalkompositionen der zwanziger Jahre', in Werner Keil (ed.) *Musik der zwanziger Jahre* (Hildesheim/Zürich/New York: Georg Olms Verlag, 1996): 281–317.

Bullerjahn, Claudia. 'Musik zum Stummfilm. Von den ersten Anfängen einer Kinomusik zu heutigen Versuchen der Stummfilmillustration', in Josef Kloppenburg (ed.) *Das Handbuch der Filmmusik. Geschichte–Ästhetik–Funktionalität* (Regensburg: Laaber, 2012): 27–85.

Burch, Noël. *Life to those Shadows*, trans. and ed. by Ben Brewster (Berkeley: University of California Press, 1990).

Burrows, Jon. *Legitimate Cinema: Theater Stars in Silent British Films, 1908–1918* (Exeter: University of Exeter Press, 2003).

Chandravarkar, Bhaskar. 'Sound in a Silent Era', *Cinema Vision India: Pioneers of Indian Cinema, The Silent Era* 1 (1980): 117–119.

Chion, Michel. *L'Audio-Vision. Son et image au cinéma* (Paris: Nathan, 1990) trans. and ed. by Claudia Gorbman as *Audio–Vision: Sound on Screen*, foreword by Walter Murch (New York: Columbia University Press, 1994).

Chion, Michel. *La voix au cinéma* (Paris: Cahiers du Cinéma/Editions de L'Etoile, 1982) trans. and ed. by Claudia Gorbman as *The Voice in Cinema* (New York: Columbia University Press, 1999).

Comisso, Irene. 'Theory and Practice in Erdmann/Becce/Brav's *Allgemeines Handbuch der Film-Musik* (1927)', *The Journal of Film Music* 5/1–2 (2012): 93–100.

Comuzio, Ermanno. 'Industria e commercio dell' "Incidental film music"', *Immagine* 2 (1986): 16–21.

Comuzio, Ermanno. 'Pianisti estemporanei e di carriera, orchestrine e orchestrone', *Immagine* 23 (1993): 19–22.

Cooke, Mervyn. *A History of Film Music* (Cambridge, MA: University Press, 2010).

Crafton, Donald. *Before Mickey: The Animated Film, 1898–1928* (Cambridge, MA: MIT Press, 1982).

Crafton, Donald. 'Playing the Pictures: Intermediality and Early Cinema Patronage', *Iris* 27 (Spring 1999): 152–162.

Crafton, Donald. *The Talkies. American Cinema's Transition to Sound, 1926–1931* (Berkeley: University of California Press, 1999).

Dall'Ara, Mario. *Editori di musica a Torino e Piemonte* (Torino: Centro studi piemontesi, 1999).

Davison, Annette. 'Workers' Rights and Performing Rights: Cinema Music and Musicians Prior to Synchronized Sound', in Julie Brown and Annette Davison (eds.) *The Sounds of the Silents in Britain* (New York: Oxford University Press, 2012): 243–262.

254 *Bibliography*

Davis, Ronald L. *John Ford: Hollywood's Old Master* (Norman, OK: University of Oklahoma Press, 1995).

Debussy, Claude. *Klavierstücke*, edited by Ernst-Günter Heinemann (Munich: Henle, 1997): 41/11.

DeCordova, Richard. *Picture Personalities: The Emergence of the Star System in America* (Champaign: University of Illinois Press, 2001).

Dewald, Christian and Werner Michael Schwarz (eds.) *Prater. Kino. Welt. Der Wiener Prater im Film* (Vienna: Filmarchiv Austria, 2005).

Dulac, Germaine. *Écrits sur le Cinéma (1919–1937): Textes réunis et présentés par Prosper Hillairet* (Paris: Éditions Paris Expérimental, 1994).

Edström, Karl-Olof (Olle). *På begäran: Svenska Musikerförbundet 1907–1982* (Stockholm: Tidens förlag, 1982).

Sergei Eisenstein, Vsevolod Pudovkin and Grigori Aleksandrov, 'Budushchee zvukovoi il'my: Zaiavka' [The Statement on Sound], *Zhizn' iskusstva* 32, (August 5, 1928); translated in Richard Taylor and Ian Christie (eds.) *The Film Factory: Russian and Soviet Cinema in Documents 1896–1939* (London and New York: Routledge, 1988): 234–235.

Elsaesser, Thomas. *Metropolis* (London: British Film Institute, 2000).

Elsaesser, Thomas. *Weimar Cinema and After. Germany's Historical Imaginary* (London and New York: Routledge, 2000).

Erdmann, Hans. 'Der künstlerische Spielfilm und seine Musik', in Rudolf Pabst (ed.) *Das deutsche Lichtspieltheater in Vergangenheit, Gegenwart und Zukunft* (Berlin: Prisma-Verlag, 1926): 100–117.

Erdmann, Hans, Giuseppe Becce and Ludwig Brav. *Allgemeines Handbuch der Film-Musik* (Berlin–Lichterfelde: Schlesinger, 1927).

Fahle, Oliver. *Jenseits des Bildes: Poetik des französischen Films der zwanziger Jahre* (Mainz: Bender, 2000).

Ferrell, Gerry. 'The Early Days of the Gramophone Industry in India: Historical, Social and Musical Perspectives', *British Journal of Ethnomusicology* 2 (1993): 31–53.

Finocchiaro, Francesco. '*Panzerkreuzer Potemkin* zwischen Moskau und Berlin: Parallele Leben eines Meisterwerks', *MusikTheorie* 27 (2012): 213–228.

Fleeger, Jennifer. 'Projecting an Aria, Singing the Cinema: In Search of a Shared Vocabulary for Opera and Film Studies', *Music, Sound, and the Moving Image* 2/2 Special Issue 'The Future of Sound Studies' (Autumn 2008): 121–125.

Fleeger, Jennifer. 'How to Say Things with Songs: Al Jolson, Vitaphone Technology, and the Rhetoric of Warner Bros. in 1929', *Quarterly Review of Film and Video* 27/1 (January 2010): 27–43.

Fleeger, Jennifer. *Sounding American Hollywood, Opera, and Jazz* (New York: Oxford University Press, 2014).

Franklin, Peter. *Seeing Through Music: Gender and Modernism in Classical Hollywood Film* (New York: Oxford University Press, 2011).

Fritz, Walter. *Geschichte des österreichischen Films* (Vienna: Bergland Verlag, 1969).

Fritz, Walter. *Kino in Österreich, 1896–1930: Der Stummfilm* (Vienna: Österreichischer Bundesverlag, 1981).

Fuller-Seeley, Kathryn. *At the Picture Show: Small Town Audiences and the Creation of Movie Fan Culture* (Washington, DC: Smithsonian Institution Press, 1996).

Fuller-Seeley, Kathryn. *Hollywood in the Neighborhood: Historical Case Studies of Local Moviegoing* (Berkeley: University of California Press, 2008).

Bibliography 255

Fuller-Seeley, Kathryn and Q. David Bowers. *One Thousand Nights at the Movies: An Illustrated History of Motion Pictures 1895–1915* (Atlanta: Whitman Publishing, 2013).

Gallagher, Tag. *John Ford: The Man and his Films* (Berkeley: University of California Press, 1986).

Gariazzo, Pier Antonio. *Il teatro muto* (Torino: Lattes, 1919).

Garncarz, Joseph. *Maßlose Unterhaltung. Zur Etablierung des Films in Deutschland 1896–1914* (Frankfurt am Main: Stroemfeld, 2010).

Gaudreault, André and Germain Lacasse (eds.) with Jean-Pierre Sirois-Trahan. *Au pays des ennemis du cinéma ... Pour une nouvelle histoire des débuts du cinéma au Québec* (Québec: Nuit Blanche, 1996).

Gervink, Manuel. '(Art.) Programmmusik', in Manuel Gervink and Matthias Bückle (eds.) *Lexikon der Filmmusik* (Regensburg: Laaber, 2012): 404–405.

Glanz, Christian. 'Unterhaltungsmusik in Wien im 19. und 20. Jahrhundert', in Elisabeth T. Fritz-Hilscher and Helmut Kretschmer (eds.) *Wien Musikgeschichte. Von der Prähistorie bis zur Gegenwart* (Vienna, Berlin: Lit Verlag, 2011): 487–534.

Goldmark, Daniel. *Tunes for 'Toons, Music and the Hollywood Cartoon* (Berkeley: University of California Press, 2007).

Goldmark, Daniel, Lawrence Kramer and Richard D. Leppert (eds.) *Beyond the Soundtrack: Representing Music in Cinema* (Berkeley: University of California Press, 2007).

Gomery, Douglas. *The Coming of Sound: A History* (New York: Routledge, 2005).

Gorbman, Claudia. 'Teaching the Soundtrack', *Quarterly Review of Film and Video* 1/4 (1976): 446–452.

Gorbman, Claudia. *Unheard Melodies: Narrative Film Music* (Bloomington: Indiana University Press, 1987).

Gorbman, Claudia. 'Scoring the Indian: Music in the Liberal Western', in Georgina Born and David Hesmondhalgh (eds.) *Western Music and its Others* (Berkeley: University of California Press, 2000): 234–54.

Grimm, Hartmut. 'Hermann Kretzschmar: Restitution der Affektenlehre als wissenschaftliche Grundlegung musikalischer Hermeneutik', in Anselm Gerhard (ed.) *Musikwissenschaft – eine verspätete Disziplin? Die akademische Musikforschung zwischen Fortschrittsglauben und Monernitätsverweigerung* (Stuttgart and Weimar: Metzler, 2000): 88–97.

Hansen, Miriam. 'Early Silent Cinema: Whose Public Sphere?', *New German Critique* 29 (Spring 1983): 147–184.

Harms, Rudolf. *Philosophie des Films* (Leipzig: Meiner, 1926).

Heidenreich, Achim. 'Zwischen Klanginstallation und Konzert – Der Komponist Bernd Thewes', *MusikTexte* 95 (November 2002): 13–18.

Hickman, Roger. *Reel Music: Exploring 100 Years of Film Music* (New York: W. W. Norton, 2005).

Hubbert, Julie (ed.) *Celluloid Symphonies: Texts and Contexts in Film Music History* (Berkeley: University of California Press, 2011).

Hughes, Stephen. 'The Music Boom in Tamil South India: Gramophone, Radio and the Making of Mass Culture', *Historical Journal of Film, Radio and Television* 22 (2002): 445–473.

Jaglarz, Weronika. 'Dziesiąta muza w Gliwicach – Pierwsze lata i Rozwój', in Andrzej Gwóźdź (ed.) *Historie Celuloidem Podszyte. Z Dziejów X muzy na Górnym Śląsku i Zagłębiu Dąbrowskim* (Kraków: Rabid, 2005).

256 *Bibliography*

Jaročinski, Stefan. *Debussy, a impresionizm i synmbolizm* (Warsaw, 1966); English translation by Rollo Myers as *Debussy – Impressionism and Symbolism* (London: Eulenberg Books, 1976).

Joshi, G.N. 'A Concise History of the Phonograph Industry in India', *Popular Music* 7 (May 1988): 147–156.

Kahn, Douglas. *Noise, Water, Meat: A History of Sound in the Arts* (Cambridge, MA: MIT Press, 1999).

Kalinak, Kathryn. *Settling the Score: Music and the Classical Hollywood Film* (Madison: University of Wisconsin Press, 1992).

Kalinak, Kathryn. *How the West Was Sung: Music and the Westerns of John Ford* (Berkeley: University of California Press, 2007).

Kalinak, Kathryn. *Film Music: A Very Short Introduction* (Oxford: Oxford University Press, 2010).

Kenneth, H. Marcus. *Musical Metropolis: Los Angeles and the Creation of a Music Culture, 1880–1940* (New York: Palgrave Macmillan, 2004).

Kiening, Christian and Adolf Heinrich. *Der Absolute Film. Dokumente der Medienavantgarde (1912–1936)* (Zürich: Chronos 2011).

Kraft, James P. *Stage to Studio: Musicians and the Sound Revolution, 1890–1950* (Baltimore/London: The Johns Hopkins University Press, 1996).

Krones, Hartmut. 'Optische Konzeption und musikalische Semantik. Zum "Allgemeinen Handbuch der Film-Musik" von Hans Erdman, Giuseppe Becce und Ludwig Brav', in Hartmut Krones (ed.) *Bühne, Film, Raum und Zeit in der Musik des 20. Jahrhunderts* (Vienna: Böhlau, 2003): 119–142.

Lacasse, Germain. *Histoires de scopes. Le cinéma muet au Québec* (Montréal: Cinémathèque québécoise, 1989).

Lacasse, Germain. *Le bonimenteur de vues animées. Le cinéma muet entre tradition et modernité* (Paris: Méridiens Klincksieck, 2000).

Lakoff, George and Mark Johnson. *Metaphors we Live by* (Chicago/London: University of Chicago Press, 1981).

Lang, Edith and George West. *Musical Accompaniment of Moving Pictures: A Practical Manual for Pianists and Organists and an Exposition of the Principles Underlying the Musical Interpretation of Moving Pictures* (Boston: Boston Music, 1920), repr. (New York: Arno Press, 1970).

Lastra, James. 'Reading, Writing, and Representing Sound', in Rick Altman (ed.) *Sound Theory, Sound Practice* (New York: Routledge, 1992): 65–86.

Lastra, James. *Sound Technologies and the American Cinema: Perception, Representation, Modernity* (New York: Columbia University Press, 2000).

Latour, Bruno. *Die Hoffnung der Pandora* (Frankfurt am Main: Suhrkamp, 2002).

Lauridsen, Palle Schantz. *Vaudeville på dåse – Warner Bros., Vitaphone og kortfilmen* (Institut for Nordiske Studier og Sprogvidenskab, 1993).

Levy, Louis. *Music for the Movies* (London: S. Low, Marston, 1948).

Lissa, Zofia. *Ästhetik der Filmmusik* (Berlin: Henschelverlag, 1965).

Loiperdinger, Martin. 'German Tonbilder of the 1900s: Advanced Technology and National Brand', in Klaus Kreimeier and Annemone Ligensa (eds.) *Film 1900: Technology, Perception, Culture* (Herts: John Libbey Publishing, 2009): 187–199.

London, Kurt. *Film Music: A Summary of the Characteristic Features of Its History, Aesthetics, Technique; and Possible Developments* (London: Faber & Faber, 1936).

Luciani, Sebastiano Arturo. *Verso una Nuova Arte: Il Cinematografo* (Roma: Ausonia, 1920).

Bibliography 257

MacDonald, Lawrence E. *The Invisible Art of Film Music: A Comprehensive History* (Lanham: Scarecrow Press, 1998).
Maciszewski, Amelia. 'North Indian Women Musicians and Their Words', in Amlan Dasgupta (ed.) *Music and Modernity: North Indian Classical Music in an Age of Mechanical Reproduction* (Calcutta: Thema, 2007): 156–219.
Marks, Martin M. *Music and the Silent Film* (New York/Oxford: Oxford University Press, 1997).
Mattl, Siegfried. 'Wiener Paradoxien. Fordistische Stadt', in Roman Horak, Wolfgang Maderthaner, Siegfried Mattl, Gerhard Meißl, Lutz Musner and Alfred Pfoser (eds.) *Metropole Wien, Texturen der Moderne* 1 (Vienna: Wiener Universitätsverlag, 2000): 22–96.
Meisel, Edmund. 'Wie schreibt man Filmmusik?', *Ufa-Magazin* (Berlin) 2/4 (1927), repr., in Werner Sudendorf (ed.) *Der Stummfilmmusiker Edmund Meisel* (Frankfurt am Main: Deutsches Filmmuseum, 1984): 57–60.
Melnick, Ross. *American Showman: Samuel 'Roxy' Rothafel and the Birth of the Entertainment Industry, 1908–1935* (New York: Columbia University Press, 2012).
Miceli, Sergio. *Musica per Film. Storia, Estetica, Analisi, Tipologie* (Lucca: Ricordi/LIM, 2009).
Miceli, Sergio. *Film Music. History, Aesthetic-Analysis, Typologies*, trans. and ed. by Marco Alunno and Braunwin Sheldrick (Milano/Lucca: Ricordi LIM, 2013).
Mills, Melinda, Gerhard G. Van de Bunt and Jeanne De Brujin. 'Comparative Research. Persistent Problems and Promising Solutions', *International Sociology* 21/5 (2006): 619–631.
Mishra, Yatindra. 'The Bai and the Dawn of the Hindi Film Music (1925–1945)', *Book Review* XXXIII (February 2009): 46–47.
Nasta, Dominique and Didier Huvelle (eds.) *New Perspectives in Sound Studies/Le Son en Perspective: Nouvelles Recherches* (Pieterlen: Peter Lang, 2004).
Nettl, Bruno. *The Study of Ethnomusicology: Thirty-One Issues and Concepts* (Urbana: University of Illinois Press, 2005): 3–15.
Neumeyer, David (ed.) *The Oxford Handbook of Film Music Studies* (New York: Oxford University Press, 2013).
Niazi, Sarah Rahman. *Cinema and the Reinvention of the Self: Women Performers in the Bombay Film Industry (1925–1947)* (New Delhi: Jawaharlal Nehru University, 2011).
O'Brien, Charles. *Cinema's Conversion to Sound: Technology and Film Style in France and the United States* (Bloomington: Indiana University Press, 2005).
O'Brien, Charles. 'Sound-on-Disc Cinema and Electrification Prior to WWI: Britain, France, Germany, and the United States', in Richard Abel, Giorgio Bertellini and Rob King (eds.) *Early Cinema and the 'National'* (Eastleigh: John Libbey Press, 2008): 40–49.
O'Connor, John E. 'The White Man's Indian: An Institutional Approach', in Peter C. Rollins and John E. O'Connor (eds.) *Hollywood's Indian: The Portrayal of the Native American in Film* (Lexington: University Press of Kentucky, 1998): 27–38.
Pauli, Hansjörg. *Filmmusik: Stummfilm* (Stuttgart: Klett-Cotta, 1981).
Petrasch, Wilhelm. *Die Wiener Urania. Von den Wurzeln der Erwachsenenbildung zum Lebenslangen Lernen* (Vienna/Cologne/Weimar: Böhlau, 2007).
Piccardi, Carlo. 'Pierrot at the Cinema. The Musical Common Denominator from Pantomime to Film. Part III', *Music and the Moving Image* 6/1 (2013): 4–54.
Pisano, Giusy. *Une archéologie du cinéma sonore* (Paris: CNRS éditions, 2004).

258 *Bibliography*

Pisano, Giusy and Valérie Pozner (eds.) *Le muet a la parole. Cinéma et performances à l'aube du 20e siècle* (Paris: Association française de recherche sur l'histoire du cinéma, 2005).

Plebuch, Tobias. 'Mysteriosos Demystified: Topical Strategies within and Beyond the Silent Cinema', *Journal of Film Music* 5/1–2 (2012): 77–92.

Rajadhyaksha, Ashish. 'The Phalke Era: Conflict of Traditional Form and Modern Technology', in Tejaswini Niranjana, P. Sudhir and Vivek Dhareshwar (eds.) *Interrogating Modernity: Culture and Colonialism in India* (Calcutta: Seagull Books, 1993): 47–82.

Rapée, Erno. *Encyclopaedia of Music for Pictures* (New York: Belwin, 1925).

Ray, Satyajit. 'I Wish I Could Have Shown Them to You', *Cinema Vision India: Pioneers of Indian Cinema, The Silent Era* 1 (1980): 6–7.

Redi, Riccardo. 'Musica del muto', *Immagine* 36 (1996): 9–13.

Remak, Henry H.H. 'Comparative Literature: Its Definition and Function', in Horst Frenz and Newton P. Stallknecht (eds.) *Comparative Literature: Method and Perspective* (Carbondale, IL: Southern Illinois University Press, 1961): 3–37.

Robertson Wojcik, Pamela and Arthur Knight. *Soundtrack Available: Essays on Film and Popular Music* (Durham: Duke University Press, 2001).

Rügner, Ulrich. *Filmmusik in Deutschland zwischen 1924 und 1934* (Hildesheim/Zürich/New York: Georg Olms Verlag, 1988).

Sala, Emilio. 'Per una drammaturgia del ri-uso musicale nel cinema muto: Il caso di "Cabiria" (1914)', in Annarita Colturato (ed.) *Film music. Practices and Methodologies* (Torino: Kaplan, 2014): 73–107.

Sampath, Vikram. *My Name Is Gauharjaan! The Life and Times of a Musician* (New Delhi: Rupa, 2010).

Sapp, Craig Stuart. 'Comparative Analysis of Multiple Musical Performances', in *Proceedings of the 8th International Conference on Music Information Retrieval (ISMIR)* (Vienna: Österreichische Computer Gesellschaft, 2007): 497–500.

Saxer, Marion. 'Komposition im Medienwandel. Operationsketten als kompositorische Strategien bei Peter Ablinger, Bernd Thewes und Isabel Mundry', in Christian Utz (ed.) *Musiktheorie als interdisziplinäres Fach. 8. Kongress der Gesellschaft für Musiktheorie Graz 2008,* Musik Theorien der Gegenwart 4 (Saarbrücken: Pfau, 2010): 481–495.

Saxer, Marion. 'Komponierte Sichtbarkeit. Intermodale Strategien in Annesley Blacks Video-Komposition 4238 De Bullion für Klavier solo und live-elektronische Klang- und Videobearbeitung (2007/2008)', in Marion Saxer (ed.) *Mind the Gap! Medienkonstellationen zwischen zeitgenössischer Musik und Klangkunst* (Saarbrücken: Pfau, 2011): 50–66.

Schifano, Laurence. 'Trois scènes du féminin (*la Souriante Madame Beudet, Âme d'artiste, l'Invitation au voyage*): Dulac avant Dulac', in William Van Wert *Germaine Dulac: Die erste Feministin des Films [Program]* 7. Internationales Forum des Jungen Films, Berlin, 2/1–7; English translation *Women and Film* 5–6 (Santa Monica, 1974): 59–72.

Schoenberg, Arnold. 'Das Verhältnis zum Text', in W. Kandinsky and F. Marc (eds.) *Der blaue Reiter* (Munich: Piper, 1912): 27–33; English translation as 'The Relationship to the Text', in Arnold Schoenberg, *Style and Idea: Selected Writings of Arnold Schoenberg*, ed. Leonard Stein, trans. Leo Black (New York: St. Martins Press; London: Faber & Faber, 1975): 141–145.

Bibliography 259

Schwarz, Werner Michael. *Kino und Kinos in Wien. Eine Entwicklungsgeschichte bis 1934* (Vienna: Turia & Kant, 1992).

Scott, Derek B. *Sounds of the Metropolis. The Nineteenth-Century Popular Music Revolution in London, New York, Paris, and Vienna* (New York: Oxford University Press, 2008).

Segre, Cesare. *Semiotica filologica. Testo e modelli culturali* (Torino: Einaudi, 1979): 64–70.

Shklovsky, Viktor. *O teorii prozy* (Moskva–Leningrad: Krug, 1925); English translation by B. Sher as *Theory of Prose* (Elmwood Park: Dalkey Archive Press, 1990).

Siebert, Ulrich Eberhard. *Filmmusik in Theorie und Praxis. Eine Untersuchung der 20er und frühen 30er Jahre anhand des Werkes von Hans Erdmann*, Europäische Hochschulschriften 53 (Frankfurt/Bern/New York/Paris, 1990).

Simeon, Ennio. 'Appunti sulla teoria e prassi musicale nel cinema muto Tedesco', in *Trento Cinema. Incontri Internazionali con il film d'autore* (Trento: Servizio Attività Culturali della Provincia Autonoma di Trento, 1987): 74–80.

Sirois-Trahan, Jean-Pierre. *La vie ou du moins ses apparences. Émergence du cinéma dans la presse de la Belle Époque* (Montréal: Cinémathèque québécoise/Grafics, 2002).

Slowik, Mike. 'Diegetic Withdrawal and Other Worlds: Film Music Strategies before *King Kong*, 1927–1933', *Cinema Journal* 53/1 (Fall 2013): 1–25.

Smith, Jeff. *The Sounds of Commerce: Marketing Popular Film Music* (New York: Columbia University Press, 1998).

Sommer, Heinz-Dieter. *Praxisorientierte Musikwissenschaft. Studien zu Leben und Werk Hermann Kretzschmars*, Freiburger Schriften zur Musikwissenschaft 16 (Munich/Salzburg: Katzbichler, 1985).

Spadoni, Robert. *Uncanny Bodies: The Coming of Sound Film and the Origins of the Horror Genre* (Berkeley, University of California Press, 2007).

Spring, Katherine. *Saying It with Songs: Popular Music and the Coming of Sound to Hollywood Cinema* (New York: Oxford University Press, 2013).

Stenzl, Jürg. *Auf der Suche nach Geschichte(n) der musikalischen Interpretation*, Salzburger Stier 7 (Würzburg: Königshausen & Neumann, 2012).

Stenzl, Jürg. *Dmitrij Kirsanov (1899–1957) – Ein Verschollener Filmregisseur* (Munich: Edition Text + Kritik, 2013).

Sterne, Jonathan. *The Audible Past: Cultural Origins of Sound Reproduction* (Durham: Duke University Press, 2003).

Sterne, Jonathan. *MP3. The Meaning of a Format* (Durham: Duke University Press, 2012).

Stindt, Georg Otto. *Das Lichtspiel als Kunstform* (Bremerhaven: Atlantis, 1924).

Stromgren, Richard L. 'The Moving Picture World of W. Stephen Bush', *Film History* 2/1 (1988): 13–22.

Tavernier, Bertrand. 'John Ford a Paris, Notes d'un Attache de Presse,' *Positif: Revue du Cinema* 82 (March 1967): 7–21.

Tchamkerten, Jacques. 'De Frans Masereel à Arthur Honegger, ou comment *L'Idée* devient musique', in Peter Jost (ed.) *Arthur Honegger: Werk und Rezeption/L'œuvre et sa Reception* (Bern: Lang, 2009): 229–251.

Thorau, Christian. *Semantisierte Sinnlichkeit – Studien zu Rezeption und Zeichenstruktur der Leitmotivtechnik Richard Wagners*, Beihefte zum Archiv für Musikwissenschaft 50 (Stuttgart: Steiner, 2003): 161–167.

260 Bibliography

Tieber, Claus and Hans-Jürgen Wulff. 'Pragmatische Filmmusikforschung: Vom Text zum Prozess', *Montage AV* 9/2 (January 2010): 153–165.

Tomashevsky, Boris. *Teorija literatury. Poetika* (Moskva–Leningrad: Gosudarstvennoe izd-vo, 1928); English translation 'Thematics', in Lee T. Lemon and Marion J. Reis (eds.) *Russian Formalist Criticism. Four Essays* (Lincoln: University of Nebraska Press, 1965): 61–98.

Tootell, George. *How to Play the Cinema Organ: A Practical Book by a Practical Player* (London: Paxton, 1927).

Trillig, Johannes. 'Das Klischee vom "Impressionisten" Debussy', *Untersuchungen zur Rezeption Claude Debussys in der zeitgenössischen Musikkritik*, Frankfurter Beiträge zur Musikwissenschaft 13 (Tutzing: Schneider, 1983): 393–407.

Vallora, Marco. 'Il nipote di Diderot: Ejzenštejn o la scrittura delle emozioni', in P. Gobetti (ed.) Sergej Ejzenštejn, *La forma cinematografica* (Torino: Einaudi, 1986): VII–LVI.

Van Wert, William. 'Germaine Dulac: Die erste Feministin des Films', [*Program*] 7. *Internationales Forum des Jungen Films, Berlin*, 2/1–7; English translation *Women and Film* 5–6 (Santa Monica, 1974): 55–58.

Veselovsky, Alexander. *Sobranie sochineniy* (Poetika), II Vol.: Poetika syuzhetov (Sankt Petersburg: Tipogr. Imperat. Akad. Nauk, 1913).

Wagner, Richard. *Oper und Drama.* (Leipzig: Weber, 1852); English translation by E. Evans as *Opera & Drama* (London: Reeves, 1913).

Wedel, Michael. *Der deutsche Musikfilm* (Munich: Edition Text + Kritik, 2007).

Weidman, Amanda J. *Singing the Classical Voicing the Modern: The Postcolonial Politics of Music in South India* (Calcutta: Seagull Books, 2007).

Weis, Elizabeth and John Belton (eds.) *Film Sound: Theory and Practice* (New York: Columbia University Press, 1985).

Whenham, John. *Claudio Monteverdi. Orfeo* (Cambridge, MA: Cambridge University Press, 1986).

Wierzbicki, James. *Film Music: A History* (New York: Routledge, 2008).

Willemen, Paul in Yingjin Zhang, *Cinema, Space, and Polylocality in a Globalizing China* (Honolulu: University of Hawai'i Press, 2010).

Wurtzler, Steve. *Electric Sounds: Technological Change and the Rise of Corporate Mass Media* (New York: Columbia University Press, 2009).

Xenakis, Iannis. *Formalized Music. Thought and Mathematics in Composition.* 2nd Revised English Ed. Harmonologia Series 6 (Stuyvesant, NY: Pendragon Press, 1992).

Index

Note: Locators in bold refer to figures or tables.

600 000 francs par mois (Norma Film, 1925), 80

abstract films, 173–5, 193–7
adattamento musicale, 51, 56
Allgemeine Handbuch der Filmmusik, Das (1927), 51, 156–67, 219
 Thematisches Skalenregister, 157, 161–6
Alloy Orchestra, 209, 216–18
Alte Lied, Das (1919), 72, 75
Amiel, Deny, 222
amusement parks, 87–8
Anderson, Gillian, 109
Arquillière, Alexandre, 223
arrangers, 29, 31, 145
arrangements, 87, 95–7, 144, 160
Aschermittwoch (Althoff–Ambos–Film, 1925), 74
audience
 behavior, 106, 117, 131
 expectations, 126, 147
audiovisual functions, 210–13, 215, 217
avant-garde
 cinema, 196, 221, 224
 film music, 187
 theater, 222
Axt, William, 145

Bacchini, Romolo, 49, **59–61**
Baijis, 126, 129–34
ballet, **20–1**, 54, 78, 80, 107
Bakhle, Janaki, 125
Ballet Mecanique (Léger, 1924), 194
Battleship Potemkin (Mosfilm, 1925), 172, 176, **179–82**, 185, **186–8**, 237
Bauer, Emil, 96
Baumer, Jacques, 222
Becce, Guiseppe, 157, 159, 163

Beethoven, der Märtyr seines Herzens (Sascha–Messter–Film, 1918), 73
Beethoven, Ludwig van, **61**, 73, 92
Berlin, die Sinfonie der Großstadt (Deutsche Vereins-Film, 1927), 194–5
Beynon, George W., 19
bhakti, 126, 130
Bhatkhande, Vishnu, 124, 128–30, 133
Bianchi, Vitaliano, 55, **60**
Biophon system, 38
Bombay Presidency, 124, 128, 130
Borrows, John, 107–8
Brav, Ludwig, 157, 160–6
Brenon, Herbert, 110–11
Brigantin von New York, Die (Dewesti Verleih, 1924), 76
Bromme, Walter, 74
Bruckner, Anton, 95
Brunetti, Osvaldo, 55, **59**
Bush, W. Stephen, 103, **112**

Cabiria (Italia Film, 1914), 58, **60**
Capitol Theatre (New York), 24
Carraro, Omero, **53**
Carré, Michel, 107
censorship, 104–6, 114–15, 117, 221
Christus (Società Italiana Cines, 1916), 55, **60**
Cinema Moderno (Rome), 55
cinema
 orchestras, 15, 42, 45–6, 51–2, 54–6, 76, 86, 89, 90, 95–7, 104, 114–15
 programs, 36–8, 40–1, 43–7
cinema music
 repertoire, 14, 25, 44, 52–2, 55, 58–9, 72, 80–1, 84, 87, 90–1, 96, 161

261

262 *Index*

cinema music – *continued*
 publishers, 14, 16, 19, 29, 56, 96,
 157–8
 libraries, 13–19, **20–3**, 24–9, **30**,
 31, 160
 see also photoplay music
Cinema Vittoria (Turin), 55
conductors, *see* musical directors
 see also Kapellmeister
commedia dell'arte, 107
commento musicale, 51–2, 56, **57**,
 61–2
comparative research, 208–15, 219
compilation score, *see* scores
counterpoint, audiovisual, 174, 184,
 186, 202
Covered Wagon, The (Paramount
 Productions, 1923), 142
Criterion Theatre (New York), 24
cue sheets, 15, 211, 236
 in Italy, 49, 51–2, 58–9
 in Austria, 85, 92, 94

Davis, Carl, 193, 208
Day, C. R., 125
DeCordova, Richard, 107
Delluc, Louis, 224
Der absolute Film (silent film matinee)
 174, 193–4
Dermoz, Germaine, 223, 235
Deutsche Helden in schwerer Zeit
 (Filmhaus Wilhelm Feindt,
 1924), 74
doctrine of affects (baroque period),
 156, 163
Dreyer, Carl, 195
Drums along the Mohawk (Twentieth
 Century Fox Film, 1939), 147–8
Dulac, Germaine, 221–5, 234–7

Eber, Franz, 89, 96
Edison Theater, 66, **67**
Edison, Thomas, 107
Eggeling, Viking, 174, 194
Ein Walzertraum (Ufa, 1925), 73, 77
Eisenstein, Sergei, 172–3, 175–6, 185,
 187–8
 see also Battleship Potemkin
Eisler, Hanns, 193–4

employment conditions, 45, 70–1,
 91, 93
Enfant Prodigue, L' (1891), 107
Ensemble Ascolta, 195
Entr'acte (Les Ballets Suedois,
 1924), 194
Erdmann, Hans, 157, 159–60, 163–6,
 174, 184
exhibition practices
 in Austria, 88–90
 in England, 111, 113–15
 in Poland, 66–70
 in India, 127–8, 131–4
 in France, 104–6, 116–17
 in Germany, 109–11, 114–15
 in Italy, 115–16
Eysler, Edmund, 87

Fata Carabosse, La (1914), 55, **60**
Feininger, Lyonel, 193
female musicians, 37, 45–6, 71, 127,
 129, 133, 135
 see also ladies orchestras
Figaro's Hochzeit (Terra Film, 1920), 73
Film–Ton–Kunst, 96, 158–9, 162, 164
film restorations, 59, 195, 215
Fino, Don Giocondo, 55, **60–1**
Fledermaus, Die (Maxim Film,
 1923), 73
Fondo Felice Andreis, 55
Foort, Reginald, 17, 18, **20–3**
Ford, John, 141–9, 153
Fort Apache (Argosy Pictures,
 1948), 147
Fox Theatre (Philadelphia), 144
Fox, William, 142
Francklin, Martin, 18, **20–3**
Freudlose Gasse, Die (Sofar–Film,
 1925), 193
Fridericus Rex (Cserépy-Film,
 1921/22), 74
functional music (*Gebrauchsmusik*), 52

Gaiazzo, Piero Antonio, 51
General, The (Buster Keaton
 Productions, 1926), 209, 216
Gee, Harold, 27, 28
George, W. Tyacke, 19, **20–3**, 25

Index 263

Gezeichneten, Die (Primus–Film, 1922), 195
Giornate del Cinema Muto, Le (festival), 212
Girardi, Alexander, 88, 93–4
Goldmark, Karl, 95
Goldsmith, S. O., 17–18, **20–3**, 26, 30
gramophone, 38–40, 130–1, 134–5
 see also phonograph; recording technologies
Grau, Robert, 108
Grauman, Sid, 144–5
Grauman's Egyptian Theatre (Los Angeles), 143
Gretchen Schubert (Noto–Film, 1925), 76
Grünfeld, Richard, 94, 97

Händel, Georg Friedrich, 92, 159
Harms, Rudolf, 174–5, 184, 188
Harrison, Louis Reeves, 111
hermeneutics, musical, 157, 162–6
Hiller, Erich, 95
Hindustani music, 124, 128, 130–1, 133
Hisaishi, Joe, 209, 216, **218**
Hruby, Viktor, 96
Huppertz, Gottfried, 209, 215–16
hypermediacy, 205–6

I promessi sposi (Bonnard Film, 1922), 61
Ich fahr' in die Welt (Deulig Film, 1924), 75
Il Cinema Ritrovato (film festival), 212
Immortal Theater (*Svenska Odödliga Teatern*), 37–8
I.N.R.I. (Neumann–Filmproduktion, 1923), 75, 80
Intolerance (Triangle Film Corporation, 1916), 193
Iron Horse, The (Fox Film Corporation, 1924), 141–9, 153
Israel, Robert, 209, 216–18
Italian music publishers, 55–6, **61–3**
 see also cinema music publishers

Jazz, 80, 193, 196–8, 231
Jones, William, 125

Jung muss man sein (operetta, 1915), 28

Kapellmeister, 70–2, 89, 92–4, 98
Kinomusikblatt, 158–9
Kinothek, 29, 31, 56, 96, 157–9, 161
 see also Giuseppe Becce
Klein, Karl, 89
Kleiner, Arthur, 225–6, **228**, **238–43**
Klovnen (Nordisk Film Kompagni, 1917), 78
Knaak, Manfred, 227, 231–3, **234**, 234–7, **244–6**
Korngold, Erich Wolfgang, 95
Krenek, Ernst, 96
Kretzschmar, Hermann, 157, 162–6
Kußverbot, Das (Noto–Film, 1920), 73, 76
Kyd, Robert, 125

ladies orchestras (*Damenkapellen*), 45, 71
Lawrence, Florence, 107
Lehár, Franz, 87, 97
leitmotif, 227, 229, 235
Levy, Louis, 13, 15, 17–19, **20–3**
library music, *see* cinema music libraries
Lichtbildvorträge, 74
Lienau, Robert, 158
Lomnitzer, Viktor, 68, 77
Luciani, Sebastiano Arturo, 51
Lyric Theatre (New York City), 143

Malia dell'oro, La (Alberini & Santoni, 1905), 49, **59**
Mayer–Aichhorn, Josef, 89
Mazza, Manlio, 58, **60**
Menschen am Sonntag (Filmstudio Berlin, 1930), 193
Messter, Oskar, 38
Metropolis (Universum Film AG, 1927), 73, 209, 214–16
Michaud, Jean, 15, 17–18, **20–3**
Millionenonkel, Der (Sascha Film, 1913), 88, 93
Millöcker, Carl, 87
Mio diario di Guerra, Il (Latina Ars, 1915), 55, **62**

264 *Index*

Miracle, The (Continental Kunstfilm, 1912), 109
modular approach, 26, 30
mood music, 27, 157
Mort des Amants, La (Baudelaire), 223
Moving Picture World, 103–6
Mozart, Wolfgang Amadeus, 73
music films, 85, 93–5
music libraries, *see* cinema music libraries
music publishers, *see* cinema music publishers
see also photoplay music
musica per orchestrine, 52, 54–5
musical archetypes, 147–8
musical directors, 13–18, 25–7, 89, 115
musical interpretations,
multiple, 208, 213, 216, 237
comparative, 210, 214, 236
musical suggestions, *see* cue sheets
musicians, 13, 19, 25, 39–43, 46, 68–72, 90–2, 98, 108, 115, 126, 129, 132–4
union, 43–5, 70, 92–5
wages, 14, 32, 46, 43, 46, 70
see also employment conditions

Nanook of the North (Les Fréres Revillon, 1922), 76, **77**
Napoléon (Ciné France Films, 1927), 208
Neuwirth, Olga, 195
Nibelungen, Die (Decla–Bioscop AG, Ufa, 1924), 76, 193
Novembergruppe, 193

Obey, André, 222
opera, operatic selections, 19, **21**, 52, 58, 75–6, **77**, 84, 94, 98
operetta, 19, 28, 73, 75, 77–8, 80, 84, 86–8, 91, 93–4
operetta film, 73, 77, 80
Opus 2, Opus 3 and *Opus 4* (Hans Richter, 1921/24/25), 194–5
organ, 15, 50, 132–3
original scores, *see* scores

Paluskar, Vishnu, 128–31
pantomime, 106–9, 165

Pax Æterna (Nordisk Film, 1917) 89, 95
Pechstein, Max, 193
Performing Rights' Society, 72
permanent exhibition venues, 41–5, 88, 131
Peterson, Numa, 37–8
phonograph, 38, 66, 104, 134
see also gramophone; recording technologies
photoplay music, 14, 17–19, **21**, 24–5, 29
Capitol Photoplay Series, 145–6, 150–1
Filmona, 95–6
Fischer Concert Orchestra Series, 29
Fischer Playhouse, 29
Red Seal Concert Series, 146
Sam Fox Moving Picture Music, 29
Vindobona Collection, 95–6
pianists, 13–14, 42, 44, 46, 70, 86, 90–3, 104, 226–7, 231
Pilar–Morin, 107–8
Prozor, Gréta, 222
Pudovkin, Vsevolod, 175

Rapee, Erno, 24, 31, 73, 141–2, 144–7, 149–51
recording technologies, 66, 123, 129, 134–5
see also gramophone; phonograph
Red River (Charles K. Feldmann Group, Monterey Productions, 1948), 147
reformation, Indian music, 124, 128–30
Reger, Max, 96
Reinhardt, Max, 108–9
restoration, film, 193–5
Rhythmus 21, Rhythmus 23 (Hans Richter, 1921 and 1923), 194, 197–8
Rialto Theatre (New York), 24
Richter, Hans, 194–6
see also abstract films; *Novembergruppe*
Ricordi, *see* Italian music publishers
Riesenfeld, Hugo, 19, 24, 27, 31
Rivoli Theatre (New York), 24
Roby, Arthur, 13, 15–16

Rosenkavalier, Der (Pan Film, 1926), *see*
 Strauss, Richard
Rosenthal, J. J., 110–11
Rosseta, Guiseppe, **53**
Rübezahl's Hochzeit (Wegener–Film,
 1916), 75
Russell, John, 143

Sala Ambrosio (Turin), 54–5
salon orchestras, (*Salonorchester,
 Salonkapelle*), 52–6, 90–1, 93,
 95–6, 159–60
 see also musica per orchestrine
Satie, Erik, 193, 195, 227, 229,
 231, **238**
Schauburg Theater (Gliwice), 69,
 73–4, 76
Schiavo di Cartagine, Lo (Società
 Anonima Ambrosio, 1910), 55, **59**
Schultheis, Bernd, 209, 215–16
Schreker, Franz, 96
Schubert, Franz, **62**, 76, 92
Schwarze Traum, Der (Fotorama,
 1911), 95
scores
 compilation, 45, 72, 76, 95, 193
 contemporary, 80, 195, 213, 215
 original, 49, 55, 76, 215–16
Searchers, The (Warner Bros.,
 1956), 147
Sechser–Operette, Die (1928), 74
She Wore a Yellow Ribbon (Argosy
 Pictures, 1950), 147
sheet music, 91, 95, 98, 165
shringar ras, 130
Soldat der Marie, Der (Richard
 Eichberg–Film, 1926), 73
Sonate und Kreuzspiel (Ludwig
 Hirschfeld–Mack, 1922/23), 194
Spielmann, Samuel, 70
Springfeld, Tilmar, 76
Stagecoach (Walter Wanger
 Productions, 1939), 146–8, 153
Stindt, Georg Otto, 174–5, 184, 188
Stolz, Robert, 87, 93
Strand Theatre (New York), 15, 24
Strauss, Johann, 73, 76, 87

Strauss, Richard, 76, 95
 Rosenkavalier, Der (Pan Film, 1926),
 75, 95, 195
Suppé, Franz von, 87
Süße Mädel, Das (Noa–Film, 1926),
 73, 76
Svensk Kinematografi, 38
Svenska Biografteatern, 37–8
Swedish Musicians' Union, 43–5
 see also musicians' union

tariffs, *see* employment conditions
Theatre Royal Picture House, Bradford,
 13–14, 27–31
Tootell, George, 15
Trompeter von Säckingen, Der (Eiko
 Film, 1918), 77
Turner, Florence, 107

Universal Edition, 95–6
 see also cinema music publishers
Universum Film Aktiengesellschaft
 (Ufa), 69, 76, 80–1

variety theater, 78, 80–1, 88, 90, 92,
 98, 132
vaudeville, 52, 81, 105, 110, 113,
 116–17
Verdi, Giuseppe, 72, 76
Volkskunst–Vortragsfilme, 94–5

Wagner, Richard, 72, 92, 175, 193
waltz, 14, 18, **23**, 28, 84, 86–8, 94
Weill, Kurt, 95
Weinberger, Jaromir, 96
Western (genre), 142, 144–6,
 148–9, 153
Wiedemann, Arthur, 71–2
Willard, Augustus, 125–6
Wilson, M. B., 66, **67**
Woods, Al, 110–11
working conditions, *see* employment
 conditions
Wunderlich, Willi, 69, 73

Zemlinsky, Alexander von, 96
Ziehrer, Carl Michael, 87, 90, 95

CPSIA information can be obtained
at www.ICGtesting.com
Printed in the USA
LVHW020725150620
658054LV00005B/14